AFRICAN
MASTERWORKS
IN THE
DETROIT INSTITUTE
OF ARTS

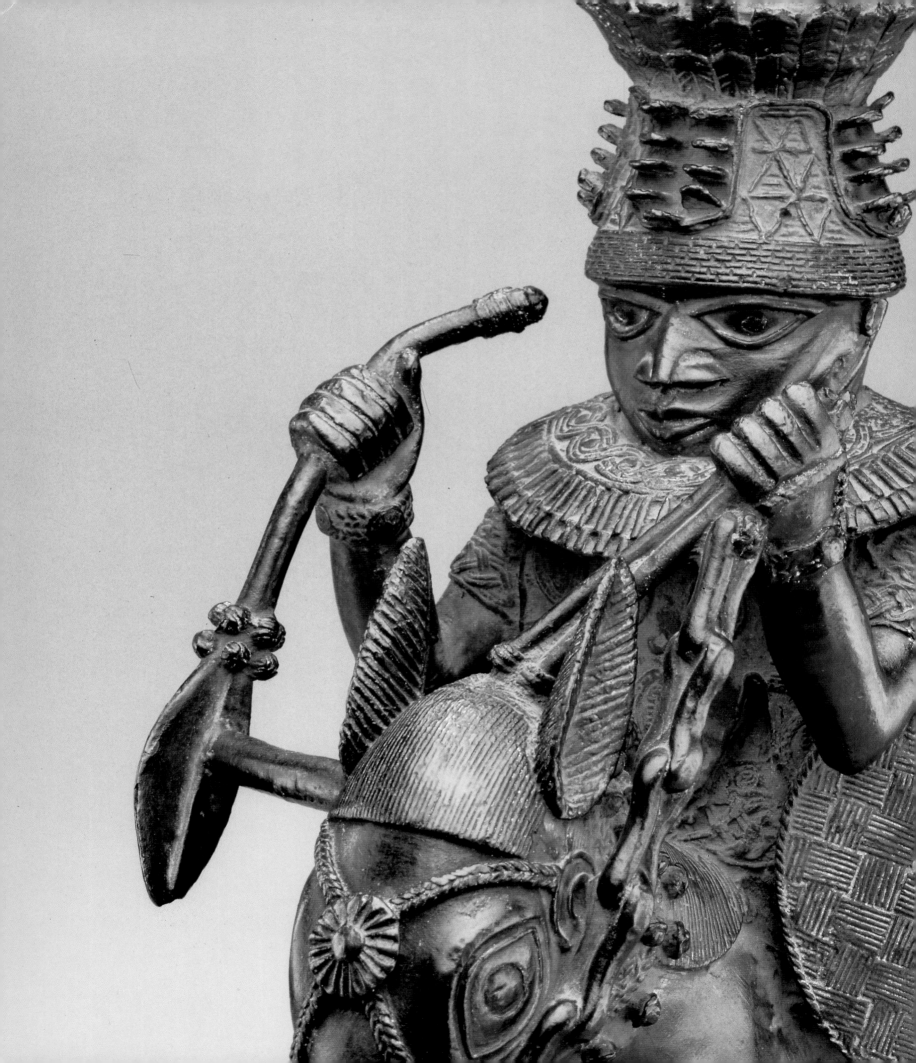

AFRICAN MASTERWORKS

IN THE
DETROIT INSTITUTE
OF ARTS

ESSAYS BY
MICHAEL KAN AND ROY SIEBER

TEXT BY DAVID W. PENNEY,
MARY NOOTER ROBERTS, AND HELEN M. SHANNON

PUBLISHED FOR THE DETROIT INSTITUTE OF ARTS
BY THE SMITHSONIAN INSTITUTION PRESS
Washington and London

For The Detroit Institute of Arts
Director of Publications: Julia P. Henshaw
Editor: Judith A. Ruskin
Editorial Assistant: Matthew Sikora
Director of Photography: Dirk Bakker
Associate Director of Photography:
Robert Hensleigh

For The Smithsonian
Institution Press
Designer: Janice Wheeler
Production Manager: Ken Sabol
Acquisitions Editor: Amy Pastan

Library of Congress Cataloging-in-Publication Data
Detroit Institute of Arts.
 African masterworks in the Detroit Institute of
Arts / essays by Michael Kan and Roy Sieber ; text
by David W. Penney, Mary Nooter Roberts, and
Helen M. Shannon.
 p. cm.
 Includes bibliographical references and index.
 ISBN 1-56098-602-6
 1. Scripture, Black—Africa, Sub-Saharan—
Catalogs. 2. Sculpture, Primitive—Africa, Sub-
Saharan—Catalogs. 3. Carving (Decorative
arts)—Africa, Sub-Saharan—Catalogs.
4. Sculpture—Michigan—Detroit—Catalogs.
5. Carving (Decorative arts)—Michigan—
Detroit—Catalogs. 6. Detroit Institute of Arts—
Catalogs. I. Kan, Michael. II. Sieber, Roy,
1923– . III. Roberts, Mary Nooter. IV. Penney,
David W. V. Shannon, Helen. VI. Title. 95-6169
NB1091.65.D48 1995 730′.0967′07477434—dc20

Support for this catalogue was provided by the
National Endowment for the Arts

A limited clothbound edition of this book was
published by the Detroit Institute of Arts for sale only
at its museum shops (ISBN 0-89558-142-6)

British Library Cataloguing-in-Publication Data is
available
Manufactured in Italy
02 01 00 99 98 97 96 95 5 4 3 2 1

♾ The paper used in this publication meets the
minimum requirements of the American National
Standard for Permanence of Paper for Printed Library
Materials Z39.48–1984.

All photographs are from the Detroit Institute of Arts,
unless otherwise noted. For permission to reproduce
any of the illustrations, please correspond directly
with the sources. The Smithsonian Institution Press
does not retain reproduction rights for these
illustrations individually, or maintain a file of
addresses for photo sources.

Cover: Cat. No. 58, *Nkisi n'kondi*, detail

Back cover: Cat. No. 23, *Soul Washer's Badge*

Frontispiece: Cat. No. 34, *Equestrian Figure,* detail

Contents page: Cat. No. 18, *Drum,* detail

THIS PUBLICATION IS DEDICATED TO THE MEMORY OF
ELEANOR CLAY FORD
(1896–1976)
A GENEROUS SUPPORTER OF THE DETROIT INSTITUTE OF ARTS

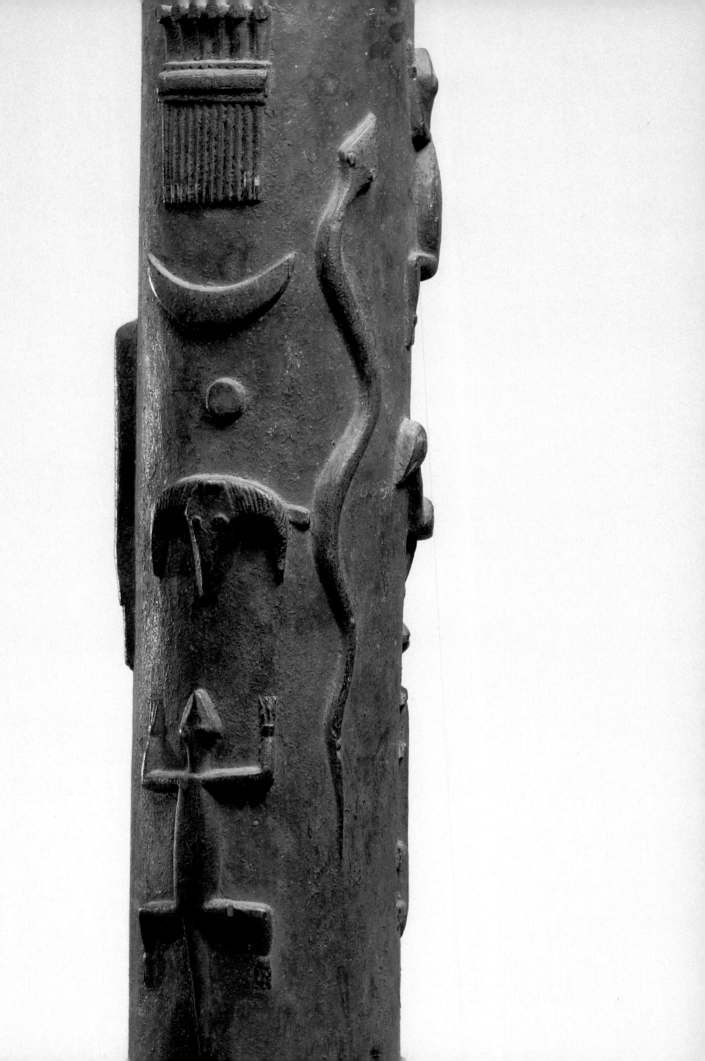

CONTENTS

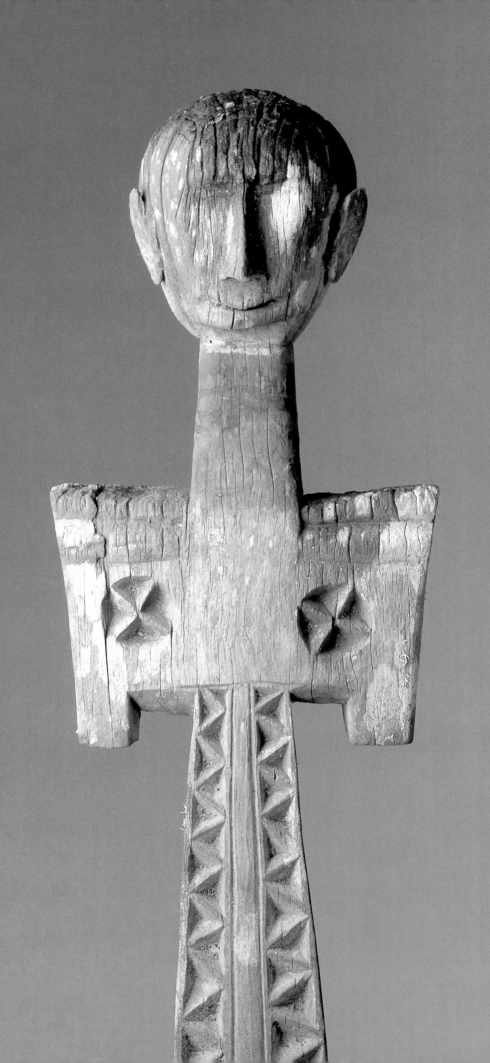

FOREWORD

The Detroit Institute of Arts possesses a varied collection of incredible richness, encyclopedic in its scope and embracing cultures from throughout the world and across the ages. The museum is well known for its superb array of early Netherlandish paintings, early Italian painting and sculpture, American art, and its *Detroit Industry* frescoes by Diego Rivera. But the recognition accorded these works of art should not eclipse or diminish the outstanding examples from other areas of the collection that may not be as familiar to a wide audience.

This volume makes more visible the many outstanding pieces of African art in the Detroit Institute of Arts. While the impressive *Nkisi n'kondi* (Kongo nail figure) and the striking Benin *Equestrian Figure* may not be as familiar to museum visitors as Pieter Bruegel's *The Wedding Dance* or Vincent van Gogh's *Self-Portrait*, they, too, are among the masterpieces of highly developed artistic traditions that deserve and demand further study.

As detailed in the introductory essays by Roy Sieber and Michael Kan, the DIA has been collecting and exhibiting African pieces for nearly one hundred years, making it one of the first museums to consider and value these wonderful works on their aesthetic merits. Like the museum's collection as a whole, the African holdings are encyclopedic, encompassing almost all sub-Saharan cultures, styles, and media. Today, there are more than three hundred objects from Africa in the DIA.

Many of the same individuals who nurtured the museum in its early days and helped build its overall collection were responsible for shaping and enhancing the holdings of African art. In the early years of the twentieth century, Frederick Stearns donated the first pieces of African sculpture to the Detroit Museum of Art, an institution that he helped to found in 1883. William Valentiner, whose tenure as director from 1924 to 1945 brought many familiar works by European artists to Detroit, also acquired notable examples of African art. His master plan for the museum's new building in the 1920s incorporated the display of African pieces as a part of the overall design for galleries.

Cat. No. 81, *Commemorative Post*, detail

Collector Robert H. Tannahill's exquisite taste is not only readily apparent in his 1970 bequest of late-nineteenth-century and early-twentieth-century works to the museum, but in his selection of African sculptures as well. Under the auspices of Director Frederick Cummings, the status of the collection was heightened with the appointment of Michael Kan as curator of the newly formed Department of African, Oceanic, and New World Cultures and the opening of new galleries in the mid-1970s. Kan has ably shepherded the growth of the collection for the past two decades and is responsible for the many fine objects acquired during that time.

It is Eleanor Clay Ford, however, who must be singled out for her far-reaching vision and dedication to building a first-rate African collection in Detroit. A supporter of this institution in innumerable ways for almost fifty years, Mrs. Ford generously provided over a million dollars earmarked solely for the purchase of masterpieces of African art. The Eleanor Clay Ford Fund for African Art allowed for the acquisition of outstanding works of art that have greatly extended the scope of the collection. It is fitting, then, that this volume showcasing our holdings of African masterworks be published in her memory.

Like the collection itself, this catalogue evolved over a lengthy period of time and resulted from the efforts of many people. First and foremost, our thanks go to the authors: Mary Nooter Roberts, consulting curator for the Museum for African Art, New York, wrote the bulk of the entries; the contributions of David W. Penney, curator in the DIA's Department of African, Oceanic, and New World Cultures, and Helen M. Shannon, independent scholar and doctoral candidate at Columbia University, rounded out the text. Roy Sieber, research scholar emeritus at the National Museum of African Art, Smithsonian Institution, and Michael Kan, curator of African art at the DIA, have provided insightful introductory essays placing African art and the collecting of objects in a historical context.

Numerous scholars in the field graciously gave of their time and ideas, providing valuable information on the works in this museum. Their contributions are acknowledged in citations in the individual entries and in the bibliography. We are also appreciative of the contributions made by collectors and dealers, who have shared their discoveries with us and given fully of their expertise. Nancy Ingram Nooter helped in myriad ways in the preparation of the manuscript, particularly in the writing of catalogue entries numbers 50, 57, 75, and 88. Lauri Firstenberg, an intern at the Museum for African Art in New York, provided research assistance.

At the Detroit Institute of Arts, Director of Publications Julia Henshaw has overseen this project from its beginnings; Judith Ruskin was responsible for editing the manuscript and making the publication a reality; and editorial assistant Matthew Sikora willingly tackled all of the details. The marvelous photographs were produced by Dirk Bakker, director of photography, Robert Hensleigh, associate director, and other members of the photography department staff. Archival photographs were

found with the assistance of Betty J. Davis, record center coordinator, and Marianne Letasi, photographic resources manager.

At the Smithsonian Institution Press, thanks go to Amy Pastan, art and photography editor, and Janice Wheeler, designer, for their enthusiastic support and assistance in the publication of this book. Amy Staples of the Eliot Elisofon Photographic Archives, National Museum of African Art, Smithsonian Institution, was most helpful in obtaining field photographs.

Research for and production of *African Masterworks* was partially funded through grants from the National Endowment for the Arts. Additional support for the catalogue was provided by the Andrew W. Mellon Foundation Fund, the Edsel and Eleanor Ford Education and Communications Fund, and the Detroit Institute of Arts Founders Society.

The book is part of a continuing series of catalogues intended to further the study, understanding, and appreciation of works in the permanent collection of the Detroit Institute of Arts. But the catalogue should also be viewed as a beginning, for it is the first, but by no means the last, volume to focus solely on non-Western works of art. It affirms this institution's ongoing commitment to diversity and the exhibition of the greatest artistic endeavors from all cultures.

SAMUEL SACHS II
DIRECTOR

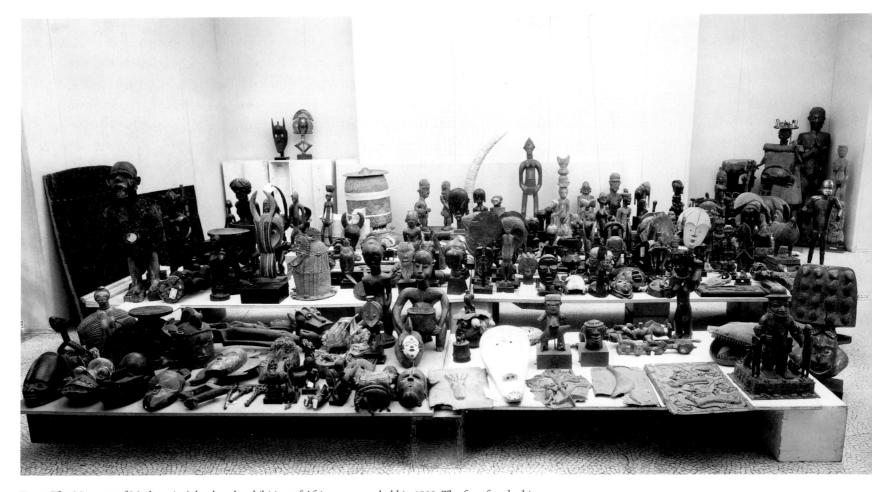

Fig. 1. The Museum of Modern Art's landmark exhibition of African art was held in 1935. The four-faced white Fang mask, now in the Detroit Institute of Arts, can be seen toward the back on the right in this assemblage of objects included in the exhibition, "African Negro Art." (The Museum of Modern Art, New York, March 18–May 19, 1935. Photograph © 1995 The Museum of Modern Art, New York.)

AN INTRODUCTION TO AFRICAN ART

The appearance of new and unfamiliar art forms needs not be at the expense of established and dearly loved older ones. Thus Picasso did not replace della Francesca nor Francis Bacon supplant Rembrandt. Rather they enhanced the corpus of art. Similarly new worlds of art—African, Oceanic, Native American—deepen our already rich artistic heritage and complement familiar traditions. Enrichment rather than replacement is the result of allowing, indeed actively inviting, new types of art into our aesthetic realm.

However, old loves, like old habits, often die slowly. The temptation to think of "either-or" rather than "in-addition" can thwart the acceptance of unusual, unknown, or unfamiliar aesthetic experiences and artistic traditions. The result is the loss of opportunities that truly broaden our experiences and our lives.

From its early years, the Detroit Institute of Arts has demonstrated an openness to embrace the unfamiliar. As Michael Kan describes in his history of the collection, the earliest African objects entered the museum in 1890, gifts of Frederick Stearns (fig. 2). This is, of itself, exceptionally early. True, there are instances of African objects entering other, mostly European, museums during the last decades of the nineteenth century, but rarely, if ever, were they art museums. The national museums in Europe were devoted to natural history and were quite distinct from art museums. Although the Stearns pieces were exhibited separately from the "old masters," they were not excluded from a museum primarily dedicated to works of art.

It may seem strange to emphasize this point now when many art museums, such as the Metropolitan Museum of Art in New York and the Art Institute of Chicago, exhibit African art as well as the arts of Oceania and the Americas. However, the history of collecting objects of "other" cultures (including the Far East and even Medieval Europe) began during the Renaissance as the accumulation of "curiosities," exotic objects quite remote from the arts in fashion at the time. Often assembled by wealthy nobles or merchants, these collections became the foundation of national public museums. This separation of "curiosities" and "art" is reflected in the museum system in England, where African art is found in the Museum of Mankind,

1

a branch of the British Museum, while the National Gallery houses works dating from the Renaissance, and the Tate Gallery exhibits more recent paintings and sculpture. This arbitrary separation never existed in Detroit.

The works that Stearns collected in Paris were available almost as a matter of accident. They were souvenirs brought back by traders or colonials who, for the most part, had little or no knowledge or experience of the arts of Africa. Most of the pieces were seen as unusual objects from strange and distant cultures. Stearns and the Detroit museum are to be congratulated for finding and recognizing the artistic worth of such objects a decade before their "discovery" by Pablo Picasso, Georges Braque, and Henri Matisse. Thus, the Detroit Institute of Arts, possibly because it was not part of the heritage of curiosity cabinets and royal collections, anticipated changes in taste and attitude toward African art that have since become established, if not routine, in art museums.

As times, taste, and museum philosophy have changed, the African collection of the Detroit Institute of Arts has kept abreast of these transformations. To choose a single example, the Guro figure (cat. no. 15) from the Robert H. Tannahill bequest documents the provenance—the pedigree of taste—a single work can acquire. Once owned by surrealist poet Tristan Tzara, it later was a part of the collection of Frank Crowninshield, editor of *Vanity Fair*. With the Philadelphia collection of Albert Barnes, Crowninshield's was possibly the major expression of American taste at the time of the 1935 exhibition of African art at the Museum of Modern Art (MOMA) in New York (fig. 1). A number of Crowninshield pieces were included in the MOMA show. The link between Tzara and Crowninshield was probably the Russian-American painter John Graham, who brought African art to the attention of many American artists and collectors shortly before World War II. Tannahill (fig. 3) acquired the Guro figure from the Crowninshield sale in 1943. Now at home in the DIA, the sculpture is not only an echo of the developing taste of the twentieth century, but exists also as an acknowledged masterwork of African art.

After World War II, there arose a rapidly spreading academic interest in Africa, its culture, history, and politics. Study centers were developed at Northwestern University, Indiana University, and the University of California, Los Angeles, among others. American scholars began specializing in African arts and conducting field research in Africa. In the same years after World War II, several important galleries specializing in African art flourished in New York, Chicago, and Los Angeles.

Justice G. Mennen Williams (fig. 4), while serving in a governmental post related to Africa, put together a collection of objects, mostly masks and figures, that were available in West African marketplaces during the 1950s and 1960s. These works reflected a period of intense and growing interest in African art that was fed in part by African dealers who searched out objects of interest to non-Africans and offered them in major African cities. Also during this time, African dealers filled hotel rooms in the United States with wood carvings. They toured many larger and some smaller

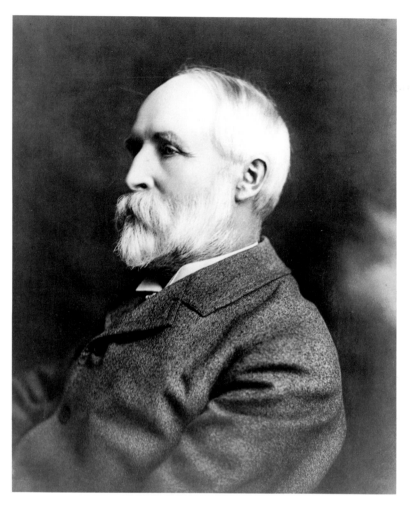

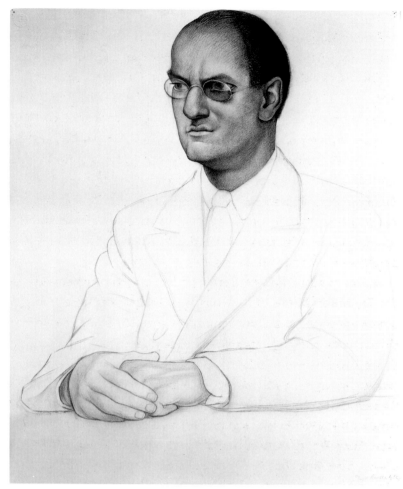

Fig. 2. Frederick K. Stearns, a founder of the Detroit Museum of Art, forerunner of the current institution, gave the museum its first African pieces in 1890 as part of a gift of more than 10,000 ethnographic objects.

Fig. 3. Robert H. Tannahill, shown here in a portrait by Diego Rivera, was well known for his outstanding collection of late-nineteenth- and early-twentieth-century European works of art. On a smaller scale, he also collected superb examples of African art. His entire collection came to the Detroit Institute of Arts in 1970. (Diego Rivera, *Portrait of Robert H. Tannahill,* 1932, red and black chalk, 73 × 57.9 cm [28¾ × 22¹³⁄₁₆ in.] The Detroit Institute of Arts, Bequest of Robert H. Tannahill, 70.332.)

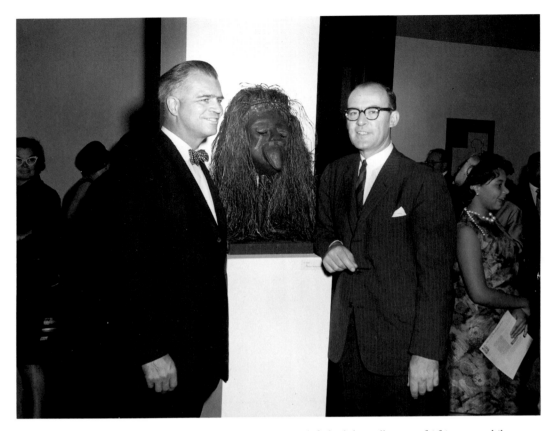

Fig. 4. Michigan Supreme Court Justice G. Mennen Williams (left) built his collection of African art while serving as Assistant Secretary of State for African Affairs. He is shown here with DIA Director Willis Woods and a piece from his collection in the mid-1960s. The museum's first permanent installation of African art opened during Woods's tenure as director.

cities in their search for clients. The objects they offered ranged from recent copies or, at times, outright forgeries to old examples of excellent craftsmanship.

However, it is since the 1970 Tannahill bequest, which included a number of significant African sculptures in addition to several marvelous modern paintings, and most particularly since 1976 with the arrival of Michael Kan (fig. 5) as curator, that the Detroit collection has blossomed until it is now one of the most significant museum holdings of African art in the United States.

A number of pieces were once part of the famous Helena Rubinstein collection, which had been amassed over several decades and was sold at auction in 1966 after her death. These pieces include the Fang head (cat. no. 52), the Bena Lulua figure (cat. no. 74) that had been collected by the German ethnographer Leo Frobenius in 1905–06, and the Fang four-faced mask (cat. no. 49), which was once in the collection of noted Paris dealer Paul Guillaume. The Rubinstein sale was a watershed with respect to the aesthetic appreciation and the prices for African sculpture, for it was the first major highly contested auction with collectors and museums vying for im-

Fig. 5. Michael Kan was appointed the first full-time curator of African art in 1976 when he was named to head the newly formed Department of African, Oceanic, and New World Cultures. He is shown here in the African galleries in the early 1980s.

portant pieces. Since then the demand for and the prices of fine examples have escalated, and what seemed exceptional in 1966 now seems quite modest.

In scope, the Detroit collection now contains representative works from most major African sculptural traditions. This goal has been reached with careful consideration of the cultural setting of the works as well as attention to their aesthetic quality.

The sculptural arts of sub-Saharan Africa, which is the primary geographic focus of the collection, are best known for pieces from much of west and central Africa, although some fine examples are known from eastern and southern Africa. This is in part due to the fact that sculpture is produced mostly by settled agricultural societies, such as those found in the west and central parts of the continent. Nomadic

groups, such as those of the eastern and southern areas, limit their arts to more easily transportable ones like jewelry, clothing, and small household objects. These forms are, of course, also found among many settled groups, but in the opinion of Westerners they have been outshone by masks and figure carvings.

Sculptures have been produced in wood, ivory, stone, terra cotta, and metal. The copper-alloy lost-wax castings of Nigeria are well known. Particularly noteworthy are the fine works from Benin, such as the magnificent equestrian figure (cat. no. 34). Gold was the metal of leadership (see fig. 26) and was especially prized among the Akan of Ghana (see cat. nos. 20, 22, 23), formerly and appropriately called the Gold Coast. Stone was used rarely and, when used, was often a soft and easily worked material such as steatite (see cat. no. 55).

Although it appears over most of the subcontinent, ivory was also used quite rarely. It was considered precious and was often limited to objects that reinforced the high status of the owner (see cat. nos. 31, 80). In the early years of European contact, ivory prestige pieces were carved for foreign visitors to take back home. One example, possibly made by a Kongo artist several centuries ago, is the knife case that came to the museum in 1925 (cat. no. 56, see fig. 18).

Wood, however, was the medium of choice for most sculptural art of Africa. Its use was certainly abetted by the widespread appearance of iron tools after 500 b.c. The relative ease of working wood with such implements was to some degree offset by the material's fragility. Unlike stone or metal, wood is easy prey to the climate and insects. With few exceptions, the life span of a wooden object, even when carefully protected, was limited to a generation or two. Once it had succumbed to the elements, it had to be replaced. Therefore, every sculpture in a collection has had its life cycle interrupted and has been preserved for us. The preciousness we attribute to the works is our evaluation, for the African owners and users, despite their respect and often awe of them, were more practical minded.

Further, Africans felt no restraint to preserve the work in the form it left the sculptor's hands. Many pieces were painted and repainted, handled, added to, or otherwise modified with no sense of unease by the user. The large Kongo *Nkisi* (cat. no. 58) is a fine example. At one time in its life it was bereft of nails; each added nail was an act of ritual commitment. At the same time, each nail modified the artist's original conception, although his original intent allowed for, indeed anticipated, those changes. Further, the figure was at one time bearded and dressed with a raffia skirt. In short, it was an active, changing object until it was collected in 1903 (however, it did not come to Detroit until 1976).

It is probable that each medium had its own specialists (see fig. 6). This is certainly true of metal casters, iron forgers, artisans, potters, and carvers of wood and ivory. The artist was most often trained in an apprenticeship system where he or she (sculptors, except for some workers in clay, were male) learned by doing and observing a master. Nearly all artisans were part-time specialists, who were also respon-

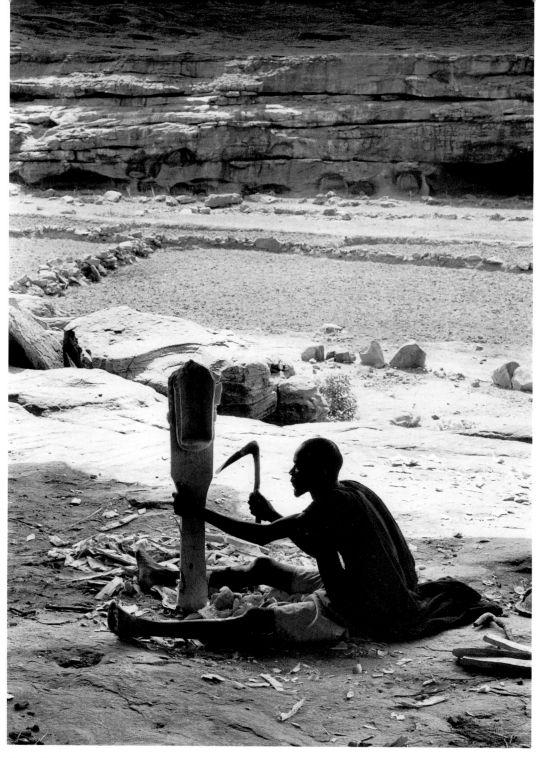

Fig. 6. Wood was the medium of choice for most African sculptures, in part because of the relative ease of carving it. Here, a Dogon sculptor in Upper Ogol village, Mali, creates a *kanaga* mask using an adze, the most common woodcarving tool. Photograph by Eliot Elisofon 1970. (National Museum of African Art, Eliot Elisofon Photographic Archives, Smithsonian Institution.)

sible for the family food supply in a society primarily dependent on subsistence agriculture. Nevertheless, the sculptor was a recognized expert in most groups and was often sought out by patrons who rewarded him for his time and talents. Nearly all works were commissioned; only very rarely did a sculptor make and stockpile masks or figures against the demands of the clientele. Thus, the patron and the

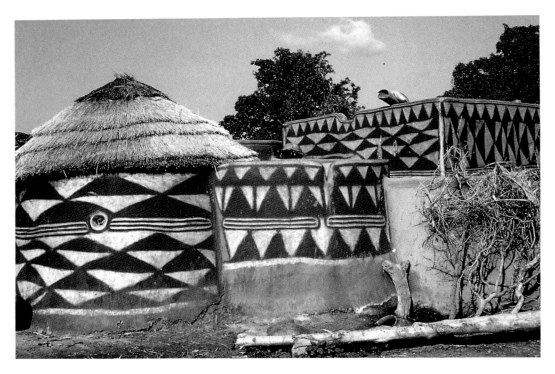

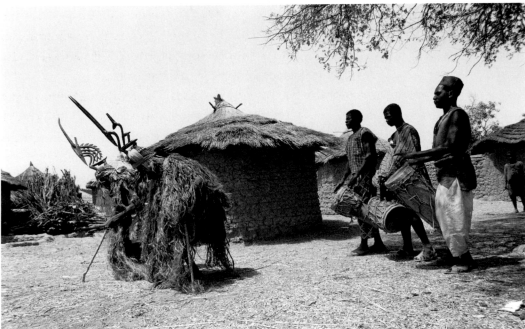

Fig. 7. (*Top*) African art is distincitive for its utilitarian base, with almost all works having a useful and often culturally significant purpose. Two-dimensional decoration, such as on these painted houses in the Northern Ghana compound of Frafra, village of Zaare, served to enhance utilitarian objects, which would be considered better and finer than unadorned ones. Photograph by Fred T. Smith, Kent State University. Fig. 8. A pair of Chi Wara antelope dancers perform during a Bamana agricultural festival in the Bamako area of Mali. Photograph by Eliot Elisofon 1971. (National Museum of African Art, Eliot Elisofon Photographic Archives, Smithsonian Institution.)

artist were in close contact, the artist produced exactly what the patron asked for, and the patron often directed quite meticulously the nature of the creation he would use.

Perhaps the most distinctive aspect of African art, in contradistinction to recent art in the Western world, is its utilitarian base. In Africa south of the Sahara, there was little art that did not have a useful, often deeply important cultural purpose. It is true that some two-dimensional ornamentation existed because it enhanced the object it decorated, but that object was itself useful almost without exception. A calabash food container might carry pyro-engraved or dyed designs; a house might be decorated with painted patterns (see fig. 7). In such cases, the decorated object was considered to be better, finer, more aesthetic than an undecorated one.

African sculpture was most often associated with religious rituals or ceremonies, and its utility was the primary justification for its existence. Did it "work" as a ritual object, if ritual was its main import; did it bring more children, if continuity of the family or group was its intention; did it make contact with the ancestral spirits, if that was its goal? Did it insure a successful harvest (see fig. 8), accurately foretell the future, ward off illness, or accomplish any of the myriad of other things for which it was intended? Until it did, no proper question of aesthetics would or could arise.

The sculptures appeared in rituals and ceremonies tied to nearly all aspects of life ranging from birth to death. Thus, it is not surprising to find that the meaning of most works was related to one or more of the basic aspects of life and that the works were for the greater part dedicated to achieving a better world.

A great number of the sculptures were dedicated to the general well being of the individual and the group and thus were felt to contribute to a more secure world. Some, such as the Bedu mask (see fig. 9, cat. no. 19), were protective of the group, guarding against evil forces that resulted in death, illness, or too few children. Others were used to swear oaths and make pacts (see fig. 10, cat. no. 58) or helped establish gender balance within the society (cat. no. 26). A large number depict women with children (see cat. nos. 39, 59) and reflect the basic role of woman as child bearer and her responsiblity for the survival of the family group. Indeed, a woman who had no children was considered to have failed to meet her primary obligation to society.

While many sculptures were group oriented, others were addressed to individuals whose lives thereby improved. The Baule female figure (cat. no. 16) may have been the "spirit spouse" of a man who having experienced difficulties with his farm or his marriage believed those troubles to have been caused by the jealousy of his spirit spouse.

As an individual moved through life, he or she went through a series of transitions: from child to adult; from single to married to widow or widower; from junior to senior to elder status. Major ceremonies accompanied many of these changes. For example, masks often played an important role in the Senufo ceremonies of

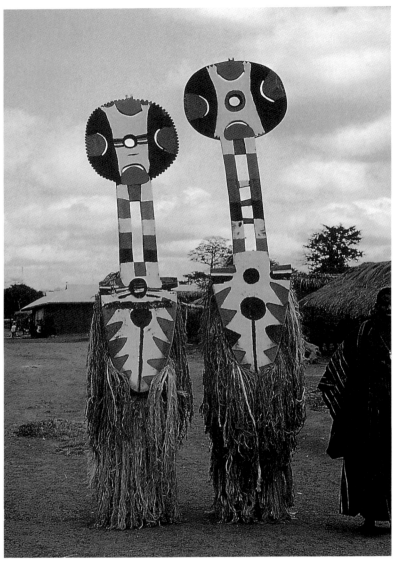

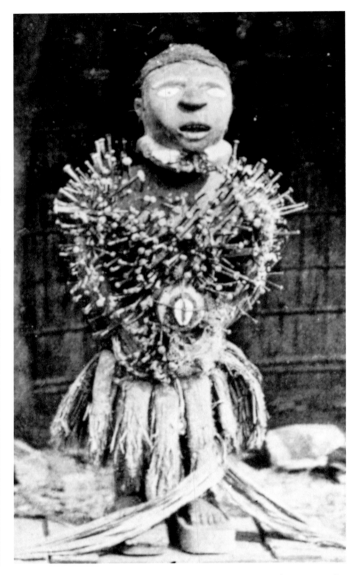

Fig. 9. Bedu masqueraders of the Nafana in Côte d'Ivoire perform at a month-long festival dedicated to the general well being of the group. Photograph by René Bravmann, University of Washington.

Fig. 10. Each nail or blade driven into a *nkisi n'kondi* signifies an act of ritual commitment, an oath or pact sworn before the sculpture. In this 1896 photograph, the nail figure, from the Kongo people of Zaire, is posed in front of the house of an *n'ganga* or ritual expert. (Photograph, courtesy The Field Museum, Chicago, neg. #57566.)

advancement in the men's Poro society (see fig. 11, cat. no. 12). Among the Lega, the Bwami society used various sorts of grade-related objects. Small ivory figures (cat. no. 80) were part of the regalia of men of the highest rank.

But perhaps the most frequent ceremonies of transition were those that celebrated coming-of-age, the formalization of the move into adulthood (see fig. 12). A training period prepared a child for his or her adult responsibilities. The novice was taught the history of the group, and, at times, a craft. In the past, the period of

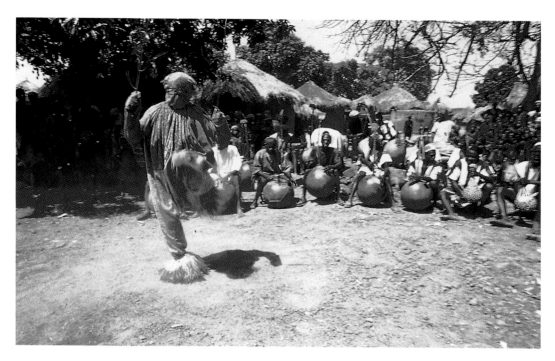

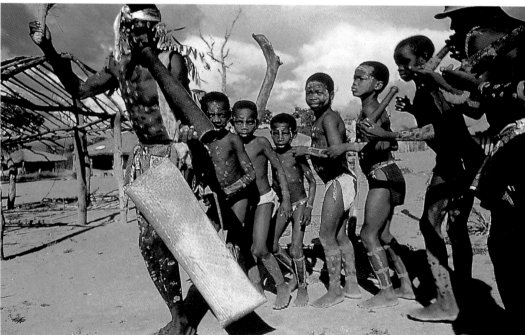

Fig. 11. (*Top*) All Senufo men are initiated into the Poro society, responsible for the social and religious education of its members. Major ceremonies, marked by masked performances such as this one held at Promafolo, near Korhogo, Côte d'Ivoire, often commemorated a member's transition through the stages of life. Photograph by Eliot Elisofon 1971. (National Museum of African Art, Eliot Elisofon Photographic Archives, Smithsonian Institution.) Fig. 12. Among the most common of ceremonies were those that marked the coming-of-age of children and young adults as fully initiated members of society. Here, Dakpa boys participate in a non-masked initiation ceremony in the Ubangi-Chari region of the Central African Republic. Photograph by Eliot Elisofon 1959. (National Museum of African Art, Eliot Elisofon Photographic Archives, Smithsonian Institution.)

preparation might take several years, but modernization has severely cut the amount of time available until now it might be encompassed in the brief period of a school vacation. Many ceremonies included masks such as those of the Bundu women's society masks of the Mende (cat. no. 14) or the Mukanda initiation school of the Yaka of Zaire (cat. no. 63).

Centralized societies often had works of art associated with the rulers. The commemorative shrines of the rulers of Benin included cast copper-alloy heads (see fig. 13, cat. no. 33). Metal containers called *kuduo* were reserved for persons of high status among the Akan (cat. no. 24). In societies that were not centralized, masks and figures often reinforced the decisions of the councils of elders in whose hands leadership rested. The Bwami society, for example, was responsible for governance among the Lega, and the works tied to that society lent credence and authority to its decisions (see cat. no. 80).

Status and prestige were reflected in many objects, some associated with leadership, like the Benin wall ornament (cat. no. 32) and the Akan gold pieces (cat. nos. 20, 22, 23). We may assume that some, such as the Cameroon beaded throne (cat. no. 40) and the Songye caryatid stool (cat. no. 78), belonged to chiefs. Others, like the Zulu men's staff (cat. no. 86) or the several neckrests in the collection (cat. nos. 65, 76, 79, 84) reflect the wealth of position attained during one's lifetime. Of special note is the Zande harp (cat. no. 47). Obviously the prized possession of a bard, this harp is exceptional in the asymmetrical depiction of a full figure.

Finally, a large number of works of sculpture were concerned with death and the ancestors. The spirits of the ancestors are frequently believed to continue to serve an important role in the life of the living. Committed to their descendants, they serve as agents in the spirit world ensuring health, children, and prosperity for the living. Thus, commemorative statuary appears over much of the subcontinent from Benin (cat. no. 33), the Fang (cat. no. 52), the Bembe (cat. no. 61), and the Kambe (cat. no. 81). In addition, many funerals are celebrated with the appearance of masked dancers. A Dogon mask (cat. no. 5) and a Senufo mask (cat. no. 12) are among those represented in the collection.

The African collection of the Detroit Institute of Arts balances the scope of sub-Saharan styles and types, paying careful attention to contexts of use and to aesthetics. It is important to note that the latter is a reflection of the taste of the West. It has been suggested that African patrons, by their choice of artists whose works have survived and by the fact that we also prize many of those works, expressed aesthetic judgments similar to our own. The Detroit collection demonstrates that among the finest—in our judgment—of African sculptures are many that stand up well in comparison with the finest works—again in our judgment—from any place and any time. But this is setting our Western culture-bound ethnocentric choices from various cultures against each other. Ultimately, it is our choice in every case. We have for Africa, indeed for much of the world, little evidence of the aesthetic taste of the

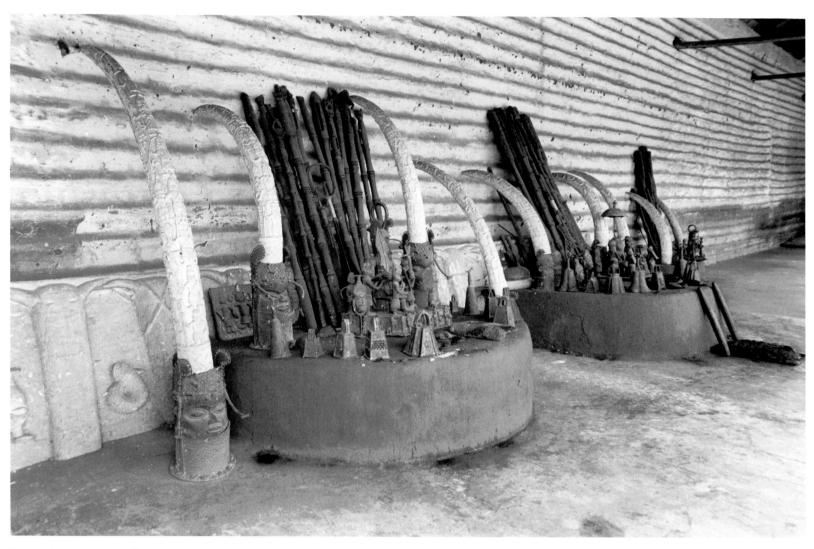

Fig. 13. Commemorative shrines were erected for Benin *Obas*, or kings, featuring bronze sculpted heads topped by carved ivory tusks. The ancestral shrine to Eweka II (died 1933) is at the left, the one for Ovonramwen (died 1914) on the right. Photograph by Eliot Elisofon 1970. (National Museum of African Art, Eliot Elisofon Photographic Archives, Smithsonian Institution.)

makers and users of works that were conceived and commissioned not as pure form but as utilitarian objects.

Indeed, the definition of a work of art is a difficult one because, in the end, it is often a judgment made by one culture about objects produced by a different, at times quite alien, culture. There is a universalistic view that holds, quite without qualification, that works recognized as fine by an observer from one culture at one moment in time will be so acknowledged by an observer from another culture or time. A more relativistic point of view argues that each culture and each time has its own aesthetic and that aesthetic judgments are both time and culture bound. Thus, it may be argued that no Westerner can fully understand or appreciate the art of another time or place. We may strive to do so by studying the history and context of the arts of other cultures and eras, but in the end we can never do better than guess at the intentions of the maker or the user, or the aesthetic response of a viewer. We can and do, with considerable success, attempt to explore the context of the work of art, searching out its role and meaning in the society that gave rise to it. We can and do, albeit with somewhat less success, study its creator, seeking to define the artist's place in the society as well as his or her biography and working methods. In general, we can conclude that the sculptor in Africa is a bit of a sport, not quite the solid citizen that the farmer is in these predominantly subsistence agricultural societies. Yet for the most part, the societies held the works in high regard, recognizing and rewarding the sculptor's skills. In this context, skill should be taken to include excellence in a very broad sense, perhaps taking into consideration line and form. Because these were acknowledged by the African audience as part of the familiar and comfortable aspects of size, style, and type, they may not have needed to have been discussed, although they would have been recognized and certainly their absence criticized.

Further, all judgments, including aesthetic ones, are comparative and all comparisons depend on the depth and breadth of experience of the viewer. However, certain difficulties prevent our understanding of the nature and complexity of African aesthetic sensibilities. In the past, a viewer's range of experience in Africa was severely limited, often to the works to be found in a single village. Extreme sophistication might have included knowledge of a few neighboring villages or groups. Anyone who pages through this book will have had far more exposure to the variety of African art than nearly any African of a few generations ago.

At the same time, when a society is small, almost everyone is to some degree knowledgeable of types, forms, and meanings. The requirements of the patrons are known, indeed shared, by the artists. Expectancies may be broadly shared and criticism expressed simply or, indeed, nonverbally. Unfortunately, earlier outside researchers failed to discuss with Africans the bases for their judgments. Thus, we know far too little of African aesthetics or the bases on which sculptors were selected.

It is clear that art has been closely identified with life in Africa. Much of the traditional ways has disappeared, and the practices and the arts that accompanied that life are diminished. Some arts—such as music—tend to persevere longer than others—such as sculpture. Sculpture faced adversaries over much of the recent history of Africa. Closely tied to traditional religion, it was considered a threat by those who opposed these religious beliefs. Missionaries, both Islamic and Christian, worked to replace indigenous religions and thereby undermined the basis for much art. Modernisms, including medicine, education, and transportation, displaced older methods of training and health and opened up Africa to outside forces that threatened traditional life practices. Colonialism, and indeed modern governments, supplanted tribal authority and denigrated the works of art that had supported it.

Thus, change comes to Africa as it must to all places and times. Never a total stranger to change, the arts of Africa will survive in some form, but the masterpieces of the past are of the past and should be revered as evidence of the major contribution Africa has made to the history of world art.

ROY SIEBER

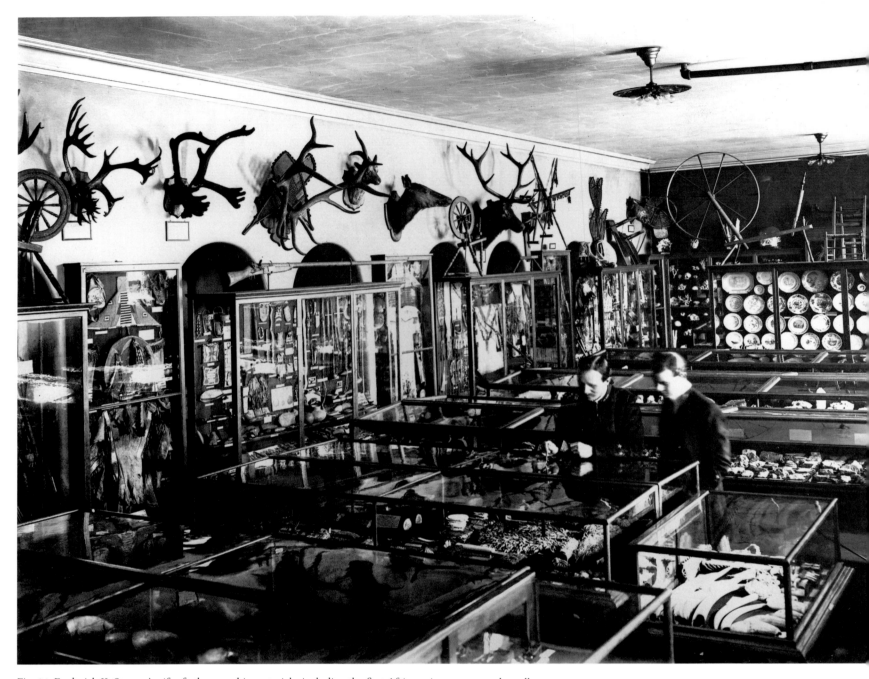

Fig. 14. Frederick K. Stearns's gift of ethnographic materials, including the first African pieces to enter the collection, was displayed along with other "exotica" in the Scientific and Historical Department of the Detroit Museum of Art. Among the fossils, animal trophy heads, and spinning wheels, a fine Native American Cheyenne shield can be seen on the middle shelf of the far left case in this photograph from about 1900.

AFRICAN ART AT THE DETROIT INSTITUTE OF ARTS

African art first came to the Detroit Museum of Art in 1890 as part of a generous gift of more than 10,000 objects amassed by one of the institution's founders, Frederick K. Stearns (fig. 2). The fledgling museum, located at the corner of Jefferson Avenue and Hastings Street, was an institution in search of a lasting identity. Was it to be a "temple" devoted to the fine arts, housing only great collections of old masters comparable to the one assembled in 1889 by another founder, James Scripps, or was it to house a broader based collection of art, science, ethnology, history, and archaeology, as well as serve the community as a social center (Peck 1991, 40–41)?

Stearns's gift clearly fell into the latter conception of a museum. His ethnographic materials, including African wood carvings, were displayed in the scientific and historical section of the Detroit Museum of Art. This conglomeration of objects crammed into cases reflects not only Stearns's somewhat indiscriminate style of collecting, but also the way in which "ethnographica" were lumped together with other exotica in turn-of-the-century displays (fig. 14). Outstanding objects, such as the Native American Cheyenne shield collected by George Armstrong Custer, were unceremoniously mixed in with fossils, animal trophy heads, and other miscellaneous items.

Stearns made a fortune in the pharmaceutical business, which enabled him to travel the world collecting from 1871 to his death in 1907. Most of the "curiosities" he gathered from the Middle and Far East ranged from everyday household objects, such as ceramics and lacquerware, to mummies and zoological specimens. A particular favorite with the museum-going public was a pair of carved oversized Sumo wrestlers (Peck 1991, 41), acquired from a Japanese exposition (fig. 15). The figures clearly had nothing to do with fine art and would certainly qualify today as masterpieces of sheer kitsch.

Unlike the British Museum and great German ethnographic museums like Berlin's Museum für Völkerkunde, which sent trained anthropologists to Africa to collect in the field, Stearns relied on secondary and even tertiary sources. He regularly bought

Fig. 15. Stearns traveled extensively, collecting everything from ordinary household objects to mummies and zoological specimens. A favorite with museum visitors at the turn of the twentieth century was a pair of over-sized Sumo wrestlers purchased at a Japanese exposition.

from curiosity dealers such as Emile Heymann in Paris, whose name has been linked to the "discovery" of African art by Matisse, Picasso, and other avant-garde artists working at the turn of the century (Paudrat 1984, 139–141), and from the African Pavilion at the Paris Exposition of 1900.

Of the many Stearns pieces in the Detroit Institute of Arts, the only ones regularly on display today are the mid-nineteenth-century Kongo *ntadi* stone commemorative figure of a man wearing a European frock coat (cat. no. 55) and a superb Chokwe female figure holding food bowls (cat. no. 66), which is very similar to a well-known female figure in Berlin, only lacking a coiffeur of human hair.

Far more typical of the objects acquired by Stearns are pieces such as an Asante stool which, to the best of our knowledge, has never been on display. The stool is well carved but must have been collected on the day it was finished, for it is totally lacking any sign of use or patina. This makes an interesting contrast to a magnificent stool of the same type in the collection of Mr. and Mrs. Donald Morris (see Detroit 1977, fig. 53), which has a warm red patina induced by years of handling.

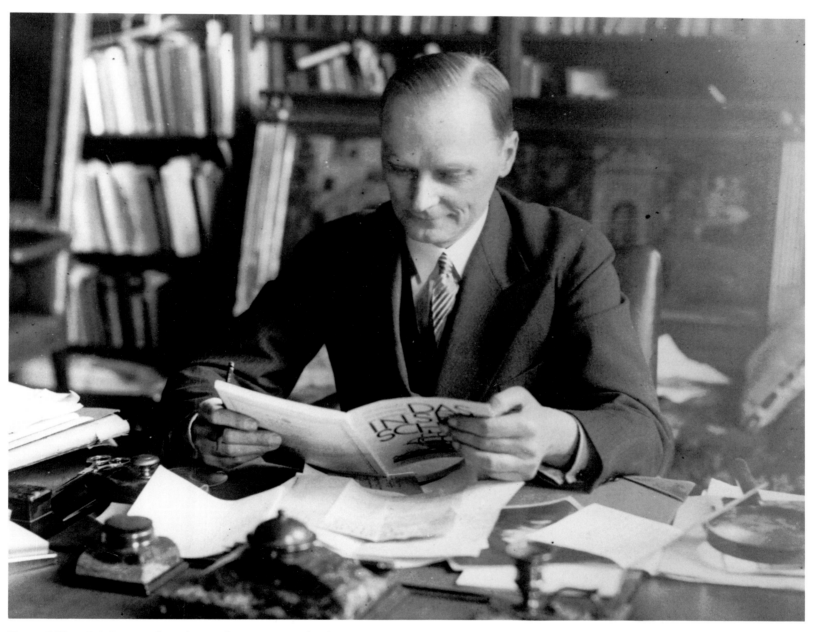

Fig. 16. William R. Valentiner, shown here in about 1930, served as director of the Detroit Institute of Arts from 1924 until 1945. He was the first professionally trained art historian employed by the museum.

AFRICAN ART IN THE TWENTIES AND THIRTIES: THE VALENTINER YEARS

By 1919, the Detroit Museum of Art had become the Detroit Institute of Arts, with a city-appointed Arts Commission to govern it and a mandate to create a great civic art museum at 5200 Woodward Avenue. The talented Philadelphia architect Paul P. Cret was hired to plan the new building, which was eventually to house an extraordinary collection installed in innovatively arranged gallery spaces. To bring to fruition

the ideas of a considerably enlarged museum and its growing collection, William R. Valentiner (fig. 16) was named a consultant to and, in 1924, director of the institution. He was the first professional art historian to be employed by the museum.

Valentiner came to Detroit with a brilliant track record. He had degrees from Heidelberg and Leipzig, served as assistant to the great director Wilhelm von Bode of the Kaiser Friederich Museum in Berlin, and was the first curator of the Department of Decorative Arts at the Metropolitan Museum in New York. His extremely varied background and working experience in many fields of the arts gave Valentiner a unique approach to the organization and installation of the galleries in the new museum. Instead of segregating painting, sculpture, and decorative arts in separate galleries as was the custom at the time, Valentiner integrated the entire range of arts into an elaborate gallery complex designed to place objects in their cultural and historical contexts (Valentiner and Burroughs 1927, VI).

At a time when African and Precolumbian art was relegated to separate museums housing ethnographic and anthropological collections, Valentiner saw fit to include objects from these cultures in installations covering the finest works of art produced during human history. In the new museum, Precolumbian, Native American, Oceanic, and African art was housed in Gallery 26, situated between the Asiatic and American sections (fig. 17). This was done to raise the issue of possible links between Asia and the lands around the Pacific rim.

An illustration from the 1927 *Guide to the Collections* of Gallery 26 (fig. 18) shows two major African acquisitions made by Valentiner in the 1920s. A rare Kongo-Portuguese sixteenth-century carved ivory knife case (cat. no. 56), which had formed part of the Guidi collection of early ivories, is shown almost directly under a bronze head of a regal *Iye Oba* or Queen Mother of the Benin court (cat. no. 33), dating from the late eighteenth or early nineteenth century. While in Berlin as an assistant to von Bode, Valentiner must have been exposed to the magnificent Benin bronzes then on display at the Dahlem Museum.

William Valentiner, museum director, art historian, and connoisseur par excellence, was only outshone by Valentiner the teacher. One of his truly unique talents was his ability to befriend and instruct groups of prominent Detroiters who would play vital roles in the development of the Detroit Institute of Arts' collections and, more specifically, its African collection. The group consisted primarily of Edsel Ford, his wife Eleanor Clay Ford (fig. 19), and her relatives, Robert Hudson Tannahill (fig. 3) and the Ernest Kanzlers. Tannahill, Mrs. Ford's first cousin, was an outstanding scholar and collector. He and the Edsel Fords had a particularly close relationship with Valentiner. They held informal social gatherings where art connoisseurship was discussed, traveled together to visit collections and dealers, and generally shared both private and museum-related collecting experiences. Tannahill was subsequently appointed to the Board of Trustees and Arts Commission as he quietly built

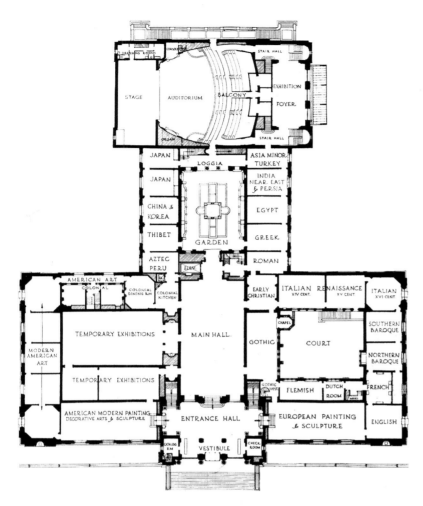

Fig. 17. Valentiner's unique plan for the Detroit Institute of Arts called for the integration of the entire range of arts into a series of galleries designed to display objects in their cultural and historical contexts. The gallery labeled "Aztec, Peru" in this 1927 floor plan was also the home of all the arts then considered to be "primitive," including those from Africa. Fig. 18. (*Top, right*) In Valentiner's installation, African art was displayed with Precolumbian, Native American, and Oceanic objects in a single gallery. The rare sixteenth-century Kongo-Portuguese ivory knife case and the bronze head of an *Iye Oba,* or Queen Mother, are visible in the case at the far left in this photograph from the 1927 *Guide to the Collections.*

Fig. 19. Eleanor Clay Ford, a staunch supporter of the Detroit Institute of Arts, established a fund to purchase outstanding African pieces for the museum. She and her husband, Edsel, were among Detroit's earliest collectors of African art.

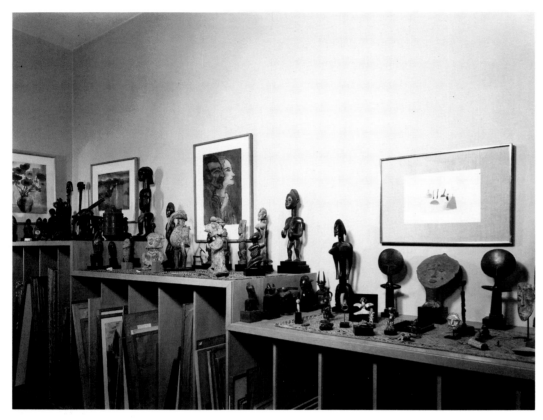

Fig. 20. Although Robert H. Tannahill is principally remembered for his bequest of post-impressionist and early-twentieth-century art to the DIA, his small, high-quality collection of African sculpture also came to the museum. His African works are seen here in his Grosse Pointe Farms home, arranged before three watercolors by Emile Nolde on the wall at the left and a gouache by Julius Heinrich Bissier on the right.

his private collection (fig. 20), which he bequeathed to the museum (Peck 1991, 77–78).

Tannahill was an ardent supporter and collector of modern art. He maintained close ties to the Museum of Modern Art (MOMA) in New York, was a founder of the pace-setting Detroit Society of Arts and Crafts (DSAC) Gallery of Modern Art, and amassed the most extensive collection of twentieth-century art in the Detroit area. Aware of the connections between the arts of Africa and the early modernist painters, Tannahill also became one of the first American collectors of African art, making his first purchases in the early 1930s (Jacob 1976, 155–159, 166). He collected primarily the styles from the French African colonies, in keeping with the traditions and tastes developed by the twentieth-century artists, such as Picasso, Braque, and Matisse, whose work he collected. The African pieces, exemplified by the Fang figure (cat. no. 51), would have appeared in Paris in the 1920s and '30s.

The Edsel B. Fords were also early collectors. Although there is a paucity of archival evidence, it is probable that they acquired their great Benin equestrian figure (cat.

no. 34) between 1935 and 1937. It appears in the M. Knoedler and Company sales catalogue *Bronzes and Ivories from the Old Kingdom of Benin* (1935, plate 13) and is recorded as having been loaned to the Albright Art Gallery of Buffalo in 1937.

The Museum of Modern Art held its landmark exhibition of African art in 1935 (see fig. 1), and the following year Tannahill arranged for Detroit's first showing of works from Africa at the DSAC Gallery of Modern Art. The Pierre Matisse Gallery in New York lent twenty-five pieces from the Ivory Coast, two from the Cameroons, thirteen from the then Belgian Congo, nine from Benin, eight from Gabon, and a selection of textiles to the exhibition. In 1937, the Detroit Institute of Arts sponsored its own show of Benin art at Alger House in Grosse Pointe (Jacob 1976, 166).

These early Detroit exhibitions are a tribute to the taste and avant-garde outlook of Valentiner, Tannahill, and the Edsel Fords. However, beyond their circle, they did not reach a wide audience. The 1937 show at Alger House was not even accompanied by a catalogue and, as a result, is difficult to document. An impressive group of eight ivory carvings and twenty-one bronzes were assembled from the collection of the famous Parisian dealer Louis Carré and circulated by M. Knoedler and Company of New York. Many objects were for sale but few remained in Detroit. Some of these pieces, worth millions today, could probably have been bought for no more than $15,000 in 1937.

Although African art was never the main thrust of Tannahill's collecting, he continued to buy steadily through the early sixties. His great knowledge and innate taste saved him from a common mistake made by many collectors. Exposure to masterpieces of American folk art and twentieth-century sculpture taught him that great African art ("primitive art" in the terminology of the '30s) did not have to be crude. The following statement, though it relates to painting, best reflects Tannahill's sensitivity to African art. According to former museum director Frederick J. Cummings, the African sculptures, embellished with superb patinas and delicately wrought textures, are the key to the artistic values Tannahill sought in his other purchases—a "preponderant joy in austere, rigorously controlled, bluntly, and clearly presented form." Cummings then likened "these iconic figures, magical in their capacity to suggest that they are extensions of a life beyond themselves" to one of the paintings in Tannahill's collection, Paul Cézanne's "austere and aristocratic portrait" of his wife (Cummings 1970, 21).

Visitors to the Detroit Institute of Arts frequently remark on how often the Tannahill name is associated with masterpieces in the galleries. The African galleries are no exception in this respect, and objects from the 1970 Tannahill bequest are prominently displayed. With the exception of the Fang figure (cat. no. 51) and the Kongo whistle top (cat. no. 60), which were bought from Pierre Matisse after the 1937 DSAC Gallery exhibition, most of the objects were acquired from famous dealers in New York like Julius Carlebach and J. J. Klejman.

A superb Guro female figure (cat. no. 15) deserves particular mention because of

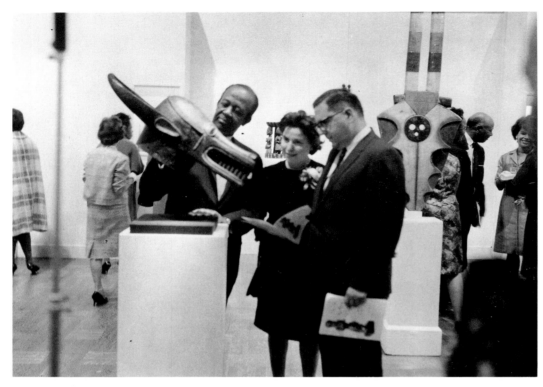

Fig. 21. Arthur D. Coar, left, was one of the founders of the African Art Gallery Committee, later to become the Friends of African and African-American Art. The group, formed in the mid-1960s, was dedicated to the support and enrichment of the museum's African collection.

its art historical importance. This piece was formerly in the collection of the famous surrealist Tristan Tzara and subsequently belonged to Frank Crowninshield, a prominent pre-World War II American collector of African art. It is also the first figure identified as Guro style by the Africanist Leon Siroto in 1953 at a time when this group was thought to have made only masks.

WILLIS F. WOODS AND THE SIXTIES

The late 1950s and 1960s saw a surge of interest in Africa and African art. Nelson Rockefeller, who had been collecting African, Oceanic, and Precolumbian art steadily since World War II, opened the Museum of Primitive Art in New York during the closing years of the 1950s. Although modest in size, it continued the traditions pioneered by MOMA's 1935 exhibition of African art, concentrating on specialized shows of outstanding objects from private collections and exhibitions devoted to specific style areas of Africa accompanied by catalogues written by the finest scholars of the time.

During this same period, art historians began to seriously study African art at the graduate level in centers such as Indiana University, Northwestern University,

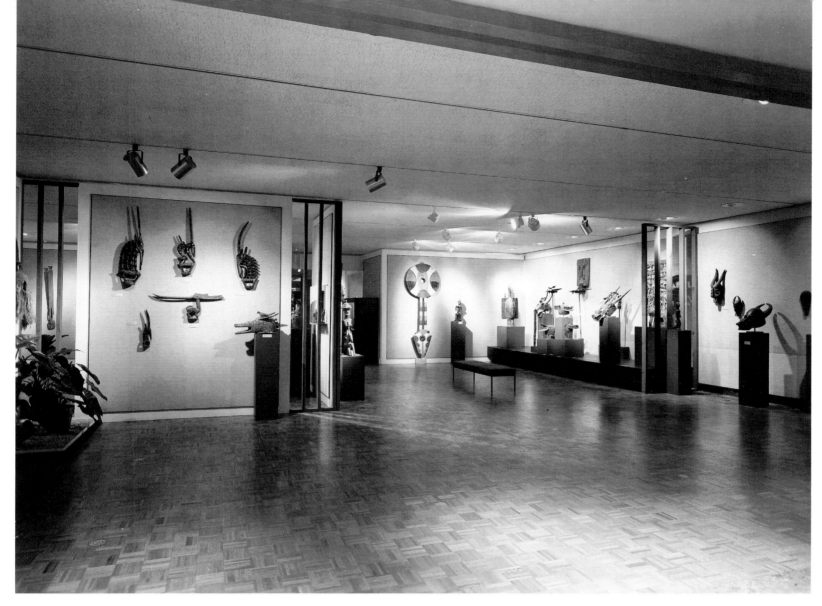

Fig. 22. By 1968, the museum's African art collection had received its first permanent gallery space in the newly opened south wing.

Columbia University, the University of California, Los Angeles, and the Institute of Fine Arts at New York University. African art was moving from the natural history museums to great art museums such as the Art Institute of Chicago, the Minneapolis Institute of Arts, and the Detroit Institute of Arts.

These events on a national front coincided with the appointment of Willis F. Woods (see fig. 4) as director of the Detroit Institute of Arts and the completion of the new south wing, in which a space in the large central court was reserved for the first permanent installation of African works art.

With the advent of the civil rights movement in the 1960s, a new awareness of cultural issues developed in Detroit's African-American community, which generated, in turn, the African Art Gallery Committee. This new auxiliary, which eventually became the Friends of African and African-American Art, was headed by Arthur D. Coar (fig. 21) and Mare Crawford of *Ebony* magazine. The group's mandate was to support and enrich the African and African-American collections. In addition, it pro-

vided assistance for the first gallery installation of African art in 1966 (fig. 22) and sponsored scholarships and programs to provide Detroit's African-American community with a heightened interest in its African heritage.

Outstanding scholars were invited to deliver lectures as part of the African Art Gallery Committee's regular programs, and the annual fund-raising event, the Bal Africain, had as guests many prominent African leaders. Individual support also came through members of the committee board and a fine Asante *kuduo* (cat. no. 24) was purchased for the museum.

The year 1966 also marked the first public showing of selections from the African material assembled by Justice and Mrs. G. Mennen Williams (fig. 4) during his appointment as United States Assistant Secretary of State for African Affairs. Their large collection, which was given to the Detroit Institute of Arts and a number of other Michigan art museums, consists mainly of figures and masks from West Africa. It is a highly representative cross section of the items being sold in major cities such as Abidjan, Lagos, and Bamako in the 1950s and 1960s. Two fine examples, a Bamana Komo Society mask (cat. no. 9) and a Yoruba palm nut holder (cat. no. 30) are illustrated in this volume.

Adding to the growing excitement and intense interest in African art during the late 1950s and 1960s was the appearance of numerous African traders who, with little or no experience in the art business, brought huge batches of good, bad, and indifferent African art to this country to be sold from hotel rooms in almost every large city. Often, entire African villages would be cleaned out and roomfuls of material offered for a fraction of the prices paid on Madison Avenue. As a result of this influx, a number of new patrons started forming collections at this time.

Although the main thrust of their collecting activity was in the field of modern art, the Hilbert H. DeLawters, assisted by art historian Roy Sieber, formed one of the finest art collections in Detroit in the 1960s. When the collection was broken up, many pieces found their way to the DIA, including the magnificent filigreed gold bead (cat. no. 1).

As a scholar and connoisseur in African art, Sieber had a strong presence in Detroit (fig. 23). He was often consulted by Director Woods and was a frequent lecturer in Detroit both at formal events at the DIA and at small informal gatherings at the Donald Morris Gallery in Detroit. Donald and Florence Morris literally "introduced" a number of important Detroit collectors to African art and played a role comparable to the one played by Paul Guillaume in Paris in the 1920s.

THE YEARS OF GROWTH: THE MID-SEVENTIES AND EIGHTIES
With the 1970s, a new and promising era began for African art in Detroit. In November 1972 the museum hosted the first comprehensive exhibition of African terracotta art seen in America. "African Terra Cottas South of the Sahara" was organized

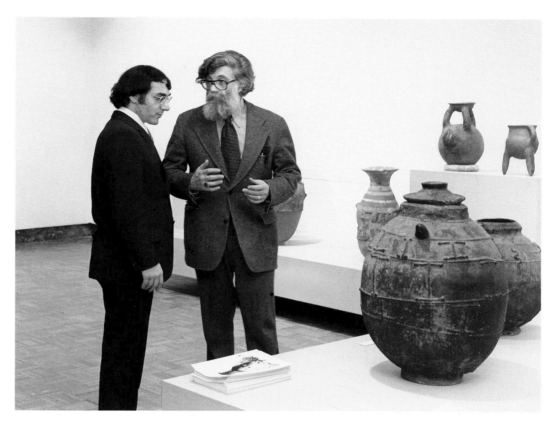

Fig. 23. Roy Sieber, right, had a strong presence in Detroit in the 1960s and 1970s as a lecturer and consultant. Sieber is seen here discussing works in the 1972 exhibition "African Terra Cottas South of the Sahara" with guest curator Daniel Mato.

by Professor Daniel Mato (fig. 23) of Wayne State University. Shortly after the opening of the exhibition, Willis Woods left Detroit to assume the directorship of the Seattle Art Museum and was succeeded by Frederick Cummings in 1973. Cummings enjoyed excellent relationships with Eleanor Clay Ford and some of the other great patron families who had been part of Valentiner's and Tannahill's circle.

From the very beginning of his tenure, Cummings showed himself to be a director with a vision committed to the continuation of Valentiner's "great intellectual plan." Central to this plan was the quest for international recognition of the collections and special exhibitions at the DIA. To reach his goal, Cummings originated a four-point plan designed to bring the African collection up to the international standards of excellence of the museum's European and American departments.

First, a full-scale department devoted to African, Oceanic, and New World Cultures was established; second, a full-time curator, Michael Kan from the Brooklyn Museum, was appointed with the combined function of deputy director; third, a generous gift of $1,200,000 was secured to establish the Eleanor Clay Ford Fund for

African Art; and fourth, plans for construction of a new gallery complex to house the new collections around the recently completed North Court were commenced.

Cummings and Lee Hills, president of the Arts Commission, met with Eleanor Ford on June 20, 1975, to discuss the future of the collection and the establishment of a fund for the purchase of African sculpture. Cummings wrote that Mrs. Ford "was immediately intrigued with this idea and agreed that it would be an exciting and worthwhile project to realize if the works acquired were masterpieces that would add substantially to the extensive collection already in the museum. Her only wish was that she remain completely anonymous." Her wish was respected until her death on October 19, 1976, when the anonymous designation was changed to the Eleanor Clay Ford Fund for African Art. Cummings noted the "fund was thus specifically established for the purpose of creating one of the world's leading collections of African art" (Detroit 1977, 6–7).

One of the department's first major acquisitions underwritten by the new fund was a Yombe nail figure from Zaire (cat. no. 58). This extraordinary Kongo figure, one of twelve known examples, stands out because of its great size and refinement of carving. Its provenance is also impeccable, having been collected by the missionary Visser in 1903 and given to the Museum für Völkerkunde in Leipzig (Mus. No. Maf 8837). It was deaccessioned from that collection by the authority of Wolfgang Koenig, the director in 1975. The purchase of the piece made headlines because of its then record-breaking purchase price of $275,000. This price seems modest today; no similar example of the same superb quality has ever appeared on the market and other types of outstanding African objects have fetched many millions of dollars.

The size, quality, and rarity of this nail figure make it the object of a curator's lifetime. Although traditional Zairian art is much-sought after by African art collectors and museums, it is extremely unusual to find works from this area with any scale. Most of the classic objects from the Kongo area are small and valued for their carving and lustrous surfaces. This figure, which is nearly four feet in height, continues in large scale a tradition established by Robert H. Tannahill, who assembled a small but choice collection of Kongo material, mostly under a foot high.

Philippe Guimiot, the prominent French dealer, wrote in February 1978 that he had seen the new Detroit piece and though he had been exposed to many nail figures, found this example one of the most monumental. Other reactions were not as positive. A piece of unsigned "hate mail" postmarked May 3, 1977, reads, "Where on earth did you get that atrocious figure full of nails? The ugliest piece of anything I have ever seen. Are we in the ugly age of this century? Ugh! Please bring us back to 'American Beauty,' pretty faces, figures, things, items. God help us if we continue showing our children more ugliness."

Money from the Eleanor Clay Ford Fund was used to purchase one of the first major Malian Djenne terra-cotta figures (cat. no. 2) from the Inland Niger Delta to be acquired by a major U.S. museum. Even today when twenty or thirty times more

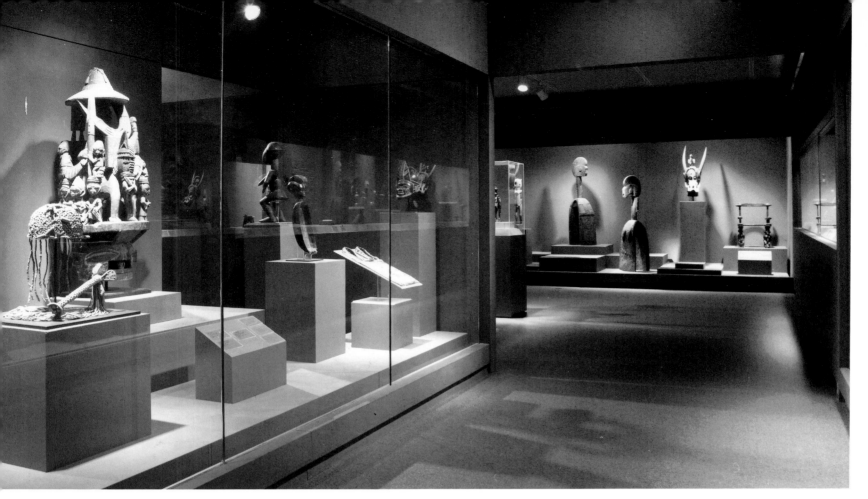

Fig. 24. The museum's African collection currently resides in a complex of galleries in the north wing, which opened in 1980.

terra cottas are known than there were in the 1970s, this piece, acquired from Alan Brandt of New York, shows an outstanding degree of refinement in its modeling. Other remarkable acquisitions made with the fund include a magnificent Fang reliquary guardian head (cat. no. 52) formerly in the Helena Rubinstein collection, the Arman collection, and acquired from Merton Simpson; a Cameroon Highlands Batscham-style mask (cat. no. 41), formerly in the Mestach collection, and acquired from Philippe Guimiot; a pair of large shoulder masks from the Upper Benue River area of Nigeria (cat. no. 38); a rare and extremely beautiful commemorative post (cat. no. 81) carved by the Kambe of Kenya, formerly in the Jacques Kerchache collection, Paris; and a Cameroon Bamileke mother and child (cat. no. 39), formerly in the Ralph Nash and John Friede collections. This last "expressionistic" masterpiece is very similar to an example from the Musée de l'Homme in Paris.

In 1977, the recently formed Department of African, Oceanic, and New World Cultures originated an exhibition of great local interest, "Detroit Collects African Art." This exhibition enabled the new curator to familiarize himself with collections in the community and highlight some of the most important pieces of African art in Detroit. Many of these, such as the great Yoruba door (see Detroit 1977, no. 90) in the Green Collection, had never before been published. A great effort was made to involve the African-American community in the museum through the Friends of

African Art. The Friends raised money to purchase a rare Epa cult mask (cat. no. 27) carved by one of the best-documented Yoruba carvers, Bamgboye of Ekiti, for the collection. The mask depicts a great mounted warrior with attendants as part of its elaborate superstructure.

The early 1980s were pivotal for the department. In July 1980, the African collection was installed in the complex of galleries surrounding the North Court (fig. 24). The new galleries, designed by Charles Froom of New York and John Hilberry Associates of Detroit, were generously funded by grants from the National Endowment for the Arts and a $1 million grant from the Hudson-Webber Foundation.

One of the most important and certainly the most widely traveled exhibition ever organized by the DIA opened in Detroit in January 1980. With guest curator Ekpo Eyo, head of the National Museums of Nigeria, the DIA organized the exhibition "Treasures of Ancient Nigeria" (fig. 25), the most comprehensive survey of Nigeria's treasures to travel outside of that country. Following its Detroit opening, the exhibition toured extensively in North America and Europe, going as far afield as Moscow and Sofia, Bulgaria. The catalogue was translated into at least a half-dozen languages. "Treasures of Ancient Nigeria" proved to be a revelation to many Americans and Europeans who held the stereotypical view that African art was "primitive" in the sense of being brutal and crude. The show's elegant and extremely naturalistic bronzes from Ife and Benin exploded these preconceptions. In European art capitals like Florence, critics fell over themselves to praise these great sculptures, comparing them to the works of Renaissance masters such as Donatello.

During the 1980s, outstanding African objects became harder and harder to find and prices continued to soar, but the museum still managed to add some superb objects to the collection. A beautifully carved Yoruba ivory bracelet from Owo (cat. no. 31) came from the collection of Baron Rolin of Brussels. On the basis of its stylistic similarity to Owo ivory carvings collected in the seventeenth century and now in the Weikmann collection in Ulm, Germany, the Detroit piece has also been given an early date. In 1981, the Friends of African Art helped the museum acquire a rare Asante gold soul washer's badge (cat. no. 22) with documentation dating to Lt. R. C. Annesley, who participated in the 1874 British attack on Kumasi. This great gold object had been in the Annesley family collection ever since. Bena Lulua figures from Zaire over a foot high are some of the rarest of African art objects, but the museum was fortunate to obtain a superb documented example (cat. no. 74), from the Entwhistles of London, with a provenance going back to Leo Frobenius and the Helena Rubinstein sale of 1966.

As a result of the close personal friendship going back many years among the late Harry Franklin of Los Angeles, his daughter Valerie, and Curator Kan, the DIA was offered in 1983 two outstanding objects from the Franklins' private collection prior to its being auctioned at Sotheby's in April 1990. These pieces were the superb four-faced Fang helmet mask (cat. no. 49) and an equally beautiful carved Baule drum

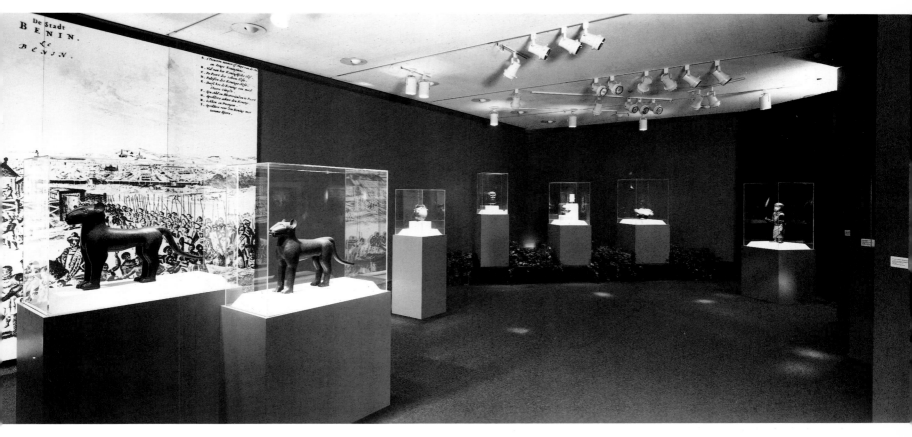

Fig. 25. The exhibition "Treasures of Ancient Nigeria," organized by the Detroit Institute of Arts, was at the time the most comprehensive survey of Nigerian art displayed outside of that African country. After its 1980 opening in Detroit, the exhibition traveled extensively in North America and Europe.

(cat. no. 18). The white-faced Fang mask has a truly unique and enviable history, having belonged to the Parisian dealer Paul Guillaume in the 1920s and 1930s, when it passed to Helena Rubinstein. While in the Rubinstein collection, the mask was prominently displayed in the landmark MOMA African exhibition of 1935; it was sold to Harry Franklin in the 1966 Rubinstein auction sale.

The 1980s also brought some outstanding gifts to the collection. A subtle white-faced Vuvi mask (cat. no. 54) from Gabon was donated by the late Max Pincus, a former Arts Commissioner, and Mrs. Pincus. André and Lois Nasser of New York City donated a magnificent "classic" style standing Hemba male figure (cat. no. 68) to the collection. The late W. Hawkins Ferry, the DIA's great patron specializing in twentieth-century art, bought a few superb African objects for display in his home. A Cameroon Babanki mask (cat. no. 44) and a Chokwe *mwana pwo* mask from Angola (cat. no. 67) are both among the finest examples of their kind and stand out as much in the African galleries as they did in the Hawkins Ferry house.

THE LATE EIGHTIES AND THE NINETIES

It had been Eleanor Ford's intention that the fund bearing her name not be set up as an income-producing endowment. Prices were rising so steeply for the great African art objects available in the 1970s and 1980s that the DIA would never have been able to afford the great Kongo nail figure (cat. no. 58) if only the income from the fund had been available. Since the depletion of the Eleanor Clay Ford Fund in the 1980s, there has been no single source to tap for the funding of major pieces costing upwards of six figures. However, a number of Detroit collectors have been extremely active and have also been very generous to the museum.

Margaret Demant has given a superb repoussé gold Asante soul washer's badge (cat. no. 23), which was probably saved from being recycled for the value of its metal. The badge is displayed beside our other Asante gold piece (cat. no. 22), which is in a very different, simpler style. The ability to display two extremely fine but stylistically different objects together is the type of refinement now needed in the collection. In 1992, the contemporary artist Arman donated an extraordinary Yoruba Epa mask (cat. no. 28) to the collection which, like the famous mask by Bamgboye (cat. no. 27), is from the Ekiti area. The helmet portion of this mask is unusually well carved and supports a superstructure showing a mother carrying a child on her back.

The Friends of African Art, under the imaginative and thoughtful leadership of Chairman Samuel H. Thomas, Jr., climbed to new heights when they obtained a large grant from OmniCare Health Plan of Detroit to sponsor the Bal Africain 1991 in conjunction with the opening of "Gold of Africa," an exhibition of selections from the superb collection of west African gold in the Barbier-Mueller Museum in Geneva, Switzerland. The guest of honor was His Royal Highness Odeefo Boa Amponsem III, King of the Demkyra, Ghana, whose many formal appearances wearing his official gold regalia served to show how these ornaments are still in use in Ghana today (fig. 26). Among the more recent acquisitions purchased with the support of the Friends is a prototypical Kuba mask (cat. no. 73), which combines the arts of woodcarving, weaving, and beadwork to achieve a richness associated with royal attire.

AFRICAN ART AND THE DIA'S SECOND CENTURY

Looking forward to the museum's second century, what will the future hold for the African collection and the Department of African, Oceanic, and New World Cultures? Should the art of the entire continent of Africa (Egypt excepted), from its beginnings to modern times, be locked into a department which must also give equal attention to the art of the South Pacific, the art of Precolumbian America, and the historic and pre-historic Native Americans? Surely Valentiner's "grand intellectual plan" is going to have to be revisited in light of current trends, which prompted

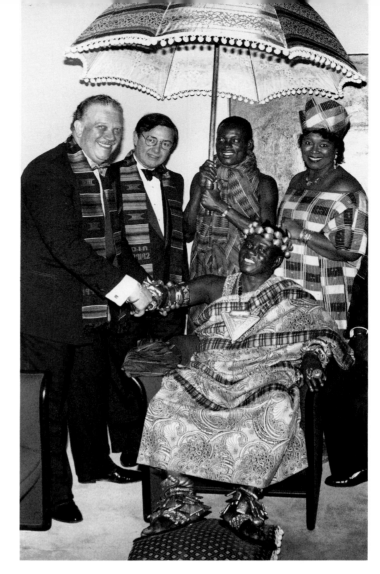

Fig. 26. His Royal Highness Odeefo Boa Amponsem III, King of the Demkyra, Ghana, wore the gold regalia representative of his rank when he was the guest of honor at the 1991 Bal Africain and opening of the exhibition "Gold of Africa." Chairman of the Friends of African and African-American Art Samuel H. Thomas, Jr., left, greets the king in the company of DIA Director Samuel Sachs II and Detroit Congresswoman Barbara-Rose Collins. The king's attendant stands directly behind the monarch.

the Smithsonian Institution to create separate museums to house the arts of Africa and of the American Indian.

Now that the study of African art history is becoming a more mature discipline, scholars are raising many new issues of how African art should be displayed, particularly in terms of recontextualizing African objects in major art museums (Vogel 1991, 192). This would necessitate seeking more meaningful juxtapositions of African art with other artistic traditions that share both geographical and cultural affinities.

Surely, the Detroit African collection has outgrown its present suite of galleries surrounding the North Court and thought must be given in the future to the positioning of the African collection vis-à-vis the European, Near Eastern, and Asian collections. So as not to carry the cultural biases of the nineteenth century into the twenty-first century, the Detroit Institute of Arts must lead the way to a new cultural vision and order.

MICHAEL KAN

Western
Sahara

Morocco

Tunisia

Algeria

Libya

Egypt

Mauritania

Mali

Niger

Chad

Sudan

Eritrea

Djibouti

Senegal

Niger River

The
Gambia

Guinea
Bissau

Guinea

Burkina

Nigeria

Benue River

Central
African Republic

Nile River

Ethiopia

Somalia

Sierra
Leone

Côte
d'Ivoire

Ghana

Liberia

Togo

Benin

Cameroon

Equatorial
Guinea

Gabon

Congo

Congo River

Zaire

Uganda

Rwanda

Burundi

Kenya

Tanzania

Angola
(Cabinda)

*Kwango
River*

Angola

Zambia

Malawi

Mozambique

Madagascar

Namibia

Zimbabwe

Botswana

Swaziland

South
Africa

Lesotho

All catalogue entries were written by Mary
Nooter Roberts except for cat. nos. 14, 23,
28, 34, 51, and 73, which were written by
Helen M. Shannon. The introductions to the
geographical sections were written by David
W. Penney.

AFRICAN MASTERWORKS
IN THE
DETROIT INSTITUTE OF ARTS

WESTERN SUDAN

The term "sudan" refers to the vast, semiarid savannah belt that stretches across the continent of Africa between the scorching desert of the Sahara to the north and the tropical forests to the south. The landscape is unrelentingly flat, save for rocky outcroppings, or inselbergs, that rise abruptly from the plain and precipitous escarpments, the consequence of ancient, geological fault lines. Savannah vegetation is characterized by grasslands broken by clumps of trees, although plant life can vary considerably depending on local conditions and rainfall. To the west, the African sudan is relieved by the great arc of the Niger River, which bends across the interior of the savannah from its sources in the coastal mountains of Guinea, flows northeast to nearly the edge of the Sahara, and then travels south to its massive delta on the coast of central Nigeria.

The Western Sudan is apparently the original homeland of the large Congo-Kordofanian language family. This group established a basic template for African civilization that·spread with an expansion of its people throughout nearly the entire continent. Today, the Congo-Kordofanian language family includes the Mande and Voltaic (Gur) languages of the Western Sudan, the Kwa of the west African forests (Akan and Yoruba among them), and all the Bantu languages of central and south Africa. In all, this group numbers over 175 million people. In the Western Sudan, Congo-Kordofanian speakers established the cultivation of millet, sorghum, cowpeas, and cotton, along with the technology of iron smelting during the first millennium B.C., laying the foundation for further cultural growth. People lived in large, agricultural communities, some growing into impressive cities during the first few centuries A.D. The open country encouraged movement, trade, and flourishing commerce. By the beginning of the first millennia

Opposite: Cat. No. 4, *Bracelet*, detail

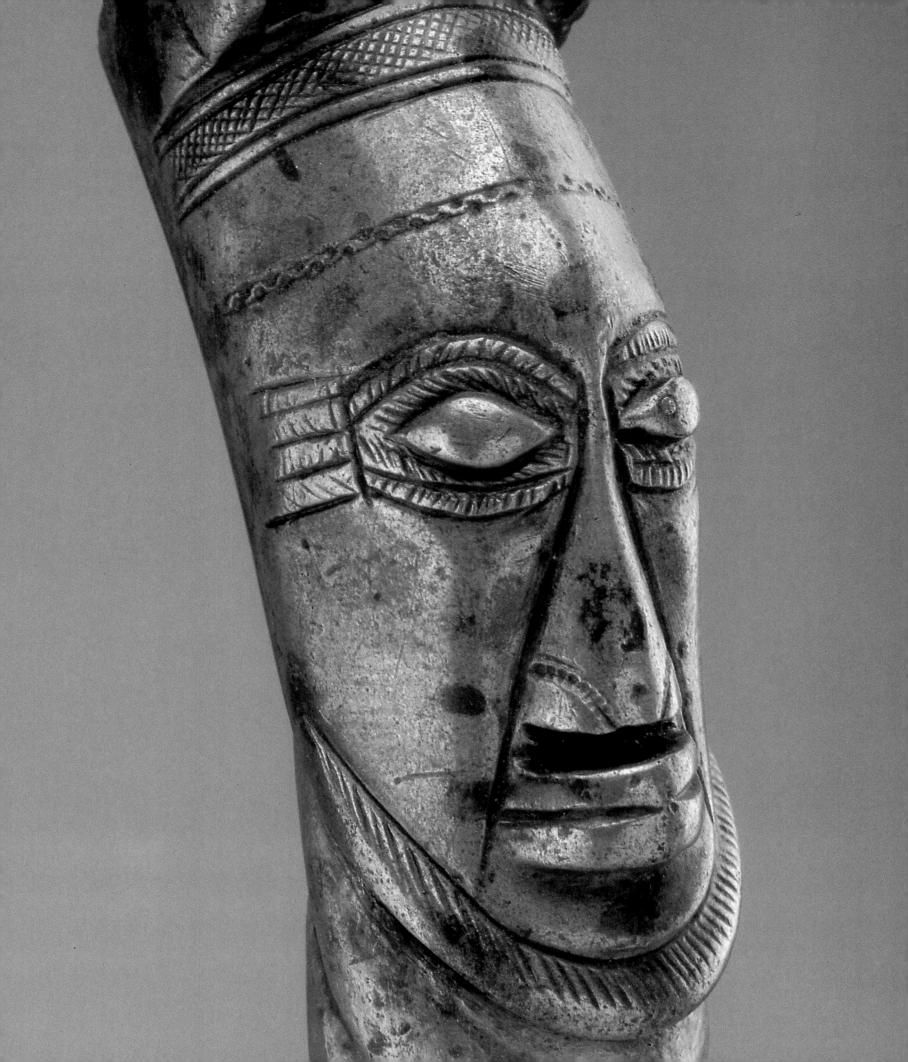

A.D., and perhaps even earlier, the basic patterns for West African kingdoms had emerged.

Information about the early kingdoms of the Western Sudan has come from the writings of Muslim scribes who accompanied the spread of Islam across North Africa during the early eighth century. Moorish writers in Morocco describe caravans numbering thousands of camels packed with slabs of salt (rare in the Western Sudan), cloth, and jewelry destined for mysterious cities across the Sahara, and emerging months later laden with gold, leather, sorghum, and bars of iron.

Powerful kings ruled the Western Sudan city-states. Some, with large standing armies, expanded their dominion using the proceeds of the caravan trade to establish extensive empires. The Empire of Ghana (not the same as the modern nation of Ghana) was the earliest, originating perhaps as early as the third century A.D. The term "Ghana" actually refers to the warrior kings of the Soninke people who themselves called their kingdom Aoukar. Aoukar was located in the Upper Niger in western Mali and eastern Senegal and numbered several hundred thousand people. Aoukar thrived with the caravan trade, establishing an elaborate system of trade laws and regulations to reap profits, tariffs, and taxes to fuel its growth and power. With an army of over 200,000 warriors at the height of its power, Ghana expanded its territory through military conquest until it reached the Atlantic Ocean, eventually encompassing an area of over 250,000 square miles with a population of several million. After several hundred years of imperial ascendancy, the Empire of Ghana collapsed in 1076 when its capital city, Kumbi Saleh, fell to an attack by long-time Berber rivals.

The Mande city of Kangaba in southern Mali, once part of the Ghana empire, established the foundation for the subsequent Mali empire, which grew during the twelfth and thirteenth centuries to rival the size and power of its predecessor. The fabled cities of Timbuktu and Djenne were its important trading centers.

Terra-cotta sculptures and cast brass ornaments excavated from sites near the city of Djenne date from this era. Djenne is located at the southwestern end of the Inland Niger Delta, a broad and fertile alluvial plain flooded seasonally by the Niger. The sculptures have been found buried in house foundations within the region and perhaps served as religious offerings. Western Sudan kingdoms employed armies of cavalry groups as instruments of power and large sculptures of equestrian warriors stem from this military domination. Djenne-style terra cottas hint at an ancient tradition of wood sculpture in the Western Sudan, which did not survive the ravages of time.

With the conversion of the Mali kings to Islam and the subsequent rise of the Islamic Songhai empire during the fifteenth century, traditional Sudanic religion was restricted primarily to village practice. A religion based upon reverence for ancestors, recognition of primordial bush spirits, and agricultural rites was preserved in agricul-

tural villages, while Islam tended to dominate the cities. Even so, Islàmic belief existed in a relatively easy, syncretic harmony with traditional religious practices among several Western Sudan groups.

The Dogon, a group of Gur speakers, sought to escape the volatile events of empire building and took refuge in the rugged cliff country of the Bandiagara escarpment, southeast of the Inland Niger Delta. Their relative isolation nurtured a rich and complex tradition of mythic narrative, ritual practice, and sculptural arts.

The Mande-speaking Bamana villagers of the upper Niger in Mali, whose ancestors had been the agriculturists of the Mali empire, preserved traditional religious practices such as the *Gwanusu* fertility cults and initiatory societies known as *Jow* (singular *Jo*). Members of blacksmith clans, which include wood sculptors, leather workers, ceramists, and other semiprofessional artists as well as iron workers, produce wood sculpture, both masks and figures, that play an instrumental role in *Jo* practices. These clans are believed to have a separate source of mythic origin from that of other people.

The large farmer and blacksmith clans of Gur speakers known collectively as the Senufo live in southern Mali and the northern Côte d'Ivoire. Villages are often composed of several large clans classified as either farmer or blacksmith. All Senufo men are inducted into their clan *Poro* association, which is responsible for their religious and social education. Poro associations collaborate to stage great commemorative festivals, which include several different masquerades presented by members, for recently deceased Poro elders. The blacksmith clans' wood sculptors produce masks and sculpture for Poro, carvings for the women's version of the society, known as *Tyekpa*, and small figures for female *Sandago* diviners. More recently, wood sculptors have established large workshops to produce carvings in vast numbers for the artifact trade.

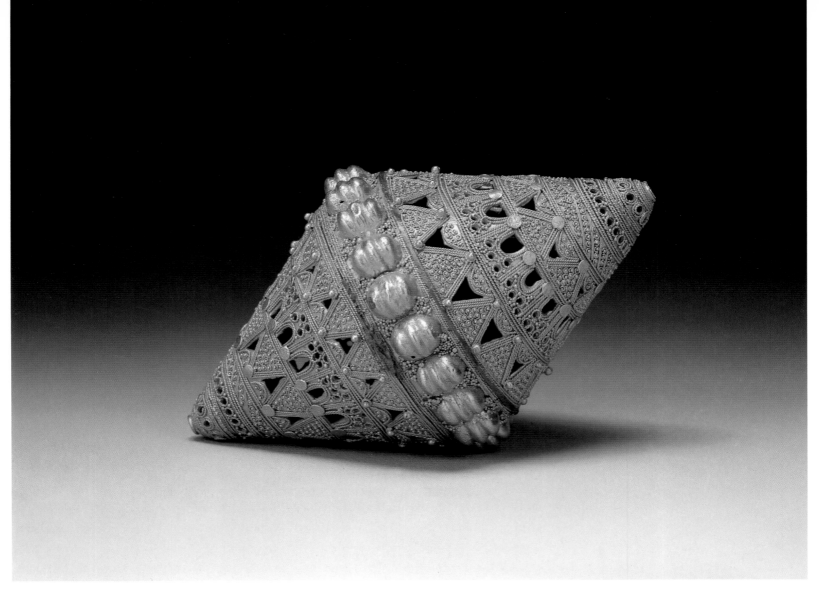

Cat. No. 1

1. BEAD

Western Sudan, Mande, 19th/20th century
Gold, length 10.2 cm (4 in.)
Founders Society Purchase, Eleanor Clay Ford
 Fund for African Art (77.10)

This resplendent ornament is one of the largest
and most intricately filigreed gold beads known
from the Western Sudan. Its delicacy and com-
plexity of design extol the skill of a superb
goldsmith and the richness of an ancient gold-
working tradition found all across the Sahel, an
arid region south of the Sahara desert and ex-
tending from Senegal east to Mali and Niger
(Garrard 1989, 20). Such beads are worn as pen-
dants by women of Mande origin in Mali, Bur-

kina Faso, and Senegal. They may be worn alone
on a chain or leather thong, or in combination
with other smaller and less elaborate gold beads.
Their hollow interiors may have served as recep-
tacles for charms or perfume (Johnson 1980,
323).

The technique used to create this bead is
quite old. Elaborate filigree objects, either made
from many small pieces of metal assembled into
an openwork form or soldered to a thin sheet-
metal base, can be found all over North Africa,
Ethiopia, Somalia, and the Sahel, following the
spread of Islam across the continent. However,
this intricate technique seems ultimately to de-
rive from Byzantine work (Ehrlich, personal
communication, 11/86).

The ogival form of the bead—two cones

united by a central joint—likewise spans a broad
geographical range and period of time. It is
thought that the first ogival beads were pro-
duced in Mali, in or near Timbuktu, and that the
tradition was later carried to Senegal with the
Toucouleur people. A copper ogival ornament
was discovered in El Oualedji near Timbuktu in
a tomb dated from the eleventh to fourteenth
centuries A.D. The same form, dating to the elev-
enth century A.D., was found in Caesarea, an an-
cient seaport and capital of Roman Palestine,
built by Herod the Great on the northwestern
coast of Israel. Malian goldsmith Fode Sissoko
claims that the ogival-shaped gold bead was an
ancient style worn in Mali for many generations
(Johnson 1980, 323).

Jewelry's trade value and portability promoted

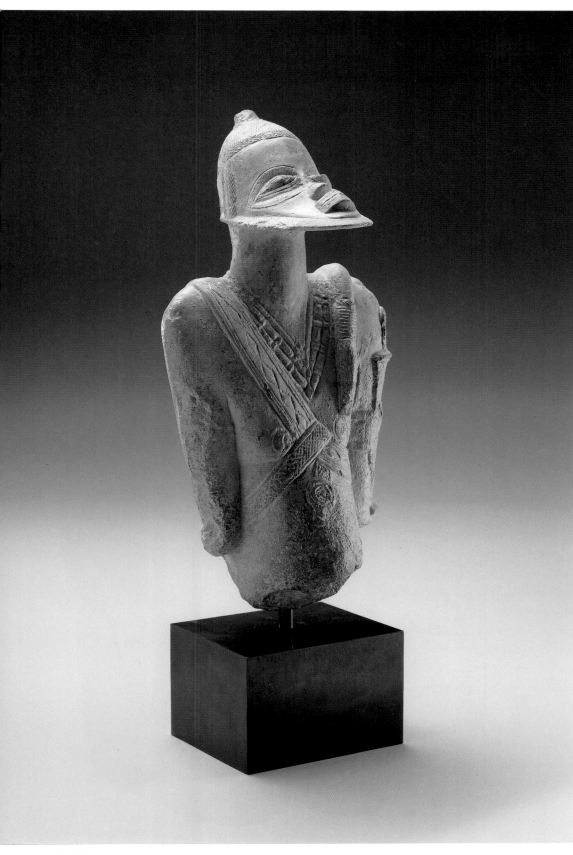

its notably wide distribution. As a result, it becomes nearly impossible to attribute this bead to any single ethnic group. The ornament closely resembles a large biconical openwork bead identified as from the Bamana of Mali (Fischer and Himmelheber 1975, no. 88; Ehrlich, personal communication, 11/86). Detroit's bead also closely resembles filigreed and granulated gold work attributed to the Wolof and Toucouleur of Senegal (Johnson 1980). Without specific documentation, this exceptional bead must be viewed not as the artistry of a single ethnic group, but as part of a widespread jewelry complex that spans the Sahel, both technologically and stylistically.

PROVENANCE: Pitt Rivers collection, Oxford. Judith Small Gallery, New York. Dr. and Mrs. Hilbert H. DeLawter.

REFERENCES: Flint Institute of Arts, *Art of Black Africa* (Flint, exh. cat., 1970), no. 41.
Roy Sieber, *African Textiles and Decorative Arts* (New York: Museum of Modern Art, exh. cat., 1972), 120.

2. WARRIOR FIGURE
Mali, Inland Niger Delta, 13th/14th century
Terra cotta, height 38.1 cm (15 in.)
Founders Society Purchase, Eleanor Clay Ford
 Fund for African Art (78.32)

Archaeological discoveries, including magnificent terra-cotta and bronze works, from the Inland Niger Delta reveal the cultural richness and diversity of Africa's past. The record of a people thought to be ancestral to the current inhabitants in the area—the Dogon, Bozo, Soninke, Marka, and Songhai—has been uncovered from the mounds of Jenné-Jeno, an ancient town two kilometers from the present city of Djenne. Without written history, these artifacts allow us our only glimpse into this all-but-vanished civilization. Excavations show that Jenné-Jeno had been established as a community during the third century B.C., although the terra-cotta sculptures such as the Detroit piece date from between A.D. 1000 and 1300.

Cat. No. 2

Clad in official regalia, this warrior communicates a sense of dignity and solemn reverence. The erect torso is laden with necklaces and bandoliers. As befits a warrior, he wears a knife on his left arm and a quiver on his back. His rather naturalistic body contrasts with a disproportionately large jaw. On his head, he has a skull cap, which rises and terminates at a central point. The exceptional size, detailed execution, and hollow construction imply that this may have been a mounted warrior, since equestrian figures are generally better executed than the majority of sitting or kneeling ones from the same area. A vertical shaft from the horse would have fit into the figure's hollow cavity. Quite possibly, the rider's flexed legs were broken off at a later date (McIntosh and McIntosh, letter to the Detroit Institute of Arts, 10/78). In addition, Bernard de Grunne (personal communication, 8/86) identifies the quiver strapped to the figure's back as a type favored by mounted warriors.

More than twenty equestrian figures are known within this regional style. Some figures have been dated to the thirteenth through the fourteenth centuries A.D. using thermoluminescence techniques. This chronology coincides with the decline in the fourteenth century of the second Sudanic Empire—the Mali Empire—which overlapped with and eventually was succeeded by the even more powerful Songhai Empire. During that Songhai period, the Dogon, Mossi, Fulani, Tuareg, and Kurumba were referred to as raiders, frequently in battle against the Songhai (Davidson 1966, 121–122). Whichever specific ethnic group this figure represents, it reads as a historical document of an era punctuated by unparalleled political expansion and growing Islamic influence in the Western Sudan.

PROVENANCE: Alan Brandt, New York.

REFERENCES: *Bulletin of the Detroit Institute of Arts 56* (1978), 5: 262, fig. 3.

3. PENDANT

Mali, Inland Niger Delta, 11th/16th century
Terra cotta, height 4.8 cm (1⅞ in.)
Founders Society Purchase, New Endowment
 Fund (80.63)

Embodied in this miniature sculpture are aspects of belief and ritual associated with a civilization that endured in the Inland Niger Delta of Mali from as early as 200 B.C. until the seventeenth century. While other terra-cotta figures from this archaeological tradition bear intricate and informative details of dress, weaponry, scarification, disease, and deformity, this stark, almost abstract figure moves us by the solemnity of its posture and expression. Rarely does African art convey emotion or depict people in informal, asymmetrical poses. Yet the manner in which this kneeling figure clasps its arms across its chest and bows its tilted head might be construed as a state of humble subservience. Bernard de Grunne (personal communication, 8/86) speculates that this figure assumes a sacred ritual pose that worshipers adopted for prayer or that it might relate to mourning.

This sculpture actually was worn as a pendant, suspended from the neck by a string that passed through a hole in the center of the figure. Although little information exists on anthropomorphic pendants, they seem to be related to a small corpus of pendants in the form of ceramic vessels. Eight to ten such pendants are known, and one large terra-cotta figure from this region is portrayed wearing one. The type of receptacle depicted in the vessel-shaped pendants is identical to ceramic pots that have been unearthed in archaeological excavations in the Inland Niger Delta (Grunne, personal

Cat. No. 3

communication, 8/86). In one instance, a terracotta anthropomorphic figure was discovered together with vessels containing food in a building that may have been an ancestral shrine (McIntosh and McIntosh 1980, 14). If there is a connection between the vessels used for sacrificial offerings in shrines and the vessels depicted on pendants, then it is reasonable to assume that these pendants had religious value and probably served as a kind of portable charm (Grunne, personal communication, 8/86).

PROVENANCE: Philippe Guimiot, Brussels.

Cat. No. 4

4. BRACELET

Mali, Inland Niger Delta, 15th/16th centuries
Copper with bronze, diameter 14.3 cm (5⅝ in.)
Founders Society Purchase with funds from
 Founders Junior Council (1987.19)

Emerging from the coiled configuration of this bracelet is the dual image of man and horse, a potent metaphor of political and religious authority in the Western Sudan. Since the first millennium A.D., the Western Sudan has seen the rise and fall of three major empires and was the crossroads of an extensive trading network linking the forest and desert zones of the continent. Among the most compelling of symbols distinguishing nobility from commoners was the horse, first employed as a rare and prestigious luxury item, and later for cavalry in warfare. Furthermore, for the Dogon people of the area, the word horse is itself the word for spirit possession, reinforcing the link between owners of horses and those who can harness their supernatural powers (Grunne 1991, 92).

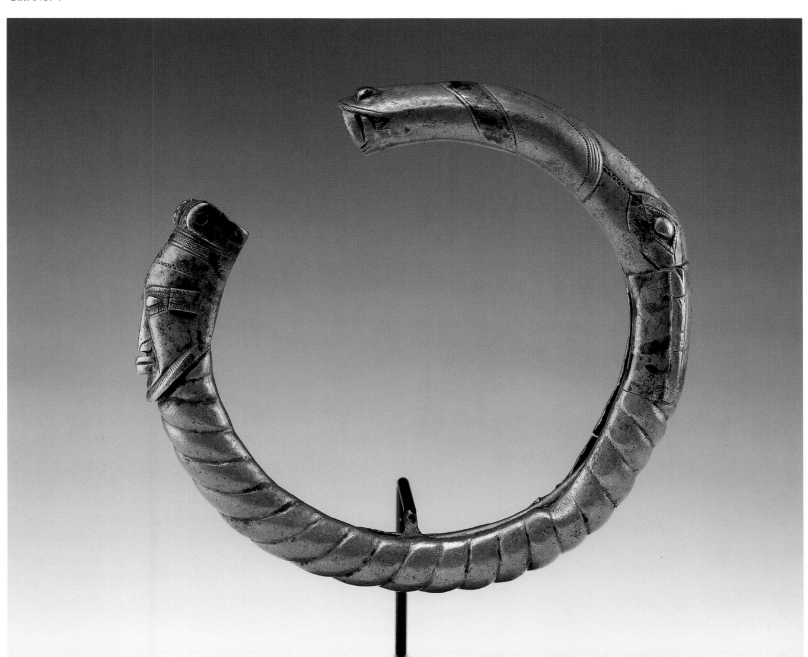

Cast and tooled in copper and bronze, this bracelet is at least three hundred years old, as revealed by thermoluminescence tests of samples from the original clay core. Stylistically, the features of the human face bear a striking resemblance to terra-cotta equestrian figures from the Inland Niger Delta (see cat. no. 2), especially in the delineation of the beard and scarification patterns. That the face simultaneously evokes the head of a bridled horse further reinforces the link to Inland Niger Delta figures, of which approximately twenty depict equestrians.

A rich corpus of material exists relating to horses in the Western Sudan, including descriptive passages from early Arab chronicles, linguistic etymology, and the ethnographic record. The evidence shows that horses were associated not simply with persons of wealth, but also with those who wielded combined judicial, priestly, and chiefly authority (Grunne 1991, 92). Trials were judged on horseback, the emperors' audiences consisted of courtiers and army officers on horseback, and horses were used as diplomatic gifts to heads of state. The human head at one end of the bracelet and the horse's head at the other may have been intended to invoke the concept of spirit possession or transformation—the human becoming possessed with a spirit persona, symbolized by the powerful image of the horse, and thus having access to otherworldly power. This reading of the bracelet is underscored by the media of metal working, which requires a literal metamorphosis of materials. In the Western Sudan, metal working skills and methods of spirit possession are deeply rooted in cosmological belief.

PROVENANCE: Madame Sekosko. John Hewitt, New York, 1964. Merton Simpson, New York.

5. MASK

Mali, Dogon, 19th/early 20th century
Wood, 74.6 × 15.2 × 94 cm (29⅜ × 6 × 37 in.)
Founders Society Purchase, Director's Discretionary Fund and the African Art Gallery Committee Fund (68.145)

"Amma (God) puts you on the road
The road to the right is the good road
The road to the left is the bad road
That Amma gives you a good road
Dead one, that he gives you a strong hand."

Recitation for the Deceased on Wasirigi,
Appendix IV
(Griaule 1963, 167)

Dogon aesthetic values are crystallized in this mask with its economy of line and extreme contrast between horizontal and vertical planes. A rectangular face distinguished by deeply recessed and elongated spaces for eyes is surmounted by an appendage that rises vertically and then cuts back at an abrupt right angle and extends for almost three feet. The dry, weathered surface with dark crevices and sheer vertical drops recalls the arid landscape of the Bandiagara escarpment inhabited by the Dogon. Dogon villages are perched on precarious cliffsides where cave-ridden precipices drop sharply to meet horizontal steps before falling again toward the fertile valley. The Dogon were driven into this area in approximately the fifteenth century by the Mande peoples from the west and the Mossi from the east. In the cliffs, the Dogon found both refuge and protection from invading peoples, and they quickly learned to cope with the harsh environment. Later, they spread out over the plateau above and the plain below, where they continue to live today. The stark beauty of this land found a place in the philosophy and art of the Dogon.

This mask was worn in Dogon funeral rites called *Dama* to mark the end of the mourning period for a deceased member of the community. Dama serves to restore order and harmony to the living by ensuring the passage of the deceased into the next world and then reintegrating the surviving relatives into the community. Dama rites are staged by members of the Awa society, an association of initiated men who speak a secret and ancient language, *sigi*. The Dama unfolds in three parts over a six-day period: first, Awa members are separated from the village and from their social roles; second, they soon re-enter the village as masked supernaturals to take control over the human realm; finally, the deceased is reborn as an ancestor and normal life for the community is restored. Masked dances are performed in a sequence that marks the transition from chaos to order and balance. Among the many beings represented by Dama masks are animals, both predatory and nonpredatory (monkey, rabbit, antelope, bird), humans (Dogon and foreigners), and inanimate abstract supernaturals.

In his comprehensive survey of Dogon masks, Marcel Griaule (1963, 601–602) illustrated several masks that represent inanimate things or abstract forms. Some of these are almost identical to the Detroit mask. The Dogon names for these similar masks translate into "elbow" and "stirring stick" (or "spoon"). The terms probably refer to the angled crest that rises above the face of the mask. These types of masks have been out of use since before 1935 (DeMott 1982, 90), which dates the museum's mask to at least the first quarter of the twentieth century. While little information exists on these particular masks, other types of abstract masks called *kanaga* and *sirige* can shed light on the significance of the Detroit piece.

Kanaga and sirige are combined with costumes of red skirts with ruffs and aureoles of fibers and bodices of cowrie shells and used in large group dances. Although Kanaga represents female traits and Sirige is associated with men, both incorporate images of the symbolic checkerboard in their large superstructures. For the Dogon, the checkerboard is the ideal model of

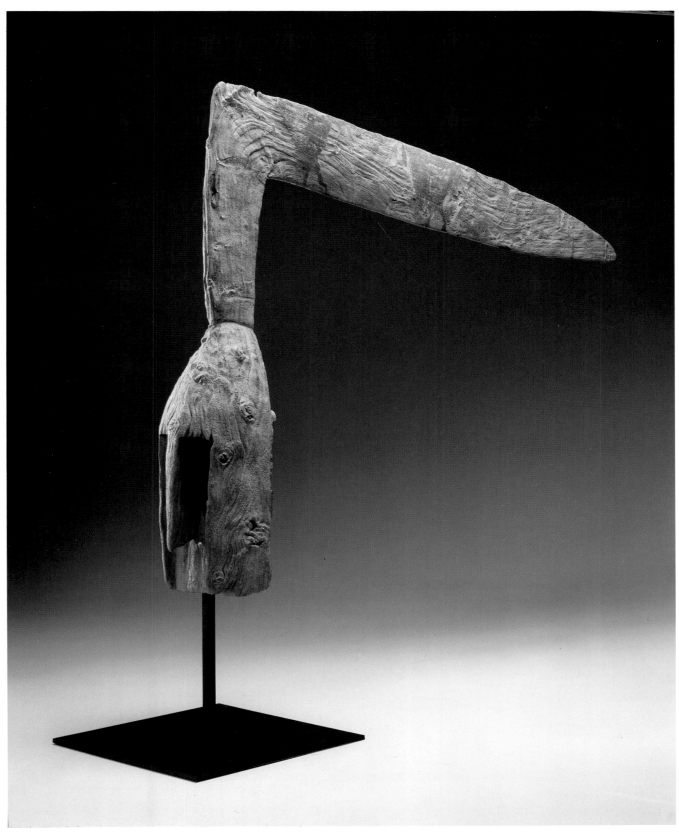

Cat. No. 5

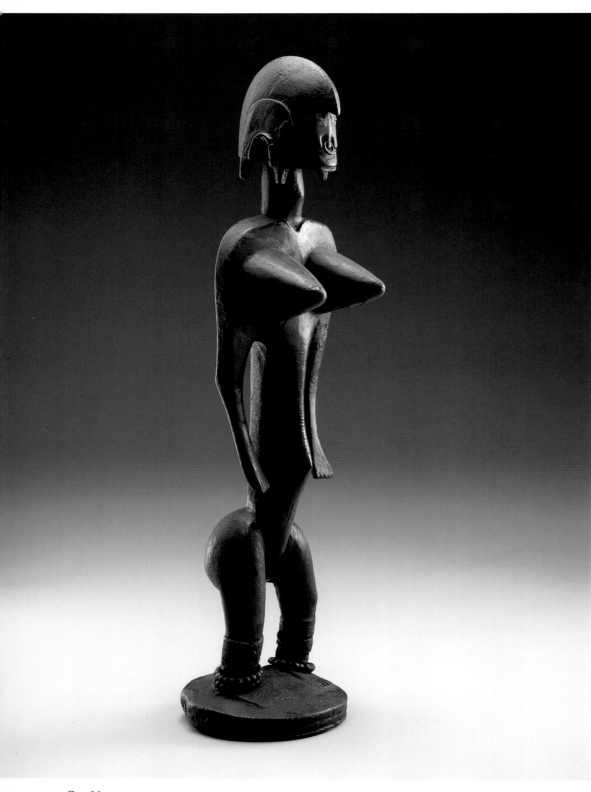

human organization and industry, characterizing the farmer's fields and the weaver's cloth (De-Mott 1982, 113). The spiral, on the other hand, is the ideal symbol of the converse realm—the supernatural. As the masked dancers perform, they create spiraling motions as reminders that the human world always operates within a supernatural universe. It is no coincidence, then, that the two objects represented by Detroit's mask—"elbow" and "stirring stick" ("spoon")—are both rectilinear in form but rotational or spiral in movement. In the harmonious intersection of a vertical and horizontal plane, this mask conveys Dogon social and religious values in their most abbreviated form.

PROVENANCE: K. Toure.

6. STANDING FEMALE FIGURE

Mali, Bamana, 19th/20th century
Wood, copper, beads, metal, 51.8 × 12.4 × 15.2 cm (20⅜ × 4⅞ × 6 in.)
Bequest of Robert H. Tannahill (70.46)

This masterful sculpture, although lacking in detailed documentation as to its village of origin, corresponds in both form and added decoration to other figures used in celebrations of the *Jo* association, an initiation society found among the southern Bamana people to which both men and women belong (Ezra, personal communication, 5/86). For young men, a particularly long and arduous initiation involves circumcision followed by six years of intense instruction culminating in a symbolic death from which they are reborn as young adults.

After this traumatic rite of passage, the newly initiated men celebrate their status. They tour neighboring villages, entertaining with songs and dances learned during initiation and collecting gifts of money and food. Divided into groups, each troupe is distinguished by its costumes, instruments, and choreography. The

Cat. No. 7

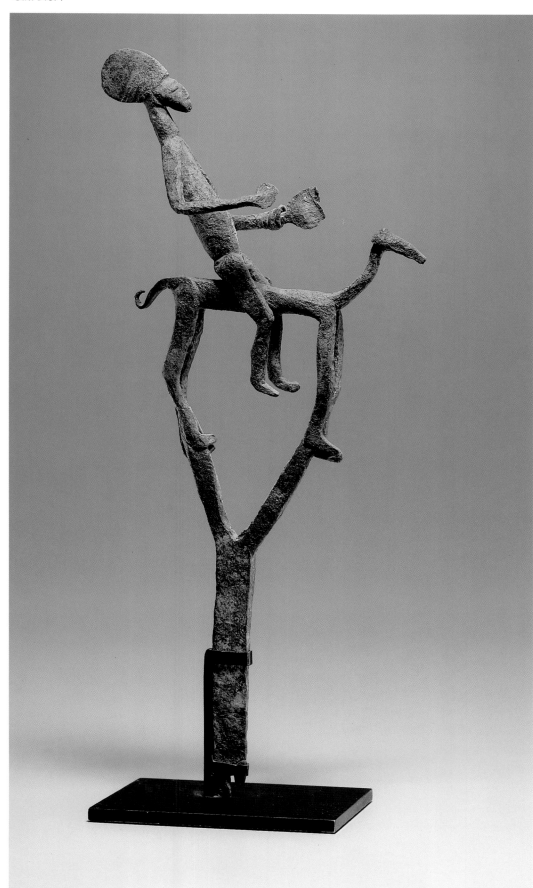

blacksmith group, *numu jo,* is the one most admired by audiences for their frequent use of figurative sculpture. Initiates either hold the sculpture while dancing or place it nearby during performances.

Called *nyeleni* or little Nyele ("pretty little one" or "little ornament")—a name frequently given to a first-born daughter—these figures depict the ideal qualities of young marriageable women. Slender torso, swelling abdomen, full buttocks, and large firm breasts allude to childbearing capacity, and faintly incised patterns on the torso represent traditional scarification marks worn by adolescent Bamana girls. By displaying such a figure, an initiate in effect advertises his desire to meet potential brides.

Frequently, the figures are the targets of sexual jokes: "When the initiates are to perform in a village, they give their statue to the head of the young men there. They tease him, saying that the statue is his girlfriend, and that he can spend the night with her if he gives them money" (Ezra 1986, 21).

PROVENANCE: Robert H. Tannahill, Grosse Pointe Farms, Michigan.

REFERENCES: Detroit Institute of Arts, *Detroit Collects African Art* (Detroit, exh. cat., 1977), no. 8.
Kate Ezra, *A Human Ideal in African Art: Bamana Figurative Sculpture* (Washington, D.C.: Smithsonian Institution Press, exh. cat., 1986), no. 16.

7. STAFF WITH EQUESTRIAN

Mali, Bamana, 19th/20th century
Iron, 40.6 × 5.7 × 15.2 cm (16 × 2¼ × 6 in.)
Bequest of Robert H. Tannahill (70.49)

Wrought iron staffs are made primarily in the southern and western Bamana territory located along the Bani River on both sides of the upper Niger and southwest of the Dogon. Bamana staffs usually depict and invariably represent mounted men or standing women perched atop

a long shaft. The Detroit staff beautifully exemplifies this most striking and ancient Bamana art form. The artist has created a work at once severe and graceful. "Master smiths forge their figures to appear taut with the energies of life, but pliable enough to act swiftly, as people should react to their environment" (McNaughton 1979a, 71). Reduced to bare essentials, this figure nevertheless has a distinguishably Bamana face and a long, straight torso. The horse is fashioned with subtle arches in its neck and legs and a curling tail. The human figure dominates the composition, however, with its strong vertical thrust. The dynamic between horse and rider may symbolize interdependence—the animal as vehicle and support for man's intellectual drive and spiritual quest.

Reputed to be charged with supernatural energy, Bamana iron staffs serve in various ritual settings. Robert Goldwater (1960, 17) described their use as insignia for the families of chiefs in the area south of the Niger River around Bougouni. During ceremonies the staffs would be tied onto tree-tops or buried. Patrick R. McNaughton, who lived among Bamana blacksmiths near Bamako for one year, notes that initiation societies commissioned staffs for placement around altars. He also was told that, due to their supreme potency, staffs had helped to divert attacking armies in the days of slave raiding (McNaughton 1980). The staffs hold prominence in rituals related to ancestor worship; Viviana Paques (1956, 375) describes the creation of four iron staffs in a community near Bougouni to commemorate an ancestor who was both a renowned warrior and village founder. Finally, Kate Ezra (1986, 9; 1983, 40–41) was informed that staffs frequently were positioned at the entrance to the sanctuary, in the *bion* or vestibule, reserved for ancestral offerings.

Since great skill, wisdom, and power are necessary to produce works of iron, blacksmiths are said to be born with especially large concentrations of *nyama,* the Bamana name for the energy

that animates the universe, giving breath to all life and activating the forces within nature. According to Bamana oral traditions, the creator god Faro originally endowed smiths with nyama. They, in turn, have protected the gift from time immemorial through endogamy, or marriage within the clan. This extraordinary concentration of nyama inherited by the blacksmiths explains their numerous roles as diviners, doctors, judges, advisors, and interpreters in Bamana religious, social, and political life. For their special knowledge and superhuman abilities, smiths are referred to as *nyamakala* of nyama, the "handle" or "staff" of energy (McNaughton 1979a, 68). As such, the iron staff is the quintessential metaphor for the blacksmith as a support for vital energy.

PROVENANCE: Robert H. Tannahill, Grosse Pointe Farms, Michigan.

8. VESSEL

Mali, Bamana, 19th century
Terra cotta, 38.4 × 40.6 cm (15⅛ × 16 in.)
Founders Society Purchase, Joseph H. Boyer Memorial Fund (72.246)

Although pottery is often relegated to the category of utilitarian household furnishings, in many African cultures there are ceramics that rank among the greatest works of art. This inventive Bamana pot is one such masterwork. Its artist, probably a woman, has divided the surface of this nearly perfect sphere into two primary horizontal registers. The lower, less visible half is incised with purely geometric patterns, while the more prominent upper register is adorned with figurative motifs raised in low relief. Turtles, lizards, crocodiles, snakes, and humans alternate around the circumference of the pot like the characters in a fable.

In an interview with a Bamana blacksmith, Kate Ezra gained valuable insight into the meaning and function of a pot very similar to this ex-

ample. According to the blacksmith, the pot was used to hold iron slag, gold, and branches from a particular tree. When the pot was filled with water, the mixture acquired protective or healing properties. At the beginning of the rainy season each year, a goat or chicken was sacrificed in honor of the pot. The snake depicted in relief on its surface served as a messenger between the village and some unspecified realm. Ezra (personal communication, 5/86) suggests that the animal reliefs on the Detroit pot may have a similar meaning as intercessors between the village and the spirit world.

Many of the animals depicted—the crocodile, snake, and turtle—inhabit two distinct environments: land and water. The ability to bridge two worlds is further implied by the extension of the animals' heads and tails across the pot's upper or lower bands, conceived in the form of wave patterns. In many African cultures, the ability to navigate freely between two environments is considered a supernatural feat and provides a poignant metaphor for the mediation of the human and spirit worlds.

PROVENANCE: Georges Rodrigues, New York.

REFERENCES: *Bulletin of the Detroit Institute of Arts 52* (1973), 1: 29.

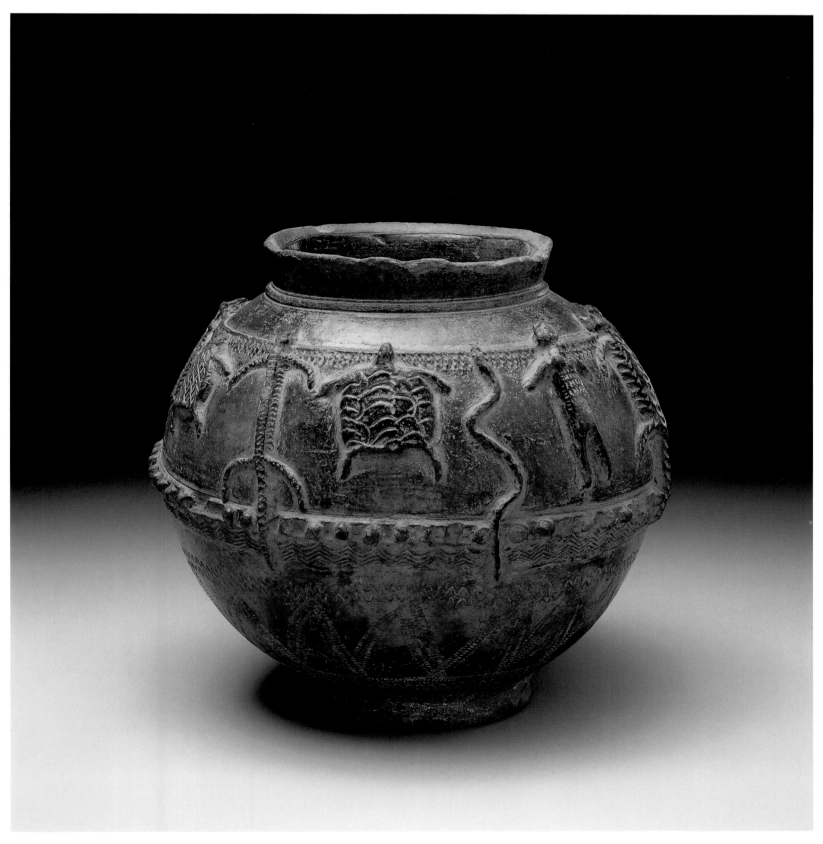

Cat. No. 8

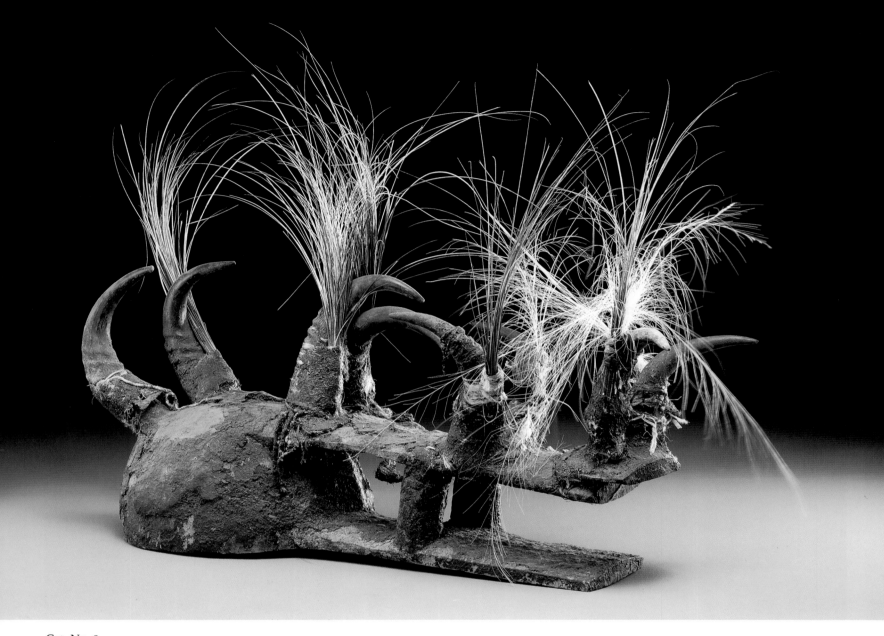

Cat. No. 9

9. KOMO SOCIETY MASK

Mali, Mande, Bamana, 19th/20th century

Wood, antelope horns, porcupine quills, mixed
 media, length without quills, 24.5 × 10.3 ×
 55.5 cm (9¾ × 8 × 21⅞ in.)

Gift of Justice and Mrs. G. Mennen Williams
 (72.734)

"The *Komo* mask is made to look like an animal.
But it is not an animal. It is a secret."

Sedu Traore, September 1973
(Quoted in McNaughton 1988, 129)

Frightening and aggressive, this mask's ambiguous form is the embodiment of secret power and knowledge—knowledge to protect, knowledge to inflict harm. Access to such power is regulated by a blacksmith's association called *Komo*, considered to be among the most influential of Mande secret initiation societies. While any male in the community may join Komo as a member, only master blacksmiths are entitled to leadership positions and to the making and wearing of masks, for years of training are required to control the immense force of such creations.

Called *komokunw*, or komo heads, the masks

are composed of a wooden scaffolding covered and packed with thick applications of animal and vegetable matter. The artist combines these substances according to personal recipes to create exceedingly potent amulets called *daliluw*, which give the dancer, who is often the blacksmith/artist himself, the agency to perform feats of supernatural power. The domelike head and the extended open jaw are surmounted by four pairs of antelope horns with attached bundles of quills. Quills are associated with arrows, darts, and bullets and, therefore, connote aggression and violence. Horns also are associated with po-

tential danger and additionally signify the esoteric knowledge of divination and healing, as they are used as receptacles for medicinal compounds (McNaughton 1988, 129–145). Knowledge and power, then, are joined effectively in this mask in order to fight sorcery, crime, and other malevolent threats to society's well-being and stability.

PROVENANCE: Justice and Mrs. G. Mennen Williams, Grosse Pointe Farms, Michigan.

10. STOOL

Burkina Faso, probably Bwa, 1875/1925
Wood, 40.6 × 20.3 cm (16 × 8 in.)
Founders Society Purchase, Eleanor Clay Ford
 Fund for African Art (79.5)

In Africa, the right to sit during ceremonial occasions is often the prerogative of royalty and other high-status members of the community. For this purpose, elaborately carved stools serve as portable seats. Despite their utilitarian nature, stools can be among the most inventive works of art, upholding aesthetic criteria while meeting functional demands. The supports of African stools frequently incorporate human and animal caryatids, although it is rare to see one such as this, whose overall form is that of a human being. Here, a figure kneels on all fours, his back serving as the seat. Created entirely from geometric shapes, the figure does not depict any par-

Cat. No. 10

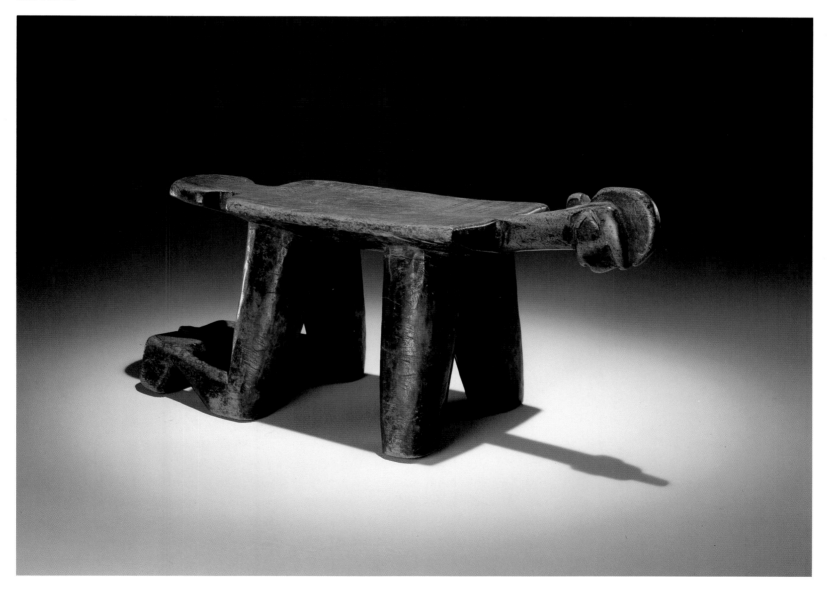

ticular person. Rather, it is a poignant metaphor for the state of subservience; with humility and grace, this figure offers himself as a support.

Lack of accompanying documentation makes it difficult to assign this unique stool to any particular ethnic group, since it was acquired in the large urban center of Bobo Dioulasso where pieces from many different areas were available. René Bravmann (personal communication, 2/87) eliminates the Bobo area as a possible place of origin because Bobo stools tend to be much more abbreviated, with legs left unarticulated. He considers the stool to be more closely related to the Bwa, whose sculpture generally conveys a more sensitive and more fully articulated treatment of forms. The stool also shares stylistic similarities with those of the Lobi to the south, especially in the rounded handle extending from the figure's back. Yet, Lobi stools tend toward a greater abstraction and elongation of form.

PROVENANCE: Collected by Harouna Zanon, Hounde, Burkina Faso, 1967. René Bravmann, Seattle, 1972.

11. MOSSI DOLL
Burkina Faso, Mossi, 19th/20th century
Wood, height 29.6 cm (11¾ in.)
Founders Society Purchase, Eleanor Clay Ford
 Fund for African Art (77.30)

MOSSI DOLL
Burkina Faso, Mossi, 19th/20th century
Wood, height 32.1 cm (12⅝ in.)
Founders Society Purchase, Eleanor Clay Ford
 Fund for African Art (77.31)

MOSSI DOLL
Burkina Faso, Mossi, 19th/20th century
Wood, height 24.8 cm (9¾ in.)
Founders Society Purchase, Eleanor Clay Ford
 Fund for African Art (77.32)

MOSSI DOLL
Burkina Faso, Mossi, 19th/20th century
Wood, leather, height 23.8 cm (9⅜ in.)
Founders Society Purchase, Eleanor Clay Ford
 Fund for African Art (77.33)

MOSSI DOLL
Burkina Faso, Mossi, 19th/20th century
Wood, leather, height 23.8 cm (9⅜ in.)
Founders Society Purchase, Eleanor Clay Ford
 Fund for African Art (77.34)

As in many parts of Africa, Mossi dolls function both as secular playthings for children and as spiritually charged sources of fertility for women. Although minimal and abstract in form, these figures nevertheless embody the most fundamental elements of femininity: finely incised lines on the face, chest, and stomach reproduce cosmetic scarifications obtained by adolescent girls; the stretched breasts are a sign of motherhood; and the head shape typifies the *gyonfo* or tri-lobed hairstyle worn by married Mossi women in which the central lobe extends from the front to the back of the head. (The curved extension from the forehead of one of the dolls [77.34] represents a braided lock that a girl wears until she marries.)

Such dolls may be commissioned from a smith or purchased at market. They are given to young girls by their mothers. Like dolls in the Western world, Mossi dolls are educational toys used to train little girls for their ultimate and important role as mothers. Called *biiga* or child, such a doll may be named, fed, clothed, washed, adorned with jewelry, and carried as a mother would carry a real child—tucked into the waistband of a skirt.

In addition to their use as toys, Mossi dolls serve also as fertility aids to newly married young women. The figure accompanies a woman to her new home in her husband's village to assure pregnancy. If she is unable to conceive, then the figure mediates between the

woman and the spirits controlling her fertility. The figures serve two major functions in this regard: *yisa biiga*, literally "to call the child," and *gidga ti da biiga lebera me,* "to prevent the child from returning." The first permits the infant's soul to enter the world of his or her parents. The second assures that the child does not die and return to the world of the ancestral spirits, but will remain with his or her mother and clan (Roy 1981, 49; Lallemand 1973, 325–346).

Should conception result from sacrifices and prayers made to the spirits, the mother will continue to nurture the figure just as she does her actual child. She bathes the doll, anoints it with shea butter (a beautifying cosmetic), and adorns it with bright beads and strands of cowrie shells. The figures eventually acquire a dark, rich, and glossy patina as a result of such lavish care. Once the figure fulfills its purpose, it may be kept as an heirloom in the woman's clan or given to the child that it helped bring into the world. If, tragically, a child dies at birth, the doll is either buried with the infant, discarded, or sold at market.

The Mossi occupy a plateau in the center of Burkina Faso, in the southwestern region of the upper Volta river basin. A Mossi doll cannot be assigned to a specific geographic area within the region on the basis of where it was collected since the figures are sold at market to buyers from many places and because women take their dolls with them to their husbands' compounds. Christopher Roy (1981, 50), however, has identified several regional carving styles for the dolls. Of the Detroit dolls, acc. no. 77.31 is in the Kaya style, which predominates in northeastern Mossi country; acc. no. 77.30 comes from the Boulsa region located in eastern Mossi country, where some of the largest and most distinctive dolls are made. The heads of Kaya figure types are characterized by a continuous curve, from which the head and breasts extend. Eastern Boulsa dolls have flattened disklike faces with elongated, cylindrical necks. Finally, Roy points out that the dolls possessing the s-shaped extensions from

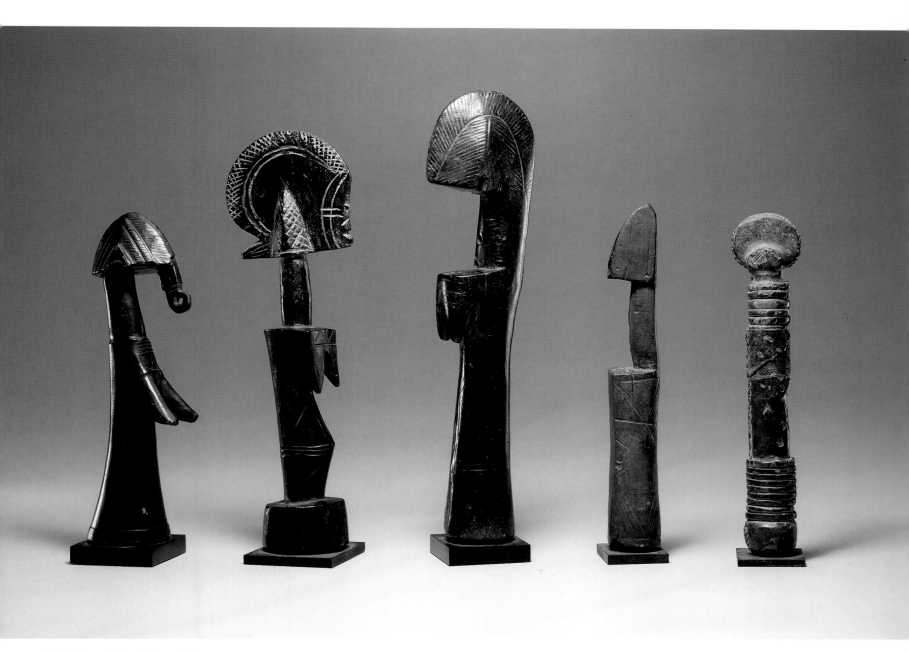

Cat. No. 11 (From left to right: acc. nos. 77.34, 77.30, 77.31, 77.32, 77.33)

their heads do not constitute a regional style; such dolls have been collected in many Mossi regions.

PROVENANCE: William Wright, New York.

REFERENCES: Christopher D. Roy, "Mossi Dolls," African Arts 14 (1981), 4: 47.

University of Michigan Museum of Art, African Images, Art and Ornament (Ann Arbor, exh. cat., 1981), no. 9.

12. FACE MASK

Côte d'Ivoire, Senufo, 1875/1900

Wood, 43.2 × 18.8 cm (17 × 7⅜ in.)

Founders Society Purchase, Joseph H. Boyer
 Fund, Joseph M. DeGrimme Memorial Fund,
 General Endowment Fund, New Endowment
 Fund, Edith and Benson Ford Fund, K. T. Kel-
 ler Fund, Laura H. Murphy Fund, Mary Mar-
 tin Semmes Fund, and Barbara L. Scripps
 Fund (80.18)

"Sweat and laughter, the taste of yams in a succu-
lent meat sauce, the fierce pride of status, the fear
of evil spirits, the tears of personal loss, and the re-
uniting of friends are as much a part of the Senufo
funeral as is the joy of aesthetic experience."

(Glaze 1981, 158)

Pure line and delicate detail distinguish this mask
from others of its kind. Called *kpeli-yehe* or *ko-
doli-yehe,* it was worn at funeral rights staged by
members of the men's *Poro* association. For the
Senufo, funerals are multi-media events intended
both to commemorate the deceased and to rein-
tegrate the mourning relatives into the commu-
nity. Feasting, song, dance, poetry, drama, and
the visual arts combine to heighten group wor-
ship and to create the appropriate atmosphere in
which the deceased leave the world of the living
to enter the ancestral realm. The festivities' cli-
max is marked by a masquerade, which symboli-
cally expresses the fundamental dualities in
Senufo thought: male/female, body/spirit, life/
death.

Face masks—small, delicately rendered, hu-
manistic representations designed to cover the
wearer's face—are connected to the feminine ele-
ment. "Sometimes called 'girlfriend' or 'wife' of
a male-associated masquerade or spirit . . . the
face is always intended to 'be beautiful' in praise
of a man or youth on the occasion of his com-
memorative funerals" (Glaze 1981, 127). Not co-

incidentally, the dancer wearing the mask fuses
quick, intricate stepwork with accentuated move-
ments of the hip and shoulder evocative of femi-
nine grace. The characteristics of womanhood
displayed in face masks, along with accompa-
nying choreography, would strike a contrast to
their male counterpart—a zoomorphic helmet
mask, massive in form, aggressive in imagery, in-
cluding antelope horns, chameleons, and wart-
hog tusks. In Anita Glaze's words, the male mask
is "an expressive evocation of the 'open and de-
vouring jaws' of Death" (1986, 32).

Provocative messages within this piece are re-
minders of its feminine nature. Its lustrous black
surface radiates like the youthful skin of a beauti-
ful, marriageable young woman. Ornamental
flanges framing the face are the baubles and ban-
gles adorning a fine Senufo woman's traditional
coiffure. Most significant and powerful of all is
the swelling at the forehead's center—a secret
symbol of the vulva with special meaning for the
immigrant artisan caste called *Kulebele,* who are
members of the wood sculptors' Poro society.
"This sexual symbol evokes a remembrance of a
highly secret entry rite for each senior-grade initi-
ate, in which he must perform an act of 'union'
with mother earth, a sexual embrace that seals
his 'marriage' to the Poro society" (Glaze 1986,
32).

The relationship of the Kulebele carvers' asso-
ciation with Poro is yet further conveyed by the
mask's superstructure. Sheep horns bisect the
central crest, symbols of the Kulebele's arrival
into the Senufo area—located in northern Côte
d'Ivoire as well as parts of Mali and Burkina
Faso—from the north in the early nineteenth
century. Additionally, the six rows of nodules on
the crest are interpreted as the pods of the ka-
pok, a splendid tree associated with civilization
and human settlement. The Senufo tend to estab-
lish their villages near sacred groves filled with
kapok trees. It is in these groves that the Kuleb-

ele learn the teachings of the "Ancient Mother,"
deity of the Poro association (Glaze, personal
communication, 7/86).

PROVENANCE: Harry A. Franklin, Los Angeles.

REFERENCES: Robert Goldwater, *Senufo Sculpture
 from West Africa* (New York: New York Graphic So-
 ciety, 1964), 15.
Bulletin of the Detroit Institute of Arts 58 (1980), 4: 170,
 fig. 1.

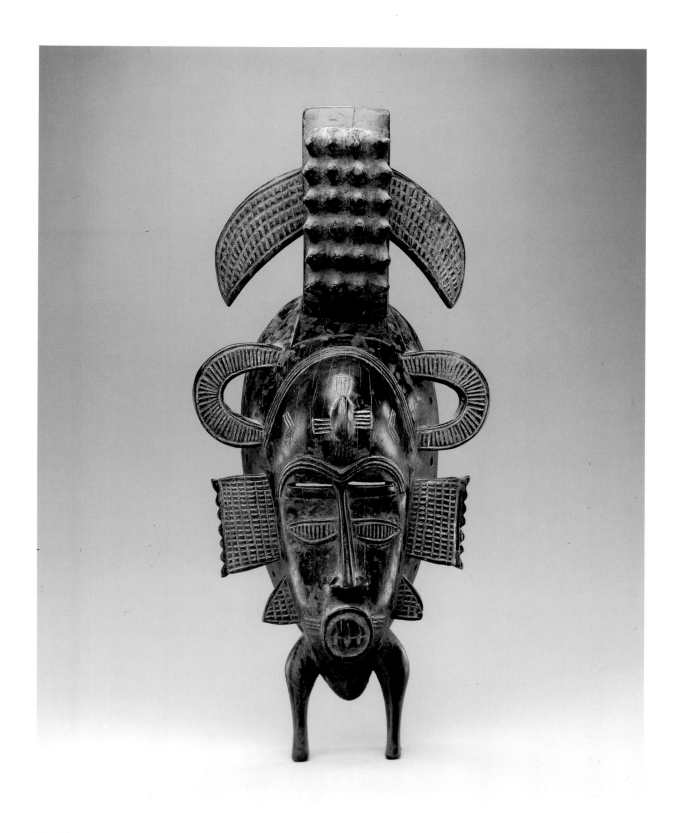

Cat. No. 12

GUINEA COAST

The dense, hardwood forests of the Guinea Coast stretch from modern Senegal to northeastern Zaire. Forests merge with mangrove swamps and tidal estuaries that characterize much of the West African coastline, thinning well to the north in the savannah country of the Western Sudan. This formidable barrier kept early European explorers from the interior and allowed West African kingdoms control of coastal trade.

Generally speaking, tropical forests are less hospitable to cultural life than the savannah region to the north. There is less animal life, the thin soil is more easily exhausted, and the impenetrable forests inhibit travel. Nonetheless, Congo-Kordofanian speakers pushed into the forested coastal belt three to four thousand years ago and brought the institutions of Western Sudanic civilization with them. The cultivation of tropical foods, such as the east Asian yam, banana, and taro—a practice that spread across tropical Africa from Malaysia and Madagascar early in the first millennium—resulted in tremendous population growth for this culturally marginal region. By the fourteenth century, the Guinea Coast supported impressive kingdoms of its own.

Farming communities to the west resisted the centralization of power that state organization required. Dan, Guro, and Baule villages remained fiercely independent, sometimes clashing in conflict. Leadership was vested in family elders. Cultural values extolled personal abilities and accomplishment.

Wood sculpture—masks and figures—were often intended to impersonate otherworldly beings who were able to influence human events. The Dan term *du*, Guro *zuzu*, and Baule *amuen* all refer to the concept of a wild spirit of the bush. The settled culture of village life, agricultural cultivation, and hu-

Opposite: Cat. No. 27, *Epa Helmet Mask*, detail

56

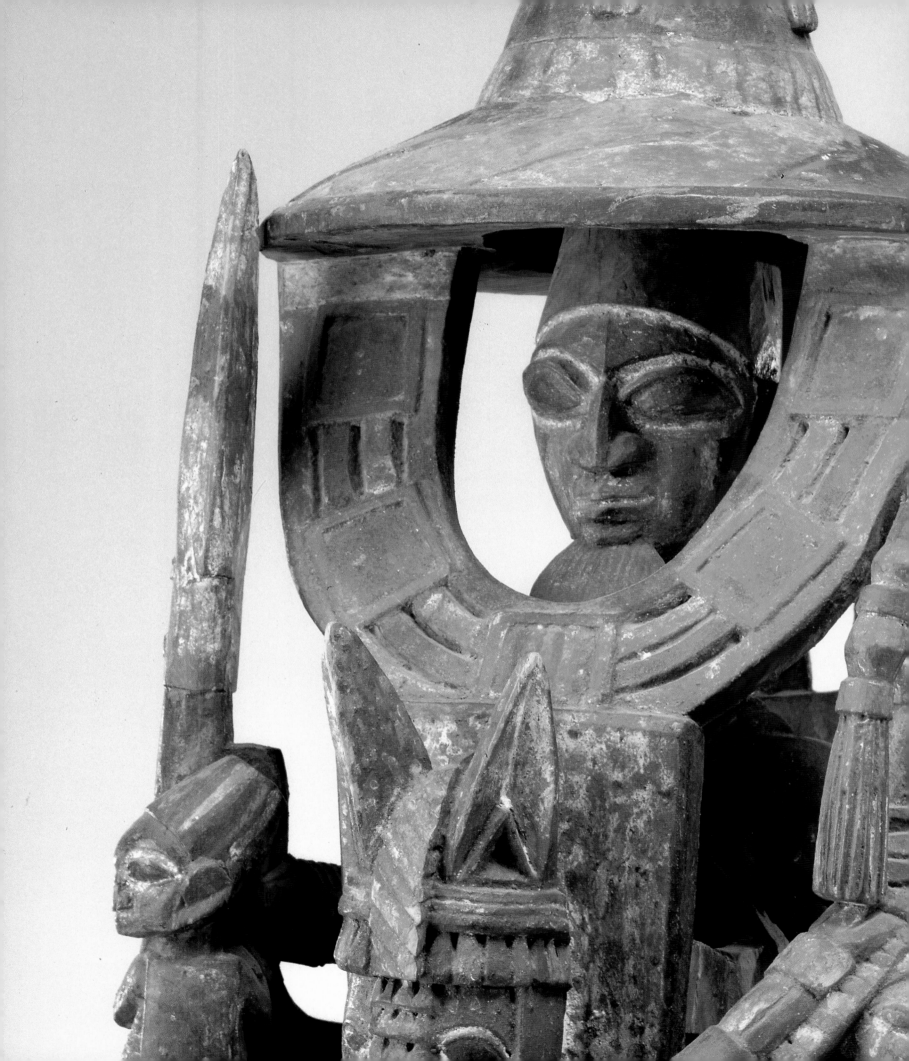

man society stand in contrast to the surrounding forests with their wild animals and powerful spirit forces. Dan, Guro, and Baule masquerades temporarily bring these forces into the village as masked impersonations of "bush spirits." Revered among the Dan were *gle-zo*, those members who possesed the right to dance with a mask. They performed important social roles within the community, using different masks to function on occasion as police, impartial judge, or military leader.

East of the Baule in present-day Ghana, the Asante clan consolidated its authority over powerful neighboring clans of fellow Akan-speakers at the Battle of Fayase in 1701. Thereafter, with the help of court councilor and sorcerer Okomfo Anokye, Osei Tutu proclaimed himself Asantehene, king of the Asante kingdom and a powerful confederacy of Akan-speaking peoples. During the public ceremony that marked the event, a golden stool symbolizing the indissoluble and sacred character of the confederacy was said to have descended from heaven and landed on the ruler's lap. The Asante kingdom, based in the city of Kumasi, became a powerful center of trade and military might in tropical West Africa. The kingdom ran afoul of British imperial aspirations when envoy Governor Sir Charles MacCarthy was assassinated in 1824. The Asante resented Britain's involvement with rivals on the coast and wished to control trade with the interior along what the British called the "Gold Coast." Continued conflict resulted in the British invasion of the Asante kingdom in 1874, the sack of Kumasi, and the establishment of a permanent British colony on the coast. Friction persisted, and when Asantehene Prempeh I attempted to seal the Asante kingdom's borders to British traders in 1896, the king was captured and banished from his capital city, bringing the history of the independent Asante state to an end.

The Yoruba are a large and successful group of urban agriculturists, numbering nine to ten million, who have long lived in southwestern Nigeria and southern Republic of Benin (Dahomey). Yoruba towns are surrounded by fields, so there is constant movement back and forth between town and country. According to Yoruba tradition, the Creator Olodumare sent Oduduwa to earth to become *Oni* or king of the first kingdom at Ife. From Ife, Oduduwa sent his sons out to create more kingdoms throughout Yorubaland. Archaeologists say that the city of Ife dates back to at least 800 A.D. and represents the beginnings of Yoruba urbanism.

The city of Oyo eclipsed the power of Ife under its kings, or *alafin*, during the seventeenth and eighteenth centuries. The Oyo empire represented the most extensive consolidation of political and military power in the history of the Yoruba people, bringing dozens of Yoruba cities under its dominion or influence. The empire proved unstable, however, and the city of Oyo was eventually abandoned after defeat by the Muslim Ilorin in 1836. The legend of Oyo greatness lives on in the cult of Shango, named after the reputed fourth alafin of Oyo, who was a great sorcerer with powers over thunder, lightning, and fire. Cities once affiliated with the Oyo

empire nurtured shrines devoted to Shango, who became an *orisha*, or deity, after his death.

The Yoruba cosmos recognizes many different cults and orisha, often with local or regional significance. Eshu-legba is the trickster intermediary and messenger between human beings and the orisha. The lore of the Ifa cult allows diviners to predict the fate of their client's ambitions. The cult of Epa celebrates the accomplishments of Orangun, the warrior farmer who successfully led Yoruba pioneers into the northeast Ekiti region after defeating their Nupe neighbors. Gelede cults of Lagos and Dahomey in southwest Yorubaland acknowledge and honor the powers of elderly women with celebratory masquerade festivals.

The Edo-speaking kingdom of Benin neighbors the Yoruba to the east. The city of Benin was the center of a powerful empire, which dominated the central Nigerian coast for nearly five hundred years prior to its destruction at the hands of a British punitive expedition in 1897. Bini peoples trace their origins to twelve ancient *Ogiso*, or mythic kings, but the current dynasty stems from Oranmiyan, one of the Yoruba sons of Oduduwa, who came to Benin from the city of Ife. Oguola, the fifth *Oba*, or ruler, in the dynastic line, brought brass casting as a royal art from Ife, perhaps as early as the fourteenth century. Brass panels decorated the walls of the palace, and royal shrines included brass portrait heads of the Oba and his Queen Mother.

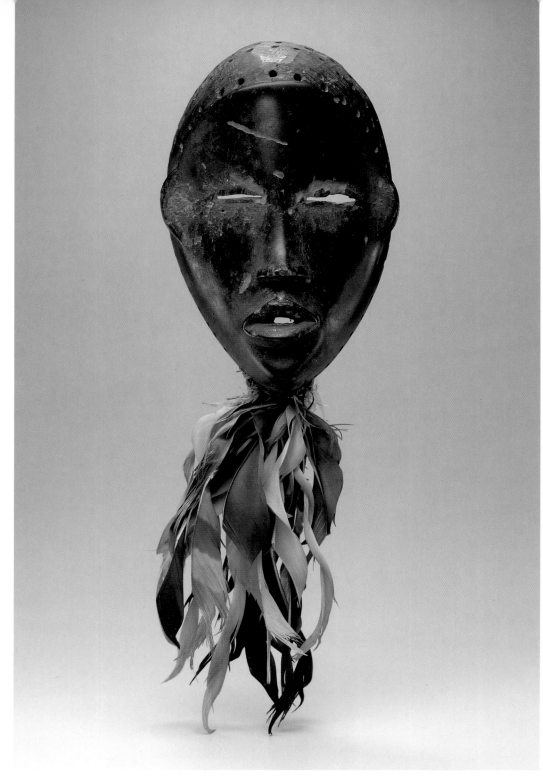

Cat. No. 13

13. MASK

Côte d'Ivoire, Dan, 19th/20th century

Wood, feathers, 21.6 × 14 × 7 cm (8½ × 5½ × 2¾ in.)

Bequest of Robert H. Tannahill (70.80)

In Dan philosophy, all living creatures, both human and animal, and spirits are composed of a special power called *du*. Human and animal du are manifest as body, breath, and character. Du spirits, on the other hand, remain invisible and shapeless, inhabiting the sacred forest where eminent persons are buried and young men are initiated. Occasionally a du spirit wishes to take on material form and participate in the human realm. The spirit then appears in some individual's dream, expressing an incarnate desire. Sometimes the spirit will seek a static form such as a bundle of powerful fur or antelope horns. Otherwise the spirit may request a more dynamic materialization, such as a mask (Fischer 1978, 18).

This sleek face mask, attributed by Eberhard Fischer to the northern Dan region—possibly the Tura area—may have been used in *Tankagle*, an entertaining masquerade performed at village festivals (Fischer, personal communication, 6/86). Tankagle means "dancing, pantomiming masquerade." Each mask in the Tankagle has its own name, most often projecting the optimistic nature of the festival. Two examples are "the one who makes me happy" and "good sauce" (Fischer 1978, 21). While most Tankagle masks have slitted eyes associated with femininity, many also have masculine features—heavy eyelids, mustaches, and in this case, a beard. For this reason, the masks are viewed as attractive young men.

In addition to a face mask, Tankagle performers wear a cape with a pantsuit and a short fiber skirt. Above all is a bonnet-like cap adorned with a strip of goat skin covered with cowrie shells. Two perforated rows across the top of this mask—distinct from the holes around the edge

for attaching the costume—indicate where the cap was secured.

A typical Tankagle performance features dancers acclaimed for the lyrical, joyful movements they perform to orchestral accompaniment. The dancers even contribute to the music itself, wearing bells around their ankles and carrying calabash rattles in their hands. Besides the dances, some of the masqueraders act out short vignettes. Still others specialize as singers.

While there is little doubt of the role of this mask in Tankagle, Dan masks in general can change in status and character during their owners' lifetimes. Like an individual who climbs the social ladder, a mask may ascend to the rank of judge or peacemaker. In this sense, form alone cannot tell a mask's life history. As the Dan explain, "Masks have mixed characters like human beings" (quoted in Fischer 1978, 19).

On the nature of Dan masks, Fischer states: "The masquerades are the spirits manifest. . . . The mask does not merely represent that spirit, it is that spirit. The spirit operates in the face mask whether it is worn or not. Consequently, old face masks which are no longer worn are still precious. Their owners often address requests for extraterrestrial help to them. To discard an old mask would be unthinkable. Old or damaged masks get copied by a distinguished sculptor and its spirit is entreated to accept the new face. A mask must be cared for with respect until it disintegrates" (Fischer and Himmelheber 1984, 8).

PROVENANCE: Galerie Percier, Paris, 1935. Robert H. Tannahill, Grosse Pointe Farms, Michigan.

REFERENCES: Detroit Institute of Arts, *Detroit Collects African Art* (Detroit, exh. cat., 1977), no. 43. W. A. Bostick, *Robert Hudson Tannahill Memorial Exhibition* (Grosse Pointe Farms, Michigan: Grosse Pointe War Memorial, exh. cat., 1978), no. 20.

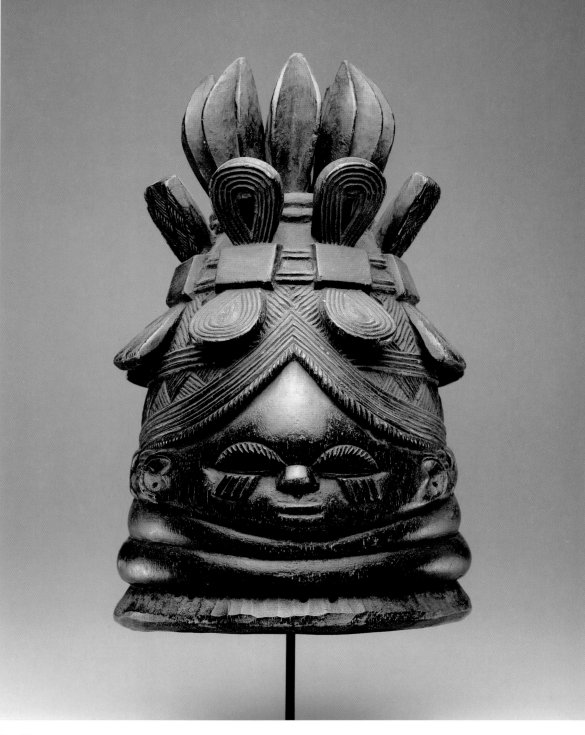

Cat. No. 14

14. SANDE SOCIETY MASK (SOWO-WUI)

Sierra Leone, Eastern Mende, Kenema district, 1940s
Wood, pigment, height 41.3 cm (16¼ in.)
Founders Society Purchase, New Endowment Fund (1990.268)

This type of wooden helmet mask, called *sowo-wui,* is exceptional in that it is worn by women, a rarity in sub-Saharan Africa where almost all

masks are worn by men. Sowo-wui are worn by members of the Mende women's association, called the *Sande* society. When the fully costumed masker, called *sowo,* appears at the initiation schooling of adolescent girls, at funerals, and other important events, she is the spirit of the Sande society. All adult women in a Mende community are members of the Sande society. Young girls are initiated at about the age of puberty and progress through the ranks of the society throughout their lifetimes. Sande educates girls about their responsibilities as wives, mothers, and community members and protects the interests of all women within the larger social group. Under its jurisdiction, the masker has the authority to identify and punish men who commit acts against women.

It is not uncommon for inner and outer beauty to be considered synonymous in many parts of Africa, and this mask exemplifies many of the traits of both physical and moral beauty among Mende women. The face is carved with the sensitive attention an adult woman would pay to her own physical appearance. The eyes, small and modestly downcast, reveal a spiritual nature. Four parallel lines carved on the cheeks indicate the scarification worn by Mende women. The closed mouth reflects restraint, which the Mende believe is needed for spiritual accomplishment. The high forehead is the seat of good fortune; the more expansive its size, the greater the beneficence one should expect.

Beneath the face are two rolls on the neck erroneously called rings of fat by earlier scholars. They have since been identified as representing the deep creases in the necks of some people, a pattern called "cut-neck" by the Mende (Boone 1986, 169). This feature is considered extremely attractive on women, but it also has a metaphorical meaning. A cut-neck pattern symbolizes the ripples produced when spirits break through the surface of a body of water to assume earthly form. The actual function of the mask's expanded neck is to allow the helmet to fit over

the head of the wearer so the rim rests over the shoulders. The surface of the entire mask is painted black, oiled, and polished to give the appearance of the burnished skin of a beautiful woman. Since the word for black also means wet in the Mende language, the color is another reference to underwater spirits.

An intricately carved representation of a braided coiffure sits atop the face. Each sowo-wui carries a different and very individual hairstyle. For the Mende, physical beauty is not thought to come naturally, but is artistically constructed. Elaborate hairstyles reveal the close ties within the community of women; hair is braided by one's friends and relatives, who must dedicate hours to the process, not for remuneration, but out of affection. Unkempt hair is a sign of uncivilized and anti-social behavior.

Surrounding the crest of the head is a band intersected by double flaps, copied from the cloth and leather flaps worn around the waists and necks of medicine men and male dancers of the *Poro* society, the male equivalent of Sande. Projecting from the mask's crown are objects that represent elements of an unidentified plant that was probably eaten ritually (Phillips, personal communication, 12/94).

There are two types of Sande society masks (Boone 1986, 248). One is called *sowei,* the same title given to the most elder and learned women in the society. It is a more restrained type with a simple hairstyle consisting of large, smooth buns of hair without further elaboration. The Detroit mask belongs to the second group worn by women in the middle levels of Sande called *ligba.* At this level, each woman commissions a mask of her own design, which she then owns herself. The masks tend to have the impressive, personalized ornamentation seen here. It is perhaps because of the uniqueness of the design that the plant elements are not easily recognized.

The masker's identity is completely concealed beneath a costume of black raffia fibers, black gloves, and socks. She is assisted by another

Sande member who interprets for her, since spirits do not communicate with words. The assistant picks up any stray pieces of raffia since they contain powerful medicine; she also carries a mat behind which sowo retreats to adjust her mask if needed. When the masker appears, she walks with the grace and elegance expected of Mende women.

PROVENANCE: Merton Simpson, New York.

REFERENCES: Mary Nooter, *Secrecy: African Art that Conceals and Reveals* (New York: Museum for African Art, exh. cat., 1993), no. 64.

15. STANDING FEMALE FIGURE

Côte d'Ivoire, Guro, 19th/20th century
Wood, beads, 52.1 × 19.4 cm (20½ × 7⅝ in.)
Bequest of Robert H. Tannahill (70.95)

This figure is not only a masterpiece of Guro sculpture, but also was a pivotal discovery in the history of African art. The existence of Guro figures was virtually unknown in the West until the 1950s. While some researchers made mention of them, none had ever knowingly laid eyes on Guro figures. Ethnographer Hans Himmelheber explained the highly religious nature of the figures and the difficulty in gaining access to them (Himmelheber in Siroto 1953, 17). Only with Leon Siroto's stylistic analysis of the piece now in Detroit was the work identified as Guro and the existence of Guro figurative sculpture confirmed. Siroto compared this undocumented figure to Guro masks with known provenance and found the facial features to be almost identical to those on an elegant Guro mask in the University Museum, Philadelphia (Siroto 1953, 17–18). This discovery led to the identification of an entire corpus of Guro figure sculptures and revealed that the artists of masks also carved figures. While the number of figures is few in relation to masks, they nevertheless reflect a fully developed figurative tradition.

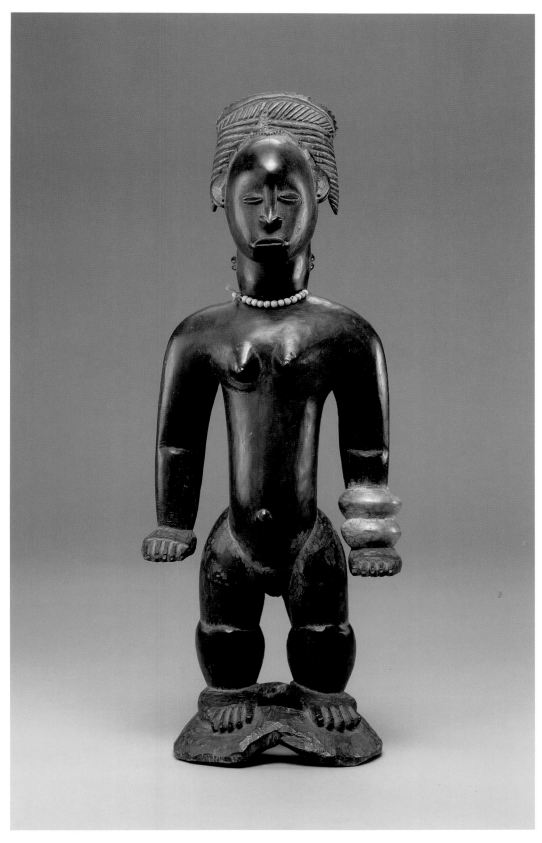

Guro figures are believed to represent protective spirits called *zuzu*. Placed against the back wall of a shrine house with other ritual objects, they receive prayers and offerings in the form of eggs and kola nuts. As intermediaries between the human and supernatural realms, the figures convey messages of practical as well as spiritual import to the living via rituals of divination (Fischer and Homberger 1985, 227–229).

This female figure's fully developed pectorals, small firm breasts, and gleaming skin convey the vigor of youth. Her smooth face with pursed lips is crowned by a richly textured coiffure set back to emphasize the prominent forehead. The braids falling symmetrically from the rectangular crest mimic the configuration of the chest and arms, while the gentle downward slope of the nose is echoed by the line of the torso. Planted firmly on a slanting base, the figure's hands press against an invisible force, literally holding her own weight.

PROVENANCE: Tristan Tzara, Paris. Kleinman, Paris. Frank Crowinshield, New York. Robert H. Tannahill, Grosse Pointe Farms, Michigan.

REFERENCES: New York, Parke-Bernet Galleries, Inc., *Frank Crowinshield Sale* (October 21, 1943), 62, no. 130.

Leon Siroto, "A Note on Guro Sculpture," *Man* 53 (1953): 17–18.

F. J. Cummings and Charles H. Elam, eds., *The Detroit Institute of Arts Illustrated Handbook* (Detroit: Detroit Institute of Arts, 1971), 167.

Detroit Institute of Arts, *Detroit Collects African Art* (Detroit, exh. cat., 1977), no. 78.

Cat. No. 15

16. FEMALE FIGURE

Côte d'Ivoire, Baule, early 20th century
Wood, 30.5 × 5.7 cm (12 × 2¼ in.)
Founders Society Purchase, Eleanor Clay Ford
 Fund for African Art (79.19)

Most African art is functional, although the pre-
cise use of a piece cannot always be determined
on the basis of form alone. And since the major-
ity of African art enters European and American
collections with little or no documentation,
there is a tendency to label unidentifiable works
as either "ancestor" or "fertility" figures. Such
simplistic designations were assigned to Baule
sculpture for decades before Susan Vogel con-
ducted extended field research in the 1970s.
Vogel's research revealed that, in fact, Baule
sculpture is not primarily ancestral, but belongs
to a complex and highly philosophical system of
thought and ritual. Virtually all Baule anthropo-
morphic figures under two feet tall serve one of
two purposes, either as spirit spouses or as na-
ture spirits.

 To explain briefly a complicated belief system,
the Baule carve figures to represent the spouse
that everyone had in the other world before he
or she was born into this one (*blolo bian,* "spirit
husband"; *blolo bla,* "spirit wife"). Men thus have
female figures, women male figures. The figure
is the locus for one's spirit spouse and becomes
the center of a shrine where a jealous or venge-
ful spirit spouse can be appeased. Not everyone
needs such a shrine, and not all shrines have
sculpted figures. Anyone who has a marital or
fertility problem is likely to be advised by a di-
viner to establish a shrine, and other problems
may also be diagnosed as having been caused by
a discontented spirit spouse.

 Other figures, less numerous than these, are
carved for nature spirits (*asie usu*) that possess or
follow a person and disrupt his or her life until a
shrine has been made and a private cult estab-
lished. Nature spirits often require their human
companion to become a professional spirit me-

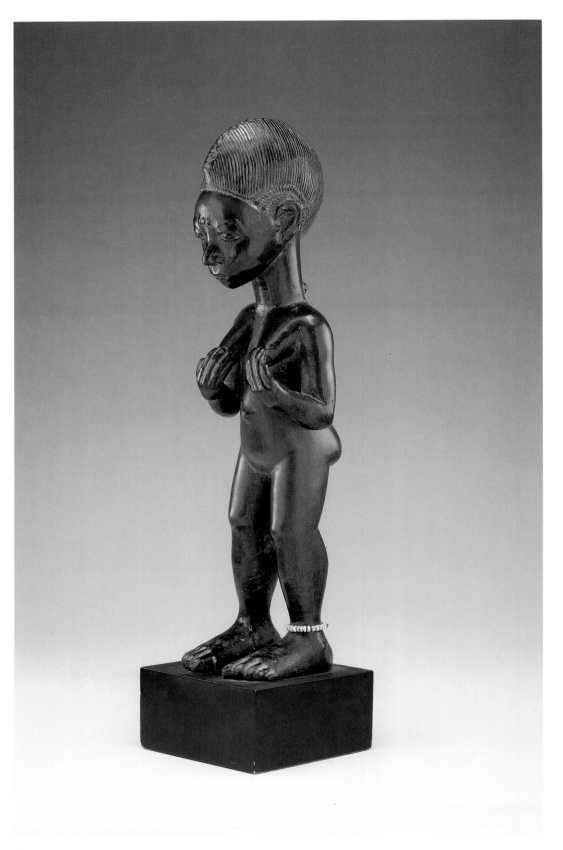

Cat. No. 16

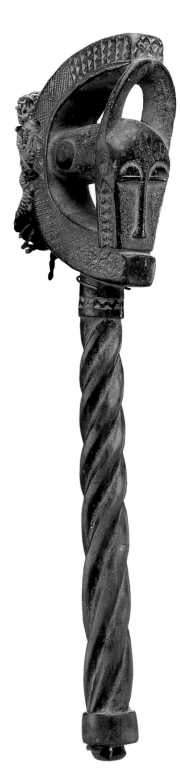

Cat. No. 17

dium (*komien*) and to do divinations for clients while in a trance. The nature spirits or the spirit spouse for whom a figure is made will indicate to the sculptor, the client, or the diviner how the figure should be carved, and sometimes which tree in the forest should be used. Details of scarification, coiffure, age, and posture are usually dictated by the spirit (Vogel 1981, 73).

Nature spirits generally acquire a soiled, encrusted surface as a result of the constant application of sacrificial offerings. This contrasts with the smooth, lustrous patina of spirit spouse figures, which comes from affectionate fondling and rubbing by its owner. It is nevertheless impossible to determine the original function of an undocumented Baule figure from the condition of the surface because many Baule pieces were cleaned and polished once they were taken from their original context.

For the Detroit figure, the artist carved an ideal of feminine beauty: a firm youthful body with small, high breasts, smooth glossy skin, and a beautiful coiffure. Yet certain aspects of the work are anomalous to traditional Baule sculpture, in particular the naturalistic body proportions with long, straight legs, and the placement of the hands on the breasts. Most Baule figures have their hands on their abdomens. These elements indicate this figure is from a relatively late period of Baule carving (Vogel, personal communication, 1/87).

PROVENANCE: Alan Brandt, New York.

17. GONG BEATER

Côte d'Ivoire, Baule, early 20th century
Wood, cloth, metal, 24.1 × 2.5 × 5.4 cm (9½ ×
 1 × 2⅛ in.)
Bequest of Robert H. Tannahill (70.125)

Like spirit mediums all over the world, the role of the Baule diviner is to identify the cause—physical or psychological—of misfortune, and to prescribe a cure. Among the varied instruments

used by Baule spirit mediums for this purpose are elaborately carved gong beaters called *lawle.* Diviners are trained to enter a trance to the steady beating of a small iron gong. Frequently the diviner enters this state in a private room prior to the consultation, although he keeps the lawle at arm's reach throughout the session with his client should the trance begin to wear off.

A spirit medium may commission a lawle from an artist, or he may carve it himself. It is very common for gong beaters to incorporate human and animal imagery combined with masks and geometric motifs. In this example, the central image is a horned animal with open jaws, a miniature replica of a men's sacred mask called *bonu amuen,* or "gods in the bush." These highly secretive masks are associated symbolically with the male realm and are noted for their aggressive and unpredictable behavior. They are kept safely hidden from women, who are thoroughly forbidden from viewing them. According to Susan Vogel (personal communication, 1/87), the depiction of a bonu amuen on a gong beater, which could be seen by women, is acceptable because the women, never having seen such masks, would, therefore, never suspect that the lawle's carved animal head was a mask.

Although now missing, a string once passed through the hole carved in the base of this lawle's handle to attach the beater to its gong. Extensive use has also led to the disintegration of the cotton pad on the back side of the lawle, which served to mute the sound, and to the loss of brass tacks once inlaid around the upper rim.

PROVENANCE: Robert H. Tannahill, Grosse Pointe Farms, Michigan.

REFERENCES: Detroit Institute of Arts, *Detroit Collects African Art* (Detroit, exh. cat., 1977), no. 67.

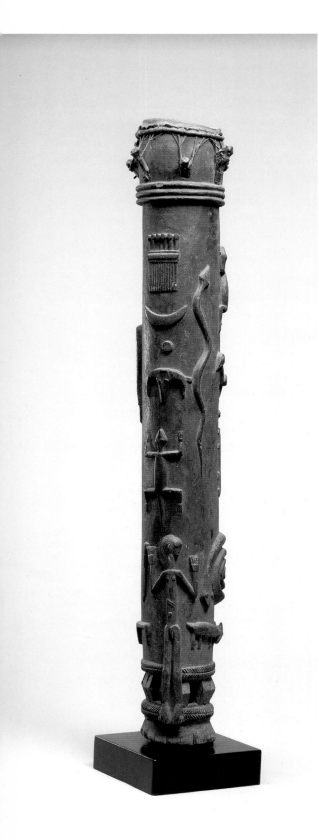

18. DRUM

Côte d'Ivoire, Baule, 19th century

Wood, hide, string, height 127.3 × diameter 19.1
 cm (50⅛ × 7½ in.)

Founders Society Purchase, New Endowment
 Fund (1983.26)

Both in its conception and execution, this drum
is the work of a virtuoso. It illustrates not only
the richness of Baule visual symbolism, but also
the best in Baule wood carving. Long drums of
this kind are used in funeral rites for eminent
members of the community. Such drums also
figure in the rites of *Attoungblan,* an ancient cult
that emphasizes seniority through the commem-
oration and exaltation of influential elders.

An openwork arrangement of flexed frets,
each embossed with a vertical line of tiny
toothlike projections, decorates the base of the
drum. This configuration closely resembles a tra-
ditional Baule stool type and is probably in-
tended as a metaphor for ancestral support. The
openwork section is bordered on top and bot-
tom by horizontal ropelike bands with herring-
bone patterns, which resemble Baule war belts
and may allude to power and bravery (Vogel, per-
sonal communication, 1/87).

Complex iconographical motifs are carved in
high relief around the body of this drum. Cen-
tral to the imagery is an attenuated male figure
whose beard indicates that he is probably an el-
der. While his feet hang limply below him, his
arms form a rigid configuration in which the
raised right arm mirrors the lowered left arm ex-
actly. A smaller female figure, also frontal with
flaccid feet, is depicted on the opposite side.
Both her arms are raised, and she holds a knife
in her right hand. Her head is turned to the left.
The diagonal mark on her stomach represents a
traditional Baule scarification pattern.

To the left of the woman, near the base of the
drum, are a number of animals, including a goat,
snake, frog, and bird. All of these animals are fa-
vorite sacrificial offerings. Above the female fig-

ure to the right is a more varied collection of
objects, both animate and inanimate, among
them a comb, a crescent representing the moon,
a circle symbolizing the sun, and a ram's head,
which is actually intended to represent a gold or-
nament.

According to Vogel, while each of these mo-
tifs is itself symbolic, their arrangement around
the drum appears to be entirely random. The
same seemingly random placement of images
characterizes the famous drum in the Musée de
l'Homme, Paris, which is identified as Baule (Vo-
gel and N'Diaye 1985, 10), but is more likely to
be Attie. Vogel considers it typical of the Baule
to organize the iconography in a way that is es-
sentially personal and not systematic.

The only pattern that emerges with any cer-
tainty is the dichotomy between left and right.
In a widely acclaimed study, Rodney Needham
(1973, xii) discusses the symbolism of left and
right as an almost universal dialectic—right be-
ing associated generally with positive ideas, and
left with danger, irrationality, and death. When
seen in this way, the placement of many of the
Detroit drum's motifs—the male figure's arm
gestures, the knife in the woman's right hand,
the sacrificial animals on her left, including a
coiled snake and a frog, both considered to be
dangerous—takes on this additional dimension
of meaning.

PROVENANCE: Franklin family, Los Angeles, ca.
 1958.

19. BEDU MASK

Côte d'Ivoire or Ghana, Nafana, 20th century

Wood, paint, 276 × 99.7 cm (9 ft.¾ in. ×
 39¼ in.)

Founders Society Purchase, Director's Discretion-
 ary Fund (64.108)

Vividly painted in the traditional colors of ocher,
white, blue and black, this mask exemplifies the
vitality and grandeur of Nafana artistry. The Na-

fana are a Senufo-related group who, according to oral traditions, migrated east sometime in the seventeenth century in search of fabled gold deposits, eventually settling in a region that now borders Côte d'Ivoire and Ghana. Their strategic location along the trade routes extending between the Asante kingdom in the southern forest zone and the Saharan cultures of the northern desert led to an uninterrupted and prosperous exchange of goods, ideas, and institutions. This colorful history is reflected in the annual performance of the Bedu masquerade, for which this mask was created.

The Bedu masquerade is an artistic phenomenon of the twentieth century. It was introduced in the 1930s by Nafana artists to replace a more ancient masking cult called *Sakarabounou* or *Sakrobundi,* which had been outlawed by colonial authorities. Bedu fulfilled the same purpose without the esoteric and frightening aspects of the Sakarabounou. The positive nature of the Bedu and the ease with which it can be understood have allowed it to transcend both ethnic and religious barriers. Since its introduction, the Bedu masquerade has been adopted by multiple ethnic groups in the east central Ivory Coast and neighboring Ghana, among them the Kulango and Degha. Furthermore, while Bedu is controlled by persons of traditonal African religious belief, it is accepted and even practiced by some Muslims, demonstrating that Islam and traditional Africa are not always incompatible (Bravmann 1974, 114–118).

Bedu masqueraders perform for an annual month-long ceremony called Zaurau as well as at funerals for important elders. During this festival, which usually occurs in late November and December, Bedu masks are used to address issues of human survival, including fertility, healing, and protection of the village from both natural and social crises. Each night of the festival, the masks emerge from the forest to the dance arena in male/female pairs clad in long raffia gowns. While male Bedu masks have been

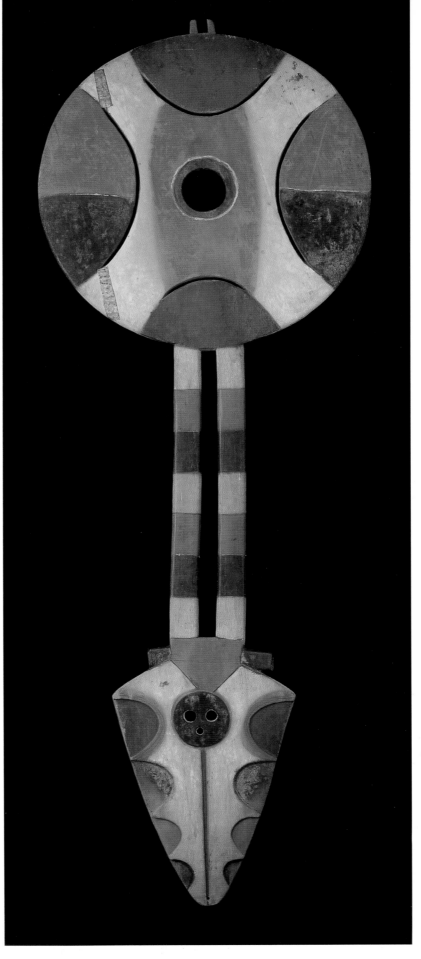

Cat. No. 19

described as having horns and female masks a round disklike superstructure, René Bravmann (in Vogel 1981, 30) found that informants disagreed over this, making it impossible to identify the gender of the Detroit mask on the basis of form alone. The male/female dualism is nevertheless important, both in the mask's symbolism and in the performance. For while men always dance the Bedu masks, women play a significant role in their painting and preparation. Bravmann sums up the significance of Bedu: "Stressing the importance of community, and praising the traditional roles of men and women and the virtue of strong families, it served to reassert time-honored Nafana values in a new and embattled political and social climate."

PROVENANCE: Julius Carlebach, New York.

REFERENCES: Detroit Institute of Arts, *Spirits and Ancestors,* Young People's Series 1 (1970), 20.
Flint Institute of Arts, *The Art of Black Africa* (Flint, exh. cat., 1970), no. 45.

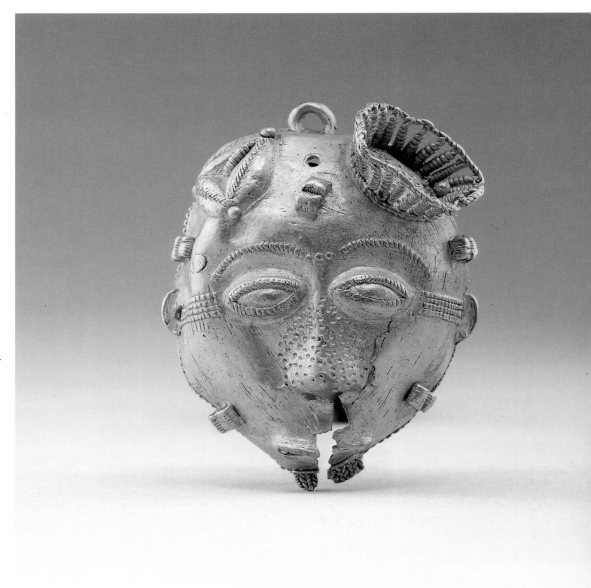

Cat. No. 20

20. PENDANT

Côte d'Ivoire or Ghana, Akan or Asante, late
 18th or early 19th century
Gold, 6 × 5.1 cm (2⅜ × 2 in.)
Founders Society Purchase, African Art Fund
 (76.26)

This miniature maskette exemplifies a rich gold working tradition found throughout the Akan-speaking regions of Ghana and Côte d'Ivoire. Yet, it poses complex questions in terms of stylistic attribution. In a comprehensive analysis, Martha Ehrlich (personal communication, 11/86) demonstrates that this object bears a closer relationship to the eighteenth- or nineteenth-century bronze casting of the Asante kingdom than to Akan gold working. Yet, the wearing of such a pendant by a person of rank is virtually unknown in traditional Asante custom, while it is common among the neighboring Baule and peripheral Akan groups.

Detroit's maskette is cast as an open shell with decorative edging visible on the cheeks. The suspension loop shows considerable wear on the top inside rim, indicating that the pendant was suspended upright. This, together with deformation and cracking along the edges, is common for thin castings of high-karat gold content that have seen much use. Ehrlich considers the work to be genuinely old, from the late eighteenth or early nineteenth century.

According to Ehrlich, human effigies in gold have three traditional uses among the courts of the Asante kingdom: ornaments for state stools, scabbard ornaments for certain types of state swords, and limited use as pendants. The first two possibilities do not apply to the Detroit example because it is much smaller and stylistically dissimilar from the human effigies attached to Asante state stools and swords. Furthermore, gold sword effigies, which represented defeated enemies of the Asante state, were traditionally suspended upside down, both to humiliate the enemies' spirits and as a warning to would-be rebels. If this were a state sword effigy, its suspension loop would be positioned on the chin rather than the top of the head.

In all likelihood, the Detroit piece served as a pendant. Among Akan and Baule peoples in Côte d'Ivoire, pendants in the form of human heads are identified as trophy heads emblematic of defeated enemies. They were worn as prestige ornaments suspended from the neck by long chains (Ross, personal communication, 5/86; Ehrlich, personal communication, 11/86). The Detroit piece, however, does not resemble Baule examples very closely. Some Baule gold human effigies are set in frames, others show the thread-work construction of the wax model, and most have two or three suspension loops. Exceptions have only one loop set at a right angle to the facial plane, not parallel to it. There is also little similarity in the eyes, ears, and facial markings between Côte d'Ivoire pendants and the piece in question; most Baule examples have eyes that are pierced or have a coffee-bean slit in the center. Only the braided coiffure and beard correspond to Baule styling.

While there are no known examples of human effigies used as pendants by the Asante, the Detroit gold piece bears a striking resemblance to early Asante goldweights of trophy heads called *ntire*. Similarities exist in the rendering of the eyes, nose, mouth, beards, and coiffures, and more generally in the robust sculptural quality of these bronze castings. Even the peculiar "freckles" across the nose of the Detroit pendant can be found in Asante goldweights of mudfish. Ehrlich (personal communication, 11/86) concludes that the gold effigy in the Detroit Institute of Arts has its closest parallels to these early Asante bronze goldweights, rather than gold castings.

The fact that the piece exhibits facial scarifications not allowed for Asante rulers does not in itself rule out a possible Asante origin of the piece; all trophy head representations have such marks to indicate the non-Asante origin of these enemies or their unfitness for rule. If it is an Asante work used as a pendant, then it may be an old sword bearer's hat decoration rather than something worn around the neck since the Asante do not wear neck pendants. While there are few stylistic parallels with Ebrie, Baule, and other Akan gold work, the fact that these people all use trophy head pendants as prestige ornaments is significant. It may be that the piece is the product of a minor or peripheral Asante state or neighboring Akan group, which used gold trophy masks as pendants but produced works closer to Asante pieces than to those of the Baule and other Akan groups of southwest Ghana and Côte d'Ivoire.

PROVENANCE: Alan Brandt, New York.

REFERENCES: *Bulletin of the Detroit Institute of Arts 55* (1976), 1: 36, fig. 25.
Detroit Institute of Arts, *Detroit Collects African Art* (Detroit, exh. cat., 1977) no. 56.

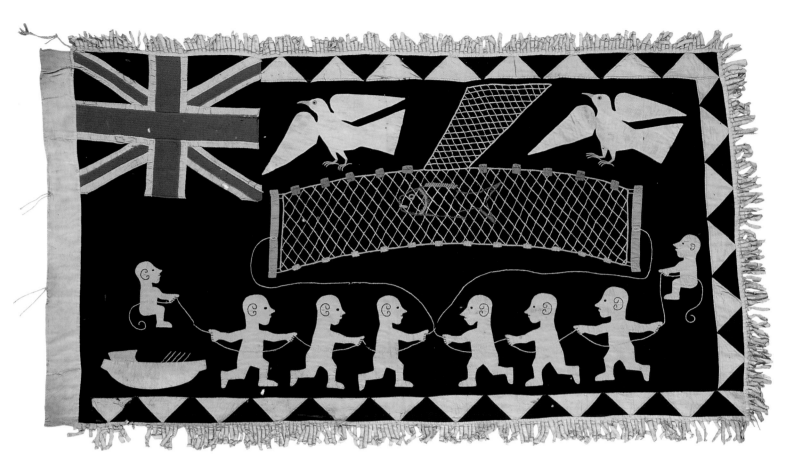

Cat. No. 21

21. ASAFO FLAG

Ghana, Akan, Fante, mid-19th century

Appliquéd and embroidered cloth, 101.6 × 182.9 cm (40 × 72 in.); with fringe 114.3 × 186.7 cm (45 × 73½ in.)

Founders Society Purchase, Acquisitions Fund (1983.17)

Colorful appliquéd flags are among the insignia used by *asafo* companies, traditional military organizations of the Fante people of the central coastal region of Ghana. Asafo constituted a critical counterpart to Fante royal authority: they served both to maintain an internal balance of power and to defend the state militarily against external threats of war and invasion from coastal foreigners and inland states like the Asante. While the companies no longer function militarily, they continue to flourish as social and fraternal organizations (Cole and Ross 1977, 186).

Historians disagree as to whether asafo is an indigenous or European-inspired institution. George Preston (1975, 36) argues for the ancient and indigenous Akan roots of asafo, but suggests that a symbiosis developed between asafo and Europeans during periods of intense military and commercial activity, which accounts for the Fante receptivity to certain Western symbols of military power. Among the most dynamic and conspicuous of these symbols are flags called *frankaa,* owned collectively by each asafo company to express group identity, solidarity, and creativity. They are commissioned and financed by each captain or *asafohene* for the day of his investiture. Usually they are suspended from poles erected in the center of the *posuban,* a sculptural edifice serving as a military shrine. But they also are displayed and danced for special occasions, like the investiture of a company captain, the royal yam festival, the "path clearing" festival, and funerals for company members (Cole and Ross 1977, 192).

This flag was presented to Preston, an American scholar, in 1970 on the occasion of his own installation as an asafohene. Preston was told that it was part of a cache of six flags in various styles, all of which were the property of the family of Asafohene Obuokwan ("Pathfinder") Sam. According to family tradition, this flag had been carried by the great grandfather of Asafohene Sam, Asafohene Kofi Mensah II, at the Battle of Prempah Sah (Bobikuma Nkrampon mu sa) or Bobikuma Thicket in 1863.

Both appliquéd and embroidered, this flag bears an identical image on both sides of the cloth: stylized figures maneuvering a large net in which a fish has been caught. Two birds hover above the net, and the British Union Jack appears in the upper left-hand corner. The imagery on asafo flags is both allegorical and historical and often relates to proverbs. The explanation of this flag's meaning was related to Preston as follows: "The Europeans have mighty machines. They erect a stone fort (i.e., Anomabu Fort) but the Africans can use many, many men to 'catch' a fort. You know they netted a mighty fish because you see the great gulls hovering over the catch. These (gulls) are other Europeans who would take the spoils" (Preston, written communication to DIA, 1983).

PROVENANCE: Princes Atta-Panyin and Atta-Kakra. Asafohene Kofi Mensah. The family of Asafohene Obuokwan ("Pathfinder") Sam. Dr. George Preston, 1970. Damon Brandt, New York.

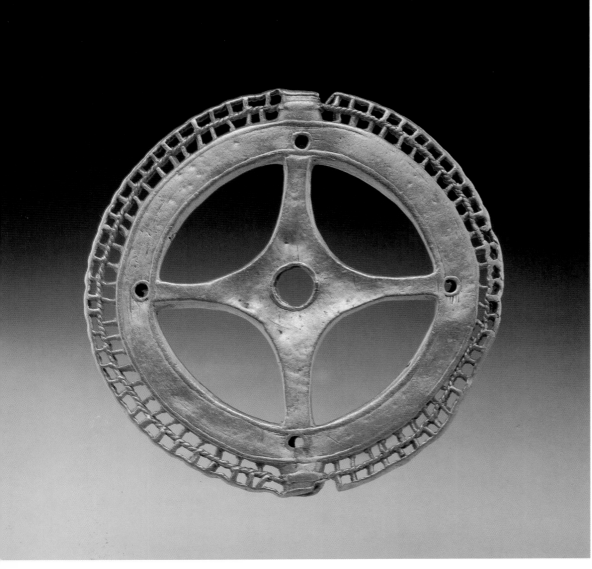

Cat. No. 22

22. SOUL WASHER'S BADGE

Ghana, Asante, mid-19th century
Gold, diameter 8.6 cm (3⅜ in.)
Founders Society Purchase, New Endowment
 Fund and Friends of African Art Fund (81.701)

Included among the lavish ornaments and insignia in the nineteenth-century Asante court were repoussé and cast gold pendants. Called "soul disks" or "soul washer's badges," these circular gold breast plates are worn generally by sword tenders, a type of palace guard, who participated in the soul renewal rites of chiefs and kings. Evidence suggests that they also were donned by the leaders themselves, in addition to other court officials not directly connected with the pu-

rification rites. The spiritual purity of the chief or king was important to the health and well-being of the entire kingdom. The badges were further displayed on other regalia, including the seats of the ruler's black stools, swords, treasury boxes, and royal coffins (Cole and Ross 1977, 153).

This particular badge can be traced to the personal treasury of Asantehene Kofi Karikari, who reigned over the Asante kingdom between 1867 and 1874. It was taken from the king's bedroom by Lt. R. C. Annesley, a member of the 79th Queens Own Cameron Highlanders, during the British overthrow of the city of Kumasi on February 4, 1874. The plundered gold was subsequently auctioned to help provide for the British wounded and next-of-kin of those killed in the expedition. Lt. Annesley purchased the badge at this sale.

Most soul disks are in the form of rosettes (see cat. no. 23), a motif adopted by the Asante and Akan from Muslim leatherwork and other items obtained through trade with North Africa (Cole and Ross 1977, 158). The Detroit disk, with its radiant geometry and simplicity, is atypical. Doran Ross (personal communication, 5/86) speculates that the unique configuration is the result of the disk being modeled after the main balance wheel of a clock. Ross notes that timepieces were relatively common gifts to asantehenes; a repeating watch was presented to Asantehene Osei Sonsu as early as 1819 (Dupuis 1824, 93–94). Among the various items found in the Kumasi Stone Palace in 1874 were a number of clocks, all stopped with the rust of years (Boyle 1874, 348). "Given the Asante interest in the European mechanical devices and the ready availability of broken clocks, it is easy to imagine Asante casters copying clock mechanisms in beadwork and other jewlery" (Ross, personal communication, 5/86).

PROVENANCE: Asantehene Kofi Karikari, Kumasi. Lt. R. C. Annesley, 1874. Lance and Roberta Entwistle, London.

REFERENCES: *Bulletin of the Detroit Institute of Arts* 60 (1982), 1/2: 34, fig. 19.

Werner Gillon, *A Short History of African Art* (Middlesex: Viking, 1984), 149–151.

23. SOUL WASHER'S BADGE (akrafokonmu)

Ghana, Asante, 20th century

Hammered gold, diameter 11.4 cm (4½ in.)

Founders Society Purchase with funds from Margaret H. Demant (1990.19)

The radiating floral motif found on this and many other soul washer's badges does not appear to be indigenous to the Asante aesthetic. Rather, it reflects the kingdom's pivotal position in the gold trade and the Asante's ability to adapt for their own use cultural elements from the Islamicized nations to the north and from the European traders who arrived on the Atlantic coast to the south.

Gold regalia were assigned to members of the Asante court as a way of marking rank and position. This type of disk would have hung around the neck of a soul washer, who participated in rituals intended to purify the soul (*kra*) of the king or a chief. Similar badges also could be worn or displayed by chiefs, sword bearers, and other members of the court on different occasions. The repoussé design on the Detroit disk was created by impressing a thin layer of gold foil onto a patterned form. The badge would have been suspended from a white cord, made of pineapple-leaf fiber, running through the small projections on the outer edge of the rosette.

The designs, as well as the spiritual function, of the soul washer's badges may stem from Islamic talismans worn by the Asante. Some Asante, although not themselves converts to Islam, wore leather pouches, decorated with circular, tooled floral motifs and containing Muslim writings. Talismans worn by chiefs had gold or

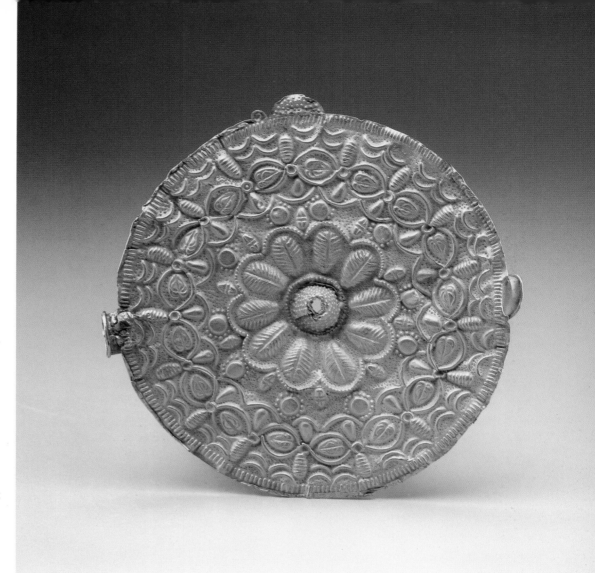

Cat. No. 23

silver leaf pressed onto the surface, producing much the same effect as the repetitive design of the repoussé soul washer's badge (Cole and Ross 1977, 153; McLeod 1981, 68–69).

Another possible design source may have been European floral motifs, which Asante rulers and court craftsmen could have seen on any number of trade and tributary items brought to the kingdom by Europeans. Such items may have included embossed bowls and plates, brass and gold furniture fittings, armor, or the engravings in printed books (Crownover 1964, 13; McLeod 1981, 84).

PROVENANCE: Donald Morris, Birmingham, Michigan.

REFERENCES: *Bulletin of the Detroit Institute of Arts* 66 (1990), 2/3: 47, fig. 16.

24. CONTAINER (kuduo)

Ghana, Asante, early 19th century

Bronze, height 15.9 × diameter 16.5 cm (6¼ × 6½ in.)

Founders Society Purchase, Dr. Lula Belle Robinson African Art Fund (67.129)

Kuduo are ornamental receptacles used for personal valuables, such as gold dust, beads, and cowrie shells. They also figure into the regalia of kings' and chiefs' sacred stool rooms as well as in an astonishing array of religious rituals, among them "soul washing" or purification rites, female initiation ceremonies, twins festivals, and funeral rites (Cole and Ross 1977, 67). In all of these cases, the kuduo holds spiritual offerings and sacrifices.

Akan kuduo derive from Islamic vessels of strictly geometric design employed in similar ritual contexts in North Africa and the Western Sudan. The vessel type was introduced to the Akan area in approximately the fourteenth century by traders from the northern cities of Djenne and Timbuktu. The Akan not only incorporated the kuduo in their origin myths, but also ingeniously adapted it to traditional artistic conventions: the animated figurines adorning many kuduo strike a contrast to the sobriety of the vessel's lower form and design and reflect a later development purely Akan in origin.

The images exhibit the same anecdotal quality of figurative brass weights used for measuring precious metals, another Akan adaptation of a geometric Islamic tradition. Like the brass weights, figurative kuduo scenes relate to the verbal arts of proverb, fable, and legend. The association of verbal and visual arts is not uncommon in Africa, but it is especially pronounced among the Akan who place tremendous importance upon skilled oratory. Proverbial images adorn most Akan objects ranging from linguists' staffs to royal swords and umbrella finials. The art pro-

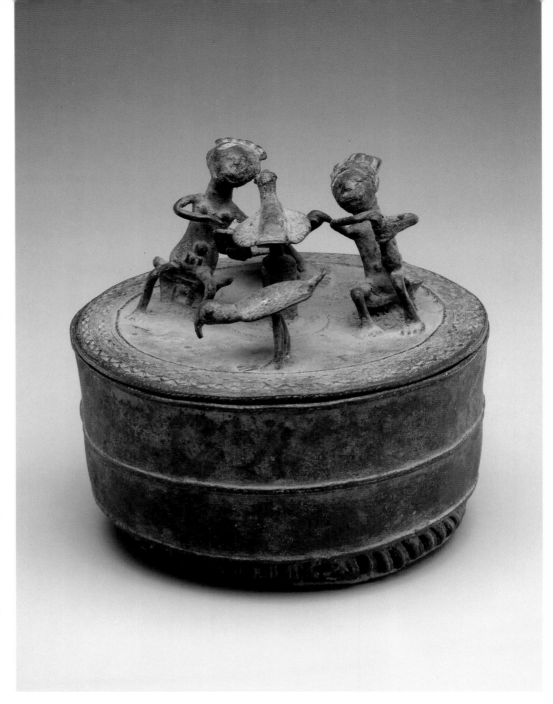

Cat. No. 24

vides visual metaphors for sayings relating to such concerns as gender roles, the uses and abuses of power, and humankind's relationship to nature. Together, image and word poignantly bespeak humanity's delicate strength.

Two seated figures and three birds adorn the lid of the Detroit kuduo. The woman appears to be holding a book and the man a palm wine container. The birds are apparently hornbills and one seems to be perched on a gin bottle. Doran Ross (personal communication, 5/86) states that,

to his knowledge, the imagery of the lid is unique. Its meaning is unclear, although "books, alcoholic beverages, and hornbills often figure in proverbs and folktales concerning the nature of wisdom."

PROVENANCE: K. Toure.

REFERENCES: Detroit Institute of Arts, *Detroit Collects African Art* (Detroit, exh. cat., 1977), no. 58.

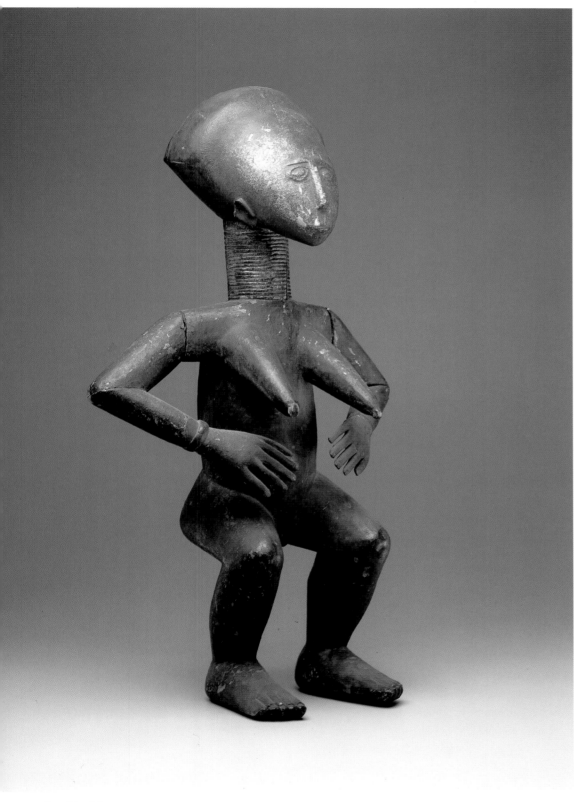

Cat. No. 25

25. FEMALE FIGURE

Ghana, Brong, early 20th century
Wood, gold, silver, paint, height 61 cm (24 in.)
Founders Society Purchase, Eleanor Clay Ford
Fund for African Art (76.94)

The Brong, neighbors to the northwest of the Asante, claim to be both the oldest centralized Akan state and the originators of Akan gold-smithing and weaving crafts. These artistic traditions, however, were adopted by the Asante after their victory over the Brong in 1723 (Warren 1975, 16).

This carving may have functioned as part of a figurative ensemble displayed by popular music and dance troupes. Such displays became common in Ghana during the late 1920s and 1930s. The figure's stance mimics a common Akan dance posture—bent legs like those of a downhill skier, coupled with arms akimbo and the hands held away from the body. A more prevalent gesture places the hands pressed against the body. Because of the posture, it is likely this was a secular piece associated with traditional popular bands rather than a work intended for a shrine (Ross, personal communication, 5/86).

These popular bands played for a variety of social occasions ranging from weddings and births to investitures and funerals. Competition between the bands encouraged elaborate costumes, instruments, and stage sets. Hence, the bands embraced the visual arts. The most spectacular items were large drums decorated with symbols carved in relief and brightly painted sculptural ensembles. Included in these portable stage sets were mother-and-child images, policemen, kings with their entourages, colonial officers, prisoners, and dancers like this figure—in short, the panoply of characters that populate a community (Cole and Ross 1977, 176). The gold and silver paint still evident on the Detroit piece was quite fashionable for the figurative ensem-

bles in the 1930s (Ross, personal communication, 5/86).

PROVENANCE: Jeff C. Leff. Furman Gallery, New York.

REFERENCES: Detroit Institute of Arts, *Detroit Collects African Art* (Detroit, exh. cat., 1977), no. 59. *Bulletin of the Detroit Institute of Arts* 56 (1977), 1: 58, fig. 32.

26. GELEDE HEADDRESS

Nigeria, Yoruba, Anago, 1850/1950

Wood, 35.6 × 21.6 cm (14 × 8½ in.)

Founders Society Purchase, Eleanor Clay Ford Fund for African Art (79.3)

"All powerful mother, mother of the night bird . . .
My mother kills quickly without a cry
To prick our memory suddenly
Quickly as woodpecker pecks the tree on the farm
The woodpecker who hammers the tree while
 words
rush forth from his mouth"

Efe Singing Masquerader
(quoted in Drewal and Drewal 1983, 90)

A fervent belief in the powerful nature of certain women lies at the heart of the Efe/Gelede masquerade festival. The festivities are held annually between March and May when rains arrive and the new agricultural cycle begins and extemporaneously during communal crises such as famine and death. The pageantry propitiates elderly, ancestral, or deified women, called "our mothers" by the Yoruba, who are thought to possess heightened spiritual knowledge. Their transcendent power unfolds positively in the mystical creation and nurturing of life, and conversely in destructive and nefarious witchcraft. The supreme life force, or *ashe,* of women brings health, fertility, and prosperity to the land and its people, but it can also wreak tragedy and disaster in the form of drought, epidemics, and pestilence. The latter form of power is an overwhelming fear of Yoruba men, who consequently stage these masquerades to honor and appease "our mothers, the witches."

The Detroit headdress, exceptional in its beauty and composure, is credited to an unidentified artist from the Anago Yoruba. At least five other Efe/Gelede headdresses are attributed to the same workshop, and possibly the same artist (Fagg, Pemberton, and Holcombe 1982, 56, 62, 110, 150; Roy 1985, 64). The very concise treatment of the face makes this among the most important of Gelede masks. The three vertical lines on both cheeks are facial marks called *pele.* Both Yoruba men and women wear these marks, which are signs of high aesthetic consciousness. The three markings on the forehead identify the headdress as coming from the southwestern Yoruba region. The stylized headgear resembles a leaf form, but its precise meaning remains unclear.

The sculpture has a finely delineated beard, which signifies wisdom or represents a Muslim cleric. While the beard identifies the headdress as male, it is not possible to definitively determine its gender since all Gelede masks glorify the principle that the female generates life in both its male and female aspects. The costume worn with this male mask was probably female. Through its ambiguous gendering and precise iconography, as well as the superlative aesthetic dance presentations of which it was a part, this headdress honored potential witches and reduced the consequence of their displeasure.

PROVENANCE: Donald Morris, Birmingham, Michigan.

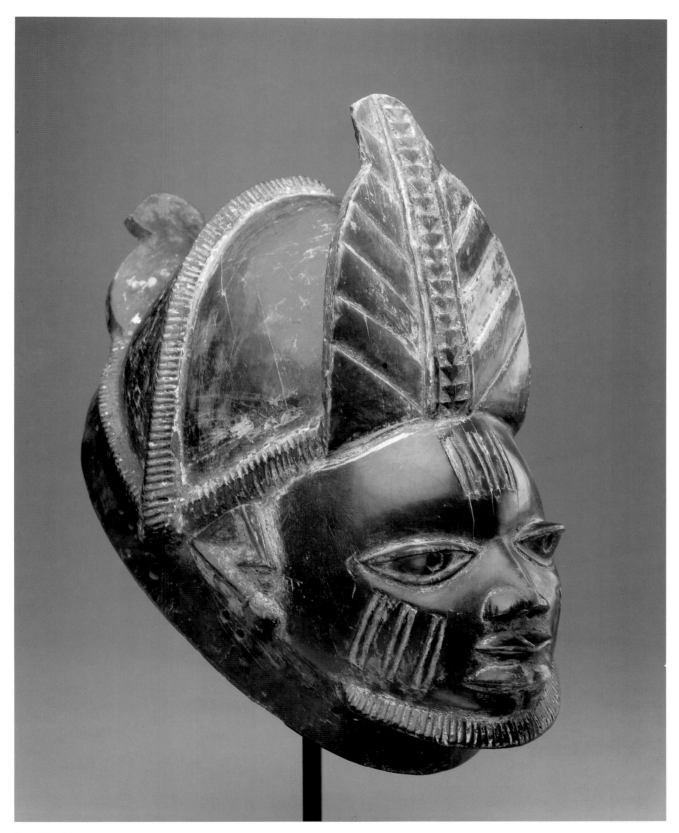

Cat. No. 26

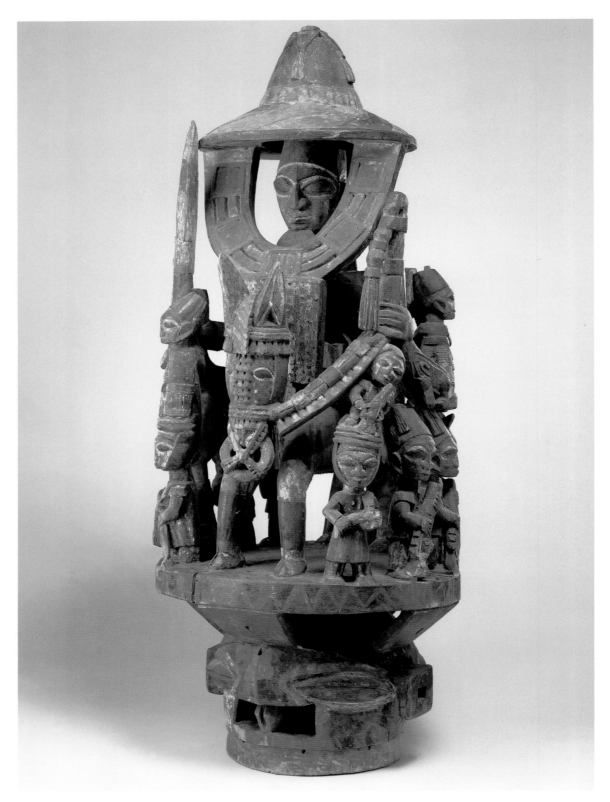

Cat. No. 27

27. EPA HELMET MASK: WARRIOR

Bamgboye, died 1978
Nigeria, Yoruba, Ekiti (Odo-Owa), 1925–1930
Wood, height 121.9 cm (48 in.)
Founders Society Purchase, Friends of African
 Art Fund (77.71)

The regal warrior hero surmounting this Janus-faced helmet mask bears the prestigious emblems of his office—a gun, a spear, and a flywhisk. A retinue of minor characters—warriors, musicians, and women with children—occupy two tiers around this culture hero, thereby simultaneously framing and elevating him to a privileged status. Such magnificent hierarchical compositions characterize the works of Bamgboye, a master Yoruba artist and holder of the title Chief Alaga of Odo-Owa. Of all twentieth-century Yoruba artists, Bamgboye's Epa masks are unsurpassed in structural complexity and internal coherence. Carved between 1925 and 1930, this piece represents Bamgboye at his artistic peak, when deep feeling and aesthetic excellence infused his work.

Many towns and villages in the Ekiti region of northeastern Yorubaland (west-central Nigeria) pay tribute to important historical figures through masquerade festivals. Called *Epa* in northern Ekiti and *Elefon* in southern Ekiti, these celebrations are organized by a family or lineage group to honor a long-deceased ancestor whose lifetime deeds contributed to the establishment or defense of the town and its cultural enrichment. The festival reaches its climax with a performance that includes headdresses surmounted by complex figurative scenes. The masqueraders are identified by accompanying songs and praise names. The sculpted figures are not intended as portraits; rather, they represent idealized types which evoke the cultural values and collective social experience that the festival strives to uphold

(Fagg, Pemberton, and Holcombe 1982, 72, 78). The Detroit piece is one of a series of monumental masks that appeared in a specific order during the Epa festivals of northern Ekiti towns. The representation of this equestrian accompanied by a retinue of soldiers, musicians, and wives celebrates the fact that the northern Ekiti towns had been established by immigrant Yoruba groups led by warrior-chiefs who pressed the neighboring Nupe northward, opening new territories to settlement. The conquering hero holds a spear, a gun, a flywhisk, and the reins of his horse while his retinue clusters around him.

PROVENANCE: Pace Primitive, Bryce Holcomb, New York.

REFERENCES: Evelyn S. Brown, *Africa's Contemporary Art and Artists* (New York: Harmon Foundation, 1966), 68.

Robert Farris Thompson, *African Art in Motion: Icon and Art in the Collection of Katherine Coryton White* (Los Angeles: University of California, exh. cat., 1974), 20, 28, 33–35, 37, 40, 42, 45, 50.

Bulletin of the Detroit Institute of Arts 56 (1978), 5: 307, fig. 28.

Detroit Institute of Arts, *100 Masterworks from the Detroit Institute of Arts* (New York: Hudson Hills Press, 1985), 70–71.

Henry John Drewal and John Pemberton III with Rowland Abiodun, *Yoruba: Nine Centuries of African Art and Thought* (New York: Center for African Art, exh. cat., 1989), 195–197, fig. 225.

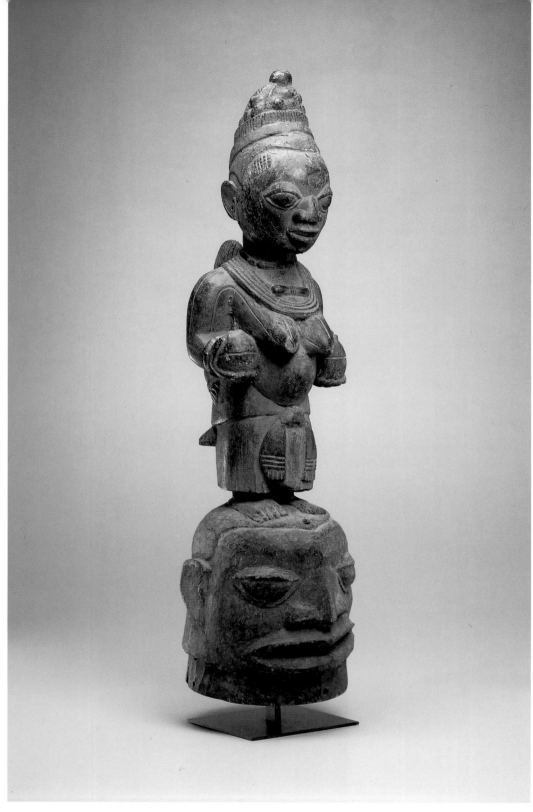

Cat. No. 28

28. EPA/ELEFON MASK

Nigeria, Yoruba people, Ekiti region, Efon-
 Alaiye, 20th century

Wood, pigment, 99.1 cm (39 in.)

Gift of Corice and Armand Arman (1992.53)

This type of female mask would appear at the conclusion of the ceremonies for the *Epa/Elefon* masquerade, performed in the northern region of Yorubaland called Ekiti. The mask celebrates the powers of women as mothers and would have been given a name that specifically refers to the importance of bearing children. Epa/Elefon is designed to maintain a sense of communal solidarity that extends from the family to the larger community by reinforcing the importance of the cultural beginnings of the Yoruba people.

During the ceremony, held either annually or biennially sometime between March and September, masked dancers would appear in a prescribed order over the course of a few days. The first mask to appear is usually one depicting a leopard attacking an antelope, followed by a warrior or hunter riding a horse, and next an herbalist. The final, female mask sometimes appears with a male mask representing the king and his sacred powers. Together the pair would symbolize the female and male components of society: men as the bearers of public political power, women as the private nurturers and formers of society through the raising of children (Drewal and Pemberton 1989, 189).

From the top of her elegant headdress through her mature body, the Detroit figure represents feminine ideals. Her protruding stomach and full breasts attest to the role of women as the source of future generations. The rounded jars she holds in both hands, perhaps fashioned from gourds, echo the fruitfulness of maternity. A child is securely tied to her back by a wrapper that is knotted just under her abdomen. On her breasts rest a representation of a necklace of coral beads, a sign of chiefly rank, a position open to women in traditional Yoruba society.

Although Epa/Elefon masks may vary in their imagery, they have a standard format—a helmet mask surmounted by animal or human figures (see also cat. no. 27). The helmet, called *ikoko,* or pot, rests on the shoulders with the masker

peering out through the mouth. The helmet's roughly carved surfaces with its visible tool marks contrasts sharply with the naturalism and finesse of the standing female figure. It is the more crudely carved helmet that is the sacred and most important element of the mask, honoring a family's ancestors (Drewal and Pemberton 1989, 189).

The festivals are not simply a form of entertainment, but also serve to educate the populace about the roles of the earliest Yoruba ancestors. Women will request from the female mask the ability to conceive and bear healthy children to help maintain the continuity of the community. A typical song might beseech the "spirit which came from heaven and earth . . . to grant that I may carry a baby on my back" (Cole 1989, 85).

Comparisons with similar masks suggest that this particular one was made in the town of Efon-Alaiye in the southern Ekiti region. The masks, which belong to a family lineage group, are commissioned to honor the memory of ancestors and are then kept in the home of the lineage head or the town chief. Rather than merely being stored away, the masks become shrines (Drewal and Pemberton 1989, 194).

PROVENANCE: Corice and Armand Arman, Paris.

29. DANCE PANEL

Nigeria, Yoruba, 19th / 20th century
Linen, beads, glass, 34 × 27.6 cm (13⅜ × 10⅞ in.) without strap
Founders Society Purchase, Insurance Recovery Fund (81.714)

Resplendently beaded articles of dress and regalia are a relatively recent artistic flowering among the Yoruba. During the nineteenth century, seed beads—small trade beads of European manufacture—became readily available in local markets. Their colorful spectrum coupled with their luminosity and limitless combinational pos-

Cat. No. 29

sibilities drew Yoruba artists to incorporate them into an already broad and sophisticated range of media (Fagg 1980, 9). Due to their high cost and exotic aura as foreign imports, seed beads became a royal and religious prerogative; in short, used within the exclusive domain of those persons with the ability to navigate between secular and sacred spheres.

Dance panels or *yata* are among the most significant forms of beaded regalia. Worn with the strap over one shoulder, they are seen at annual festivals held for any one of the Yoruba deities or *orisha* belonging to a group called "the orisha of the white cloth." These gods include Obatala, creator of human bodies; Osanyin, provider of medicinal herbs; Osun, goddess of life-giving waters; and Oko, god of the farm and guardian against witches.

This example resembles a yata worn by the Osun (goddess of water) priestesses in the city of Ila on the concluding day of the Osun festival. Led by the chief priestess, three bowl carriers, cradling brass vessels filled with water from the Osun River, dress themselves in white cloth and don a pair of yata. The priestesses suspend the yata from their shoulders so that the panels rest on their hips with the straps intersecting across the chest and back (Pemberton, personal communication, 9/86).

In the Detroit panel, vivid dissonant colors are surrounded by a red cloth frame. The dominant colors of blue, yellow, and white are associated with Osun, while the row of red triangles across the top recalls the leather fringe on *laba* bags worn by members of the cult of Sango, the god of thunder and lightning. As Pemberton (personal communication, 9/86) explains, "It is not unusual to have the colors of more than one orisha present, since there is often more than one deity's shrine in a compound" or in an individual's ritual life.

Central to the composition is a schematized human face arranged mouth-to-mouth with a

chameleon or lizard. In Yoruba iconography, the head projects the inner *ori inun,* or spiritual power, of the worshipper and refers to his or her personal destiny. The chameleon also holds a meaningful place in Yoruba religion; the original creation myth recounts how the chameleon initially was put on earth to pave the way for human settlement. Indirectly, the chameleon divines individual potential and reveals the means for making a propitious journey through life. The face-chameleon connection reiterates that only the gods in the pantheon can show the way to one's full destiny (Pemberton in Fagg 1980, 42, 60).

Although current Osun priestesses at Ila cannot identify the artists of their yata, one elderly devotee believes that they were made by the artist Basanyin. It is equally possible, however, that they were crafted by the bead workers in Efon-Alaiye, since Ila's kings have commissioned beaded crowns from these artists over the years (Pemberton, personal communication, 9/86).

PROVENANCE: Pace Gallery, New York.

REFERENCES: William Fagg, *Yoruba Beadwork: Art of Nigeria* (New York: Rizzoli, 1980), no. 51.

30. PALM NUT CONTAINER

Nigeria, Yoruba, early 20th century
Wood, metal, indigo, height with cover 29.2 × diameter at base 20 cm (11½ × 7⅞ in.)
Gift of Justice and Mrs. G. Mennen Williams (74.45)

The Yoruba produce an array of ritual bowls whose rich sculptural compositions transcend the functional intent of their forms. Here, six figures support a bowl with a hinged cover on which a reclining figure smokes a large pipe. Each of the supporting figures is different: an equestrian with a hat, a trumpet player, a drummer, a woman presenting a tray, a warrior with a gun, and another pipe smoker.

According to Henry Drewal (personal communication, 1990), the imagery of this bowl relates to hunters and warriors, who frequently use pipes. The standing figure with a pipe wears a hat that recalls long cloth caps worn by hunters to hold protective medicines. As shown here, the tail of the cap is traditionally pulled over to the left side. The figure on top of the lid has what looks like a top-knot of hair; sometimes the Yoruba allow hair to grow over the place where medicine has been inserted into the head to ensure health, strength, or success in the hunt (M. Drewal 1977, 43). This figure also assumes a position of quasi-prostration; among the Yoruba, the male gesture of respect is to go down on the ground. Drewal suggests that the figure may be "greeting" or offering his respects to the palm nuts inside the bowl, which hold the key to his destiny.

Called *ikin,* palm nuts are the primary instrument of Yoruba divination. Orunmila, the god who was present at creation and knows the secret of divination, introduced the nuts for this purpose. Many palm nut containers belong to professional diviner-priests or *babalawo* ("fathers of the secret"), who use sixteen sacred palm nuts

to perform divination based on knowledge of *Odu Ifa,* a body of sacred oral literature. However, the hunter/warrior imagery together with the reclining figure on top of this bowl suggest that the container may have been intended for an individual's personal set of palm nuts. Any man who undergoes the Ifa ceremony of *itefa* may establish a personal shrine with his own palm nuts so that he may behold the secrets of his destiny. If such a man goes to consult the Ifa diviner, he may take his palm nuts with him.

On the basis of style, Drewal attributes this piece to the northern Yoruba. The shape of the head and the delineation of the ear on the reclining figure, the vertical stance of the other figures, the zigzag textured patterns on the trousers of the drummer, and the marks on the cheeks are all traits associated with the northern and northeastern Yoruba, perhaps in the area between the Igbomina and Ekiti regions.

PROVENANCE: Justice and Mrs. G. Mennen Williams, Grosse Pointe Farms, Michigan.

REFERENCES: *Bulletin of the Detroit Institute of Arts, 53* (1974), 2: 64 (ill.).

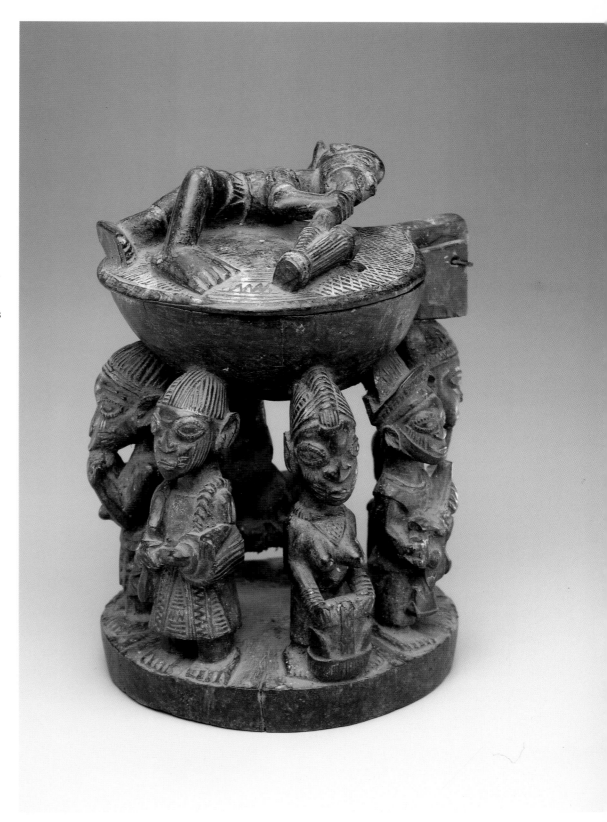

Cat. No. 30

31. BRACELET

Nigeria, Yoruba, 16th/18th century
Ivory, diameter 11 cm (4⁵⁄₁₆ in.)
Founders Society Purchase, Acquisitions Fund
(80.42)

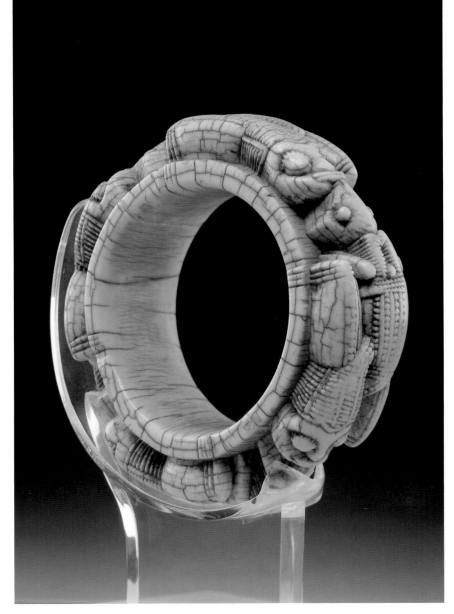

Cat. No. 31

In the historic kingdoms of Nigeria, including those of the Yoruba and Benin, ivory bracelets were emblems of divine kingship and sanction. Their rich symbolism embodied powerful references to rulership, and for this reason, they were worn only by kings. The rendering of the eyes and the coiffure (or cap) of the human figure on this bracelet identifies it as coming from Owo, a city in southeastern Yorubaland renowned for its superb ivory carving tradition (Fagg and Bassani, personal communication, 3/86; Pemberton, personal communication, 9/86). In its style and iconography, this bracelet resembles two Owo bracelets in the Ulmer Museum, Ulm, and one in the Nationalmuseet, Copenhagen. All date approximately to the seventeenth or eighteenth centuries (Bassani, personal communication, 3/86; see Micots 1994, figs. 9, 10).

Carved in high relief around the surface of this bracelet is the repeated image of a human head mouth-to-mouth with a crocodile. Crocodiles, the favored sacrificial victim for Olokun, deity of the sea, appear frequently in the art of this coastal area. It is from Olokun that the kings of Owo and Benin are said to have received their coral beads, which form an important component of their regalia. Furthermore, the crocodile's ability to navigate freely between two realms, land and water, provides a metaphor for kingship. As Pemberton (1977, 17) explains, "the king belongs to two realms—the realm of ordinary life, the world and experience of his subjects, and the realm of the gods and spirits. Like the crocodile and the mudfish, he inhabits two realms. He crosses boundaries that others may not cross. And in his sacred person he alone has the power of life and death over other persons."

The connection of the human head with the crocodile suggests that the figure may represent Olokun. The association of Olokun with a crocodile appears on two other bracelets from the Owo complex (see Vogel 1981, 129, no. 71), in which the figure is depicted with the same coiffure or cap and with legs terminating in the forms of sacrificial animals—a crocodile and a mudfish. Pemberton (1977, 18) interprets the significance of this iconography as a celebration of the king's *ase*, or vital power. Just as Olokun's palace beneath the sea is a source of beauty, wealth, and fecundity, so is the king's palace on earth the source of beauty, wealth, and fecundity for his

people. That the king is Olokun's earthly counterpart is very likely the message conveyed by Detroit's bracelet as well.

PROVENANCE: Muller-Van Iterbeek, Brussels. Frederic Rolin, Brussels.

REFERENCES: Musée Royal de l'Afrique Centrale, *Art D'Afrique dans les Collections Belges* (Tervuren, exh. cat., 1963), no. 663.

Maire Eliane d'Udekem and Marguerite Klobe, *African Ivories* (New York: F. Rolin & Co., Inc., 1978), 33–35, no. 52.

Susan M. Vogel, "African Ivories, F. Rolin & Co.," *African Arts* 12 (1978), 1: 97.

Bulletin of the Detroit Institute of Arts 59 (1981), 4: 124, fig. 17.

Marie-Therese Brincard, ed., *Beauty by Design: The Aesthetics of African Adornment* (New York: African-American Institute, exh. cat., 1984), C30.

Henry John Drewal and John Pemberton III with Rowland Abiodun, *Yoruba: Nine Centuries of African Art and Thought* (New York: Center for African Art, exh. cat., 1989), 105–106, fig. 105.

Cory Micots, "Warriors, Chiefs, and Composite Animals: An Ivory Bracelet Attributed to Owo, Nigeria," *Bulletin of the Detroit Institute of Arts* 68 (1993), 3: 16–25.

32. WALL ORNAMENT

Nigeria, Benin, 17th or 18th century
Brass, 40 × 37.8 cm (15¾ × 14⅞ in.)
Founders Society Purchase with funds from Mr. and Mrs. James A. Beresford (72.435)

The kingdom of Benin, located in south-central Nigeria, produced some of the most remarkable works of art in bronze known to African art. This object, while unmistakably Benin in its iconography, is highly unusual in form. Its size, two-dimensionality, and images raised in high relief bear a certain resemblance to Benin bronze plaques that once adorned the walls of the king's palace. Yet, the horseshoe shape and the open spaces are never seen on the plaques, which generally are square or rectangular, and are solid casts of brass. Nevertheless, the Detroit object's large size and suspension rings suggest its use as a wall ornament. According to Paula Ben-Amos (personal communication, 5/86), it fits in stylistically with some eighteenth-century Benin works of art. A semicircular plaque of identical size and highly similar iconography is part of the collection of the National Museum, Benin City (see Eyo 1977, 132), but its probable use is not documented.

Iconographically, the object has all the richness and ambiguity of Benin symbolism. The work depicts the *Oba,* or king of Benin, in a frontal pose, flanked and supported by two attendants shown in three-quarter view. All three figures wear the costume of the court, including headgear, and a high collar that represents the beaded coral necklace of the Oba. The possession of coral beads is the prerogative of the reigning monarch. While high-ranking officials of his court may wear necklaces, bracelets, and anklets of coral beads, only the Oba may wear the complete beaded costume, including tunic and skirt (Ben-Amos 1980, 20). The king's legs terminate in the form of mudfish—animals occupying a prominent place in Benin symbolic thought—while the legs of his attendants are reduced to diminutive size. Adorning the curved edge of the ornament is a variety of animals, including crocodiles and frogs, raised in relief on a guilloche background, a design often present in Benin art.

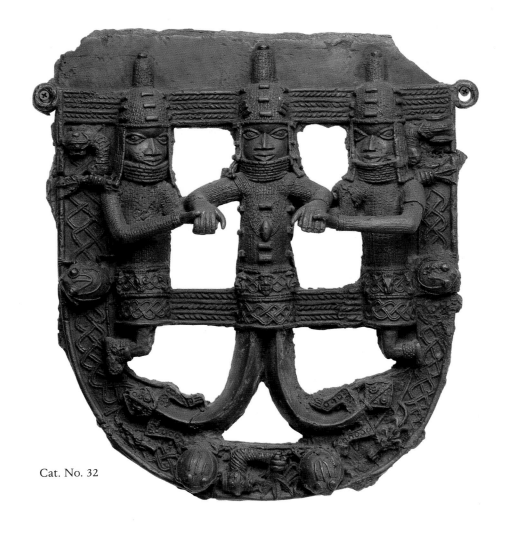

Cat. No. 32

Near the top, on either side of the attendants, is an arm emerging from a mudfish form and ending in a hand holding some kind of plant.

The Oba is the spiritual as well as political leader of the Benin kingdom. He is the earthly counterpart to Olokun, deity of the waters, from whose domain flows fertility, wealth, and prosperity. The mudfish legs of the Oba symbolize his identity with Olokun and also express the notion of transformation and liminality as a symbol of power. The African mudfish can move across land to seek water during droughts, and therefore moves symbolically between two cosmological realms: land and water. Similarly, the Oba operates equally between the terrestrial and spiritual realms of the cosmos. The very substance of this plaque adds another layer of meaning. Brass is considered to be ritually charged because of the transformation from solid to liquid that it undergoes in casting, a reference to the liminal stage. Moreover, because it never rusts or corrodes, it has a lasting permanent quality. Its lustrous surface is thought to reflect the spirit world, and its reddish color, like that of the coral beads, gives it power to drive away evil forces, all qualities that symbolize the king.

PROVENANCE: Cranbrook Academy of Art, Bloomfield Hills, Michigan. John Wise Ltd., New York, 1938. Thomas Joyce. R. K. Granville.

REFERENCES: *Bulletin of the Detroit Institute of Arts* 52 (1973), 1:29.

33. QUEEN MOTHER (IYE OBA) COMMEMORATIVE HEAD

Nigeria, Benin, 19th century
Brass, 53.3 cm (21 in.)
City of Detroit Purchase (26.180)

This commemorative sculpture, portraying an *Iye Oba,* or Queen Mother, memorializes the special role the Queen Mother played in the life of her son, the Oba, or king. The regal head embodies the wisdom, vision, and strength with which the Iye Oba supported and sustained her son in his monumental task of leadership. Cast in the "lost-wax" method, the Detroit piece with its stylized rendering dates to the Late Period (eighteenth and nineteenth centuries) of this aggressive expansionist state. While Early Period heads (fifteenth and sixteenth centuries) have naturalistic proportions and place emphasis on the face, the Late Period favors regalia almost to the total exclusion of the human element. This head, however, is a particularly sensitive example. The dense lower mass lightens as the sculpture tapers toward the top, terminating in a pointed cone. And the intricately textured patterning on the head and neck sets off the smooth, organic quality of the face.

The Iye Oba position was established during the Early Period by the king Oba Esigie for his mother during the fifteenth century. Since then, the Queen Mother has fulfilled a most critical role in Benin political life with a status equivalent to a high-ranking chief. The Queen Mother is a cherished advisor to her son, consulting with him on all matters concerning leadership and decision making. Among her privileges, she possesses the supreme right over life and death, provides political refuge, and can appeal to the Oba on behalf of petitioners. Many Queen Mothers are remembered for their advice during their sons' accession to the throne or for the spiritual

and practical aid they gave their sons in times of war (Ben-Amos and Rubin 1983, 79–83).

Once a king installs his mother as Iye Oba, however, direct contact between the two is forbidden. Set a short distance from the royal city in her own palace, the Queen Mother has her own court with titled chiefs and numerous retainers. From that palace she conducts her office and communicates with her son exclusively through emissaries (Ben-Amos and Rubin 1983, 80–81).

Upon a Queen Mother's death, the king dedicates an altar to her memory, where he annually holds a private commemorative service, adorning the site with rattle staffs, bronze heads, and ornate rectangular altarpieces. The heads, as well as the altarpieces, depict the Queen Mother (Ben-Amos and Rubin 1983, 82). Customarily she is shown wearing beaded ornamentation: a thick choker, a coral shirt with crossed strands as worn by the highest ranking chiefs, and a crown that covers the Queen Mother's distinctive coiffure, called a "chicken's beak" (Ben-Amos 1980, 25).

PROVENANCE: Fritz Gurlitt, Berlin.

REFERENCES: North Carolina Museum of Art, *Masterpieces of Art in Memory of W. R. Valentiner* (Raleigh, exh. cat., 1959), no. 217.

The University Art Gallery, Oakland University, *World Primitive Art, 1965* (Rochester, Mich., exh. cat., 1965).

Detroit Institute of Arts, *Detroit Collects African Art* (Detroit, exh. cat., 1977), no. 86.

Paula Ben-Amos and William Rubin, eds., *The Art of Power, the Power of Art: Studies in Benin Iconography* (Los Angeles: Museum of Cultural History, University of California, Monograph Series No. 19, exh. cat., 1983), 79, fig. 60.

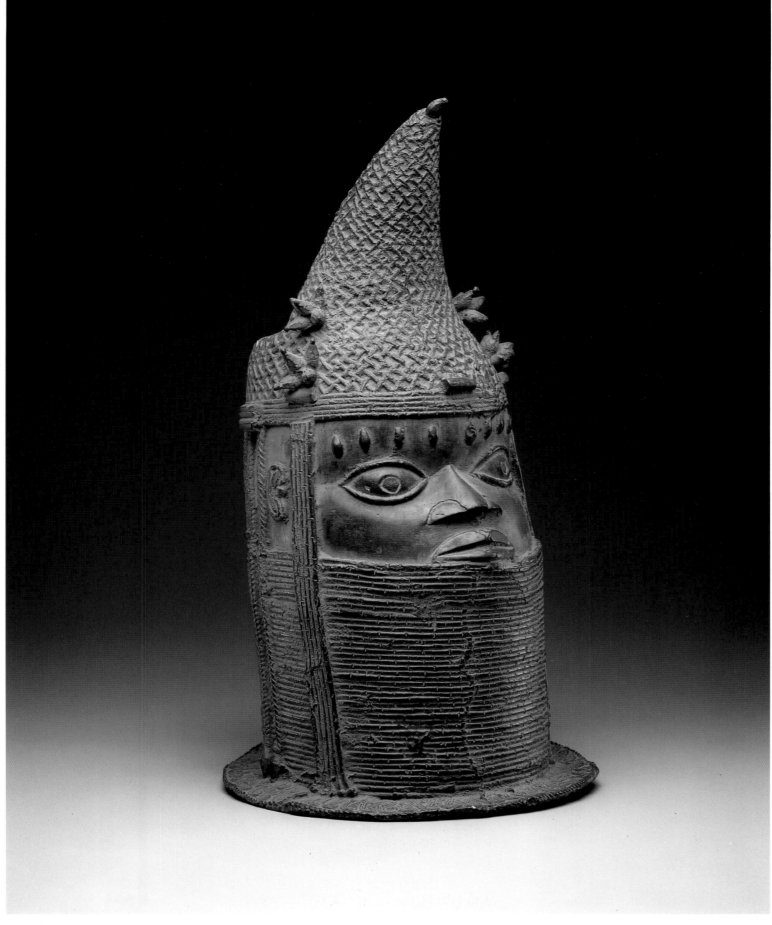

Cat. No. 33

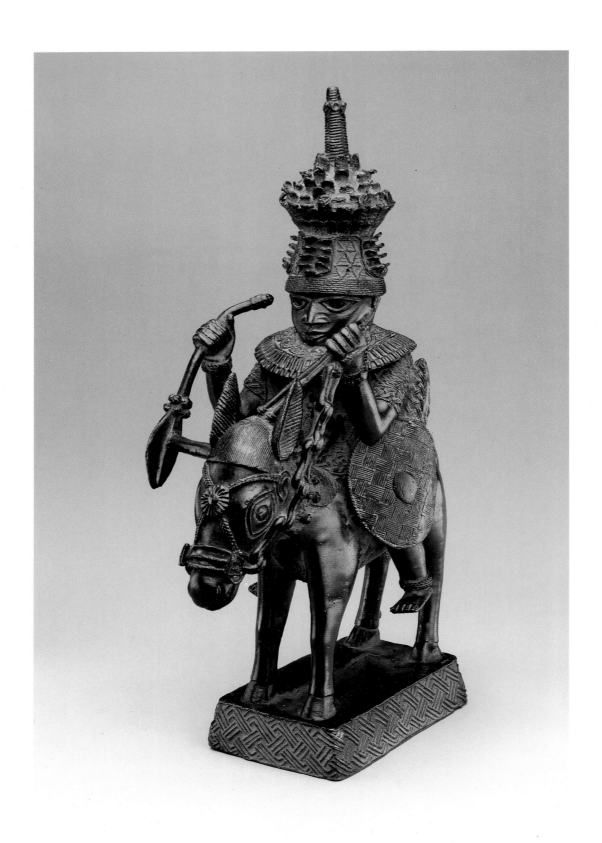

Cat. No. 34

34. EQUESTRIAN FIGURE

Nigeria, Benin Kingdom, mid-16th century
Bronze, height 47 cm (18½ in.)
Gift of Mrs. Walter B. Ford (1992.290)

This beautifully rendered mounted warrior is one of about twelve known versions of this type of equestrian figure. While the works share certain similarities, each is a unique cast with individual features. The Detroit rider controls his mount in the typical African manner, with the reins held only in the left hand. Several arrows are also bunched in the left hand, while a spear is held in the right hand. The figure wears spurs on his feet and bells encircle the spear and the horse's neck. The four hooklike projections on the pinnacle of the headdress, visible on other versions of the sculpture, are missing from the Detroit piece. As a group, the sculptures appear to date from two time periods—the mid-sixteenth through early seventeenth centuries and the late eighteenth century (Fagg 1978, 43). One of the earlier pieces has a thermoluminescence date of A.D. 1560 +/−40 years (Karpinski 1984, 56). The Detroit piece belongs to this early period.

Although these figures have been found on royal ancestral altars, the rider cannot be positively identified as an *Oba* or other member of the Benin court. The tall headdress with feathers at its crest and the wide patterned collar are unlike the coral-beaded headdresses, high collars, and clothes illustrated on hundreds of plaques and other free-standing sculptures depicting Benin courtiers (see cat. no. 32). The rider does not use a saddle, which was more typical of horsemen from the northern areas of Nigeria than from Benin. The shield on his left hip is woven from reeds; it, too, is unlike Benin shields.

These differences suggest that the figure may depict a foreigner. Joseph Nevadomsky (1986, 40–47) argues that the rider portrays the *Ata,* or

king, of Idah, the neighboring kingdom of the Igala people, north of Benin. After Benin won a hard-fought battle against the Igala people in the early sixteenth century, the Ata became the vassal of the Oba's court. The equestrian figure, then, may represent the defeated enemy, wearing native dress and bearing arms, prepared to ride into battle. Similar sculptures were cast over the next two centuries and placed on the royal shrines to earlier Obas in commemoration of the victory.

However, the figure has also been associated with Oranmiyan, a Yoruba prince from the neighboring kingdom of Ife (Ben-Amos 1980, 37), and with the Obas themselves (Tunis 1979, 392; Karpinski 1984, 60). Oranmiyan was invited to Benin to start a new ruling dynasty. It would be entirely appropriate to place a statue representing the founder of the current royal line on altars dedicated to past rulers. Oranmiyan also is said to have introduced the horse to Benin.

The animals, equated with royal power and prerogative, became a prestige item for Obas, who were often shown seated on one. It is possible that the mounted figure could be an Oba dressed in the regalia of the defeated Ata to show Benin's military and political domination. It is also possible that the unusual costume is based on Western clothing given to Obas as gifts by visiting Europeans who had had contact with the kingdom since the 1480s (Ryder 1969, 39–41).

PROVENANCE: Louis Carré, Paris. Edsel and Eleanor Ford. Mr. and Mrs. Walter B. Ford II, Grosse Pointe, Michigan

REFERENCES: M. Knoedler and Company, *Bronzes and Ivories from the Old Kingdom of Benin* (New York: M. Knoedler and Company, exh. cat., 1935), fig. 13.

Paris, Musée d'Ethnographie, *Exposition des Bronzes et Ivoires du royaume de Bénin* (Paris: Musée d'Ethnographie, exh. cat., 1935), 7, no. 26.

Detroit Institute of Arts, *Detroit Collects African Art* (Detroit, exh. cat., 1977), fig. 84.

Michael Kan, "Detroit Collects African Art," *African Arts* 10 (1977), 4: 24–31, fig. 12.

I. Tunis, "Cast Benin Equestrian Statuary," *Baessler-Archiv* 27 Neue Folge (1979), 2: 389–416, fig. 9.

Joseph Nevadomsky, "The Benin Bronze Horseman as the Ata of Idah," *African Arts* 19 (1986), 4: 40–47, 85, fig 1.

Roy Sieber and Roslyn Adele Walker, *African Art in the Cycle of Life* (Washington, D. C.: National Museum of African Art, 1987), fig 45.

Warren Robbins and Nancy Nooter, *African Art in American Collections* (Washington, D. C.: Smithsonian Institution Press, 1989), fig. 561.

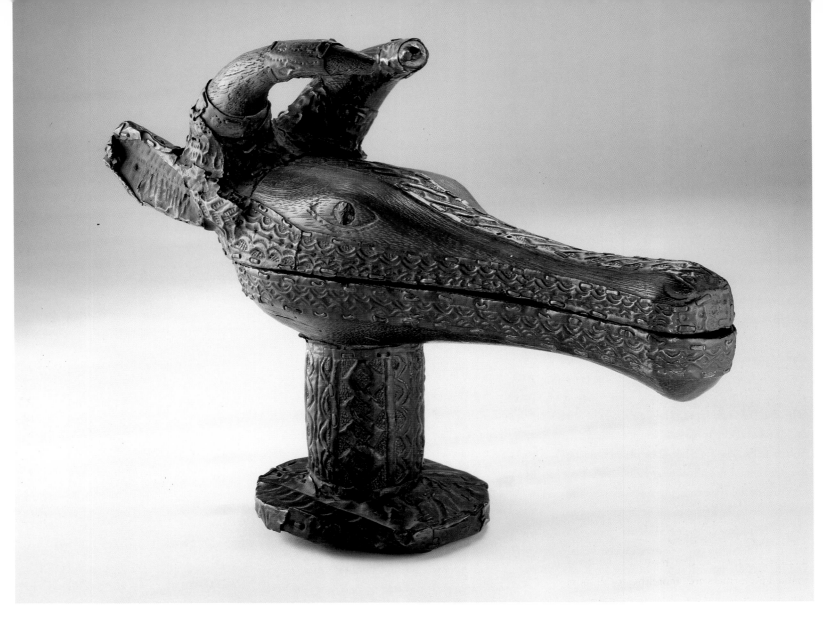

Cat. No. 35

35. KOLA NUT CONTAINER

Nigeria, Benin, 19th century

Wood, metal, top 10.8 × 12.1 × 35.6 cm (4¼ × 4¾ × 14 in.), bottom 12.4 × 11.4 × 27.9 cm (4⅞ × 4½ × 11 in.)

Gift of Mr. Solomon Maizel (80.112)

In the kingdom of Benin, it was common practice to offer kola nuts to guests from a carved wooden bowl, either rectangular, circular, or as here, in the form of an animal. The possession of such an ornate and finely crafted box distinguished a person of wealth and rank from other members of society who might serve the nuts from a simple plate or with bare hands. To the people of Benin, the offering of kola nuts by a host to his guests was not only a sign of gracious hospitality, but also of "supernaturally sanctioned sociability." As such, the kola nut was considered the ultimate symbol of civilization. Following a ritual invocation to the spirits of important ancestors, a kola nut was divided and distributed among the guests in order of seniority. This practice distinguished the cultivated from the uncouth, who are described in a Benin adage as "people who gobble up kola nuts without peeling and dividing them" (Ben-Amos 1976, 244).

The sleek, dignified animal head depicted in this container has been described by Benin informants as both a cow and an antelope (Ben-Amos 1980, 78). As Paula Ben-Amos (1976, 245) points out, "the cow and antelope are equally effective artistic symbols through their exemplification of traits of physical attractiveness and social docility. Both are considered beautiful animals, the cow for its rich, fat body and the antelope for its smooth gait and curving horns. These qualities, plus their gentle natures and desirability as food, make them favourite sacrificial offerings." Since kola nuts are sometimes placed as offerings upon religious altars dedicated to ancestral spirits,

their association with a sacrificial animal is understood (Blackmun, personal communication, 10/86).

PROVENANCE: Solomon Maizel, Wayne, New Jersey.

REFERENCES: *Bulletin of the Detroit Institute of Arts* 59 (1981), 4: 110, fig. 8.

36. "MAIDEN-SPIRIT" MASK

Nigeria, Igbo, 19th/20th century
Wood, paint, height 30.5 cm (12 in.)
Bequest of Robert H. Tannahill (70.99)

In north-central Igboland (southeastern Nigeria), initiated men are divided into three age brackets, each with its own repertoire of masks, songs, and dances. This mask was used by the middle age group, comprising men from thirty to fifty years old. Compared to the wildfire exuberance displayed by the youngest grade, these older masked performers are "more theatrical, more organized, more socially significant, more feared, more beautiful, more grotesque, and more spiritually charged" (Cole and Aniakor 1984, 120).

Every year during the dry season, and occasionally for important funerals, a festival called "Fame of Maidens" takes place. It celebrates the "incarnate dead"—those collective ancestors who assure prosperity and protection for the living community. During this ceremony, the ancestors "re-appear" as beautiful maidens (actually masked men) from the spirit world. Hence, the white surface, which stands for a fair complexion and is associated with death.

Once the orchestra has warmed up and a large crowd of villagers and guests has gathered, the spectacle begins. Young "sister" maidens appear in sequence, each one executing more rapid, exuberant choreography. Following their

Cat. No. 36

exit, the "mother of spirits" then enters the arena. Her dance is slower, more indicative of her dignity and rank as an older, titled woman. The festival continues with crescendos and frenzied bursts until the exhausted spirits retreat. The Detroit mask was once used in such a spectacle, but it is not certain in what capacity.

"Maiden-spirit" masks take a variety of forms, from wooden helmets surmounted by super-

structures to small facial masks like this one. Worn atop a colorfully appliquéd body suit, a facial mask is crowned by a cloth and fiber halo with attachments such as glittering mirrors, bright ribbons and yarns to highlight haircrests, wooden combs, and hairpins. The masks, along with graceful movement, convey an idea of femininity: fine features, youthful figure, and confident bearing all serve a maiden's physical beauty

and testify to proper upbringing and good character.

PROVENANCE: Robert H. Tannahill, Grosse Pointe Farms, Michigan.

REFERENCES: F. J. Cummings and Charles H. Elam, eds., *The Detroit Institute of Arts Illustrated Handbook* (Detroit: Detroit Institute of Arts, 1971), 168.

37. OGBOM DANCE HEADDRESS

Nigeria, Ibibio, Eket (?), early 20th century
Wood, height 68.6 cm (27 in.)
Founders Society Purchase, Eleanor Clay Ford
 Fund for African Art (79.164)

The swelling musculature of this figure and the curving plane of the face with its sharp overhanging brow are characteristic of headdresses used in the annual *Ogbom* ceremony, which celebrates the powers of fertility and reproduction of Ala, the goddess of the earth. The ceremony may be performed at the time of harvest to give thanks for abundant crops. The centerpiece of the celebration is a dancer concealed by a dramatic costume of cloth and parrot feathers over a cane-work frame and surmounted by a fully sculptured figure in wood. During one episode in the ceremony, women dance around the figure in a state of joyous excitement to the rhythms of a drum orchestra (Jones 1973, 62).

Ogbom figures are made by both the Igbo and the Ibibio of eastern Nigeria. But while the vast majority of Igbo Ogbom figures depict young women, those of the Eket subgroup of the Ibibio usually are male, like this example. Seven holes ring the bottom of the base where basketwork presumably was attached for lashing the headpiece to the wearer's head.

The Igbo today still continue to perform the Ogbom ceremony and dance, but without the headpieces, which went out of use in the early 1940s (Cole and Aniakor 1984, 174).

PROVENANCE: Marc Leo Felix, Brussels.

38. MALE/FEMALE MASK PAIR

Nigeria, Upper Benue River, 1850/1950
Wood, ocher, brass tacks, male: height 158.8 cm
 (62½ in.), female: height 157.5 cm (62 in.)
Founders Society Purchase, Eleanor Clay Ford
 Fund for African Art (78.41, 78.42)

These monumental headdresses reflect a rich, although little known, sculptural tradition located along the Benue River in northern Nigeria. Yoke masks—worn over the shoulders—are rare in African art compared to face and helmet masks. They are found only among the Baga of Guinea and several northern Nigerian groups. Arnold Rubin, who has conducted field research in the Benue River valley in northern Nigeria, saw yoke masks among both the Mumuye and the Jukun. He also received reports of them among the Wurkun, Jen, and Chamba. Yet, stylistically, this pair does not closely resemble any of those artistic traditions. The rendering of the sagittal crest and the overall form lead Rubin (personal communication, 5/86) to attribute the masks to an unidentifiable group north of the Benue River.

Lack of information notwithstanding, the mask pair ranks among the most striking of art forms from this region of Africa. The contrast between the masks' simple, massive contours and diminutive facial features, the shifting interplay of profile and frontal views, and the detailed attention to the coiffure, sexual features, and surface decoration demonstrate the artist's great sculptural sensibility. The masks evidently were worn with large costumes, probably made from fiber and threaded through the holes found along the edges of the yokes. An indigenous repair on the right shoulder of the female attests to the value ascribed to the mask by its users and their attempts to preserve the piece.

PROVENANCE: F. Rolin Co., New York. Gaston de Haven.

Cat. No. 37

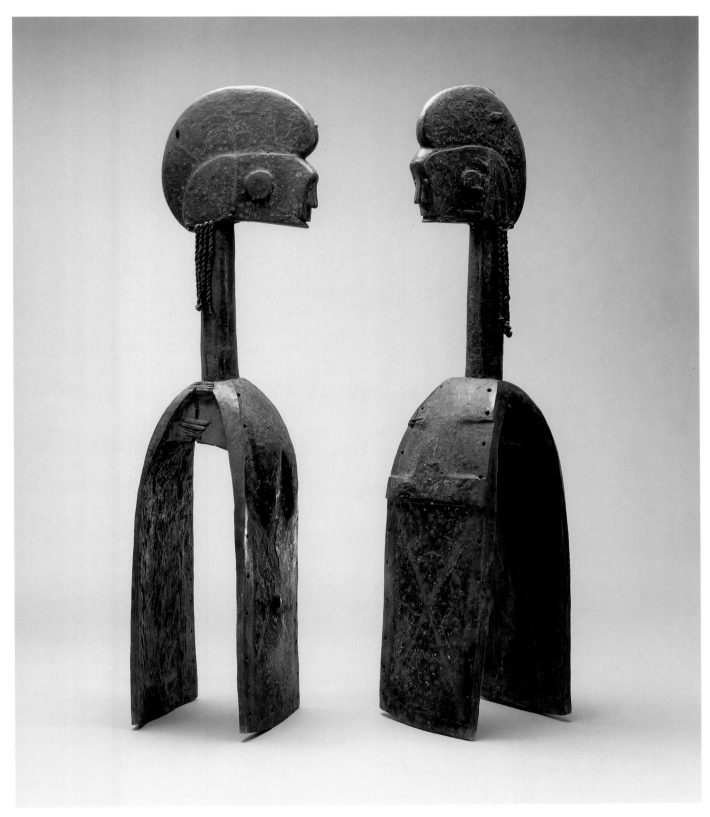

Cat. No. 38

CAMEROON AND CENTRAL HIGHLANDS

Opposite: Cat. No. 40, *Throne*, detail

The Savannah belt of mixed forest and grasslands, which proved so beneficial to the growth of sub-Saharan societies to the west, continues east across Africa, extending to northeastern Zaire. East of the lower Niger River, a chain of mountains and highlands, including Mount Cameroon on the coast and extending northward to the Mandara hills, forms a natural border between Nigeria and Cameroon (both colonial inventions as nations). The volcanic cone of Mount Cameroon rises abruptly from the coast as a notable landmark. Early Portuguese explorers named the river that drained into the bight, or bay, of Biafra below the volcano "Rio de Cameroes" ("river of shrimp") after the abundant number of crustaceans observed in the water. The area came under German control during the latter part of the nineteenth century and its name altered to Cameroons.

The modern nation of Cameroon extends from dense tropical forests on the coast to the arid steppes south of Lake Chad. The nomadic and Islamic Fulani have dominated the northern savannahs for the last three hundred years. To the south, several petty kingdoms emerged on the sheltered grassy Bamenda plateau on the eastern shoulder of the mountainous border region. Kings, known as *fon*, stood at the center of elaborate court life, which included workshops of sculptors who produced architectural ornament for the palace, effigies of the royal family for the palace treasury, and masks. Fon Yu, who reigned over the Kom kingdom from 1865 to 1912, was himself an accomplished sculptor. The power of the fon was tempered by the *kwifon*, a regulatory council of family elders responsible for implementing police actions against the disruptive forces in society. The collective and impersonal character of the council was emphasized through use of masks, whose display at public festivals symbolized the elders' power.

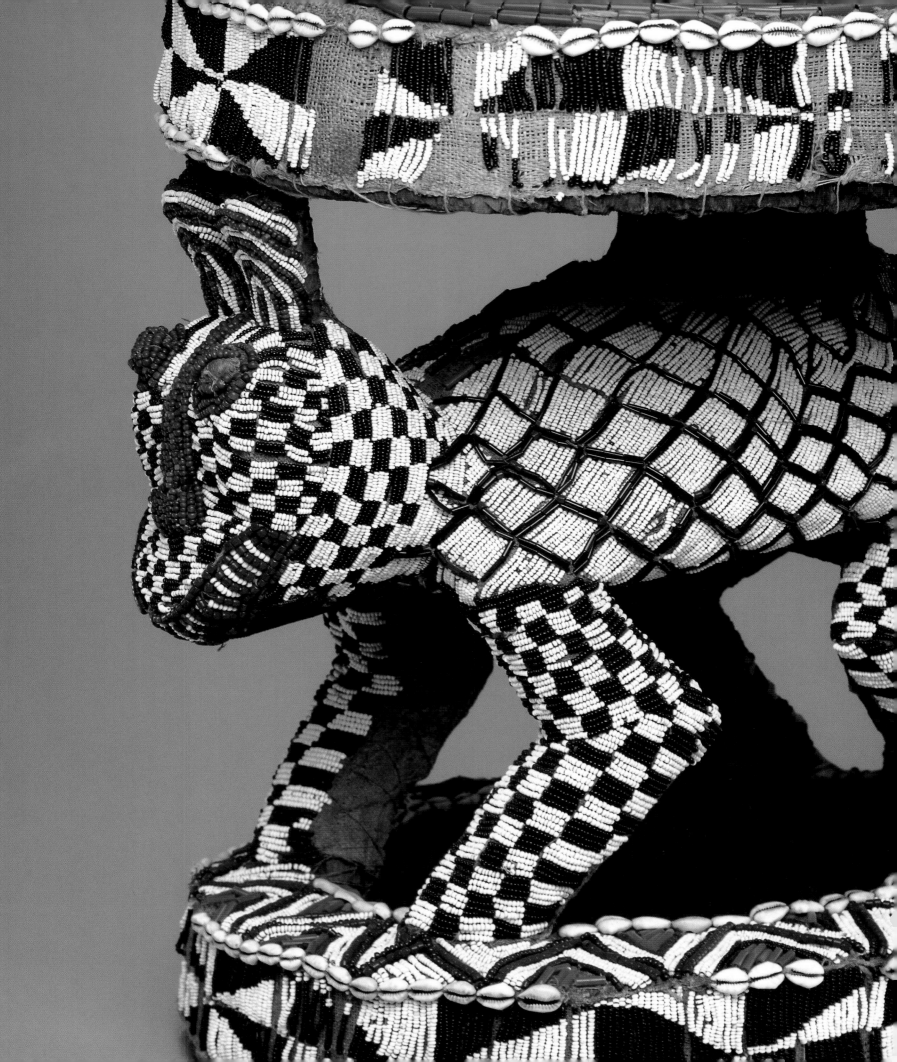

Masked members of the kwifon might also threaten, coerce, or even punish citizens during dreaded night visits.

The Ubangi River basin, located east of Cameroon between the Lake Chad and Zaire River watersheds, forms the border region between the modern Central African Republic and Zaire. The hunting, farming, and cattle-herding traditions of the Bantu and central Sudanic peoples were combined during waves of migration, resulting in dramatic, regional population growth after A.D. 1000. By the eighteenth century, the Zande to the north and east had organized into several principalities. To the south in northern Zaire, the Mangbetu established their own kingdom during the nineteenth century under the leadership of the chief Nabiembali. The elaborate court of his son, King Mbunza, was celebrated in the 1870 dispatches of explorer and naturalist Georg Schweinfurth and published in the London *Illustrated News*. The Mangbetu kingdom collapsed shortly thereafter as a result of conflicts attendant to the southern Sudan slave and ivory trade. The Ubangi basin became part of the Belgian Free State in 1884 as a result of a compromise negotiated by King Leopold between the contending colonial interests of England and Germany.

Zande and Mangbetu art is a curious admixture of sumptuous prestige objects and tourist curiosities. Unlike their Bantu-speaking neighbors to the south, the Mangbetu did not possess a tradition of figural sculpture, but quickly invented one to satisfy the desires of colonial collectors during the late nineteenth and early twentieth centuries. More typical to the region is the figural embellishment of utilitarian objects such as cylindrical cosmetic boxes, knives, pipes, and musical instruments (harps, drums, thumb pianos, or *sansa*). Zande and Mangbetu objects employ the distinctive heads and bodies of high-ranking women, identified by their fan-shaped coiffures.

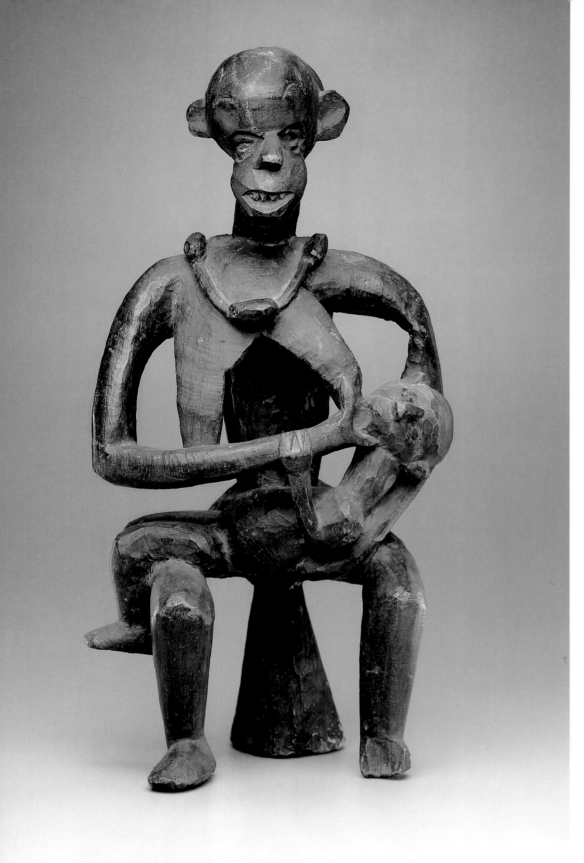

Cat. No. 39

39. MOTHER AND CHILD

Cameroon, Bamileke, 1850/1950
Wood, height 59.1 cm (23¼ in.)
Founders Society Purchase, Eleanor Clay Ford
 Fund for African Art (79.22)

Among the Bamileke, the power of a newly in-
stalled king was not operative until one of his
wives had borne him a healthy child. It mattered
little whether the child was male or female; the
birth simply bore proof to the king's virility and
his capacity to continue the royal blood line.
The wife, in turn, was commemorated for her
role with a large sculpture of this type. Further-
more, the mother of the king's first child was fre-
quently elected as the administrative head of
domestic affairs at the royal palace, in charge of
delegating responsibility among all the king's
other wives. This figure, therefore, may not only
depict a royal wife, but also a woman of signifi-
cant political influence (Northern, personal com-
munication, 7/86).

Royalty, however, was not the only privileged
class to be celebrated sculpturally; people of
prominent lineage also provided the models for
these portraits. Within the domain of the family,
a lineage head performed the same role as king.
This figure's spare accoutrements suggests she
might depict a nonroyal personage. The figure
lacks the armlets and anklets customarily worn
by royal women and shown in abundance on
many royal sculptures. Only the chevron-beaded
necklace is identifiably royal, but even this was
often bestowed upon lineage heads in return for
favors rendered at the palace. Tamara Northern
(personal communication, 7/86) nevertheless
identifies this as a royal memorial figure since
sculpture from the southern Bamileke character-
istically lacks elaborate ornamentation and even
royal sculptures are relatively unadorned.

The dramatic angularity and an ingenious in-
terplay of voids and solids closely relate this
mother and child to a figure in the Musée de

l'Homme, Paris. The latter was collected in 1934 by Henri Labouret in the kingdom of Bangante, in the Bamileke region of the Cameroon Highlands, but it was actually carved by a sculptor from Bawok, a village renowned for its artists that was unfortunately destroyed in a war with Bangante (Vogel and N'Diaye 1985, 141). The two pieces show many similarities and probably came from the same workshop. Both figures are seated with legs and arms held open and away from the body. The sweeping support of their stools mimics a third leg and completes the central axis of the sculptures. In both, a child lies limply across the mother's lap, legs hanging freely over her right thigh, and sucking her left breast. The two mothers proudly wear beaded necklaces that rest upon their swelling chests, but both are lacking any further royal accoutrements.

PROVENANCE: Ralph Nash, London. John Friede, New York.

REFERENCES: Roslyn A. Walker, *African Women/African Art: An Exhibition Illustrating the Different Roles of Women in African Society* (New York: African-American Institute, exh. cat., 1976), 28.

40. THRONE

Cameroon, probably Bamenda plateau, 19th century

Wood, beads, height 47 cm (18½ in.)

Founders Society Purchase, Eleanor Clay Ford Fund for African Art (79.18)

Richly beaded stools supported by human and animal caryatids served as prestigious furniture used by royalty in the Cameroon Highlands. Kings of Bamum, the largest of the Highland states, were known to sit upon such seats in their private chambers when receiving their wives or intimate attendants. The queen mother—an important political advisor to her son, the king—also owned a similar stool. In addition to their court use, stools were included among the regalia distributed through gift exchanges and trade. Christraud Geary (personal communication, 4/86) attributes a considerable number of stools, including this one, to workshops in the Bamenda plateau despite its distance from the Bamum kingdom.

Using a poised leopard as a support is very common in the Highlands. The motif stems, in part, from the king's metaphorical association with the most powerful and aggressive beasts in the animal kingdom. Indeed, the king was addressed as leopard, lion, or elephant. Sitting atop a leopard both enhanced the king's image and signaled his domination over the most predatory beasts. The leopard also symbolized a belief in the ruler's ability to transform himself into the animal. A slain leopard might be a king in his transformed state, and special rites were performed, including an invocation and a vow of innocence on the part of the killer. Following this purification, parts of the leopard were distributed among members of the court. Pelts were used in the palace as a cover for the royal bed, claws and teeth were worked into jewelry, the dried bones were rubbed on the children of the king for strength, and the heart—most sacred of all—was eaten by the king and selected guests (Geary 1983, 110).

The intricate beadwork adorning the Detroit stool would further testify to the Bamum king's wealth and power. Beads were reserved strictly for use in the palace. They beautified many objects in the royal treasury, including thrones, masks, calabashes, flywhisks, and pipe stems. Beads of Venetian, Dutch,

Cat. No. 40

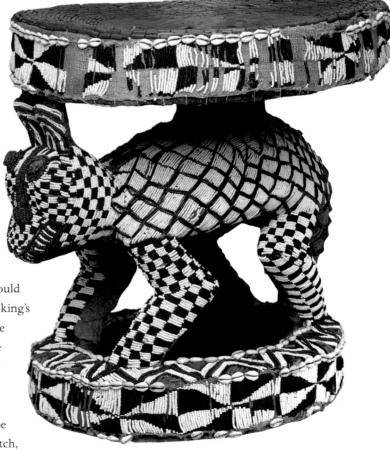

Portuguese, and Bohemian manufacture were especially valued and were obtained prior to the twentieth century through the markets to the north in the Benue River valley and Banyo. A specialized but dependent artisan class, living at the Bamum king's court, held the appointment for production of the beaded embroidery for all royal insignia and gifts (Geary 1983, 86–88).

PROVENANCE: Pace Gallery, New York.

REFERENCES: Detroit Institute of Arts, *Detroit Collects African Art* (Detroit, exh. cat., 1977), no. 117.

41. MASK

Cameroon Highlands, Bamileke, Batoufam,
 19th/20th century
Wood, height 87.6 cm (34½ in.)
Founders Society Purchase, Eleanor Clay Ford
 Fund for African Art (78.9)

This colossal head is from a series of masks called *Batscham,* in reference to the village where the first mask was collected in 1904. In actuality, the masks come from many different kingdoms in the central Bamileke region of the Cameroon Highlands. Virtually all are abstractions of the human face, except for several zoomorphic examples depicting buffalo or elephants. In addition to old masks, replacements have been made for some, and copies are still being made at Bandjoun by Paul Thabou, who traces his workshop back four generations to the artists of the earliest known masks in this style.

Despite their overwhelming size and massive weight, Batscham masks were worn atop the head in public performances. They were fastened to the head with fiber strung through holes lining the base's rim where cowrie shells are carved in relief. Pierre Harter (personal communication, 7/86) states that only one such mask belonged to a kingdom at any given time. They figured in rare and extremely sacred occasions of state, such as the selection of a successor to the throne, the investiture rites for a new

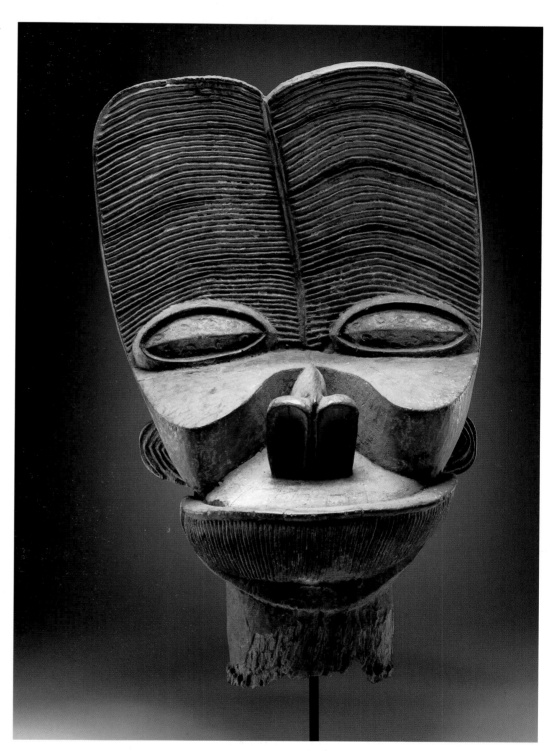

Cat. No. 41

king, or at funerary and commemorative ceremonies for deceased rulers.

The Detroit mask, collected in 1971, is the sole example from Batoufam, a kingdom south of the many locales where these masks have been discovered. While the museum's piece shares the same overall form as the others, certain stylistic details, including the high, almost vertical nostrils, elevated cheeks, and pierced frame at the back, differentiate it. Other distinguishing features are the circles engraved in the eyes and the mask's exceptional size. The circular eye markings, which Harter interprets as the pelt markings of the supreme royal animal, the leopard, further emphasize the mask's connection to kingship. These idiosyncrasies lead Harter, who has studied the entire series of masks systematically, to attribute this mask not merely to a different artist than that of the earliest examples, but to one working within a very different stylistic idiom (Harter, personal communication, 7/86).

Through comparison with other Bamileke mask types, Tamara Northern (personal communication, 7/86) suggests a different possibility for the use of this particular mask. If the dominant vertical plank represents a coiffure rather than hyperextended eyebrows, then the mask corresponds to some "leader" masks in which the hairstyle has a central division between two striated tufts of hair. A leader mask is the first to appear in a performance of mask groups belonging to historically important lineages. They commemorate high-ranking members. The male face depicted in a leader mask generically symbolizes royal and lineage ancestors.

PROVENANCE: W. Mestach, Brussels. Philippe Guimiot.

REFERENCES: *Bulletin of the Detroit Institute of Arts* 56 (1978), 5: 266, fig. 6.
Bulletin of the Detroit Institute of Arts 57 (1979), 1: 7, fig. 3.

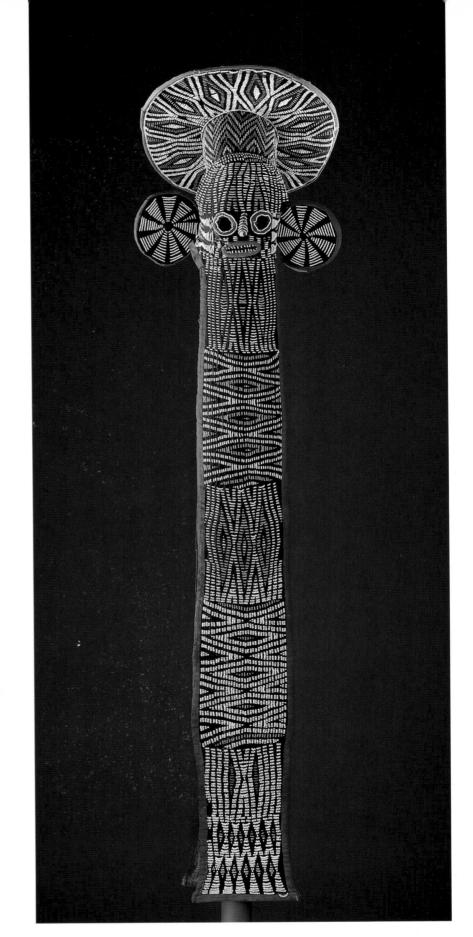

Cat. No. 42

42. ELEPHANT SOCIETY MASK

Cameroon Highlands, Bamileke, early 20th
 century
Wood, cloth, raffia, beads, height 175.2 cm
 (68¹⁵⁄₁₆ in.)
Founders Society Purchase, Eleanor Clay Ford
 Fund for African Art (77.56)

The royal arts of the Cameroon Highlands are characterized by a vibrant interplay of color, pattern, texture, and shape. Geometric motifs abound in this mask with its long vertical structure flanged by two pinwheels and a large umbrella-like headpiece. Except for the facial features, all the beaded patterns form variegated isosceles triangles differing only in colors, widths, lengths, and the horizontal and vertical axes.

For the Bamileke, this type of mask represents in a most distilled form an elephant's face, trunk, and ears, while the geometric patterns recall a leopard's pelt. Such a combination unites the leopard's speed and cunning with the power and might of the elephant. These two animals metaphorically allude to the divine power bestowed upon the ruler and his entourage.

This mask once constituted part of the regalia of the Elephant Society, a state association for titled warriors and court officials. The Elephant Society assisted the king or *fon* in his efforts to reinforce a rigid sociopolitical hierarchy. The society, among other things, secured arms during wartime, sanctioned taxes among villages, and acted diplomatically in neighboring kingdoms. Its ultimate purpose, however, was to regulate, maintain, and affirm a privileged class system in which wealth and titles determined one's station in life (Northern 1975, 19–20).

Never were social inequalities among the Bamileke more apparent than when Elephant Society members ostentatiously donned expensive finery. This usually occurred on special occasions such as the funeral rites for respected individuals or the association's biennial general assembly. During these public celebrations, members clad themselves in beaded masks with front and back panels, beaded vestments, belts in the form of double-headed serpents, voluminous garments made from royal blue and white cloth trimmed with cowrie shells, and leopard pelts hanging like capes from their shoulders (Northern 1984, 162). The high value of imported beads, made bead-laden elephant masks—dubbed "things of money" by the Bangwa of the Cameroon Highlands—a literal and powerful demonstration of prosperity (Geary 1992, 249).

While elephant masks have been broadly distributed in the Highlands, most come from Bamileke chiefdoms. Based upon the extreme schematization and dense patterning in this example, Tamara Northern (personal communication, 7/86) suggests the north-central Bamileke chiefdom of Bamendjinda as a likely place of origin. Northern emphasizes, however, that schematization is not particular to a single ethnic group or kingdom. It is equally possible that this mask hails from the southern-most Bamileke territory known as Bandjoun. Several masks of great length—very similar to this one—are known to originate from Bandjoun.

Abstract and schematic beaded designs, popularized in the 1920s, are more likely to indicate a piece's relative age than its geographic origin. Examples made prior to the 1920s tend to have less florid, more open, and spare compositions, possibly due to the greater rarity and cost of beads in the nineteenth century. The identical pairings of the ears on the Detroit piece suggest the twentieth century; earlier masks had different patterns on each front ear panel as well as both back ear panels. According to Northern (personal communication 7/86), no other single example corresponds exactly to this mask. The innovative horizontal registers on the front panel are highly unusual; more typically the panels are sectioned vertically, as on the back of this piece.

PROVENANCE: Morton Lipkin, New York.

REFERENCES: *Bulletin of the Detroit Institute of Arts 56* (1978), 5: 325, fig. 38.

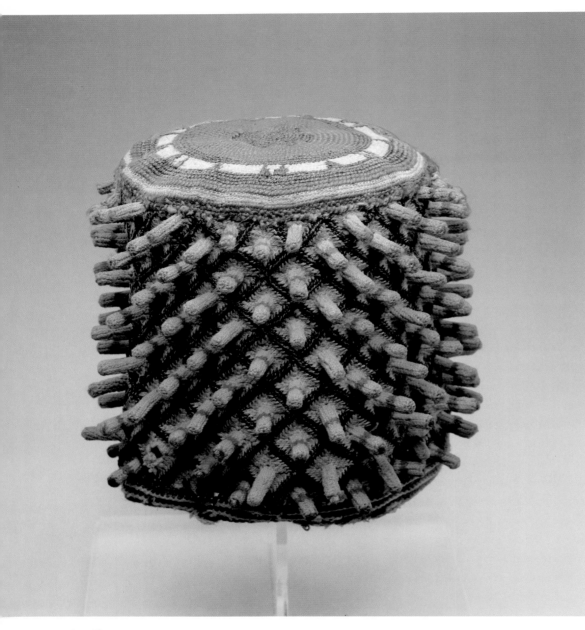

Cat. No. 43

43. PRESTIGE CAP

Cameroon Highlands, 20th century
Cloth, cotton, wool, 24.1 × 23.2 cm (9½ × 9⅛
 in.)
Founders Society Purchase, Eleanor Clay Ford
 Fund for African Art (F78.44)

Covering a ruler's head with richly handcrafted
caps and veils is a universal tradition in Africa.
Elaborate headgear draws attention to a ruler
while simultaneously and paradoxically conceal-
ing him as a means of protection. Furthermore,
headpieces bestow transformative powers; en-
ergy generated by the ruler's ancestors is chan-
neled and contained in the cap. The richly
textured and colorful headwear found through-
out the Cameroon Highlands denotes high social
rank. They are generally woven from naturally
colored and dyed cotton threads, although the
earliest examples were made of raffia fiber. Some
types include appliqué and embroidery inspired
by the tailoring of the Hausa, an Islamic trading
people. Other caps are adorned with beads,
shells, and feathers. The elongated burls on this
cap indicate that it had belonged to an eminent
official—a king, chief, or queen mother (Geary
1983, 103).

While its intricate detail and inventive designs
can be much appreciated, the cap's vitality
comes from its use. Together with other objects
in the royal treasury—beaded calabashes,
thrones, tobacco pipes, drinking horns,
flywhisks, ivory trumpets, and jewelry—caps
were a visual and metaphorical extension of the
ruler. According to Douglas Fraser and Herbert
Cole (1972, 326), "interacting, man and symbol
achieve a higher existence than either can reach
alone. Together they can transform ordinary
time and ordinary space into an extraordinary
event—one of those intensified moments in hu-
man existence that combine pageantry with
mystery, spectacle with order, theatre with maj-
esty—moments which are so rightly termed oc-
casions of state."

44. MASK

Cameroon, Babanki, 19th/20th century
Wood, 50.8 × 39 cm (20 × 15⅜ in.)
Bequest of W. Hawkins Ferry (1988.191)

This mask is from the Babanki region in the
Western Highlands of the Northwest Province of
Cameroon, where ethnic groups are organized
into small kingdoms. Each is headed by a ruler
or *fon,* who is supported by a hierarchy of
ranked titleholders representing royal and com-
moner lineage groups, a regulatory society, and
a council of notables. These groups own and con-
trol masks, used in particular ceremonies that
function in ways which reflect the social or politi-
cal position of their owners. Many masks of the
palace and the regulatory society *kwifon* are sa-
cred and their use is surrounded by secrecy, but
masks owned by lineages, such as this example,
appear in public dance festivities. Presented only
with the permission of the fon and the kwifon,
the masks constitute prestige objects that en-
hance the standing of their group (Northern
1984, 67).

Each lineage group may own from eight to
thirty masks which, when used in ceremonial
dances, appear in sequential order. A male leader
mask is followed by female masks and then by
other male masks and animal masks, culminat-
ing in an animal leader mask (Northern 1984,
67).

For the Highlands groups, the dance is the
highest form of artistic expression (Gebauer
1979, 24), and the masks effectively heighten the
drama. Masked dances are the significant mark-
ers of important events, such as a man's funeral,
known as a "cry-die," seasonal occasions relating
to the agricultural calendar, and the annual fon's
dance, a great spectacle of both performance
and display in which all the kingdom's prestige
objects are exhibited.

The Detroit helmet mask is typical of a style
that was widely exported from the Babanki to ad-
jacent kingdoms (Fagg 1980, 140). Its features

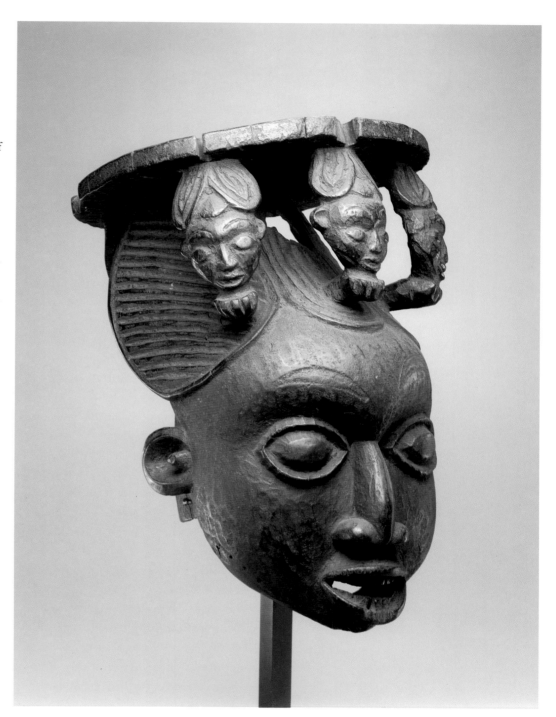

Cat. No. 44

are clearly defined and the expression is charac-
teristically animated. The row of male heads
adorning the coiffure is meant to symbolize the
strength and prestige of the lineage the mask rep-
resents (Northern 1984, 152). The top of the

mask, shaped like a platform, is pierced with holes around its circumference. These once may have held arrows or spear points as a reference to power.

PROVENANCE: Pace Gallery, New York. W. Hawkins Ferry, Grosse Pointe Shores, Michigan.

45. CEREMONIAL BOWL

Cameroon, Tikar (?), early 20th century
Terra cotta, 50.8 × 27.9 cm (20 × 11 in.)
Founders Society Purchase, Prepaid Gifts Fund, African Fund and Edsel and Eleanor Ford Fund (80.60)

With few exceptions, pottery making in Africa, including the Cameroon, has long been the domain of women, and only rarely has it been recognized as an art form rather than just a utilitarian handicraft. Early travelers and writers such as Barbot and Astley extolled the technical and utilitarian superiority of African pots (Sieber 1980, 246). Reports exist of their ritual use, but their specifically aesthetic qualities have remained relatively overlooked until fairly recent times. The "combination of usefulness and individual beauty makes clay containers artistic creations of daily life: transcending their utilitarian value, they become symbols of social expression" (Stössel 1985, 85–86).

Cameroon pottery is no exception to this generalization. Pieces were made by women and required much time and hard work. In certain areas of the Highlands, a rivalry prevailed among royal wives for the possession of the finest ornamented bowls, which were proudly displayed by their owners (Gebauer 1979, 98). These vessels, of various sizes and shapes depending upon their function, were frequently decorated with sculptural motifs, especially around their upper rims.

Large bowls such as this one, heavily embellished with anthropomorphic, zoomorphic, and other designs in high relief, were probably owned by the palace and used for ritual purposes in the Tikar area and other Highlands kingdoms. A bowl in the collection of the Museum für Völkerkunde in Berlin (see A. Lommel, ed., *Afrikanische Kunst,* Munich: Staatlichen Museum

für Völkerkunde, 1976, fig. 18, cat. no. 28), with chimerical figures connected by garland shapes like this one, is virtually identical in design to the Detroit bowl and almost certainly was created by the same hand.

PROVENANCE: Pace Gallery, New York.

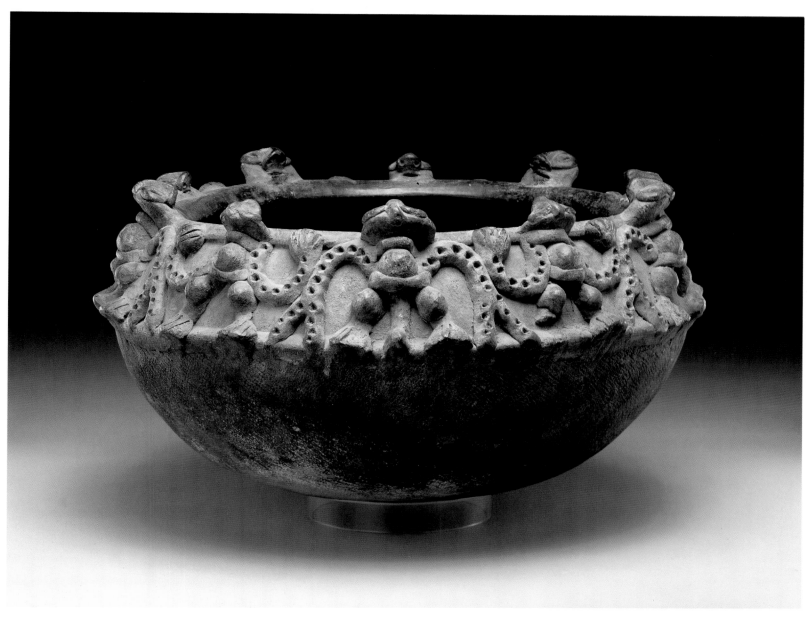

Cat. No. 45

46. SLIT DRUM

Zaire, probably Barambo, late 19th/early 20th century

Wood, pigment, 121.9 × 243 × 121.9 cm (48 × 96 × 48 in.)

Founders Society Purchase, Ralph Harman Booth Bequest Fund (1986.26)

This cowlike form is a slit drum, a large instrument used throughout Africa and elsewhere to convey important messages across long distances. An ancient and indigenous tradition, slit drums have been reported in the northeastern forest cultures of Zaire since the first European explorers passed through the area in 1870 (Schweinfurth 1874, 2:113; Overbergh and Jonghe 1909, 420–421). Although the drums are made by many peoples in the region, including the Zande, Yangere, and Boa, this one can be attributed to the Barambo on the basis of style and form (Keim, personal communication, 8/86).

Carved from a large tree trunk, this drum is constructed with a deep, longitudinal slit across the top, hence, the term "slit drum." The small,

Cat. No. 46

delicate head, punctuated by a fine protruding tongue, extends from the massive body, giving the creature the appearance of being ready to heave itself forward. The walls of the body vary in thickness, allowing the drum to emit different tones and pitches that can be made to "speak" tonal African languages. Slit-drum messages announce, for example, the outbreak of war, the news of peace, the arrival of an important visitor, or the convening of the village elders. The drum's deep resonating sound can travel many miles and serve as a unique intervillage communications system (Miller 1990, 212).

PROVENANCE: Alan Brandt, New York.

47. HARP

Zaire, probably Zande, late 19th/early 20th
 century
Wood, hide, metal, paint, 41.9 × 48.9 cm (16½
 × 19¼ in.)
Founders Society Purchase, Henry Ford II Fund,
 and Benson and Edith Ford Fund (82.29)

"They have an instinctive love of art. Music rejoices their very soul. The harmonics they elicit from their favorite instrument, the mandolin, seem almost to thrill through the chords of their inmost natures."

Description of the Zande
(quoted in Schweinfurth 1874, 2: 29)

This harp stands apart from all others from the northern forests of Zaire. It ranks among the few examples known in which the instrument's neck is sculpted as a full female figure. Most harps from the area are surmounted by a head only, with the body merely implied by the curve of the instrument itself. In addition to a fully modeled, sensuous body, this figure has arms articulated at the shoulder—a device commonly found in eastern and southern African figure sculpture but very seldomly in northern Zaire. The figure's adornment presents still other out-

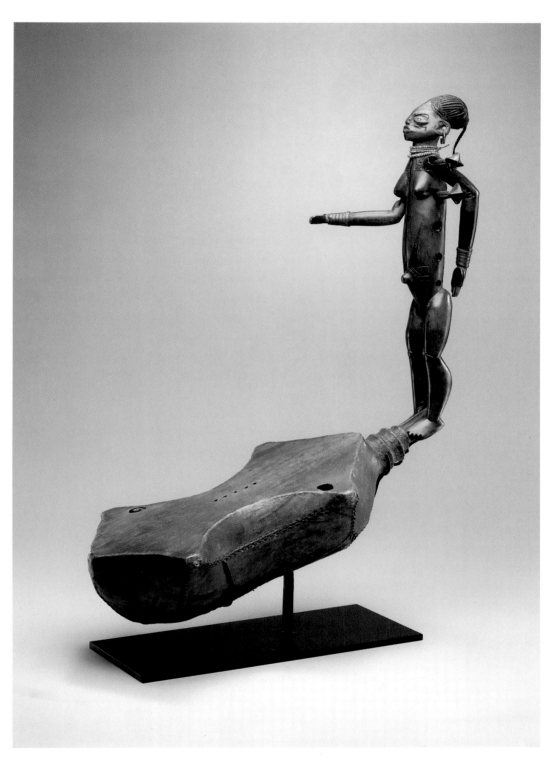

Cat. No. 47

standing features. Rendered with unusual realism, it details scarification, coiffure, and accoutrements accurately and, therefore, documents women's fashions during the late nineteenth century.

During the late 1860s when the German explorer Georg Schweinfurth passed through the northern forests of what is now called Zaire, he discovered the Zande culture. Although this society was far less stratified than that of the neighboring Mangbetu, who built a powerful and sumptuous kingdom on the spoils of slavery, the Zande nevertheless had cultivated a dynamic environment in which the visual arts, poetry, dance, and music flourished. Anthropomorphic harps of this kind usually are identified as Mangbetu because their elegance resonates with the sophisticated taste and patronage of Mangbetu court life. According to Kurt Keim (personal communication, 8/86), however, the Mangbetu did not develop a strong figurative sculptural tradition. They did make anthropomorphic harps but only in response to European commercial interests. Visual and historical evidence confirms that most traditional northern Zairian harps originated among the Zande, who are known to have used such harps in a traditional context even before European intervention, and among other related groups found in the region, such as the Barambo and Boa (Schildkrout and Keim 1990, 225–226).

The Zande harp is a string instrument with an elongated, skin-covered sound box, two apertures, and pegs for tuning the strings. While all anthropomorphic harps merge form with function, this one has a particularly ingenious invention: the uppermost tuning peg also operates as the joint rotating the arms. This harp originally had five strings made from fine bast threads or from the wiry hairs of a giraffe. The strings were pulled taut in a diagonal arrangement from the body of the instrument to the figure's torso.

Zande harps were used primarily by "wandering minstrels," who accompanied themselves on the instruments while singing. These itinerant musicians donned fantastic costumes of exotica from feathers and roots to pig's feet and tortoise shells. From town to town, they entertained villagers, charming them all through the night reciting love sonnets and other songs.

Although the Detroit harp may be rare and exotic, and consequently its origin more difficult to trace, the coiffure attests to its origin in the Zande area. Schweinfurth (1874, 2:7) described the traditional Zande hairstyle worn by both men and women: "Their hair is usually parted right down the middle; towards the forehead it branches off, so as to leave a kind of triangle; from the fork which is thus formed a tuft is raised, and carried back to be fastened behind; on either side of this tuft the hair is arranged in rolls, like the ridges and crevices of a melon." Women's coiffures differ slightly from men's in that they lack the long, twisted tresses that fall around the men's necks. The observations made by Schweinfurth correspond accurately to this figure's elegant hairstyle.

PROVENANCE: Jeanpierre Jernander, Brussels. Alan Brandt, New York.

REFERENCES: Detroit Institute of Arts, *100 Masterworks from the Detroit Institute of Arts* (New York: Hudson Hills Press, 1985), 72–73.

48. CONTAINER

Zaire, Zande, 1850/1900

Wood, fiber, 55.9 × 27.9 cm (22 × 11 in.)

Founders Society Purchase, Eleanor Clay Ford Fund for African Art (77.70)

Bark boxes, such as this one, are said to contain camwood—a pulverized red cosmetic used in many regions throughout Africa. However, their interiors rarely produce traces of this red powder (Vogel 1986, 181). More often, they serve as receptacles for personal belongings such as hairpins, jewelry, and toiletries. Like an elaborate Western jewelry box, this labor-intensive treasur-

ary probably belonged to a woman of considerable means. The polarities of Zande art, from minimal figures to highly refined objects, merge in this work—a fully modeled human head supported by a rigid, unyielding column. This dichotomy is found in the carving technique itself: the neck and head have an unfinished, gouged look, whereas the lower portion—although worked by hand—has a precise machine-made perfection. Yet, the two parts fit together with inexplicable beauty, the elegant lines of the abstract body complementing the stateliness of the naturalistic head.

The simple coiffure and large earholes for the now-missing earrings link the piece to the Zande region. Georg Schweinfurth (1874, 2:114), who visited the area in the late nineteenth century, noted that numerous household objects were made to rest on carved human feet. This not only satisfied aesthetic preferences, but also practical concerns since it protected the box and its contents from moisture in the ground. The Detroit example replaces the feet with an exquisitely flared base bearing superimposed flanges with fine silhouettes that echo the figure's delicately pointed chin.

PROVENANCE: Mathias Komor Gallery, New York. John Hewett, London.

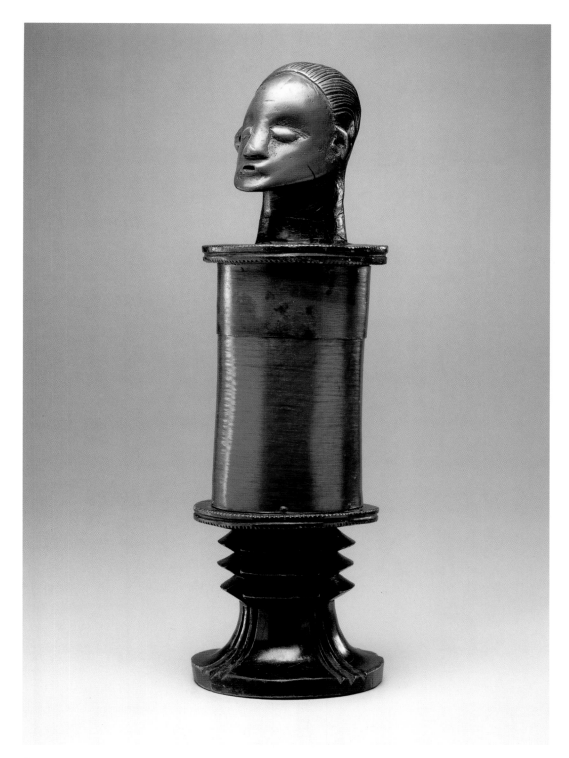

Cat. No. 48

WESTERN CONGO BASIN AND OGOWE RIVER

T he modern nation of Gabon sits astride the equator in some of the most rugged and heavily forested country in Africa. The wooded mountains are one of the last homelands of mountain gorillas, who have taken refuge in this inaccessible region. The Ogowe River and its fan of tributaries drains from the interior mountains through an extensive coastal estuary, which was the site of the first contact with European explorers. Waves of Bantu-speakers (a branch of the Congo-Kordofanian language family) migrated from their west African homeland and penetrated the Gabon forest by at least A.D. 1000, displacing the earlier Pygmy inhabitants. The Bantu-speaking Fang, one of the largest ethnic groups of the region today, began to trickle into the Ogowe basin from a homeland to the north and west during a long episode of migration beginning in the fifteenth century.

The Fang, Kota, Tsogo, and Vuvi are village people with little centralization of authority. Entire villages continued to drift from one location to another through the twentieth century so that the "ethnic map" of the region is exceedingly complex. Leadership, such as it exists, is vested in family elders, and the veneration for the authority of age is extended to spiritual beliefs as well. All of these groups rely on the intercession of powerful ancestors to assist in worldly matters. The Fang cult of *bieri* and the Tsogo and Kota *bwiti* focus on the preserved relics of ancestors. Bits of bone or entire skulls are guarded by a reliquary, or sculptural, figure. These reliquaries are kept in the men's communal meeting house and, in a sense, sanction the collective decisions of bieri cult elders by their presence. Masks painted with white kaolin pigment portray white-faced ancestors returned from the land of the dead. The color white is associated with the dead and their otherworldly state of being here and elsewhere in Africa.

Opposite: Cat. No. 52, *Reliquary Guardian Figure*, detail

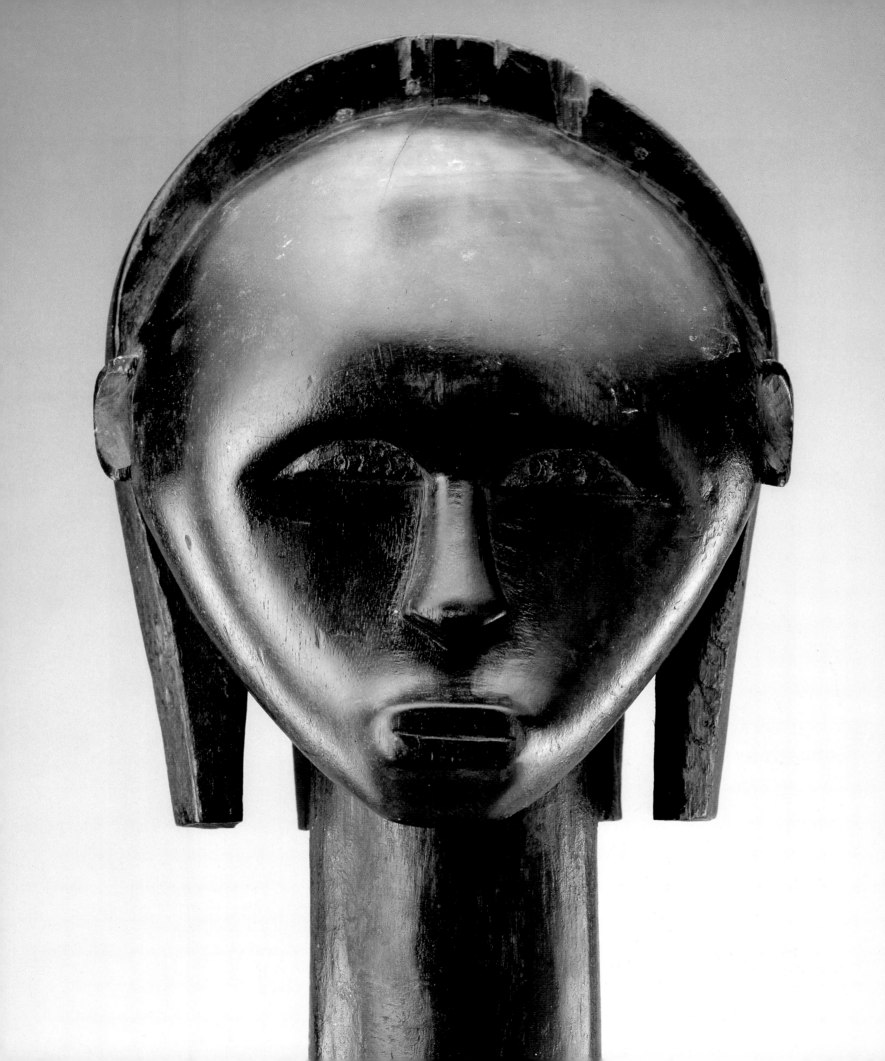

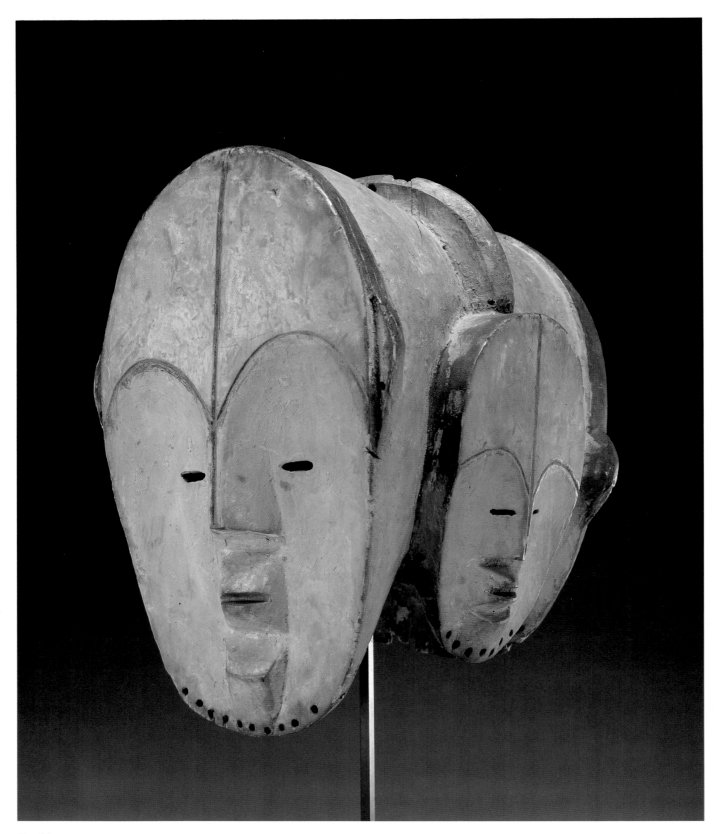

Cat. No. 49

49. MASK (ngon-tang)

Gabon, Fang, 19th century

Wood, kaolin, height of each face: 21 cm (8¼ in.), 34.3 cm (13½ in.), 29.2 cm (11½ in.), 21.5 cm (8½ in.)

Founders Society Purchase, New Endowment Fund, General Endowment Fund, Benson and Edith Ford Fund, Henry Ford II Fund, and Conrad H. Smith Fund (1983.24)

This extraordinary mask was collected among the southern Fang in the Komo River region, toward the mountains of Crista (Perrois, personal communication, 6/86). It is a helmet mask of the *ngon-tang* type, which personify "young white women" upon their return from the land of the dead beyond the sea. For the Fang, white denotes death and, consequently, ancestral spirits. The mask indirectly relates to Europeans. In Fang thought, the deceased reincarnate and return to visit the living as white Doppelgängers. For this reason, Europeans—mistaken for ancestral spirits—have been welcomed with utmost respect and treated with great reverence by the Fang.

Ngon-tang masks are worn at solemn community gatherings: occasions of birth, mourning ceremonies, important village councils. Before any public performance, the mask dancer must observe strict sexual abstinence. During this time, he is given a medicinal potion that is said to render him weightless and limber. Once rubbed with prophylactics and adorned with powerful talismans, he then may be possessed by the ancestral spirit. A singer who has undergone the same ritual precautions accompanies the dancer throughout the performance.

Generally, multi-faced sculptures in African art refer to heightened vision and the ability to see beyond this world into the next. The facial symmetry and serene expression shown on the Detroit mask refer to Fang moral values and idealized social order. However, the many-sided faces on a given mask and their significance are interpreted variously by the Fang themselves. To some, masks with four faces enumerate the four stages of human existence (birth, life, senescence, and death). For others, four faces from a single point recreate the paradigm of family unity (father, mother, son, daughter). The faces also may be viewed as the four gods in the Fang "pantheon," the largest face being that of the supreme deity (Perrois 1979, 101).

Since its appearance in the West during the early twentieth century, the Detroit mask has been well known and often exhibited. Prior to its arrival in Detroit, it belonged to the legendary Parisian art dealer Paul Guillaume, who opened the first African art gallery in 1917. Later the piece entered the renowned collection of Helena Rubinstein. Additionally, it was showcased in the landmark New York exhibition "African Negro Art" held at the Museum of Modern Art in 1935. The mask's spare lines and subtle geometry unquestionably influenced impressionable avant-garde artists of the time.

PROVENANCE: Paul Guillaume, Paris. Helena Rubinstein, New York. Valerie Franklin, Los Angeles.

REFERENCES: James J. Sweeney, ed., *African Negro Art* (New York: Museum of Modern Art, exh. cat., 1935), no. 418.

Paul Radin and James J. Sweeney, eds., *African Folktales and Sculpture* (New York: Pantheon, 1952), pl. 20.

Willy Fröhlich, *Beitrage Zur Afrikanischen Kunst* (Cologne, 1966), pl. LCII-B.

New York, Parke-Bernet Galleries, *African and Oceanic Art: The Collection of Helena Rubinstein, Parts 1 and 2* (sales cat., April 21, 29 1966), 202–203, no. 221.

Louis Perrois, *Arts du Gabon* (Arnouville: Arts d'Afrique Noire, supplément au tome 20, 1979), 97–102.

Detroit Institute of Arts, *100 Masterworks from the Detroit Institute of Arts* (New York: Hudson Hills Press, 1985), 74–75.

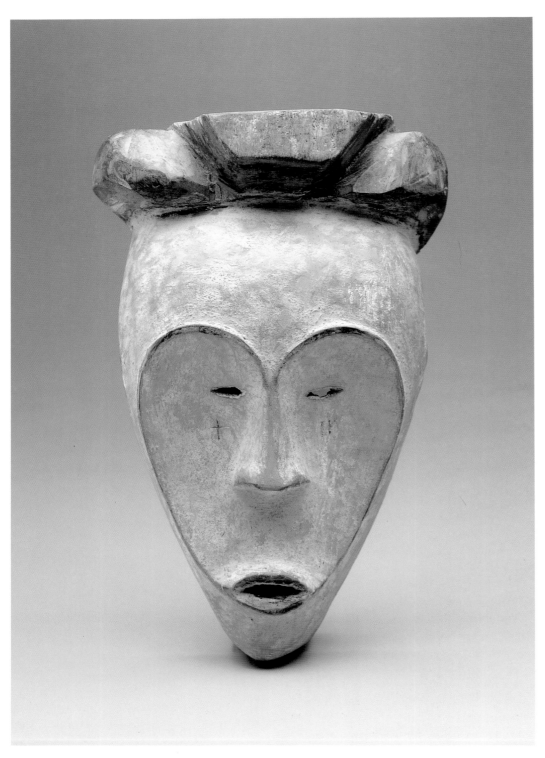

Cat. No. 50

50. MASK

Gabon, Fang, 19th/20th century
Wood, kaolin, height 22.2 cm (8¾ in.)
Bequest of Robert H. Tannahill (70.92)

Although *ngon-tang* masks are usually of the
multi-faced helmet type (see cat. no. 49), a num-
ber of single-faced masks in this genre are
known. They are sometimes confused with *ngil*
masks because of their schematic simplicity of
line, but are not as elongated as the ngil type,
which may measure up to eighty centimeters in
length. Louis Perrois (1985, 149) states that the
single-faced type is earlier in origin than the
multi-faced mask, and its exact function is not
known.

This mask exemplifies the salient features of
the ngon-tang type. As Marie-Louise Bastin
(1984, 251) points out in her description of an-
other mask, the image is reduced to its essential
traits. The concave perfection of the heart-
shaped face contrasts with the swelling convex
form of the forehead and the sides of the head
continuing down to the chin. The stark white of
the kaolined surface emphasizes the face's heart
shape outlined by a pyro-engraved black line
that delineates the brows and extends from them
around the lower lip in an unbroken contour.
Black accents also delineate lips, nostrils, and
small tattoo patterns beneath the eyes. The
three-lobed coiffure is a typical feature of many
examples of Fang art.

PROVENANCE: Robert H. Tannahill, Grosse Pointe
Farms, Michigan.

51. MALE RELIQUARY FIGURE (eyima bieri)

Gabon, Fang, Ntumu substyle, late-19th/mid-20th century

Wood, pigment, height 57.2 cm (22½ in.)

Bequest of Robert H. Tannahill (70.90)

Cat. No. 51

This figure would have sat atop a bark container holding the skulls, long bones, and vertebrae of revered ancestors, repelling both spirits and people who would cause harm to the ancestral powers. The figure was secured to the box by the pole in its back, and its legs would hang over the front. The family group that commissioned the reliquary would petition the ancestors for support in a ritual called *bieri*.

This regional style of Fang art, found in the area of southern Cameroon, northeastern Equatorial Guinea, and northern Gabon, is characterized by the slim, vertical orientation of the body. All of the sculptural elements coalesce to form an inward-focused image. The expression on the face is reserved; the gesture of the arms is contained. The heart-shaped form of the face is often found in this part of Africa. The high-domed forehead surmounting closed, oval-shaped eyes gives the face a look of powerful mental concentration. Typical of this style, the mouth projects forward directly from the chin. The neck is the same circumference as the torso, adding to the elongated look of the figure.

There is an obvious discrepancy, which cannot easily be explained, in the quality of finish between the upper and lower body. The head, neck, shoulders, and arms have been smoothly polished while marks of the cutting tools are still evident on the lower body. The figures were not known to be clothed, thus leaving the rough-hewn portions fully visible. Early Fang reliquaries are believed to have consisted only of a head on a stick positioned atop the bark container (Tessman 1913, 2: 117–121; McKesson 1987, 9). During the nineteenth century, the Fang were constantly on the move, migrating to their present location from farther to the east. It was of vital importance to maintain the ancestral bones, and the smaller heads would have been easier to transport than a full figure.

The full-body form of reliquary guardian figures evolved after the Fang permanently settled, possibly by the mid-nineteenth century, and probably first occurred in the borderland area of southern Cameroon, eastern Equatorial Guinea, and northern Gabon (Fernandez and Fernandez 1975, 740). If the original guardian figures consisted of a head at the end of a stick thrust into the bark box, this sculpture might then illustrate the transitional movement toward the complete and fully fleshed body.

The reliquary container and guardian were kept in a room of the home of the elder of the clan, but the sculpture itself would not have been considered sacred. The figures were occasionally taken out of the house to be used in secular entertainment, and Western collectors found them easy to buy during the first decades of the twentieth century.

PROVENANCE: Pierre Matisse Gallery. Robert H. Tannahill, Grosse Pointe Farms, Michigan.

REFERENCES: Detroit Institute of Arts, *Arts and Crafts in Detroit 1906–1976: The Movement, the Society, the School* (Detroit, exh. cat., 1976), no. 285.

Detroit Institute of Arts, *Detroit Collects African Art* (Detroit, exh. cat., 1977), no. 129.

Louis Perrois, *Byeri Fang: Sculptures d'ancêtres en Afrique* (Marseilles: Musée d'Arts Africains, Océaniens, Amerindiens, exh. cat., 1992), 50, 146–147.

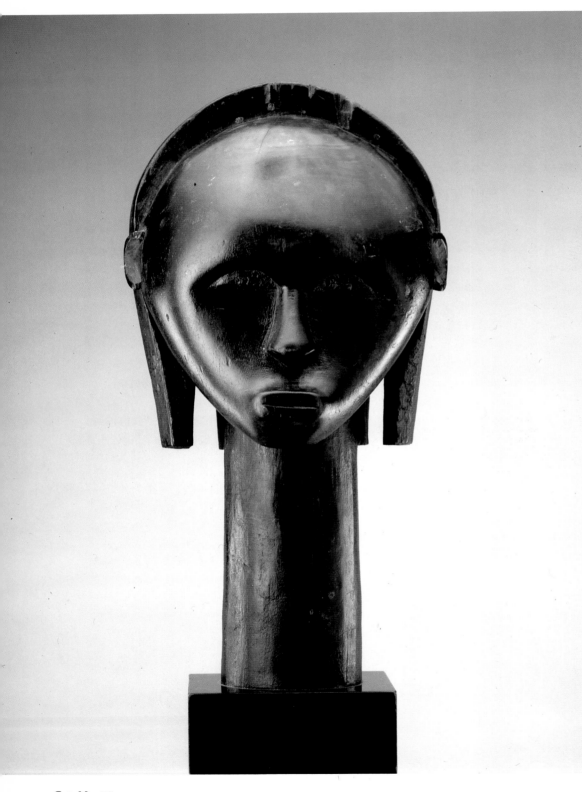

Cat. No. 52

52. RELIQUARY GUARDIAN FIGURE

Gabon, Betsi Fang, probably Okano Valley,
 19th/20th century
Wood, 30.5 × 16.5 × 11.4 cm (12 × 6½ × 4½
 in.)
Founders Society Purchase, Eleanor Clay Ford
 Fund for African Art and Mr. and Mrs. Walter
 B. Ford II Fund (77.29)

An ideal combination of youth and maturity, this head transcends the limits of age and time. Its stark simplicity invites contemplation. The bold, prominent forehead is counterbalanced by a massive coiffure of four thick tresses descending behind the columnar neck, while the burnished black surface further accents the harmonious contours of the face.

The formal simplicity of this sculpture, however, conceals complex messages. Throughout the Ogowe River area in Gabon, many ancestral cults honor the dead through the preservation and protection of sacred relics. Among the Fang, skulls and bones of the deceased are believed to contain life force and consequently provide security, aid, and strength to the living community. For this reason, such relics of important family members are kept in round bark barrels surmounted by sculpted heads or figures. Each sculpture guards the relics from human intruders (the uninitiated, women, non-family members) or malevolent supernatural forces.

With its long neck inserted into the barrel, the carving stands as a metaphorical head for the barrel or body. As with many Fang heads, this one once had eyes of inlaid metal disks; only the nails that held them in place now remain. Such reflective eyes permitted the guardian to apprehend both seen and unseen forces that passed in the night (Vogel 1986, 123–149).

Fang heads do not portray specific persons but refer to the collective ancestry who control the destinies of the living. Hence, guardians invariably capture a timeless ideal of physical

beauty. But as in most African cultures, the physical appearance of a work cannot be separated from its moral and spiritual significance. Fang sculpture embodies the ethos of Fang philosophy. The childlike depiction of a head, at once infantile and sophisticated, not only relates to the belief that children are closer to the ancestors, but also to the principle of dualities in Fang thought, in this case of age and youth. Only through the reconciliation of opposites can life's conflicts and contradictions be resolved (Fernandez 1982, 390–394).

PROVENANCE: Ratton, Paris. Helena Rubinstein, New York. Kamer, Paris. Arman, Paris. Merton Simpson, New York.

53. RELIQUARY GUARDIAN

Gabon, Tsogo, 19th/20th century

Wood, metal, brass, cloth, animal hide, camwood powder, koalin, 36.8 × 11.4 cm (14½ × 4½ in.)

Founders Society Purchase, Mr. and Mrs. Walter B. Ford II Fund and Honorarium and Memorial Gifts Fund (69.464)

Alert, yet calm, this small figure stands guard atop the leather-encased bones of a prominent community member. Such guardian figures embody the aspirations of *bwiti,* an ancestral cult that strives to establish and maintain contact with the dead through their remains. In addition, Tsogo *banzie,* or members of the ancestral cult, are renowned for the skill and otherworldly perfection with which they perform songs, dances, miraculous apparitions, and communication with the dead, often under a drug-induced euphoria obtained from the *eboga* plant. As James Fernandez (1982, 436) learned from the Tsogo, "supernaturals amaze by intervening in the natural order of things and contravening the normal. Bwiti amazes its members by interven-

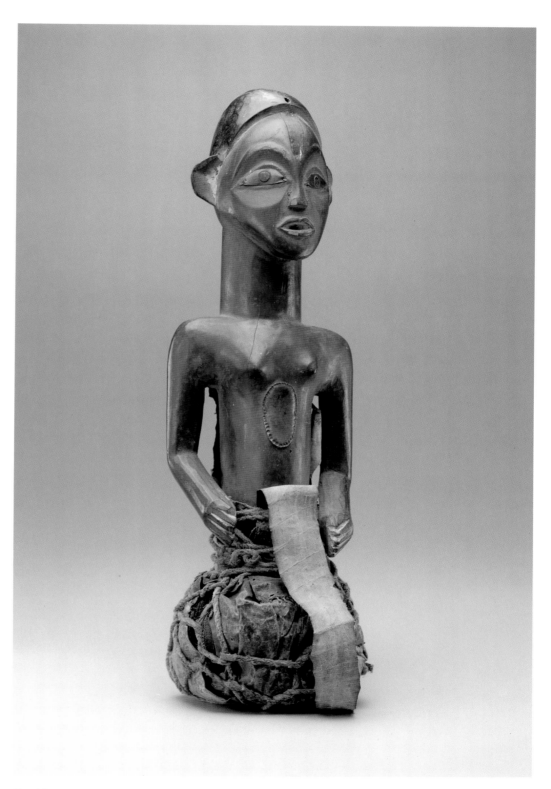

Cat. No. 53

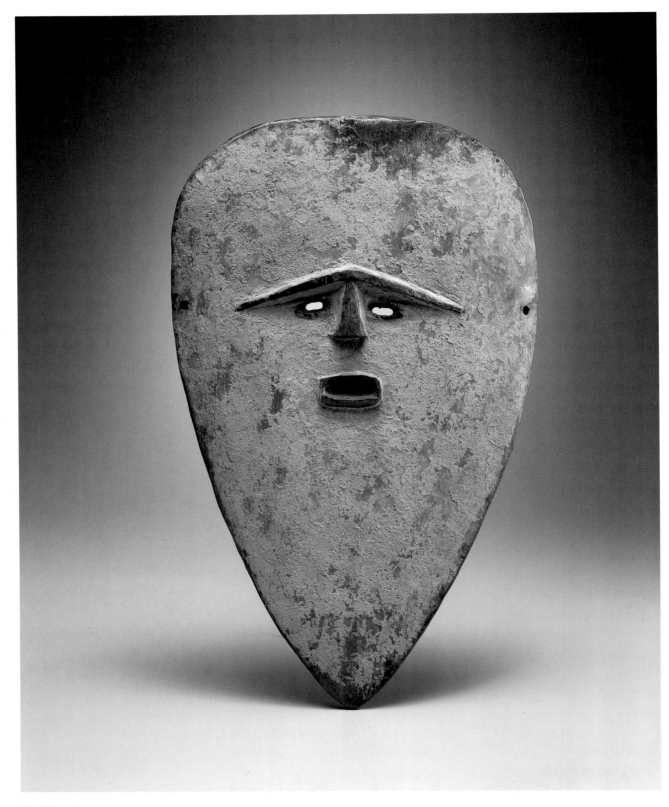

Cat. No. 54

ing in their lives in such a way as to enable them to surpass themselves and come to an understanding of the extraordinary, the unseen, 'the death side' of things, and thus be in communication with it."

This figure functioned similarly to the Fang head (cat. no. 52) once used for the *bieri* ancestral cult. When the bieri cult began to decline in influence, the Fang adopted the more dramatic, interesting, and apparently more effective bwiti association from the neighboring Tsogo. The bwiti's movement across ethnic boundaries exemplifies the "open frontiers" concept (Bravmann 1973, 9) of a cult whose beliefs, practices, and symbols are shared by many distinct peoples through cultural contact. Yet, bwiti develops in diverse and distinct ways for each group, governed by particular aesthetic tastes and needs.

Tsogo guardian figures tend toward naturalism in contrast with the group's highly abstract masks. Characteristic of Tsogo art is a brass band bisecting the forehead. The Detroit piece also has brass attachments for the eyes and an oval medallion at the torso's center. Like the copper disks set into Fang heads, these shiny metal additions serve to apprehend lurking evil forces and deflect them away from the sacred relics.

The Tsogo deliberately produce only half-figures since a basket or bag securing the bones is joined to the carving and literally becomes the "stomach," or body, of the ancestral figure. This example is extremely rare because it retains its original basket with its relics intact. In addition to the deceased's bones and skull, baskets often contain personal valuables such as brass rings, grain, shells, coins, and jewelry.

In effect, this piece encapsulates the deep emotional and intellectual ironies of death. The initial confrontation and ultimate resolution between life and death can be read in the figure's color symbolism. Red—resulting from the application of red camwood powder—is the color of life, beauty, and prosperity. White—traced in the mouth and ears—comes from kaolin and shows the color of death and ancestral forces. As James Fernandez (1982, 573) explains, "any attempt to demonstrate the coherence of the Bwiti cosmos founders upon the paradoxes with which it plays. The chief of these is the emergence by ritual activity of life in death and death in life, or what comes to the same thing, the transformation back and forth of the linear path of birth and death in a 'saving circularity.'"

PROVENANCE: Georges Rodrigues.

54. MASK

Gabon, Vuvi, late 19th/early 20th century
Wood, paint, kaolin, height 42.5 cm (16¾ in.)
Gift of Mr. and Mrs. Max J. Pincus (81.913)

The white-faced mask form reaches the height of abstraction among the Vuvi, Tsogo, and Sango peoples, who inhabit the banks along the Offoue River. This particular mask is attributed to the Vuvi in the Koulamoutou region in the valley of the Lolo (Perrois, personal communication, 6/86). It differs, however, from most Vuvi masks, which have double inverted arcs for eyebrows (a style which also appears on the tattooed initiation emblem of the *bwiti* cult), and parallel "tear streaks" below the eyes. Nothing in this mask is so superfluous; eyes, nose, and mouth simply punctuate the broad, flat, shieldlike surface. The sharp angularity marking the eyebrows and the overall austerity gives the mask a troubled, yet elusive expression, which contrasts with the serenely arched eyebrows and heart-shaped faces seen on most Vuvi masks.

Although little information is available on Vuvi art, this kind of mask seems related to the bwiti ancestral cult and probably serves as the agent through which ancestral spirits reappear during solemn community gatherings.

Throughout the region, the color white equates with death. As among the Fang, Vuvi white masks may embody the spirits of deceased young women who have returned to participate in certain rites (Roy 1985, 98). Or, as for the neighboring Tsogo, each white mask may be a unique forest spirit with its own name, song, choreography, and meaning (Perrois 1980, 192).

In any event, according to Louis Perrois, the blackened facial features have symbolic importance. The color black represents the esoteric knowledge handed down from the ancestors, engendering a metaphysical discourse about the nature of life and the inevitability of death. As such, the form of the mask reflects the profound understanding of metaphysics attained by bwiti initiates.

PROVENANCE: Mr. and Mrs. Max J. Pincus.

REFERENCES: Detroit Institute of Arts, *Detroit Collects African Art* (Detroit, exh. cat., 1977), no. 132.
Bulletin of the Detroit Institute of Arts 60 (1982), 1/2: 10, fig. 6.
William Rubin, ed., *"Primitivism" in 20th Century Art: Affinity of the Tribal and the Modern* (New York: Museum of Modern Art, exh. cat., 1984), 364.
Mary Nooter, *Secrecy: African Art that Conceals and Reveals* (New York: Museum for African Art, exh. cat., 1993), no. 70.

LOWER CONGO AND KWANGO BASIN

The Congo River system arcs through the heart of central Africa, its drainage defining the political territories of modern Zaire and the Republic of the Congo. The mouth of the river was naturally the colonial platform for European penetration into central Africa, events that dominated the last several centuries of the region's history. Portuguese explorers at the river's mouth encountered a powerful and proud Bantu-speaking people, the Kongo, for whom the river was named. The Kongo had invaded the region from the northeast during the thirteenth century under the leadership of the war-chief Wene, who conquered the indigenous hunting people and organized a kingdom around the capital city of Mbanza Kongo. The kingdom was administrated by regional chiefs, related to the king, and by village chiefs of local clans. After Portuguese contact during the late fifteenth century, members of the court traveled to Rome for religious teaching. In 1506, King Joao I converted to Catholicism, which subsequently became a kind of royal cult. The power of the kingdom eroded over the subsequent centuries as a result of invasion, local wars, and ongoing internal dissension. By the eighteenth century, the Kongo had divided into several chiefdoms, such as the Yombe, Vili, and Woyo, recognizing only symbolic allegiance to the king.

The Yaka neighbor the Kongo to the west. Speakers of the Kongo language Kikongo, they fell victim to the invasion of the Kongo kingdom by the Jaga during the sixteenth century, part of an expansion of the Lunda peoples from Angola. The Jaga intermarried with the Yaka and settled along the Kwango River valley, a southern tributary of the lower Congo River. Since then, the Yaka have been linked to the history of the Lunda, who established a significant and influential empire based in northern Angola during the seventeenth century. The Yaka

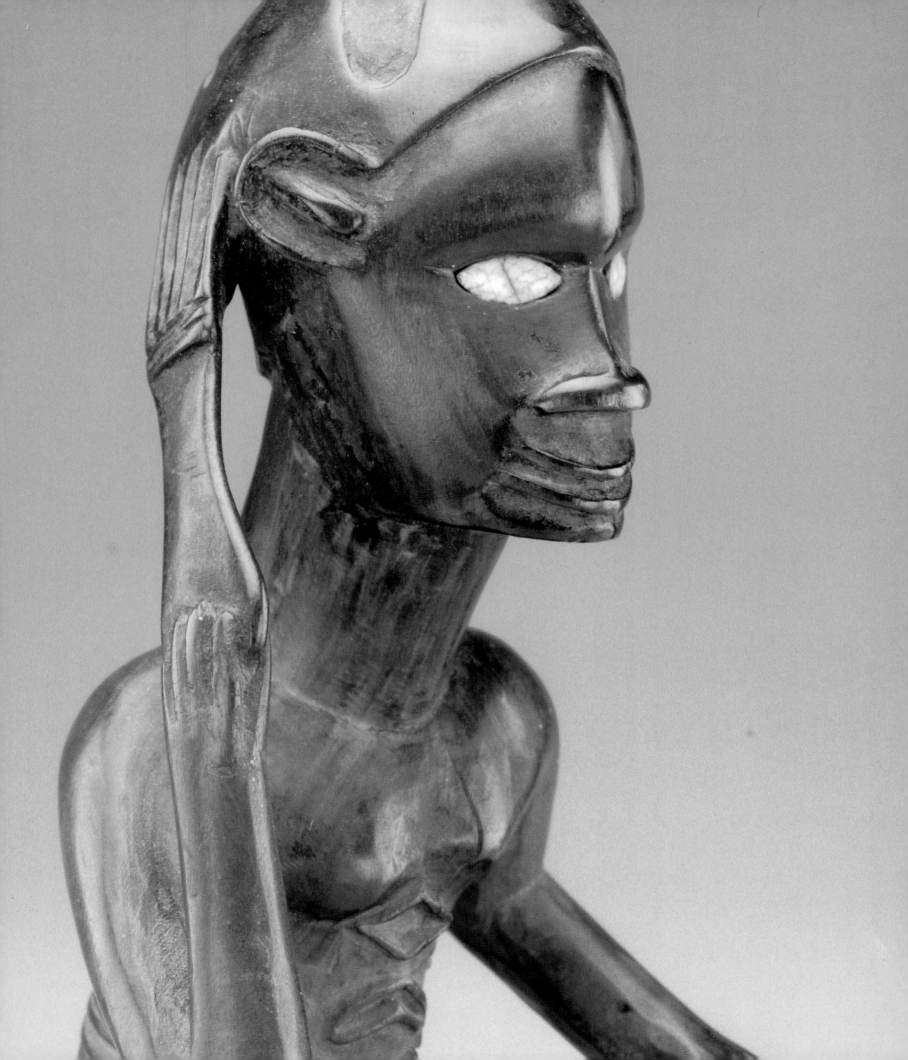

kingdom, a kind of tributary state, comprised forty-one regional chiefdoms ruled by the *kiamfu* of Lunda origin. As a result of their intermediate position between the Kongo and Lunda, Yaka culture intermixes various cultural traits, such as the protective and medicinal figures known as *nkisi* among the Kongo, which the Yaka call *biteki*, and the *mukanda* rites of initiation, which are linked to the Lunda.

55. COMMEMORATIVE FIGURE (ntadi)

Angola and Zaire, Kongo, Boma region, late
 19th century
Stone, height 52.1 cm (20½ in.)
Gift of Frederick K. Stearns (90.1s14462)

Carved from steatite, or soapstone, and painted in vivid colors, this figure belongs to a group of sculptures called *mintadi* (singular *ntadi*). It is attributed to a workshop in the Boma region of what was formerly the kingdom of Kongo, located in present-day northern Angola and adjacent parts of Zaire. Most mintadi were found between Boma, on the left bank of the lower Zaire River, and San Salvador, the ancient capital of the kingdom of Kongo. The steatite itself comes from Noki, near the town of Matadi, which means stones.

Mintadi are made to adorn the graves of important deceased members of the community. The tombs are grouped together according to clan in an enclosed burial space. Chiefs' graves are very elaborately adorned with a rich and varied assortment of articles, including imported porcelain wares, brass crucifixes, elephant tusks, guns, umbrellas, and figures in both wood and stone. Taken together, the myriad grave goods surmounting the tomb proclaim the wealth and status of the deceased.

The stone figure may represent the chief himself. During the chief's lifetime, mintadi may serve as surrogates in his absence; after his death, the figures provide a receptacle for the ruler's spirit. Certain iconographical details of the Detroit sculpture affirm that it represents a ruler. First, it wears a *mpu* cap, a woven, tight-fitting hat adorned with the claws and teeth of leopards and reserved for the eminence of chiefs. Secondly, the object on which the figure stands represents a royal chest that contains the relics and insignia of preceding rulers, including those belonging to the founder of the royal lineage. During royal investitures, the new chief uses the

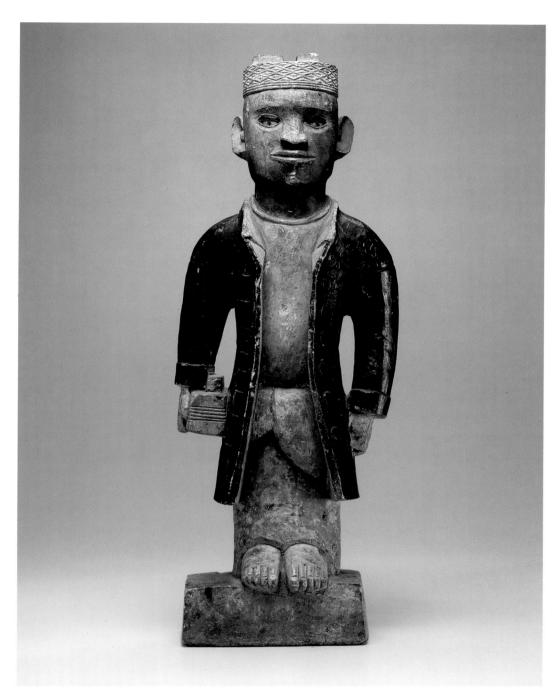

Cat. No. 55

chest as a throne to symbolize his descent from an ancient and prestigious royal line. Finally, the figure wears a European frock coat, which—although not traditional—was a status symbol for Kongo chiefs, proclaiming their worldliness and

their right to the ownership of exotic foreign goods.

Stylistically, this figure unquestionably belongs to the corpus of stone mintadi figures collected among the Kongo Boma by research associates

of the Institut des Musées Nationaux du Zaire. In its facial features, the Detroit piece also resembles a stone sculpture in the Brooklyn Museum's African collection (see Thompson and Cornet 1981, 102–103, fig. 73). Yet, Detroit's ntadi differs in certain fundamental respects. Most early mintadi were conceived in active, asymmetrical poses with an emphasis on gesture (Cornet in Vogel 1981, 205; Thompson and Cornet 1981, 99). By contrast, this piece assumes a static, stiff, frontal pose, which, combined with the incorporation of European-style clothing and the application of paint, suggests that the figure dates from the late nineteenth century.

Although the figure has not been dated scientifically, the frock coat helps to determine the relative chronology of the work. The coat's knee-length style with a high waistline was introduced in 1890 and became the hallmark of the frock coat throughout the following decade. Since Frederick Stearns purchased this piece in 1900 from a Parisian art dealer, it can be dated to the years just prior to the turn of the century. The figure's arrival in Europe only a short time after it was sculpted also explains the vivid colors, which would have worn away had the piece remained in situ for any length of time. While the nineteenth century is considered an early date for most African art made of wood, it is quite late in the historical sequence of mintadi. Two examples can be traced to the seventeenth century (Thompson 1974, 234). This ntadi, therefore, represents a late nineteenth-century style, and may have been a response to the colonial presence and changing political structures at the turn of the century.

PROVENANCE: Emile Heymann, Paris. Frederick Stearns, Detroit, 1900.

REFERENCES: Detroit Institute of Arts, *Detroit Collects African Art* (Detroit, exh. cat., 1977), no. 138.

56. KNIFE CASE

Zaire, Kongo-Portuguese, late 16th/17th century
Ivory, height 32.4 cm (12¾ in.)
 diameter at base 11.1 cm (4⅜ in.)
City of Detroit Purchase (25.183)

The delicacy and detail in this knife case demonstrate the abilities of a confident, skilled craftsman. The elongated, vertical container is supported by four truncated caryatids, who bear the weight in solemn homage. At the top, in high relief, are four men dressed in European fashion, two holding daggers across their chests alternating with two whose hands are clasped in prayer. The remaining pale blond ivory surface is covered with a highly ornamental, interlaced pattern.

The patterns unquestionably issue from the decorative repertoire of the Kongo people inhabiting the Congo River Delta. The plaited, guilloche design originates with basketry motifs and can be found in all Kongo art forms ranging from raffia pile cloths, mats, and knitted caps to carvings in ivory and wood. The design also exists as a prominent Kongo body scarification pattern, as can be seen on the backs of a series of wooden maternity figures in museum collections and in recent photographs of young Kongo women. A tradition pre-dating European intervention (1482), the use of the pattern prevails to this day (Fagg and Bassani, personal communication, 3/86).

Based on the unusual shape of the container's cavity, this object was described in a 1902 sales catalogue as a "knife-case." If true, then it must have been created for export; there is no evidence of this artifact type in a traditional Kongo context (Bassani and Fagg 1988). The combination of traditional African style and essentially European form characterizes a rare hybrid known as "Afro-Portuguese" ivories. When Portuguese sailors arrived on the African coast in the fifteenth and sixteenth centuries for trading

purposes, they recognized the great mastery among African ivory carvers. Providing models for local artists, the Portuguese began to commission fine works that they would present as exotic gifts to nobility and royalty upon return to Europe.

The first art historical treatment of these works was published in 1959 by William Fagg. Three principal carving centers along Africa's Atlantic coast have since been identified: Sierra Leone (Sapi-Portuguese), the Benin Kingdom in Nigeria (Bini-Portuguese), and the mouth of the Congo River (Kongo-Portuguese). While those from Sierra Leone and Nigeria are numerous and varied (spoons, forks, oliphants or hunting horns, saltcellars, dagger handles, and pyxides), those of the Congo are limited to six oliphants and this knife case.

The European figures carved on the knife case do not themselves constitute a foreign commission. The Kongo had considerable contact with Europe after 1482 and frequently incorporated outside elements, such as clothing, the Christian crucifix, books, and gin bottles, into their traditional arts. It is, rather, the ingenuity—the synthesis of African and European styles—and the exact correspondence to the taste of sixteenth-century European nobility that suggests the piece's destination: a "cabinet de curiosités" or a parlor of the European Renaissance.

PROVENANCE: Guidi, Rome Galleria. Canessa, Naples.

REFERENCES: Rome, San Giorgi's, *Guidi Sale* (sales cat., April 21–27, 1902), no. 10.
William Fagg and Margaret Plass, *African Sculpture: An Anthology*, (London: Studio Vista, 1964), 118.
Detroit Institute of Arts, *Spirits and Ancestors: The Sculpture of Black Africa*, Young People's Series 1 (1970), 11.
Werner Gillon, *A Short History of African Art* (Middlesex: Viking, 1984), 273.
Ezio Bassani and William B. Fagg, *Africa and the Renaissance: Art in Ivory* (New York: Center for African Art, exh. cat., 1988), no. 271.

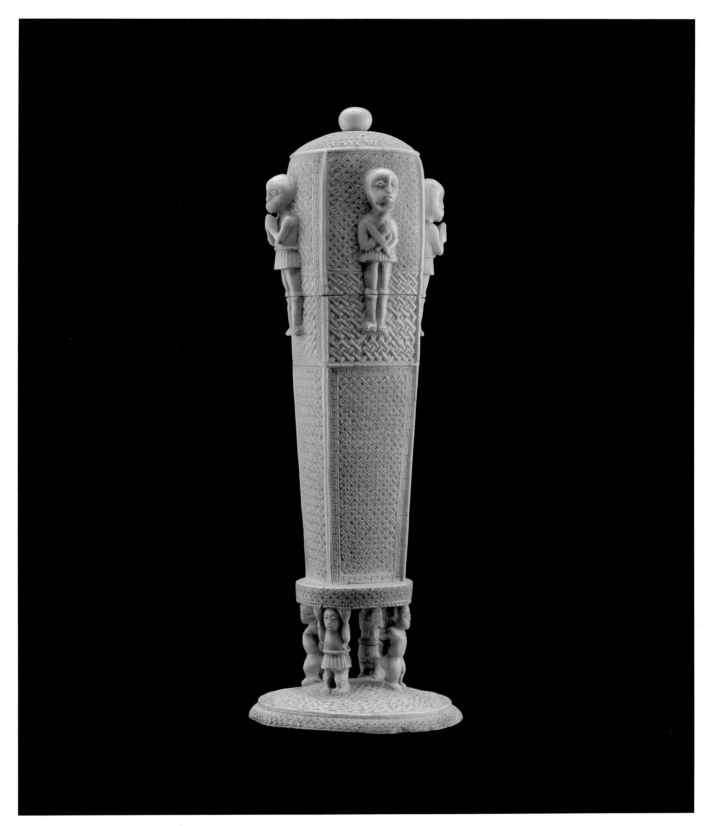

Cat. No. 56

57. SEATED MALE FIGURE

Zaire, Kongo, 19th/20th century
Wood, 17.8 × 7.6 × 5.7 cm (7 × 3 × 2¼ in.)
Bequest of Robert H. Tannahill (70.28)

A notable feature of Kongo art is a kind of naturalism that departs from the usual symmetry of African sculpture and serves to individualize each image. This small figure, with its asymmetrical pose and animated expression, is both a typical example of Kongo sculpture and a singular interpretation within the genre—typical in its posture, but unique in its own special bearing.

The depiction of an embroidered cap, a sign of high social rank, identifies this figure as a chief (Duponcheel 1980, 6). Enlivening the image are the erectly held head and open mouth, and the eyes that probably once sparkled with inlaid fragments of glass or porcelain, which are now lost (Cornet 1971, 32, 34). The cross-legged position is characteristic of chiefly figures as well as of maternity figures called *phemba,* which are posed in the same manner but have a child across their knees.

The precise use of these figures is not well understood, but it is generally agreed that they were associated with ancestral cults (Cornet 1971, 34). Even after the kingdoms of the area had fragmented into many tribal units, the concepts of royal ceremony persisted at the level of clan chiefs (Delange 1974, 185). Commemorative statuary portraying both chiefs and maternal figures symbolized perpetuation of the lineage and housed ancestral spirits who were consulted on special occasions (Bastin 1984, 276). The sculptures' naturalism was a way of idealizing the ancestors in order that the descendants would continue to honor them and summon their assistance (Cornet 1971, 34).

At the back of the open mouth of the Detroit piece is a hole, which may have been intended to allow the addition of substances that could

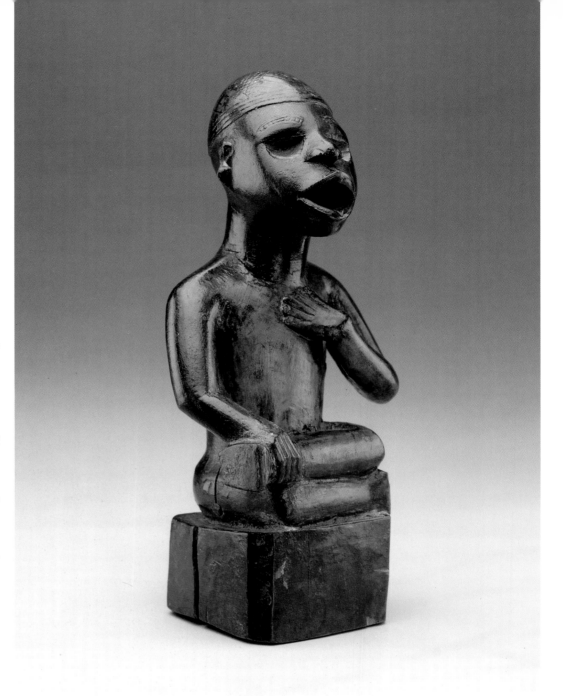

Cat. No. 57

change the way in which the figure would be used. In the hands of a medicine man or *n'ganga,* who would insert the effective ingredients, the figure could be empowered to serve as a protective or healing device.

PROVENANCE: Robert H. Tannahill, Grosse Pointe Farms, Michigan.

REFERENCES: Detroit Institute of Arts, *Detroit Collects African Art* (Detroit, exh. cat., 1977), no. 142.

58. NKISI N'KONDI

Zaire, Yombe, 19th century
Wood, metal, shells, height 116.8 cm (46 in.)
Founders Society Purchase, Eleanor Clay Ford Fund for African Art (76.79)

This massive figure with its aggressive stance and blade-stippled surface belongs to a class of objects called *minkisi n'kondi* (singular *nkisi n'kondi*), endowed with healing power. Minkisi

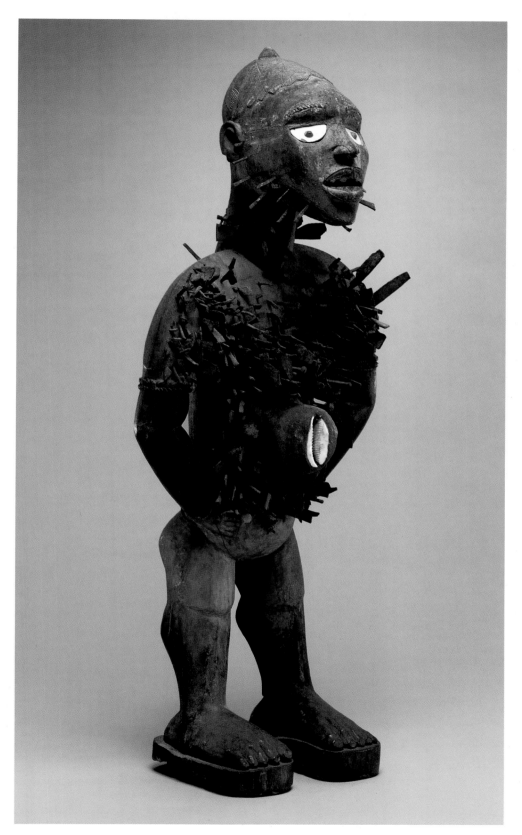

Cat. No. 58

n'kondi are multi-functional, serving as representations of a chief, doctor, priest, and judge all at one time. Kept under the care of a *n'ganga,* a "master of ceremony," these powerful figures protect the community through their ability to hunt down criminals, witches, and other malefactors who attempt to undermine societal structure. Oaths are sworn, trials are held, and pacts are sealed before this figure. All agreements or vows are rendered permanent and binding by the hammering of nails and blades into the figure's surface. The predominance of blades over nails in this figure indicates its use primarily in civil matters (Thompson 1978, 215).

Every iconographical detail of this figure has spiritual significance. The finely patterned chief's cap symbolizes ancient, esoteric wisdom, while the small knob at the top marks the "navel of the head" that allows the passage of supernatural secrets to the chief. The pierced ears act as antennae for the figure's receptivity to all problems, while the open mouth may relate to the ritual licking of the iron blades by the n'ganga before insertion. Although missing now, this figure originally had a large beard of resin, clay, and fiber, as well as a straw skirt—both of which traditionally were worn by ritual specialists. The hands-on-hips gesture means awareness and alertness, and double bracelets on the figure's arms certify its ability both to give and to take life. Finally and most importantly, the swelling over the navel capped with an enormous white cowrie shell covers the carefully combined medicines that lend the figure its overwhelming power (Thompson 1978, 214–216).

Collected by the missionary E. Visser in 1903, this work is attributed to a late nineteenth-century master sculptor working in the Shiloango River area. According to Ezio Bassani (1977, 38), it belongs to a workshop that produced twelve large figures, all characterized by the resinous beard, a large cowrie over the abdomen, and certain anatomical anomalies, including the sharp edges of the shoulders. This corpus

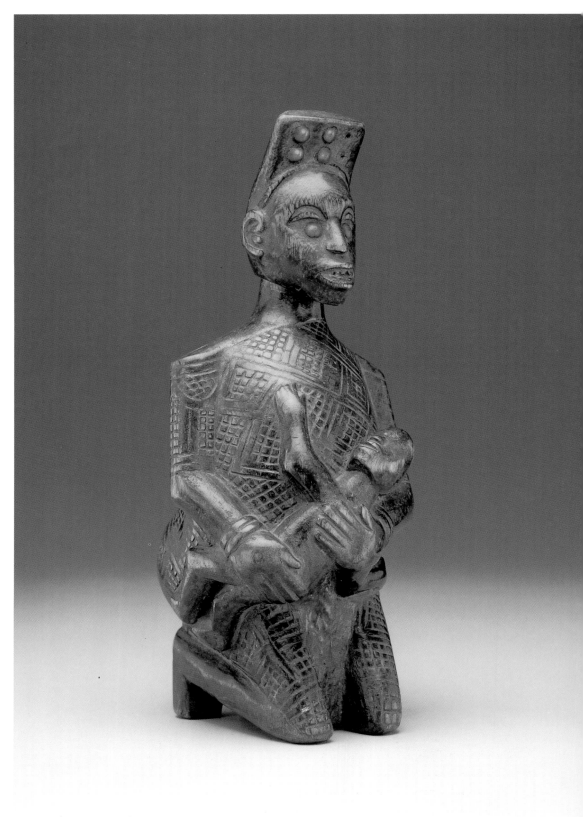

Cat. No. 59

of works is more precisely carved than most minkisi, with articulated body parts and sensitive faces. Nevertheless, all minkisi are cumulative art works created as much by the users as by the sculptor. The insertion of the bristling blades and potent medicinal substances increased the figure's impact.

PROVENANCE: Museum für Völkerkunde, Leipzig. Walter Randel, New York.

REFERENCES: Detroit Institute of Arts, *Detroit Collects African Art* (Detroit, exh. cat., 1977), no. 136.
Robert Farris Thompson, "The Grand Detroit *N'kondi*," *Bulletin of the Detroit Institute of Arts* 56 (1978), 4: 207–221.
Robert Plant Armstrong, *The Powers of Presence: Consciousness, Myth, and Affecting Presence* (Philadelphia: University of Pennsylvania Press, 1981), fig. 2.
Robert Farris Thompson and Joseph Cornet, *The Four Moments of the Sun: Kongo Art in Two Worlds* (Washington, D.C.: National Gallery of Art, exh. cat. 1981), cat. no. 80.
William Rubin, ed., *"Primitivism" in 20th Century Art: Affinity of the Tribal and the Modern* (New York: Museum of Modern Art, exh. cat. 1984), vol. 1, frontispiece.
Robert Ferris Thompson, "Kongo Power Figure," in *Perspectives: Angles on African Art,* ed. Michael J. Weber (New York: Center for African Art, exh. cat., 1987), 180–181.

59. VESSEL IN THE FORM OF A MOTHER AND CHILD

Zaire, Yombe, 19th/20th century

Wood, metal tacks, 23.2 × 9.8 × 9.5 cm (9⅛ × 3⅞ × 3¾ in.)

Bequest of Robert H. Tannahill (70.129)

This type of sculpture, called *phemba* by the Yombe, a sub-group of Kikongo speakers, upholds the Yombe aesthetic ideal of feminine beauty and productivity: a kneeling female figure cradles a small child who clings to her with tiny, uncertain hands. The depiction of motherhood illustrates the importance ascribed to fecundity and childbirth. The Detroit piece is in the form of a receptacle, with the mother's head functioning as the stopper for the vessel.

The surface of the woman's body is replete with scarifications in the form of cross-hatched lozenges. The figure's elegant adornments—raised coiffure, scarification, and filed teeth—are signs of her elevated position in society and her firm identification with Yombe culture. Finally, her calm, composed attitude reflects a high state of moral goodness and perfection.

Raoul Lehuard (personal communication, 1986) points out that Yombe human representations rarely are covered so completely with scarifications. This, combined with the fact that the scarifications are incised rather than raised, suggests that this sculpture was carved later in the nineteenth century. It is impossible to pinpoint precisely from which Yombe region the sculpture originates, however, since the geographic location of its workshop was never documented.

This style of receptacle has been described in the literature as a flask for gunpowder (Schmalenbach 1954, 96). Yet, all known Yombe powder flasks have a suspension system for portability. This one does not and, therefore, it seems unlikely that this particular vessel was ever used for such a purpose.

PROVENANCE: Robert H. Tannahill, Grosse Pointe Farms, Michigan.

REFERENCES: Detroit Institute of Arts, *Detroit Collects African Art* (Detroit, exh. cat., 1977), no. 143.

60. WHISTLE

Zaire, Yombe, 19th century
Wood, height 15.9 cm (6¼ in.)
Bequest of Robert H. Tannahill (70.14)

WHISTLE

Zaire, Yombe, 19th century
Wood, antelope horn, height 16.2 cm (6⅜ in.)
Founders Society Purchase, Eleanor Clay Ford
 Fund for African Art (79.151)

WHISTLE

Zaire, Yombe, 19th century
Wood, antelope horn, height 19.7 cm (7¾ in.)
Founders Society Purchase, Eleanor Clay Ford
 Fund for African Art (79.152)

WHISTLE

Zaire, Yombe, 19th century
Wood, antelope horn, height 14.6 cm (5¾ in.)
Founders Society Purchase, Eleanor Clay Ford
 Fund for African Art (79.153)

WHISTLE

Zaire, Yombe, 19th century
Wood, antelope horn, height 19.1 cm (7½ in.)
Founders Society Purchase, Eleanor Clay Ford
 Fund for African Art (79.154)

WHISTLE

Zaire, Yombe, 19th century
Wood, antelope horn, height 16.5 cm (6½ in.)
Founders Society Purchase, Eleanor Clay Ford
 Fund for African Art (79.155)

WHISTLE

Zaire, Yombe, 19th century
Wood, antelope horn, height 15.2 cm (6 in.)
Founders Society Purchase, Eleanor Clay Ford
 Fund for African Art (79.156)

WHISTLE

Zaire, Yombe, 19th century
Wood, antelope horn, height 19.1 cm (7½ in.)
Founders Society Purchase, Eleanor Clay Ford
 Fund for African Art (79.157)

WHISTLE

Zaire, Yombe, 19th century
Wood, antelope horn, height 18.4 cm (7½ in.)
Founders Society Purchase, Eleanor Clay Ford
 Fund for African Art (79.158)

WHISTLE

Zaire, Yombe, 19th century
Wood, antelope horn, height 14.6 cm (5¾ in.)
Founders Society Purchase, Eleanor Clay Ford
 Fund for African Art (79.159)

WHISTLE

Zaire, Yombe, 19th century
Wood, antelope horn, height 20 cm (7⅞ in.)
Founders Society Purchase, Eleanor Clay Ford
 Fund for African Art (79.160)

WHISTLE

Zaire, Yombe, 19th century
Wood, antelope horn, height 20.3 cm (8 in.)
Founders Society Purchase, Eleanor Clay Ford
 Fund for African Art (79.161)

WHISTLE

Zaire, Yombe, 19th century
Wood, antelope horn, height 17.8 cm (7 in.)
Founders Society Purchase, Robert H. Tannahill
 Foundation Fund (81.715)

Whistles in the form of small antelope horns surmounted by exquisitely carved sculptures serve as ritual instruments of a category known as *nkisi*. They are made and used by many ethnic groups in the Lower Zaire region, including the Bwende, Sundi, Kongo, and Woyo, as well as by peoples of the Loango, Cabinda, and Yombe regions. Among all of these groups, such instruments serve as signal whistles in the hunt and as spirit intermediaries for diviners or *banganga*. The connection between hunting and healing is symbolic; just as a hunter stalks his prey, so does a diviner track down criminals, sorcerers, and other sources of illness, death, and suffering. Only those men who have learned the esoteric knowledge of nkisi, among them banganga and village chiefs, are authorized to use whistles.

In structure, the antelope horn fits into a cavity in the base of the sculpture. To join the two parts, a string passes from a hole in the top of the sculpture through its hollow interior to another hole carved in the narrow tip of the horn. Many whistles in museum and private collections lack their horns, including acc. no. 70.14 in Detroit, which has led to the misidentification of these sculptures as bottle stoppers. Yet, the two parts are inextricably bound, both functionally and symbolically. In many parts of the world, antelope horns are thought to contain high levels of life force and frequently are used for healing and other medicinal purposes.

The sculptures adorning these whistles display remarkable diversity in subject matter. Three are anthropomorphic: acc. no. 79.154 represents a person of eminence and means, for he wears a cap associated with nobility and wields a staff of authority and prestige; acc. no. 70.14 shows a horse and rider, and acc. no. 81.715 depicts a masklike human face surmounted by a fisted hand clutching an implement. This same gesture, suggesting aggression, is seen on Kongo power figures. In many African cultures, the head and hand are considered to be the loci of physical and spiritual strength.

Among the animal figures, monkeys and birds predominate. Both are symbols and charms for hunting, and both are called "children of nkisi." Birds have the capacity to detect sorcerers and to confound them. Birds with their heads turned backwards can prevent the rain and assure success in the hunt by charming an antelope and directing him toward the hunter (Söderberg 1974, 41).

Some of the most lyrical forms are the non-figurative, geometric whistles with their richly textured surface patterns and stately silhouettes. Sometimes an artist imitated the natural ribbing of the horn to lend a sense of unity to the two parts. Non-figurative whistles reportedly form

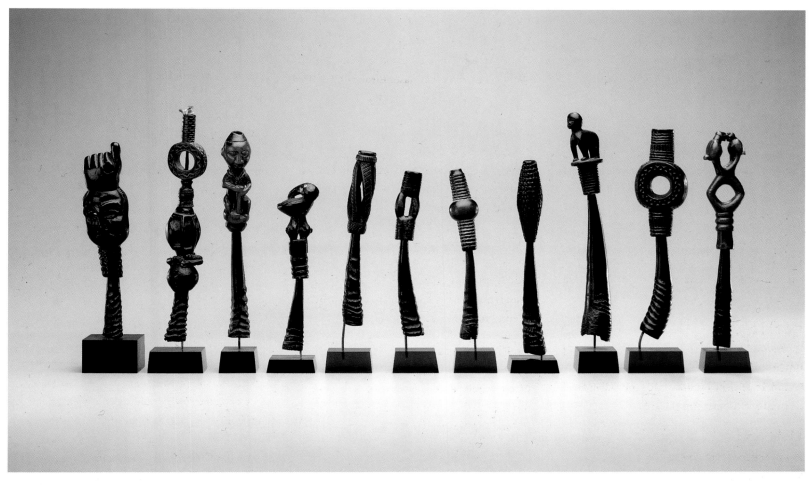

Cat. No. 60 (From left to right: acc. nos. 81.715, 79.161, 79.154, 79.153, 79.151, 79.159, 79.156, 79.155, 79.152, 79.158, 79.157. Lower right: acc. no. 70.14. Not pictured: acc. no. 79.160.)

part of the equipment of a healer or *mpongi*, whose purpose is to bring luck and to stalk criminals (Söderberg 1974, 42).

PROVENANCE: Robert H. Tannahill, Grosse Pointe Farms, Michigan (70.14). P. Ratton, Paris. S. Chauvet, Paris. Ben Brillo, New York (79.151–79.161). Linda Einfeld, Chicago (81.715).

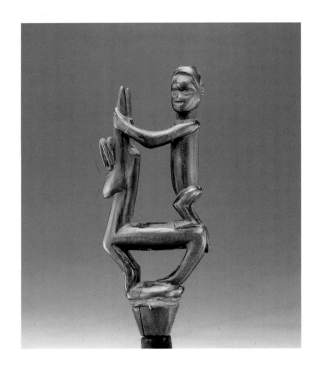

61. ANCESTOR FIGURE

Congo Brazzaville, Bembe-Ladi, 19th/20th
 century

Wood, shells, height 16.8 cm (6⅝ in.)

Bequest of Robert H. Tannahill (70.17)

A miniature masterpiece, this figure sits on his
haunches, poised and alert like a leopard ready
to spring. Inlaid shells set his eyes aglow, igniting
them with vision beyond the ordinarily visible.
Scarifications energize the elongated torso as the
center of gravity and wellspring of life. A fly-
whisk, which would have been made from
buffalo tail and reserved for the eminence of
chiefs and judges, extends from the right hand
and echoes the form of the right arm. This ob-
ject naturally links hand and head; the flywhisk's
ultimate purpose is to extend its user's reach
physically and metaphorically.

The single most important feature of the De-
troit figure is a plugged hole just inside its rec-
tum containing medicinal substances. This hole
designates the figure as a *mukuya,* related to the
Kongo *nkisi,* an ancestral representative sancti-
fied by a diviner, or *n'ganga.* During an initiation
rite, a diviner captures the spirit of an important
ancestor and seals it inside the sculpture with a
binding resin that plugs the hole. The diviner
then incorporates the spirit into the figure and
the piece becomes a protective source for its fam-
ily. Kept in a bag or a basket, the statue is said to
evoke premonitions in its owner's heart if that
person should ever be menaced by danger (La-
man quoted in Söderberg 1975, 36).

The Detroit figure is attributed to an im-
portant Bembe substyle called "Bembe-Ladi."
The Bembe and the Ladi inhabit the Mouyondzi-
Sibiti districts of Brazzaville (Söderberg, personal
communication, 7/86). Contact between these
two peoples began in pre-colonial times when
some Bembe fled their own country to escape
turbulent intervillage warfare. They found sanc-
tuary to the west amidst the Ladi. Many Ladi

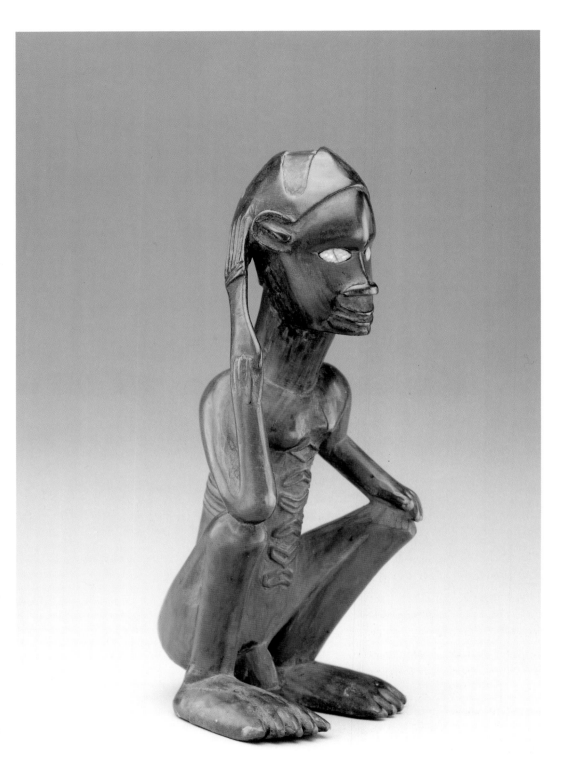

Cat. No. 61

since have transplanted themselves to the original Bembe homeland. A small corpus of fine old figures documents this cultural refugee exchange.

PROVENANCE: Robert H. Tannahill, Grosse Pointe Farms, Michigan.

REFERENCES: Detroit Institute of Arts, *Detroit Collects African Art* (Detroit, exh. cat., 1977), no. 148. African-American Institute, *Masterpieces of the People's Republic of the Congo* (New York, exh. cat., 1981), no. 39.

62. FIGURE

Zaire, Hungana, 19th century
Wood, height 18.4 cm (7¼ in.)
Founders Society Purchase, Eleanor Clay Ford Fund for African Art (77.57)

Some of the most striking interpretations of the human form come from south-central Zaire. This example is attributed to the Hungana, a small group inhabiting a cluster of villages along the west bank of the Kwilu River. The Hungana are renowned for their ironwork technology (*hunga* means "to forge") and taught the techniques to many neighboring groups, including the Pende, Tsong, Ngongo, Mbuun, and Mbala, with whom the Hungana are closely related culturally and artistically (Biebuyck 1985, 153).

In this work of art, the artist has created an interplay between the forms of the head and arms. A dynamic relationship exists between the crested headdress rising in three parallel lobes and the arms, which curve upward to meet the chin. The figure's hairstyle reproduces a traditional Hungana coiffure in which three long plaits of hair extend from the forehead down the back (Roy 1985, 139).

Very little is known about Hungana wooden sculptures; none has been documented in terms of function and context. Based on the close connection between these figures and certain figures of the neighboring Yaka and Suku peoples—par-

ticularly the configuration of hands-to-chin posture—one may extrapolate that Hungana figures serve in a healing and/or protective capacity.

According to Daniel Biebuyck (1985, 155), Hungana ritual experts can be male or female, and usually excel in a particular aspect of divining, healing, or protecting. The most common rituals are intended to assure success in the hunt, warfare, fertility, the accumulation of wealth, and the preservation of the people's allegiance to the village; or to fight against illness, sorcery, and crime. Wooden anthropomorphic figures are among the more important objects used by ritual experts. Some figures are said to embody the souls of departed ancestors, and it is their vital energy that assures the object's efficacy.

PROVENANCE: Morton Lipkin, New Jersey.

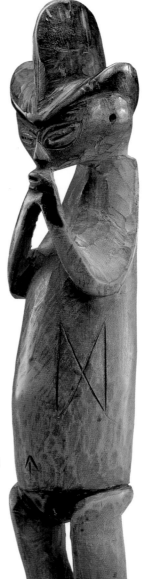

Cat. No. 62

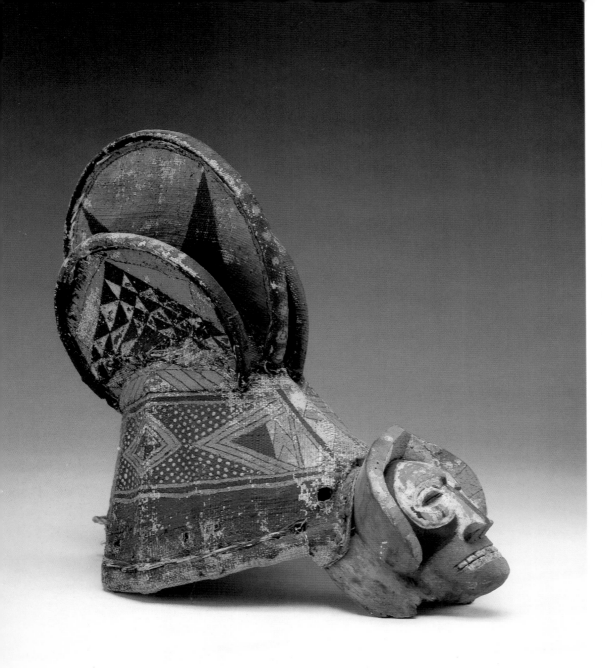

Cat. No. 63

63. INITIATION MASK

Zaire, Yaka, 1850/1900
Wood, paint, raffia, height 26.7 cm (10½ in.)
Gift of Dr. Nathan Barrett (76.99)

The most important event in the Yaka ceremonial cycle is the initiation of young boys into adulthood. During adolescence, boys enter a school isolated in the forest where they undergo the instruction necessary to prepare them as decisive leaders and circumcision, which tests their

courage and permanently distinguishes them from the uninitiated. During this training period, the boys speak a ritual tongue, obey dietary and behavioral taboos, learn the arts of oratory, song, and dance, and gain experience in legal and administrative skills.

To mark the end of the educational period, festivities are held in which the initiates perform with newly carved masks on a tour throughout the region. The tour celebrates the new status of the youths. Additionally, it showcases the most startling masks and the most spectacular dances (Biebuyck 1985, 179). At the closing of the ceremonies, both the masks and the forest initiation compound are burned. The young men then re-turn home for re-integration into the community as full citizens (Bourgeois 1984, 119–121).

This mask has been identified as one of the eight masks used in a series during a coming-out ceremony for new initiates (Bourgeois 1985, 13–19). Judging by the coiffure, this mask most likely belonged to the *myonda* or *ndeemba* pairs that rank somewhere in the middle of the series. Some of the masks portray erotic and domestic activity and serve to satirize sexual roles and deviant or anti-social behavior. In its original condition, the Detroit mask would have included a raffia-leaf ruff around the collar and a vertical wooden handle at the base of the chin. It would have been worn or carried by a newly initiated boy.

According to Arthur Bourgeois (personal communication, 4/86), the Detroit mask relates to five others, two in the collection of the Institut des Musées Nationaux, Kinshasa, known to derive from Popokabaka Zone, Lufuna Sector, an area directly west of Popokabaka but closer to the banks of the Lubisi River.

"The grinning near-skull-like aspect given to the mouth, together with eye treatment, facial proportions, and visor" in particular tie the Detroit piece to the others, however, the point given to the visor is unique. This example appears to be older than the others, Bourgeois

states, "in that the coiffure construction is made of raffia cloth rather than cotton. In later examples, the mouth is slightly open, and the carving less petite. The painted designs on the coiffure are more spectacular than usual, although triangles, chevrons, and dots are common."

PROVENANCE: Dr. Nathan Barrett.

REFERENCES: Detroit Institute of Arts, *Detroit Collects African Art* (Detroit, exh. cat., 1977), no. 78.

64. FIGURE

Zaire, Yaka, 1850/1950
Wood, brass, 34.3 × 10.2 cm (13½ × 4 in.)
Founders Society Purchase, Eleanor Clay Ford
Fund for African Art (79.17)

Among the Yaka, wooden figures of this type are called *yiteki* and serve as receptacles for powerful medicinal substances. They contain and control evil influences of a hereditary nature, protect property, and inflict injury upon witches or other malefactors.

The most striking feature of this figure is its prominent, upturned nose, which is very characteristic of Yaka art. The nose refers both to the elephant, which is the most powerful animal of the bush, and male sexuality (Bourgeois 1984, 170). This attribute, combined with the geometric rendering of the face and body, demonstrates the ingenuity with which African artists reinterpret and reinvent the human form.

There are three specialized subtypes of yiteki (Bourgeois 1984, 107–110), but their identification is tied to function, not appearance. Based on form alone, it is impossible to ascribe the Detroit figure to any one of these types. Figures resembling each other were known to fulfill entirely different functions, while figures divergent in appearance could possess a similar kind of power. In all likelihood, this figure once incorporated medicinal compounds around the torso or suspended in packets from the neck, arms, or

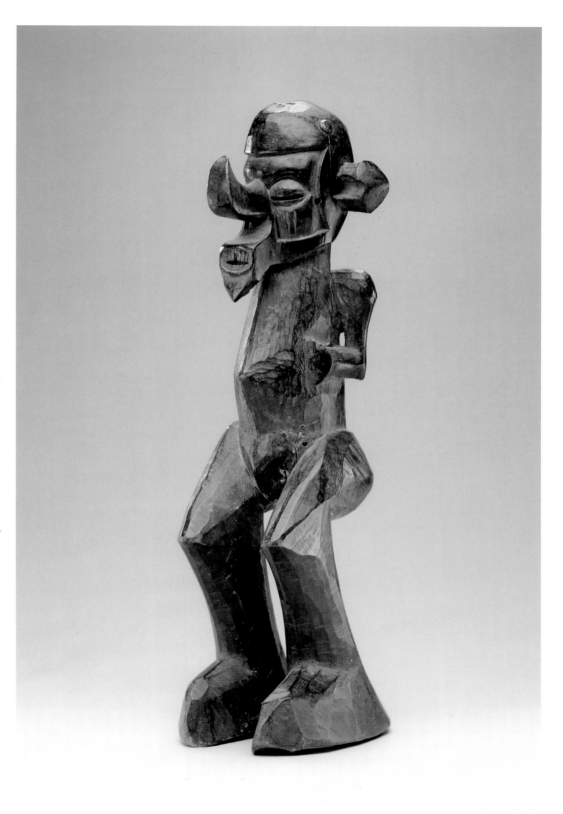

Cat. No. 64

waist. The Yaka would deem a figure that lacked these vital substances as utterly devalued.

Stylistically, Yaka figures mirror the complex, overlapping political, social, and ritual characteristics of the region of the Kwango/Kwilu divide of southeastern Zaire, the "frontier" between Kikongo speakers and Lunda-related peoples to the east. Certain features of this piece—the forward curve of the relief line surrounding the upper face and the massive ears—suggest that it may have been produced among the western extensions of the Yaka and may even be eastern Kongo in origin.

PROVENANCE: Alan Brandt, New York.

65. HEADREST

Zaire, Yaka, 1850/1950
Wood, brass studs, copper, brass wire, 17.5 × 24.1 cm (6⅞ × 9½ in.)
Founders Society Purchase, Eleanor Clay Ford Fund for African Art (78.76)

This headrest, supported by an animal form, exemplifies Yaka artistic genius. The artist deftly counterbalances the arc of the headrest with the convex back of the animal. Additions of coiled wire and gleaming metal studs animate the image, as do the angular legs. The juxtaposition of organic and geometric forms creates a dynamic balance attesting to the artist's considerable sculptural sensibility.

Throughout central and east Africa, headrests have great personal importance. They comfortably support the head just below the ear of a person lying on his or her side and help protect elaborate coiffures. Yaka headrests serve more than utilitarian purposes; they are also known to assist with dream interpretation. Such ritual usage is confirmed by the incorporation of medicinal substances, either suspended from or placed within the headrest's hidden cavities (Bourgeois 1984, 70). Called *musaw* or *musawu* by the Yaka,

headrests and their use today are rare (Bourgeois, personal communication, 4/86).

The caryatid supporting this headrest most closely resembles a pangolin, also called a scaly anteater, an animal of special importance in African life. The pangolin is one of the only animals that the leopard cannot kill. The pangolin's reptilian scales, like the defensive shell of the turtle, repel even the most savage attack. For this reason, pangolin scales are widely used as a charm against evil. The incorporation of a pangolin in the headrest provides the object's owner with a source of protection.

PROVENANCE: George Ortiz. Frederic Rolin, Brussels.

REFERENCES: New York, Sotheby Parke-Bernet, *George Ortiz Collection* (sales cat., June 29, 1978), lot 51.

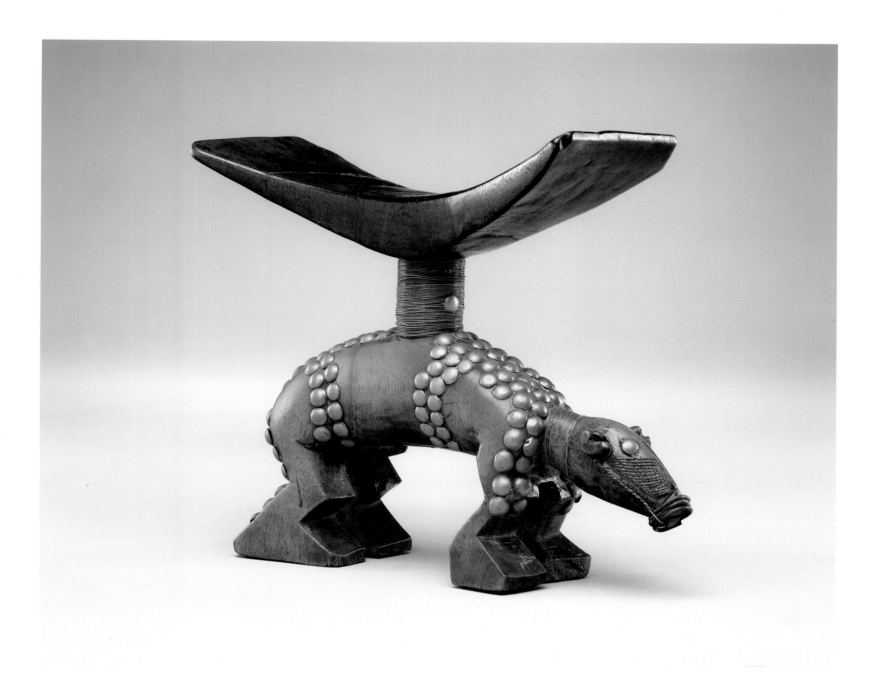

Cat. No. 65

EASTERN CONGO BASIN

Opposite: Cat. No. 73, *Mask*, detail

South of the wide forest belt contained within the sickle-shaped mainstream of the Congo river, the dense, tropical forests open out to savannah country. Southern tributaries of the Congo River—the Kwango, Kasai, Lulua, and Lualaba Rivers principle among them—cut through the area, creating a series of broad, forested valleys separated by rich grasslands. These forested valleys were settled gradually after A.D. 1000 by migrant Bantu agriculturalists, who displaced and merged with indigenous populations of Pygmy hunters. The Bantu speakers brought with them their customary social organization of village chiefs, which lay the groundwork for the rise of powerful, lineage-based kingdoms after the fifteenth century. Eastern Congo Basin kingdoms expanded their authority from a centralized court by means of a pyramidal structure of subordinate kings, regional governors, and village chiefs. While exercising considerable power at the center, authority diffused rapidly in proportion to the distance from the court. As a result, the borders of kingdoms historically were indefinite and changeable as conquest, political maneuvering, and revolt reshuffled the balance of power at any particular moment.

Luba oral tradition recounts the arrival of a culture hero named Mbidi Kiluwe to the Katanga region between the Kasai and Lualaba Rivers of southeastern Zaire at a date of about 1600. He and his son Kalala Ilunga are credited with establishing the Luba kingdom, which grew to dominate much of southeastern Zaire over the following three centuries. The Luba state incorporated kingdoms that paid tribute to and otherwise supported its court, but were administrated more-or-less independently. Centralized power lay in the aura and ideology of sacred kingship rituals and the court's ability to influence marriage and succession among tributary rulers.

A portion of the territory of the Hemba, located to the

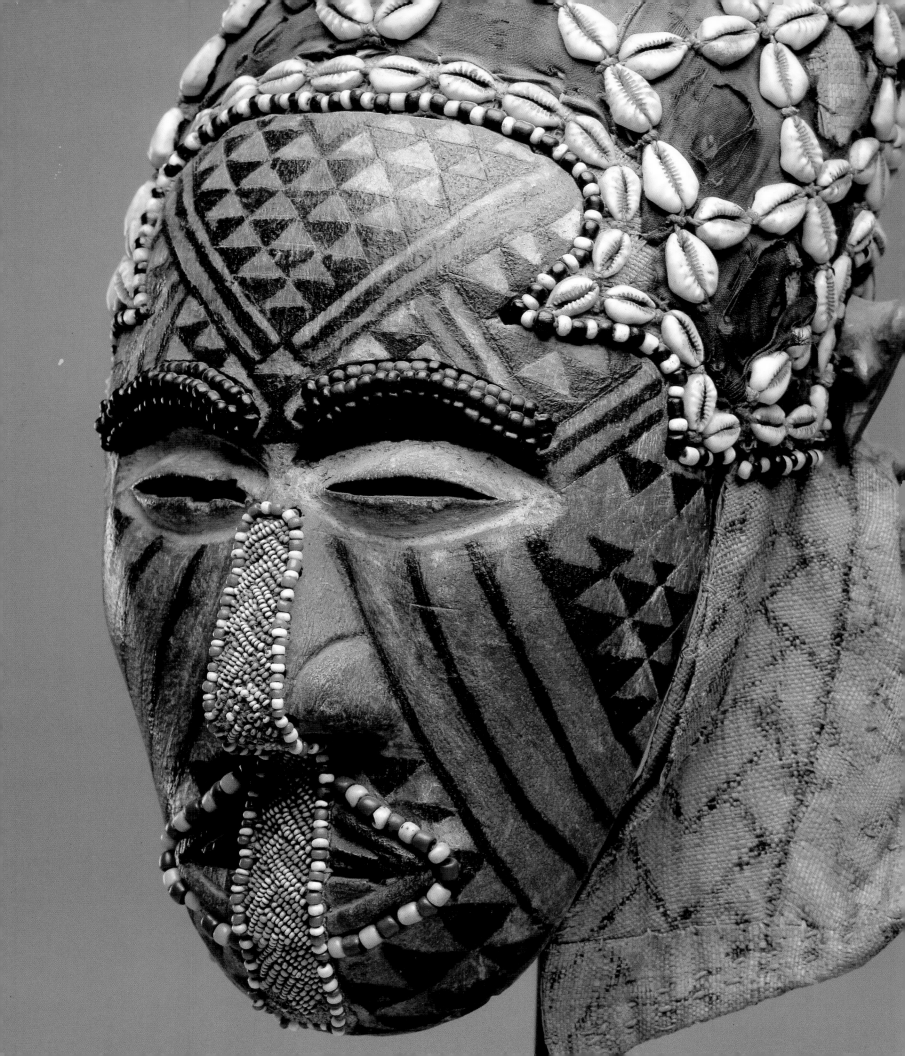

northeast, was brought into the Luba state briefly, but by and large Hemba chiefdoms remained satellites on the fringes of Luba power. The Songye, to the west, were long-time rivals of the Luba and never incorporated into the latter's political sphere, although both groups trace their origins of kingship to the same Luba culture hero. The people known as Bena Lulua were once Luba (Luba-Kasai), who migrated west to the Kasai River during the seventeenth century and only began to assert an independent ethnic identity late in the nineteenth century.

Cibunda Ilunga, a son of the Luba king Kalala Ilunga, left the Luba court during the seventeenth century and traveled to the Angolan plateau south of Zaire to establish among the resident Lunda the principles of Luba kingship. He married the female head of a local matrilineal clan and subordinated the other Lunda chiefs in the characteristic central African pattern. Mwata Yanvo, Cibunda's son and successor, expanded the Lunda empire during the eighteenth and nineteenth centuries, bringing under his rule many of the peoples of the southern Zaire and Angola frontier.

The Chokwe of this region, for example, paid tribute to the Lunda until, at midnineteenth century, they revolted and occupied the Lunda capital city. The Chokwe celebrated Cibunda Ilunga as a kind of culture hero; Chokwe chiefs commissioned sculptural images of themselves in the idealized guise of the heroic founder of the Lunda empire. The Pende had been pushed north out of Angola as part of Lunda expansion and in the process adopted a number of Lunda cultural traits, including the initiation practices of *mukanda,* which were similarly embraced by the neighboring Yaka and Suku. Although the Lunda produced no sculpture of their own, their empire had a profound effect on the art-producing cultures within the Lunda orbit of influence.

In about 1600, the people known today as Kuba settled among the Pygmy inhabitants found in the vicinity of the confluence of the Kasai and the Sankuru Rivers. The Bushoong subgroup of the Kuba established a system of centralized rulership, borrowing traits from neighboring kingdoms, including Lunda rites of initiation. They slowly consolidated power over what became the Kuba confederacy. The Bushoong myth of origin is represented in masquerades by the characters *Mwaash a mbooy,* the primordial king; *Ngaady a mwaash,* his sister and queen; and *Mboom,* the mystic, resident of the Kuba land of Pygmy ancestry.

66. STANDING FEMALE FIGURE

Angola, Chokwe, mid-19th century
Wood, height 41.9 cm (16½ in.)
Gift of Frederick Stearns, 1901 (68.191)

At the nineteenth-century Chokwe court, the chief's entourage comprised the queen mother, the chief's first wife, and other younger, titled wives. This sculpture represents the young wife called a *mukwakuhiko*. In accordance with her title, she was responsible for the preparation of the ruler's meals. The utensils she carries makes her easily identifiable: a pot for boiling meat and a basket containing cassava porridge (Bastin, personal communication, 4/86).

Divine law decreed that the ruler eat only food prepared by the mukwakuhiko assigned to the task. Furthermore, his food was always cooked over a fire lighted by flint—a sacred method introduced by ancestral spirits. Such ritualistic precautions reduced the constant threat to Central African monarchs of poisoning by anxious pretenders to the throne. Divine rulers were also forbidden to eat in public, for an intruder's glare might deplete the potency of the amulets worn around the chief's neck and thereby render him powerless. Anyone who by happenstance caught the ruler eating or drinking could be punished by death. These strictures have been practiced by the Chokwe since the adoption of chieftainship from the Lunda kingdom in the sixteenth century.

Stylistically the Detroit sculpture is comparable to a mukwakuhiko effigy purchased in 1853 at Benguela (Angola), now housed in the Museum für Völkerkunde, Berlin. It came from a Chokwe chiefdom located at the mouth of the Kasai and Kwango Rivers in the mountainous region of Mussamba. The posture and simplicity of these two pieces are characteristic of the Mussamba sculptural style. Like the Berlin figure, the

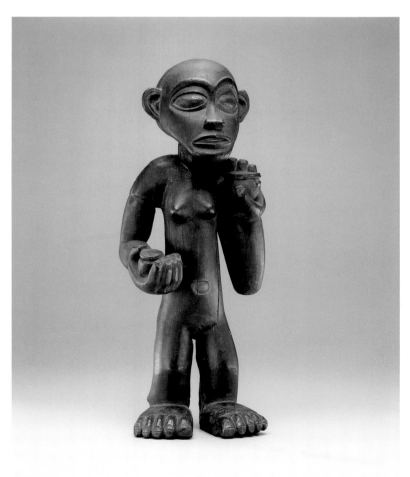

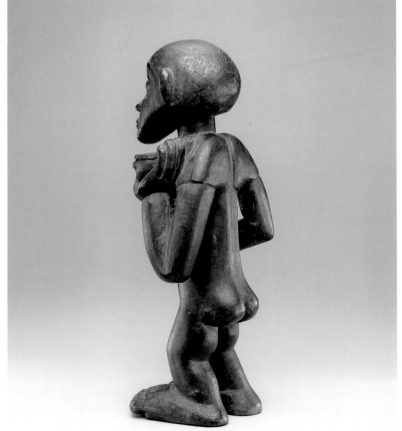

Cat. No. 66

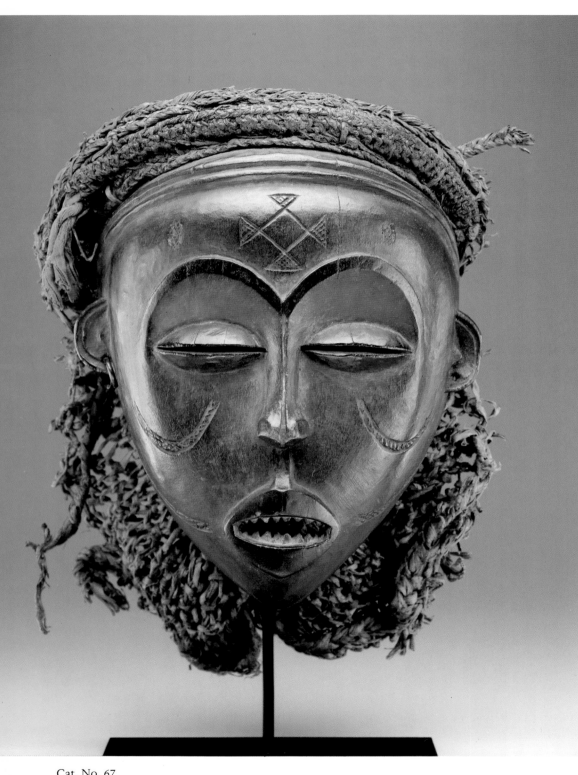

Cat. No. 67

Detroit piece originally wore a wig made from natural hair. Marie-Louise Bastin (personal communication, 4/86) dates the figures to the mid-nineteenth century, before Chokwe expansion toward the north and the eventual discontinuation of the tradition of royal sculpture.

PROVENANCE: Frederick Stearns, Detroit.

REFERENCES: Detroit Institute of Arts, *Detroit Collects African Art* (Detroit, exh. cat., 1977), no. 159.

67. MASK (mwana pwo)

Angola, Chokwe
Wood, hemp 20.3 × 15.5 cm (8 × 6⅛ in.)
Bequest of W. Hawkins Ferry (1988.193)

Female masks of the Chokwe people in Angola and Zaire are called *mwana pwo* and form part of an ensemble of masks used in *mukanda,* or initiation ceremonies for young men. Mwana pwo masks, delicately carved in wood and incised with designs, embody an ideal of feminine pulchritude, although they are always worn by men. They often are inspired by a particular woman renowned for her exceptional beauty. The Detroit mask exemplifies such qualities, radiating refinement, serenity, and grace with a symmetry of features. The delicate oval of the face, enhanced by arched eyebrows over half-closed eyes, a sensuous mouth, and finely carved nose epitomize elegance of form.

The woven headdresses of these masks are patterned with knotted fiber, beads, shells, and buttons. The tightly fitted knit costume worn with the masks includes false breasts and a bustlelike fringe over the hips. Designs on the cheeks are scarification patterns identifying a particular workshop or area of origin. An interlaced design in the form of a cross, a special mark of beauty and rank, is incised on the foreheads of most mwana pwo masks. Called *cingelyengelye,* the motif derives from a tin-plate pendant of Portuguese origin, circulated by Chokwe traders and

worn on the ear, the chest, or attached to the coiffure. According to the Chokwe, the symbol represents their god, Nzambi (Bastin 1984, 72).

There are some thirty masked character types in the Chokwe dance repertoire, but only four are essential in present-day mukanda ceremonies. Three are male, representing *chihongo,* an old chief; *chikunza,* "master of the mukanda lodge"; and *kalelwa,* an elaborate mask of bark cloth. The fourth is mwana pwo. Both mwana pwo and chihongo masks and costumes are kept by their owners, who are the only ones authorized to use them (Bastin 1984, 41).

Chokwe masks may personify either guardian spirits or deified ancestors and now commonly appear at secular festivals as well as in mukanda ceremonies. Mwana pwo represents the female ancestor, and in performance, is meant to impart fertility to the spectators (Bastin 1982, 88). The bearing and gestures of the dancer set an example of graceful behavior for the women.

PROVENANCE: W. Hawkins Ferry, Grosse Pointe Shores, Michigan.

68. STANDING MALE FIGURE

Zaire, Hemba, late 19th/early 20th century
Wood, height 76.2 cm (30 in.)
Gift of Mr. and Mrs. André Nasser (1986.54)

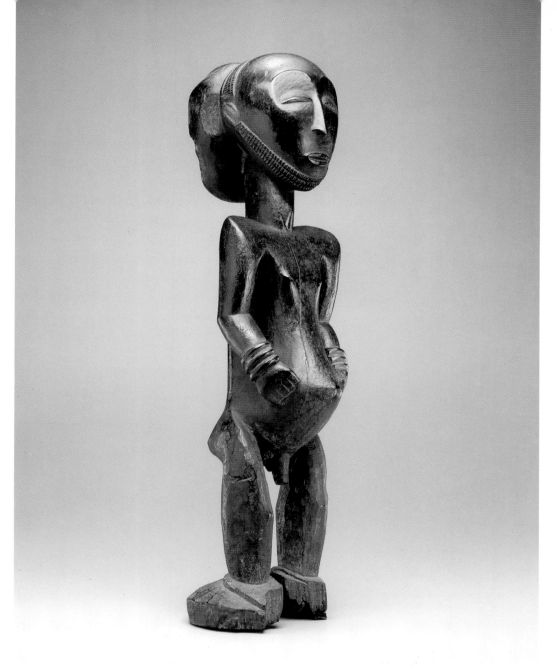

Cat. No. 68

Steadfast and quietly serene, this figure articulates the pride and genealogical perpetuation of an entire clan. It belongs to a sculptural genre called *singiti,* made to honor important departed ancestors. Kept in a special shrine house and provided regularly with offerings and prayers, the figure formed a material channel through which communication passed between the living and the dead. Named after a specific ancestor, these Hemba figures are portraits in spite of the fact that they do not duplicate the realistic features of individual persons. They are better termed "representational portraits" (Borgatti and Bril-

liant 1990), whose idealized forms are metaphors for family unity and the anatomy of kinship.

The high arched brows, aquiline features, pursed lips, finely grooved beard, and distinctive cruciform-shaped coiffure are characteristic of Hemba sculpture in general; however, ancestor figures of regional clans or chiefdoms can be identified on the basis of style. In his study of Hemba sculpture, François Neyt (1981, 280) attributes the Detroit figure to the southern Niembo classic style of the Mbulula region. The Niembo

are the dominant clan of the Hemba people. Neyt points out that this figure is one of only a few that have bracelets around the wrists, a possible reference to powerful symbols of sacred rule worn only by invested chiefs.

PROVENANCE: Mr. and Mrs. André Nasser.

REFERENCES: François Neyt, *Traditional Arts and History of Zaire: Forest Cultures and Kingdoms of the Savannah* (Brussels: Société d'Arts Primitifs, 1981), 281, fig. XIV.16.

69. TOBACCO MORTAR

Angola, Ovimbundu, 19th/20th century
Wood, height 6.2 cm (2⁷⁄₁₆ in.)
Founders Society Purchase, General Endowment
 Fund (82.36.2)

The Ovimbundu, most numerous of the peoples of Angola, are organized into chiefdoms and occupy a high plateau in the western section of the country. They practice an agricultural and pastoral existence and have had a long history of commercial and cultural exchanges with neighboring peoples (Bastin 1969, 35). Because of this, their art traditions have been influenced by other groups, especially by the Chokwe peoples to their east, whose original and inventive creative genius set a powerful example for the groups around them.

Ovimbundu art varies in style from extreme naturalism to highly schematic expression (Bastin 1984, 323). There are numerous types of pieces. Sacred objects, including staffs, gongs, hatchets, bracelets, horns, and fly whisks representing the reigns of specific rulers, were kept in special receptacles in the chief's compound. Decorated pieces such as figures, staffs, chairs, pipes, and mortars for tobacco or snuff were also kept and used by other persons of rank.

Tobacco, a New World plant introduced into Africa centuries ago by European travelers and settlers, is cultivated throughout the continent. Smoked in pipes or inhaled as snuff, it attained a wide popularity that has given rise to many art forms relating to its use. Among the Angolan peoples, carved pipes, tobacco mortars, and snuff containers—often lavishly embellished with figures or decorative motifs—were valued not only for their usefulness, but also were coveted as prestige objects.

Cat. No. 69

70. LINTEL MASK

Zaire, Eastern Pende, 1875/1925
Wood, 21.6 × 52.1 × 16.5 cm (8½ × 20½ × 6½
 in.)
Founders Society Purchase, Eleanor Clay Ford
 Fund for African Art (79.37)

Unlike most masks that conform to the vertical axis of the human face, this mask extends in a lateral direction. The forehead recedes sharply from the facial plane and is bisected by a crest. Enormous almond-shaped eyes are accented by arched brows, and the entire face is encircled by

an incised zigzag line that separates the red and white pigmentation. The oblong form tapers at both sides, where it is echoed again by miniature lozenges that represent ears and extend the face still further into space. The compression of the face with its winged projections and rising forehead give this mask a weightless quality.

Among the eastern Pende, the treasure of each local chief is kept in a special house called *kibulu*, elaborately decorated with two- and three-dimensional carvings. Sculptures of women and animals adorn the summit of the roof of this dome-shaped structure; polychrome panels with incised carvings flank the entrance; and a large painted lintel mask hangs above it (Biebuyck 1985, 246). This sculpture with its elliptical form may have served as part of a lintel for one such house.

Usually, the lintel is based on the *panya ngombe* mask, one of three associated with chiefly insig-

nia. The panya ngombe, the rarest of the three, is reserved only for the highest echelon of chiefs. The mask was worn by a dancer dressed in chief's garb and carrying a sword or machete. It would appear only during the period of initiation to the men's fraternity. A representation of the mask on a lintel is a mark of prestige, signaling that the owner of the kibulu belongs to the highest ranking of chiefs.

While the use of mask forms as architectural sculpture is very prevalent in Oceania and ancient Mexico, it is less common in Africa. In some areas, the placement of a mask upon a structure is an attempt to anthropomorphize it, particularly at the time during the ceremony when young initiates are symbolically consumed by the house and eventually reborn as men. For the western Pende, masks are used primarily in initiation rites. Among the eastern Pende, however, masks figure in a wider variety of contexts,

including ceremonies of state and healing rites, and are treated with even more secrecy than in the west (Sousberghe 1958, 63).

PROVENANCE: Harry A. Franklin, Los Angeles.

REFERENCES: *Bulletin of the Detroit Institute of Arts 58* (1980), 4: 225, fig. 29.

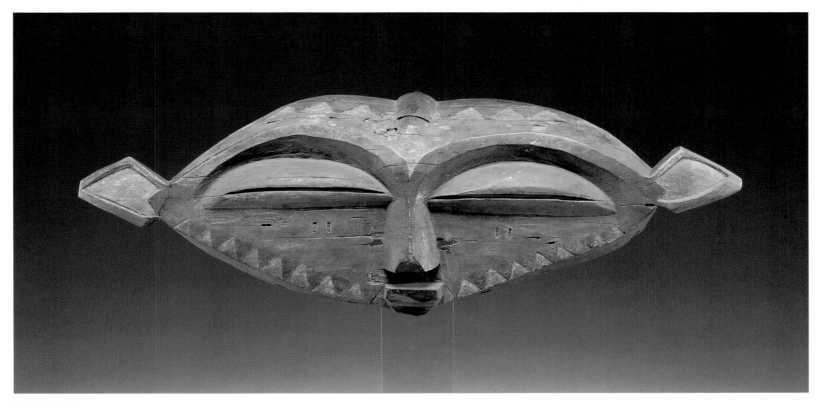

Cat. No. 70

71. PALM WINE CUP

Zaire, probably Wongo, 19th/20th century
Wood, 6 × 14.9 × 16.2 cm (2⅜ × 5⅞ × 6⅜ in.)
Bequest of Robert H. Tannahill (70.31)

This double cup, remarkable for its sculptural complexity, expands upward and outward from a small round base. The swelling figures are crisply delineated, with richly textured fields of pattern set off by smooth, glistening surfaces. The two halves pose in near perfect symmetry—

much like identical twins—one mirroring the other almost exactly.

The Kuba and their neighbors produce an astonishing array of cups, many with single and double (janus) heads, some with full figures, and still others with carved human feet forming the base. The inclusion here of two cups indicates sharing, symbolizing the exchange of ideas and the cementing of ties. Commissioned from artists by wealthy patrons, or made by artists for their own use, cups are generally utilized for drinking palm wine, a popular beverage in many parts of Africa obtained from the *Raphia vinifera* (Roy 1979, 176). Palm wine is consumed on ceremonial and social occasions where men gather for business, news, or plain gossip.

Double cups have a broad distribution throughout East Central Africa. Jan Vansina (personal communication, 7/86) attributes this cup to the region west of Kuba where the Lele, Wongo, and northern Pende reside. Based on the scarification marks, it most closely resembles the Wongo style. Joseph Cornet (1978, 220) comments that the raised facial markings are not scarification patterns per se, but rather scars from bloodletting treatments for certain diseases.

Cat. No. 71

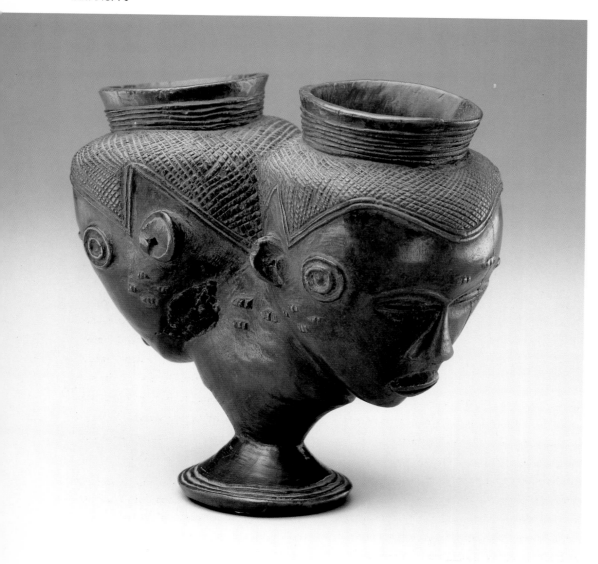

72. INITIATION MASK (mulwalwa)

Zaire, Southern Kuba
Wood, polychrome, copper, 52.1 × 29.2 cm (20½ × 11½ in.)
Founders Society Purchase, Eleanor Clay Ford Fund for African Art (77.17)

Southern Kuba peoples use a diversity of masks in *mukanda,* a complex of men's initiation rituals that extend throughout northeastern Angola, western Zambia, and southern Zaire. Masked officials oversee the proceedings in a forest camp, safeguard the well-being of the initiates,

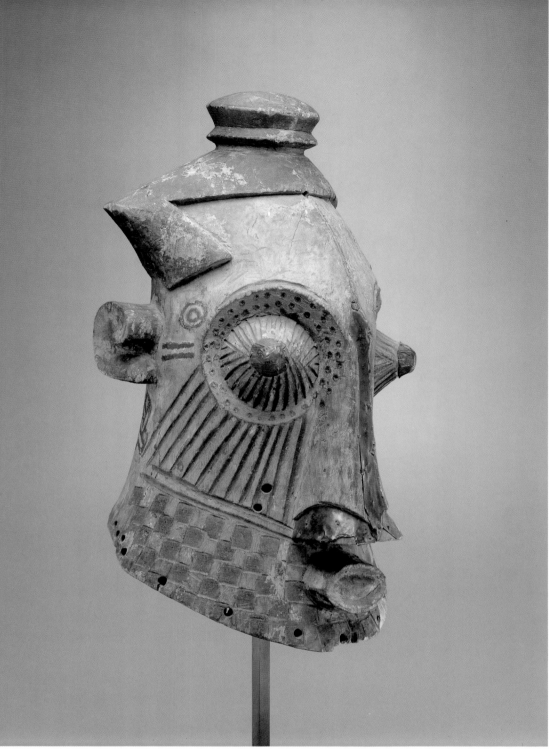

Cat. No. 72

ture spirits, titleholding, and the acquisition of secret esoteric knowledge (Binkley 1988, 118–119).

This *mulwalwa* mask represents an aggressive male figure who must be physically restrained by an attendant during its dance. The small inverted pot on his head refers to the pots used for the consumption of palm wine throughout the initiation rites. The pot indicates that the masked dancer may be intoxicated and a potential threat for those who test his patience or incite his wrath. The protruding striped conical eyes, like those of a chameleon, also identify the mask as mulwalwa (Binkley in Koloss 1990, 40–47).

Holes on either side of the nose indicate that this mask probably was worn. Mulwalwa masks are usually donned with a dramatic costume consisting of eagle and parrot feathers and a skirt of Colobus monkey skins. Some masks of this kind, however, are made only for display on the initiation wall, an edifice whose painted designs symbolize principles relating to titles, rank, and authority. On the wall, mulwalwa masks may be positioned on either side of the central peak that features the dominant mask *Bwoom* (Binkley 1988, 90–94).

The Detroit mask retains traces of the original bright yellow pigment, a color favored by certain Kete groups (Binkley, personal communication, 1990). The front is embellished with striated lines and an alternating light and dark checkerboard pattern, while painted and incised interlaced patterns adorn the back. These geometric designs reflect the Kuba predilection for dense surface decoration, which is manifest in virtually all forms of their artistic expression, including sculpture, architecture, beadwork, textiles, scarification, and painting (Cornet 1985).

PROVENANCE: Robert Duperrier, Paris. Merton Simpson, New York. James Goodman, New York. Donald Morris, Birmingham, Michigan.

and also protect nonparticipants during the volatile period of the ceremonies. Unlike many Central African peoples who ascribe the power of masquerade figures to ancestral spirits, the southern Kuba do not have a tradition of ancestor worship for they believe in the rebirth of deceased individuals after one or two generations. The power of southern Kuba ritual and masks instead derives from consideration of a number of issues, including the powers of the forest and na-

73. MASK (Ngaady a mwaash)

Zaire, Kuba, 20th century
Cowrie shells, glass beads, raffia cloth, pigment, height 82 cm (32½ in.)
Founders Society Purchase, Mr. and Mrs. Allan Sheldon Fund and funds from the Friends of African Art and Pierians, Inc. (1992.215)

While the Kuba believe in the importance of the aesthetic enhancement of every object, whether sacred or secular, royal or common, the most sumptuous decoration is reserved for royal articles such as this mask. The incorporation of shells and beads, items of trade in traditional Kuba society, indicates royal wealth. The costume that covered the masker's body would also be encrusted with the same ornaments.

The pattern of light and dark painted triangular shapes on the Detroit mask was undoubtedly drawn from the woven and cut-pile textiles for which the Kuba are famous. The lines drawn down the cheeks have been referred to as "tears" (Cornet 1982, 270). The headdress is fabricated from raffia cloth and is the same as that worn by the young regent. The cowrie shells sewn into the cap duplicate the diamond shapes present on the face. The separate ears attached to the side of the head are unusual; on most African masks, all of the facial features are carved from a single piece of wood.

This type of mask, called *Ngaady a mwaash*, appears with two other culture heros during various ceremonies, including initiation rites, funeral services, and royal occasions, where core mythological beliefs of the Kuba are reenacted and an appeal is made to the ultimate ancestors. Ngaady a mwaash was the sister and wife of Woot, the mythical first ancestor of the Kuba and their first king. The transgressive nature of their incestuous relationship separates Woot from the world of mortals for whom the act is naturally forbidden.

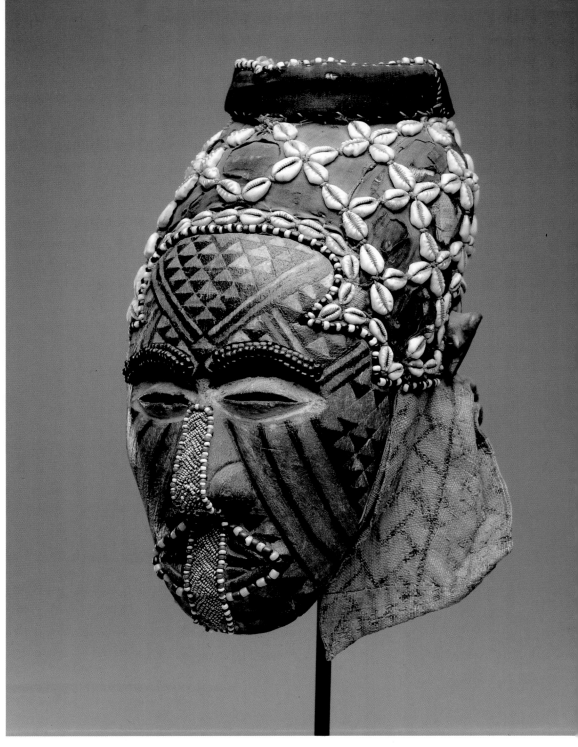

Cat. No. 73

The other masks portray two male ancestors both seeking the affections of Ngaady a mwaash. *Mwaash a mbooy* embodies the royal power that Woot himself enjoys; *Mboom* is thought to represent the nonroyal constituents of the Kuba kingdom. The emotional tension among the three symbolizes the bonds and constraints that help unify the Kuba people. Through their relationship to the ancestral woman, the two men are emblematic of the balance of power between the king and commoners.

PROVENANCE: Tambaran Gallery, New York.

74. MALE FIGURE

Zaire, Bena Lulua, early to mid-19th century
Wood, shell, height 51 cm (20 1/16 in.)
Founders Society Purchase, with funds from
L & R Entwhistle and Co., Ralph Harman
Booth Bequest Fund, Abraham Borman Family Fund, Joseph H. Boyer Fund, Joseph M. De-
Grimme Memorial Fund, General
Endowment Fund, New Endowment Fund,
Mr. and Mrs. Benson Ford Fund, K. T. Keller
Fund, Laura H. Murphy Fund, Mary Martin
Semmes Fund, Barbara L. Scripps Fund, Edna
Burian Skelton Fund, Mr. and Mrs. Conrad H.
Smith Memorial Fund, Henry E. and Consuelo S. Wenger Foundation Fund, and Matilda R. Wilson Fund (82.49)

The Bena Lulua ("people of the Lulua River") inhabit an area below that of the Kuba in south-central Zaire. The close identification of the Lulua with the river that provides their livelihood finds symbolic expression in this sculpture. Its harmonious composition recalls the fluid passage of water as it glides freely through rocks and driftwood: moving—yet still; changing—yet constant. Indeed, water is suggested in its every detail. On the surface, engraved concentric patterns allude to body scarification and derive from the rippling created by a stone cast in a pool of water (Timmermans 1966, 19). The large conch shell carved on the back metaphorically spirals to the riches of the sea.

Large male figures of this type—armed with receptacles for magical substances—are rare and date to the early or mid-nineteenth century. Several examples in museum or private collections are attributed to the Bakwe Damfunyi in the western Demba region, including one fine old figure that is virtually identical to this one (except for the loss of one leg) and is surely by the same master (see Neyt 1981, 190, fig. IX.5). A Lulua elder explained that such figures accompanied warriors into battle. The power of the

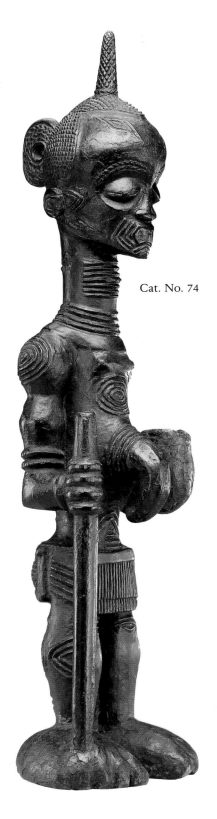

Cat. No. 74

substances stored in the sculpture's receptacles fortified the combative spirit, uplifted morale, and helped to divert the attacking enemy (Timmermans 1966, 18).

Certain iconographic features of this figure have historical and cultural importance. Both the finely plaited, centrally vertical coiffure and the concentric scarification are styles from an early period in Lulua history. With the advent in the latter half of the nineteenth century of the charismatic and progressive leader Kalambe Mukenge, traditional practices of body adornment—as well as numerous other Lulua customs and beliefs—were abandoned for newer ones. But this figure accurately documents the accoutrements and prestige emblems of the earlier era. Carved around the figure's elegant neck are expensive necklaces, which would have been strung with blue and white beads. From his waist hangs a skirt, probably of leopard skin, a luxury reserved for a chief. Finally, a bowl held in the left hand and a conch shell strapped to the figure's back contained the supernatural mixture that would assure triumph on the battlefield. Traditionally, the ingredients for this potion came from the personal reserve of the chief's counselors. The figure, then, did not specify one person but symbolized the Lulua people (Timmermans 1966, 18, 19).

PROVENANCE: Leo Frobenius, 1905/1906. Museum für Völkerkunde, Hamburg. Charles Rattan, Paris. Helena Rubinstein, New York. Jean-Jacques de Launoit, Brussels.

REFERENCES: New York, Parke-Bernet, *African and Oceanic Art: The Collection of Helena Rubinstein, Parts 1 and 2* (sales cat., April 21, 29, 1966), 210–211, no. 277.

Mary Nooter, *Secrecy: African Art that Conceals and Reveals* (New York: Museum for African Art, exh. cat., 1993), no. 18.

75. MASK

Zaire, Bena Lulua, 19th/20th century

Wood, pigment, fiber netting, 39.4 × 15.9 cm
 (15½ × 6 in.)

Founders Society Purchase, Eleanor Clay Ford
 Fund for African Art (77.50)

This mask, with its dark brown patina enhanced by delicately drawn designs in light tan, is an admirable example of artistic restraint. The fine tracery that defines and emphasizes the planes of the face constitutes a design that is both complete and spare, illustrating a true artist's use of economy of line.

Unlike Lulua statuary, of which there are abundant examples, masks are quite rare and usually differ from the figures in style. In general, masks are more schematic and less naturalistic than the figures but share with them a fineness and delicacy of design. Reflecting the influence of Kuba and Chokwe art, Lulua masks nevertheless adhere to certain stylistic principles that are distinctively their own, including high rounded foreheads, deeply cut eye sockets with coffee-bean or button-shaped protrusions, and small round mouths. Painted surface decoration refers to Lulua scarification patterns, and often the masks are surmounted by small crestlike projections. On some masks, incised patterns on the forehead or the addition of brass tacks may serve as points of emphasis. It has been suggested (Cornet 1971, 151) that these embellishments are the result of Chokwe influence and that other characteristics, such as the carved crests, show Kuba or Kete influence (Neyt 1981, 191).

The Lulua are a people of diverse origins, being related to the Luba-Kasai peoples as well as to others, including the Kete and Bindji. Except for a brief period of attempted consolidation begun by Chief Kalambe Mukenge in 1870, the Lulua were never a centralized society, but rather were composed of lineage groups headed by chiefs who were virtually autonomous in their political, religious, and judicial powers.

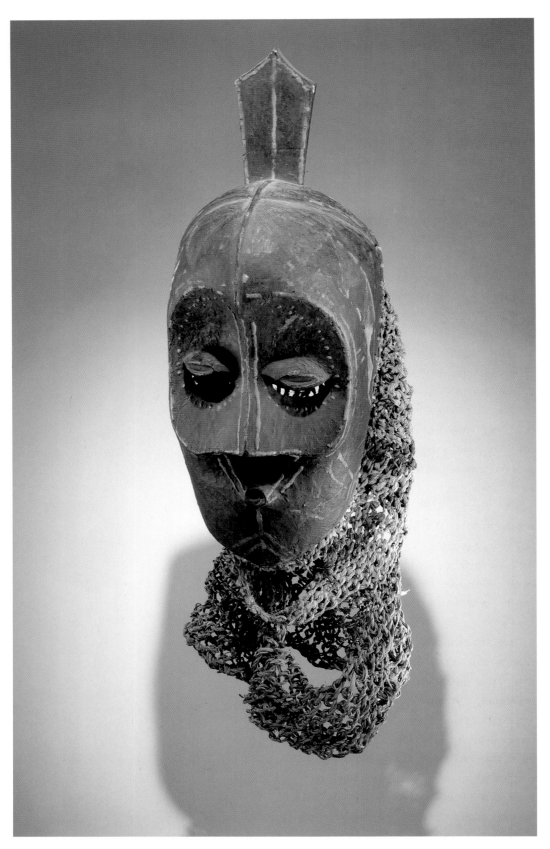

Cat. No. 75

In spite of a lack of political homogeneity among groups in the area, religious practices involving the use of statuary and masks are quite general. Sculpture is used for protecting women and children and for preserving authority, good fortune, and beauty. As is generally true of masks from central Zaire, those of the Lulua were used principally for the initiation ceremonies of young men. However, they were also employed in the funerals of notables and are said to represent the spirits of the dead (Fagg 1980, 136).

Frans Olbrechts (1946, cited by Willett 1971, 190) observed that masks of this central African area are used by religious and initiation societies whose spheres of influence cut across ethnic boundaries. As a result, mask types may be more subject to neighboring influences than statuary whose characteristic styles remained distinctive within each group. Jacqueline Delange (1974, 211) suggests that mask forms may originally have been borrowed from neighboring groups and reinterpreted by the Lulua.

PROVENANCE: Harold Rome, New York. Merton Simpson, New York. Ben Heller, New York.

76. HEADREST

Zaire, Songye, Nsapo-Beniki, early 20th century
Wood, height 13.5 cm (5⁵⁄₁₆ in.)
Founders Society Purchase, Henry Ford II Fund (1983.27)

In the African heat, the coolest, most comfortable beds and pillows are those carved from wood. This miniature carving is an elaborate variation of the otherwise utilitarian household pillow. Compressed into less than six inches stands a human figure with monumental presence. Most prominent are the enormous feet splayed in low relief on the round base. Planted firmly between this powerful foundation and the upper platform for the head stands a compact, strong little body with arms held tight to the torso, legs bent at the knees, and head slightly

bowed to bear the burden above. With use, headrests wear to fit their owner's particular contour and thus become highly personalized and irreplaceable objects. Additionally, headrests protect the elaborate coiffures worn by both men and women, which are expected to last for several weeks.

This headrest is virtually identical to others in the Musée Royal de l'Afrique Centrale in Tervuren, Belgium; the Stanley Collection in the University of Iowa Museum of Art, Iowa City; the Dallas Museum of Art; the National Museum of Poland, Warsaw; and still others in Italian collections (Felix, personal communication, 8/86). Jean Willy Mestach (quoted in Roy 1985, 167) attributes this sculptural type to the Nsapo, a Beniki subgroup who inhabit the far southwest

Cat. No. 76

corner of Songye territory, particularly to a workshop in Kananga (formerly Luluabourg)—an area rich with converging cultures. These headrests and a large figure in Leipzig collected in 1907 exhibit the large distinctive feet and the diminutive, lowered face with large, almost insectlike eyes that are trademarks of the so-called "Master of Beniki" (Roy 1985, 167).

Prominent feet frequently appear as a feature in Songye art as well as the arts of the Luba, Kuba, and Shilele. A symbol of power, the motif specifically refers to the confiscation of territory in warfare—the conqueror takes possession of land by standing on it (Mestach quoted in Roy 1985, 166). The anomaly between the Detroit figure's left foot with five toes and the right foot with only four remains a mystery, and differs from other figures by this artist in which both feet regularly have five toes.

This figure's composed, contemplative attitude and smooth, satinlike patina express a Songye aesthetic ideal related to *kutaala,* a local term for beauty. "*Kutaala* is associated with water in the river and by extension, with the river itself. As it flows past the village, the Lupupa River is deep and calm, and a further association is made by the people between *kutaala* on the one hand and coolness and calmness on the other . . . Thus it appears that what is 'beautiful' . . . is what is calm, cool, and collected" (Merriam 1974, 325).

PROVENANCE: Marc Leo Felix, Brussels.

77. STOOL

Zaire, Luba, 19th century
Wood, metal studs, 34.5 × 28 cm (13½ × 11 in.)
Founders Society Purchase, Eleanor Clay Ford
 Fund for African Art (79.36)

Stools are potent symbols of authority for the Luba of central Shaba Province and for neighboring peoples who share the ideological and material trappings of Luba sacred kingship. Called *kipona* or *lupona,* stools are the material embodiment of a complex set of ideas relating to the metaphorical "seat" of a king's authority. Stools are also used by many ritual specialists.

On the day of a ruler's investiture into office, the candidate is transported on the shoulders of an official to a central arena where he is lowered onto a finely sculpted caryatid stool placed on a leopard skin. Flanked by his two principal wives, he holds his staff and spear in his right and left hands respectively as he proclaims himself king and takes the oath of office. This is the only time the stool is exposed to public view. Thereafter, it is guarded by a royal clan in a separate village, carefully covered in cloth, to assure its protection from those with motives to overthrow the king. Royal stools are thought to contain special powers, and are treated with reverence and fear.

Most of the Luba stools in Western collections depict a seated, kneeling, or standing female figure in the round supporting the seat of the stool with raised arms. However, examples in the National Museum of Zaire in Lubumbashi reveal the prevalence of another stool type that may represent a precedent to the more familiar caryatids: a stool with four bowing supports, decorated only with geometric patterns. The Detroit Luba stool represents a hybrid of the two types. The seat and base are joined by four bowed supports, each embellished with geometric patterns, while at the center is a standing female figure with raised arms, wearing three necklaces, and with scarification patterns on her torso. The seat

is decorated with metal studs, testimony to the owner's wealth, strength, and endurance.

Stools with four supports but no figures are still in use in Mutombo Mukulu, a kingdom that lies to the extreme west of the Luba heartland, as illustrated by field photographs taken in 1986 in a town called Kaniama by Veronique Gobelet (Eliot Elisofon Photographic Archives, National Museum of African Art, Washington, D.C.). Mutombo Mukulu was an independent subkingdom of the Luba state and represents a cultural bridge between the Luba and Lunda kingdoms in terms of royal ritual and regalia. The photographs reveal the use of non-figurative stools in Mutombo Mukulu by a group of spirit mediums called *bilumbu* (diviners-healers) in a ceremony enacted for the reinforcement and renewal of the kingship.

PROVENANCE: Helena Rubinstein, New York. Alan Brandt, New York, 1974. J. Frederick Byers III.

REFERENCES: New York, Parke-Bernet, *African and Oceanic Art: The Collection of Helena Rubinstein, Parts 1 and 2* (sales cat., April 21, 29, 1966), lot 229. Hotel Drouot, *Art Primitif* (sales cat., December 19–20, 1974), lot 63.

78. CARYATID STOOL

Zaire, Luba-Songye, late 19th/early 20th century
Wood, 52.7 × 35.4 × diameter 33.7 cm (20¾ ×
 13¹⁵/₁₆ × 13¼ in.)
Founders Society Purchase, Robert H. Tannahill
 Foundation Fund (75.1)

Female caryatid stools are part of the artistic repertoires of matrilineal peoples. They are pervasive among the Luba who traditionally were a matrilineal group, although they became patrilineal in the recent past. Luba kings used such stools as their thrones on state occasions. Among the Songye, caryatid stools are extremely rare and did not begin to appear until the early twen-

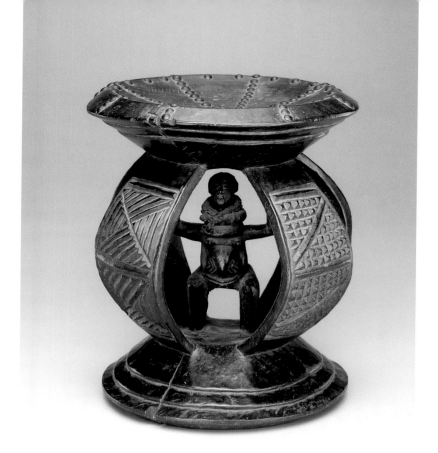

Cat. No. 77

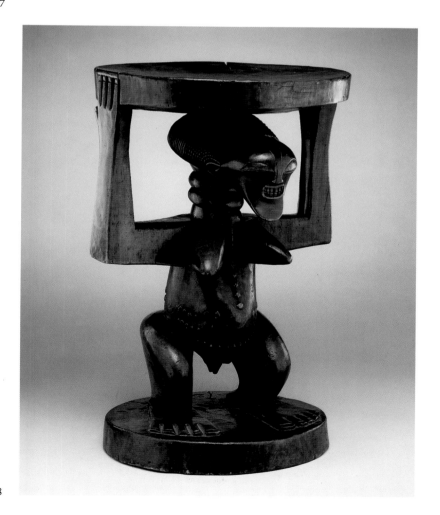

Cat. No. 78

tieth century and only in areas bordering the Luba (Mestach, personal communication, 7/86).

This merging of predominately Songye iconography and Luba form lead Jean Willy Mestach (personal communication, 7/86) to attribute this stool to a workshop that innovated a "Luba-Songye" style, a hybrid recognized for the first time by Frans Olbrechts (1959). Mestach dates this work to the reigns of Lupungu (the supreme Kalebwe chief who lived at Kabinda) and Kasongo Niembo (the last of the Luba kings), both of whom presided in the early twentieth century. Several other sculptures from the same workshop have been identified, and virtually all of them, with the exception of two male figures, are caryatid stools. Conceivably this workshop was responsible for carving all royal stools.

More specifically, the Detroit stool may be the creation of a Songye artist who worked in a workshop bordering the Songye and the Luba (southern edge of Kabinda-Kisengwa and northern Kabongo). Removed from the royal centers of either ethnic group, he was free to draw upon Luba artistic conventions at will. Whatever his own ethnic roots, the artist understood the cross-currents within his cultural setting. Synthesizing Songye and Luba artistic elements, he created a work that accurately documents a people's confluence during the expansionary period of the Luba kingdom.

PROVENANCE: F. A. Snow, England, 1914–1922. Lambert G. Snow (Sold 1970). Merton Simpson, New York.

79. HEADREST

Zaire, Luba, Mwanza, 19th/20th century

Wood, 16.2 × 13.7 cm (6⅜ × 5⅜ in.)

Founders Society Purchase, Mr. and Mrs. Allan
Shelden III Fund, Mr. and Mrs. Conrad H.
Smith Fund, and Joseph M. Boyer Memorial
Fund (72.243)

The artist of this headrest has combined architectural elements to create a work of linear and curved solids vented by open passages. The circular base is echoed by the curving of the legs around the thick, columnated torso. The piece is surmounted by a three-tiered horizontal structure, two levels of which comprise the actual headrest, while the third level is suggested by the taut configuration of the arms. Although miniature in size, the figure's density and mass give her enormous presence and make her supporting posture appear effortless and graceful. Headrests were used much like pillows by rulers and other ranking officials to raise their heads above the surface of the bed and protect elaborate coiffures. Luba headrests generally are supported by one or two figures, usually female in gender. Frequently the carved figures themselves have elaborate headdresses, denoting prestigious social standing as well as specific ethnic origins.

Although utilitarian in purpose, headrests were symbolically potent. Albert Maesen (personal communication, 2/82), who did field work among the Luba in the 1950s, related that when an important person died and the body was irretrievable, his or her headrest was buried instead. Maesen observed the personal attachment of the elderly to their headrests; they carried them everywhere. During severe iconoclastic upheavals with the Yeke, who overthrew Luba rule at the end of the nineteenth century, all headrests were burned, while stools, staffs, and other objects were left intact.

Virtually all Luba art incorporates female imagery. Noting the idealized aspect of these images, Jack Flam (1971, 57–59) interprets them as a symbolic statement of continuity of the matrilineal line and, therefore, of kingly power. Some women did fulfill a spiritual role, as the incarnation of deceased kings. Certain women called *mwadi* represented a link with the ancestral realm. Luba history also demonstrates the important role women played in the sociopolitical sphere. During the expansionary nineteenth century of the Luba kingdom, female relatives of the king were sent to the provinces as ambassadors, counselors, and leaders. That royal women were active participants and even powerful dignitaries in the political arena may explain the important place they hold in Luba art (M. Nooter 1984, 73–75; M. Nooter 1991; M. Nooter 1992).

REFERENCES: Detroit Institute of Arts, *Detroit Collects African Art* (Detroit, exh. cat., 1977), no. 187.

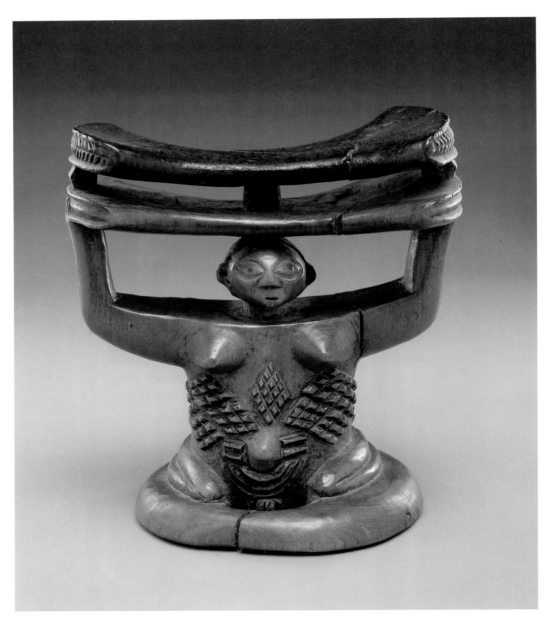

Cat. No. 79

80. INITIATION FIGURE (kinsamba)

Zaire, Lega, 19th/20th century

Ivory, height 20.3 cm (8 in.)

Founders Society Purchase, Eleanor Clay Ford
 Fund for African Art (77.16)

This figure, with its bald head and toothless mouth, probably represents an elder. Eyes in the form of cowrie shells imply heightened vision, while the smooth glossy surface metaphorically stands for the highest moral state. Double rows of scarification patterns decorate the browline and both sides of the torso from the arms to the navel. These patterns are acquired in the prime of one's youth and remain forever as testimony to time's inevitable passage.

The essence of Lega life is advancement through the levels of *Bwami,* a lifetime association to which all men and women belong. The ultimate purpose of Bwami is the pursuit of wisdom and moral excellence through teachings conveyed by songs, proverbs, and objects (Biebuyck 1973, 411). Each grade or level is identified with particular emblems, both natural and man-made—the latter consisting of masks and figures in wood and ivory. These act as badges, or seals of office, as well as aids for conceptualizing the society's teachings. The meaning of a piece is never static, however, since it may be modified according to the context in which it is used. Works of art may be displayed on the ground or grouped in baskets, or initiates may dance with them.

This type of ivory figure was used in one of two rites in which aspects of Lega moral philosophy were revealed. Its name, *kinsamba,* refers to a genus of white mushrooms with beautifully light, glossy surfaces. In Lega thought—as in many African languages—the words for "beauty" and "goodness" are the same, reflecting an intimate connection. As Daniel Biebuyck (1973, 178–179) points out, the white, lustrous color of mushrooms also characterize ivory. The

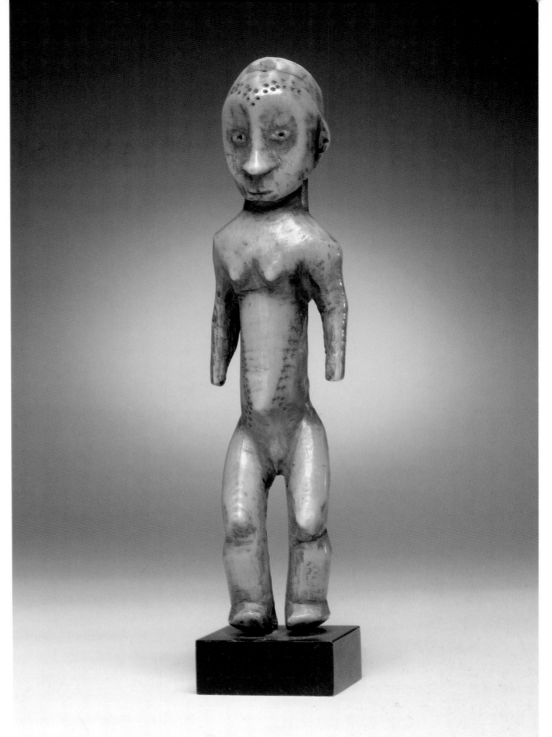

Cat. No. 80

Lega admire the smooth hard surface of ivory because it evokes durability, strength, and permanence. For this reason, only members of the two highest grades are entitled to own and use works made of ivory.

Like many African pieces, Lega ivory figurines attain a state of completion through time and usage. Only by annointing them with oils and perfumes do they acquire the lustrous, reddish-yellow patina so admired by the Lega. This process, called *kubongia,* intends "to bring into harmony and produce unison" (Biebuyck 1973, 179). It portrays how the use of a work of art—its interaction with it owners—affects its aesthetic impact.

PROVENANCE: John Freide, New York.

EAST AND SOUTH AFRICA

Among the Greeks, Romans, and Egyptians, the East African coast was famous for trade, attracting seafarers and merchants from southern Arabia and distant Indonesia. Ancient Mediterranean texts mention the civilization of the Asanians south of Ethiopia. These Cushite peoples settled in farming communities within the East African interior as well as establishing trade ports on the coast. Cushite farmers shared the interior region with Khoasian hunters, a Pygmy/Bushman peoples, until the massive Bantu and Niolitic migrations into the area after the sixth century A.D. Originating from a homeland in what is today southern Sudan, the Nilotic people brought with them a culture and economy based on cattle. Successive waves of Bantu peoples migrated to the Eastern Congo Basin during the same era. Of these four large groups, only the Bantu are represented here with their traditions of wood sculpture and other visual arts. Bantu contact and intermingling with the rich ethnic mix of East Africa, however, contributed several distinctive features to the visual arts of the area.

The traditions of memorial post sculpture among the Mijikenda provide a good example of the cultural mélange found in East Africa. The Mijikenda, a populous group of East African Bantu, inhabit over five thousand square miles of the Kenyan and Tanzanian coast. They had drifted south along the coast to that location during the sixteenth century after having been part of a larger and earlier push of Bantu speakers into northeastern Kenya and Somalia. Mijikenda traditions for carving memorial posts, which include those produced by the Kambe, may have drawn on the Indonesian-derived memorial carvings of Madagascar combined with the chip carving drawn from the Islamic decorative arts traditions of the Swahili, the Kenyan and Tanzanian coastal dwellers of Arab, African, and Indian descent.

Opposite: Cat. No. 85, *Meat Dish*, detail

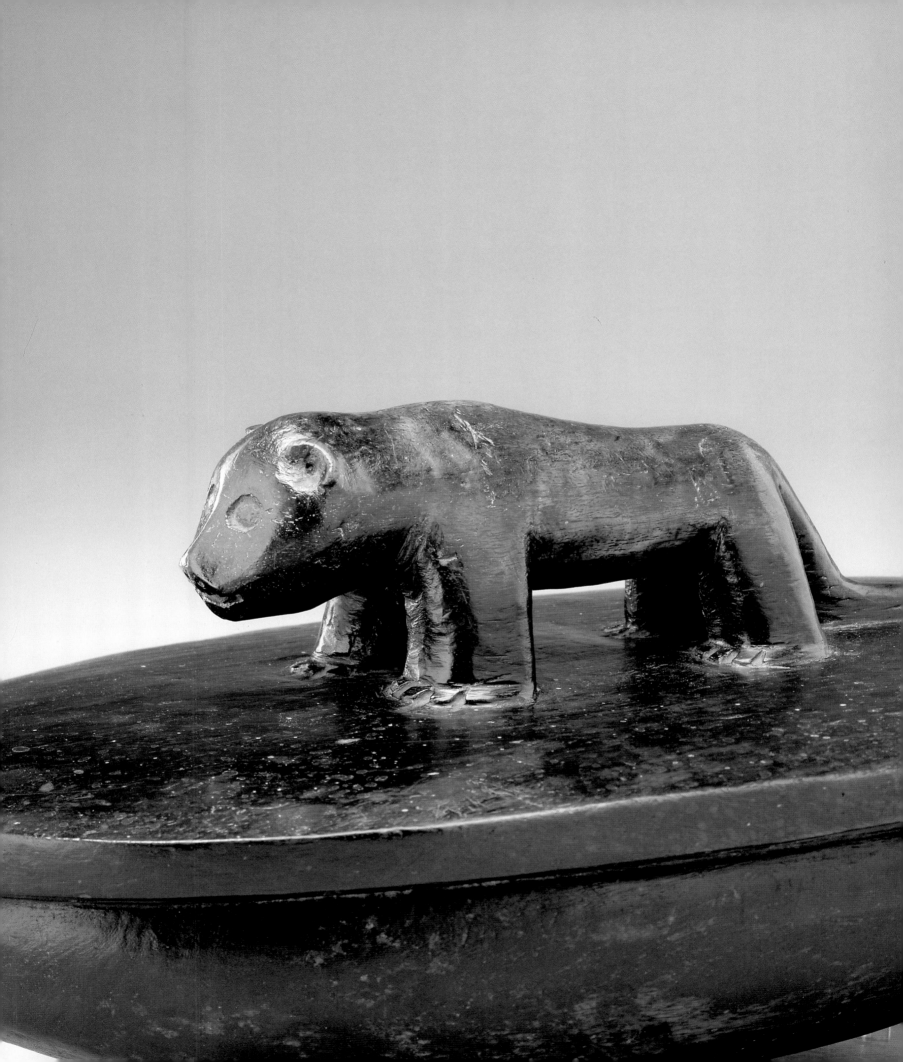

To the south, the Makonde live in the plateau region north and south of the Tanzania and Mozambique border. Linguistically, they are classified as part of the Central Bantu of the Eastern Congo Basin. Although the range of Makonde sculpture is far more limited than the closely related eastern Congo peoples, the Makonde are well known for wooden masks used during boyhood initiation festivals. The highly inventive modern Makonde wood sculpture has found great success as a tourist art.

An explosively expanding population caused the Bantu also to push south in several waves of migration, displacing or intermingling with the earlier hunter groups, the Pygmy, Bushmen, and Hottentot. All of the southern Bantu possessed cattle and combined herding with agriculture in differing degrees. The Rotse and Shona were primarily agriculturalists. The Rotse of central Zambezi shifted residences seasonally from villages built on artificial mounds located in the fertile Zambezi River floodplain to those built on elevated terraces located farther away, out of reach of the annual inundation. Archaeological evidence suggests that groups of Shona first entered their present homeland in southern Zimbabwe and adjacent Mozambique by A.D. 600, perhaps the earliest Bantu penetration of the region. Ancestors of the present-day Shona may have been responsible for the impressive masonry architecture found at the mysterious ancient walled village of Zimbabwe. The site plan of Zimbabwe mimics, on a grand scale, the compact walled villages of the modern Shona, which are built around a central corral, or *kraal*.

The Nguni, which include the Ngoni, Ndebele, and Zulu, represent the southern-most extension of Bantu speakers. Nguni peoples entered the rolling grasslands of South Africa at least a century prior to European exploration of the coast in the late fifteenth century. A unifying, cultural homogeneity contributed to a strong political organization, and Nguni expansion benefitted from an aggressive, military tradition. The Zulu grew to a powerful nation-state of one million under the leadership of their most famous warrior-king, Shaka (1787–1828), who centralized Zulu control by establishing himself as a divine ruler and reorganizing the military into one of the strongest and most effective armies of indigenous Africa. Following suit, the Ndebele also experienced a period of military success and expansion, invading Shona territories and establishing control there in 1838. The Nguni peoples possessed a less developed tradition of wood sculpture than other Bantu peoples, although their visual arts are rich in ornament as evidenced by their dress and architectural painting.

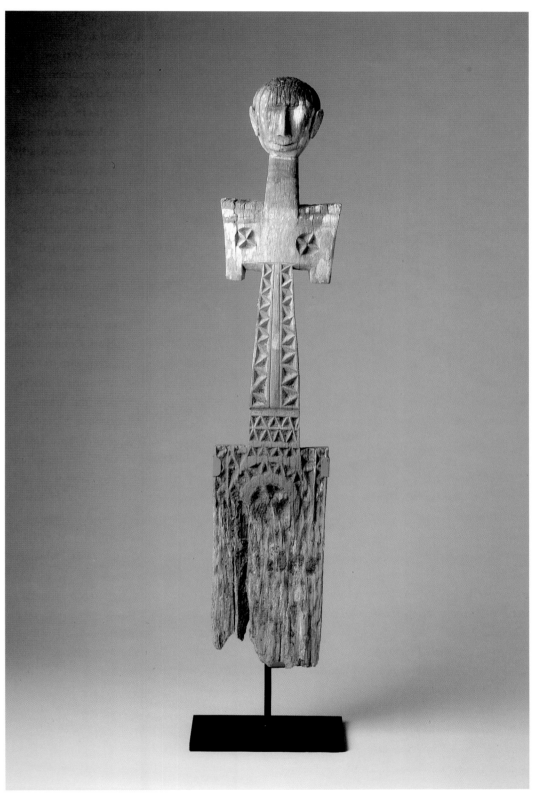

Cat. No. 81

81. COMMEMORATIVE POST (kigango)

Kenya, Kambe, ca. 1850
Wood, 113 cm (44½ in.)
Founders Society Purchase, Eleanor Clay Ford
 Fund for African Art (78.14)

"Son, there is sickness in your village. Your animals are not well, and you are unhappy. I too am unhappy. I want to return to my village. Why have you forgotten for so long? I am suffering from the damp of the grave. Bring to me the warmth of the village: put up a *kigango* for me and I then will help you."

From a dream of ancestral spirits
(quoted in Wolfe 1981, 36)

For the Mijikenda peoples of Kenya, communication between the living and the dead is vital to the maintenance of life. During the year following the death of an important person, but prior to his or her burial ceremony, the deceased's spirit may visit the most senior male of the family to offer assistance and guidance. In return, the senior male commissions an artist to make a *kigango* (plural *vigango*) post in the deceased's honor. The artist installs the post in front of the family's house together with posts dedicated to other ancestors. The posts form an ensemble, a visual kinship chart recording the history of the lineage and preserving memories of family land rights. The posts remain in place for perpetuity, even when the people move their village, to hail those who tilled the land. Originally, the Mijikenda were a homogeneous people; after several centuries of migration, however, they split into separate groups, including the Chonyi, Rabai, Duruma, Kauma, Jibana, Ribe, Digo, Kambe, and Giryama. The constant migration, resulting in loss of land, may explain the important association of the vigango with the land.

The practice of erecting vigango is restricted to members of the *Gohu* society, a group of senior and wealthy men who sponsor lavish feasts.

Members of Gohu strive to become influential leaders who may one day each have a kigango in his name.

Weathered by time and the elements, the Detroit post from a Kambe village retains its clarity of form and detail with the exception of the base, where the wood has given way to the effects of the soil. Through the juxtaposition of geometric and organic forms, the sculpture evokes both human and other-worldy qualities. The naturalistic modeling of the head with features in the round contrasts with the abstract two-dimensional rendering of the body. The Mijikenda hold that the portrayal need not be life-like; they know how their relatives looked. The figures only need to depict enough of a human semblance so that the spirit will know to inhabit it.

The social significance conveyed by certain sculptural features is more important than imitating nature. The large size and elaboration of this figure, for example, implies the high status of the deceased. Most posts simply have a flat, circular head with incised features and a straight uncarved plank as a body. The emphasis on the head here may relate to a general belief in Africa that the head is the locus of wisdom and strength. The patterning on the plank not only energizes and enlivens the otherwise weathered surface, but also refers to vital organs of the human body. Some designs have specific meanings; the number of spokes in the circle at the base, for example, indicate to which Mijikenda group the deceased belonged. Some posts have an hourglass pattern that recalls the bittersweet Mijikenda epigram, "Life is brief."

The practice of honoring the dead with monumental graveposts is found all along the east coast of Africa. Among the cultures sharing in this tradition are the Bongo of Sudan, the Konso and Gato of Ethiopia, and the peoples of Madagascar. It has been suggested that the posts stylistically share great similarity with the archi-

tectural sculpture of the Swahili coast—lintels and door frames that bear intricate patterns inspired by Indian, Asian, and African confluence over the course of centuries (Sieber in Wolfe 1981, 31; N. Nooter 1984, 34–38, 96). The Mijikenda posts nevertheless are a unique sculptural form borne out of changing historical circumstances and stand as testimony to the importance of cultural continuity.

PROVENANCE: Jacques Kerchache, Paris.

REFERENCES: Leon Siroto, "A *Kigangu* Figure from Kenya," *Bulletin of the Detroit Institute of Arts* 57 (1979), 3:105–113.

Roy Sieber and Roslyn Adele Walker, *African Art in the Cycle of Life* (Washington, D.C.: National Museum of African Art, exh. cat., 1987), 143.

82. STANDING FIGURE

Tanzania, Ngoni, early 20th century
Wood, glass beads, height 25.1 cm (9⅞ in.)
Founders Society Purchase, Henry Ford II Fund (1983.29)

This free-standing figure with moveable arms is attributed to the Ngoni, who are part of the Nguni complex, a cultural and linguistic term used to denote a number of southern African peoples, including the Zulu, Swazi, Matabele, and Ngoni. The Ngoni are descendants of Zulu bands that fled Natal around 1920 to resettle in Malawi, Zambia, and Tanzania. Michael Conner (personal communication, 9/86), who carried out field work among the Ngoni of Malawi, questioned this attribution since figurative art is extremely rare in this group. He is unaware of any other free-standing Ngoni figures. There are only subtle references to the human form in such objects as dance staves, dolls, axes, and headrests, and they do not resemble the Detroit figure. In addition, religious and secular rituals of the Ngoni, like other Nguni peoples, do not incorporate figurative sculpture or masking.

Although figurative art may not belong to the traditional repertoire of Nguni art forms, which include beadwork waistbands, meat trays, headrests, staves, gourds, and snuff containers, Conner points out that mission and trade contact with the Nguni began as early as the eighteenth century. This led to an active demand for curios in Natal, along the coast of what is now South Africa, by 1840 and, prior to 1890, in the hinterlands of Malawi, Zambia, and Tanzania, where the majority of Ngoni ultimately settled. Most sought after were figures and masks like those collected by sailors and merchants along the coast of west Africa, but which were not common in eastern or southern Africa (Conner, personal communication, 9/86).

Stylistically, the figure shares elements of both eastern and southern African art. Conner considers it to be typically southeastern with its broad, triangular nose, restraint of decoration, blocky, geometrical body, heavy stance, and comparatively naturalistic body proportions with only scant depiction of fingers and toes. Yet it also closely resembles east African figures from Tanzania. The small, beaded eyes characterize figures from many regions, particularly the eastern shore of Lake Tanganyika, and the moveable arms are found in Zaramo works from central Tanzania (Fagg 1965, fig. 119). These stylistic elements, combined with the aforementioned historical factors of migration and trade, suggest that this figure derives from a Ngoni group that settled in Tanzania. Their integration and eventual acculturation into east African society is reflected in this work, which nevertheless preserves the flavor of the group's southern origins.

PROVENANCE: James Willis, San Francisco.

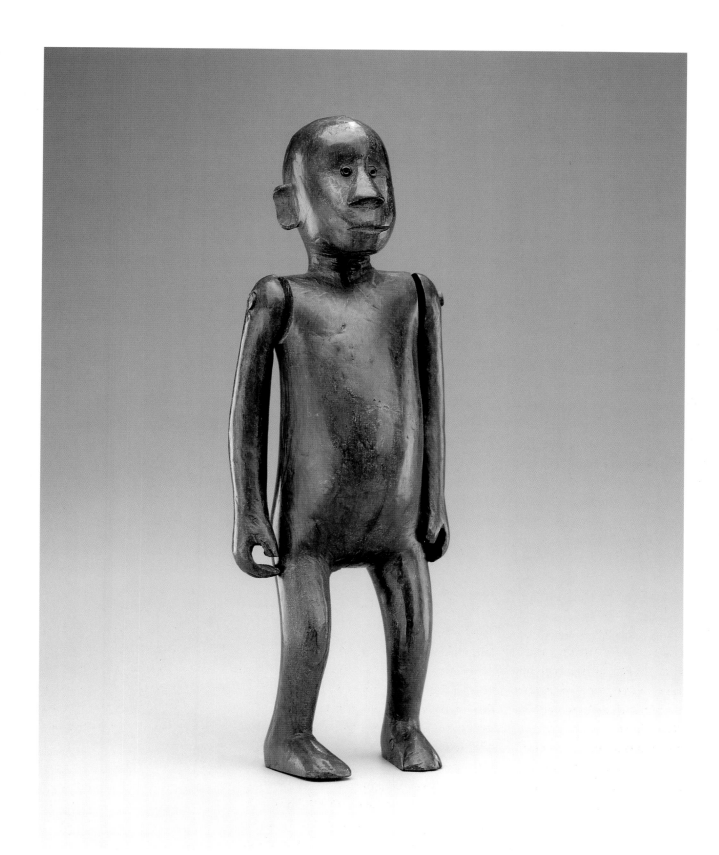

Cat. No. 82

83. HELMET MASK (midimu)

Mozambique, Makonde, early 20th century
Wood, wax, fiber, 22.9 × 20.3 × 26.7 cm (9 × 8 × 10½ in.)
Founders Society Purchase, African Art Gallery Committee Fund (76.25)

This mask, with its parted lips and intense gaze, is both haunting and mesmerizing. Its swollen features provide a canvas for abstract patterns that enliven the surface. The head is further transformed by the coiffure's silhouette.

Helmet masks of this kind are worn at the coming-out celebrations of boys and girls from their respective initiation camps. Although the length of the instruction period differs for each sex, the ritual cycle is scheduled so they emerge from the forest schools on the same date. Then, for three consecutive days, villagers dance and feast until the most climactic event—a spirit dance called *midimu* performed by the initiation sponsors. Dispersed into satellite dance troupes, the sponsors pay their respects at each initiate's home where they dance and collect gifts of food and money. Usually a masked dancer is accompanied by five drummers, two pairs of singers, and in the recent past, a chorus of women and children (Wembah-Rashid 1971, 44).

The midimu masks allude to the initiates' newly acquired membership into adulthood. This membership is hard-earned. The mask's finely rendered teeth recall the painful fracturing process that takes place during initiation rites for both sexes to shape incisors into points. This modification enhances beauty and testifies to the intiates' endurance and strength. Likewise, the facial designs executed on the mask with wax denote scarifications obtained during the initiation. In addition to the aesthetic embellishment of the face, such markings signal ethnic identity, "to show I am Makonde." They also symbolize, in a general fashion, a "complete" person, for the cru-

cible of scarification and pain prepares one for the physical and emotional rigors and demands of adulthood.

Among the Makonde, the scarification process involves piercing the skin in a desired pattern, then rubbing pulverized charcoal over the face. The face is sun-dried, washed, and then black lines begin to emerge. This whole procedure is repeated several times before the lines become permanent and easily visible (Schneider 1973, 28). The scars on this mask conform to traditional patterns with superimposed chevrons on the forehead and zigzag lines above and below the mouth. The chevron's tip points upwards, however, in a relatively new style that deviates from tradition. One Makonde elder explained that in the past, the tip of the chevron always pointed down (Schneider 1973, 28).

The Detroit mask is almost identical to one collected in 1958 by William Fagg for the British Museum from a colonial outfitter who claimed to have had it for thirty or forty years. As Fagg (letter to the Detroit Institute of Arts, 12/7/75) points out, the use of wax is a mark of age; it is found on most female masks up to World War I and some time thereafter, but completely disappears well before the 1940s. Since then, Makonde masks have become quite naturalistic, but also much more like European caricatures.

PROVENANCE: Alan Brandt, New York.

Cat. No. 83

REFERENCES: *Bulletin of the Detroit Institute of Arts 55* (1976), 1: 7, fig. 3.

Detroit Institute of Arts, *Detroit Collects African Art* (Detroit, exh. cat., 1977), no. 197.

84. HEADREST

Zimbabwe, central or eastern Shona, 19th/20th century

Wood, 12.7 × 14.6 cm (5 × 5¾ in.)

Founders Society Purchase, Eleanor and Edsel Ford Exhibition and Acquisition Fund (1983.12)

This delightful headrest is typically Shona in its combination of certain stylistic details: the figure-eight shaped base, the patterning of chip carving, and the decorative rows on both ends of the curved platform. Yet, the incorporation of an animal caryatid, perhaps some kind of feline, is very unusual in predominately non-figurative Shona art. A comparable headrest with an animal caryatid is in the Frankfurt ethnographic museum, although it differs stylistically from this one, which has been attributed to the central or eastern Shona (Dewey, personal communication, 6/86).

Carved wooden headrests have a long history among the Shona as grave offerings. At a burial site dating to 900 A.D., fragments of gold foil remained scattered where the skull once lay. These gold fragments most likely adorned a wooden headrest. Gold-covered headrests from the fourteenth and fifteenth centuries have been found at Great Zimbabwe archeological site locations. Shona people today confirm that important men used to be buried on their headrests. Indeed, shards of wooden headrests discovered in caves commonly used as graves can be viewed in the archaeology collection of the Queen Victoria Museum in Harare.

Within the last few centuries, headrests were employed exclusively by men who coiffed their hair in elaborate styles. In the 1860s, Thomas

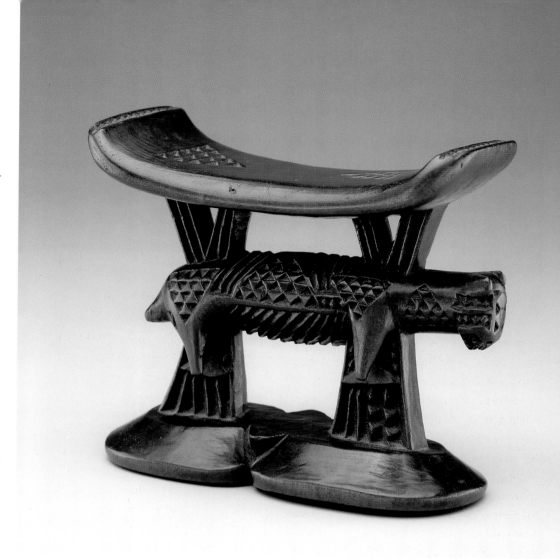

Cat. No. 84

Baines traveled through the area and recorded that in order to "keep the well-oiled locks from being soiled by dust, every man carries with him a neck pillow, like a little stool, which suffers not the head to come within eight or ten inches of the ground" (Baines 1864). Many headrests still have an attached cord, which enabled Shona men to carry them around their necks, similar to the way Westerners transport a bedroll while traveling. Additionally, it has been noted that a man endowed with several wives would place his headrest by the house of the wife he desired to sleep with that night (Dewey, personal communication, 6/86).

Today, however, the once utilitarian function has given way to religious use. According to William Dewey (1986, 65), "One chief explained that when he prayed to his ancestors, he would take

out his grandfather's headrest and begin by saying, 'Grandfather, here is your headrest.' Another chief told me he had been having trouble judging cases and so he commissioned a headrest. By sleeping on it, he had dreams that would help him decide the cases. Sekuru Bwanya, a spirit medium, claims his headrest was made and used by the ancestral spirit that possesses him. On his manifestation, this spirit told people to go collect his things; these included the headrest, taken from where he had been buried."

PROVENANCE: James Willis, San Francisco.

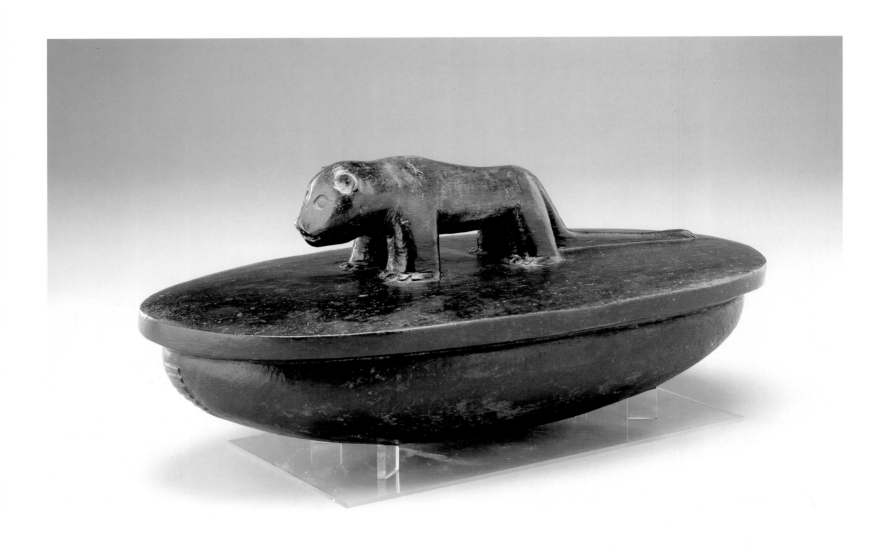

Cat. No. 85

85. MEAT DISH

Zambia, Rotse, late 19th century

Wood, 44.5 × 21.6 × 18.4 cm (17½ × 8½ × 7¼ in.)

Founders Society Purchase, African Art Gallery Committee Fund (82.50.1–.2)

Rotse food bowls for serving minced meat are often adorned with zoomorphic motifs, most frequently aquatic birds, like ducks, swimming across the top of a covered container or along the handle of a long ladle. Elephants and equestrians are also depicted on food bowls. Carved on the lid of this container is a svelte lioness,

poised solidly on all fours with tail trailing gracefully behind. The subtlety and ingenuity of African artistry are apparent not only in the placement of the most lordly of beasts on the most mundane of objects, but also in the double use of the lioness as the handle of the lid.

According to historical accounts, the Rotse (or Lozi) people of Zambia have inhabited the flood plains of the upper Zambezi for about two centuries (Fagg 1965, 98). Oral tradition holds that they overthrew a previous population to build an elaborate kingdom, which consequently gained hegemony over many neighboring groups, including the Mbunda and certain Lunda-related peoples. During this expansionary period of

Cat. No. 86

Rotse political history, talented members of the subjugated classes were recruited to work as craftsmen in the service of the king. These artists specialized in the carving of various sorts of containers and utensils used for the preparation and presentation of food at the royal court. Purely secular in nature and utilitarian in purpose, many of these implements are highly inventive works of art.

PROVENANCE: Linda Einfeld, Chicago.

86. STAFF

South Africa, probably Zulu, late 19th/early
 20th century
Wood, height 96.5 cm (38 in.)
Founders Society Purchase, Eleanor Clay Ford
 Fund for African Art (80.24)

This spare shaft surmounted by a diminutive human head originated among the peoples on the southeastern African coast. The figure is crowned with a head ring worn by adult males among both the Nguni-speaking peoples, including the Zulu and Swazi, and the Tsonga people to the northeast. The overall rendering, however, appears more akin to Zulu carving than to any other southern African group. Zulu traits include small glass eyes, C-shaped ears, a slit mouth, a smooth surface, and elegant simplicity (Kennedy, personal communication, 7/86; Nettleton, personal communication, 8/86).

The earliest Zulu figurative sculptures, found in European and southern African museums, date only from the 1880s and 1890s. Prior to this time, traditional woodcarving seems to have been restricted to non-figurative utilitarian implements such as meat trays, spoons, milk pails, and headrests. According to Carolee Kennedy (personal communication, 7/86), "the appearance of carved figures and figural staffs (including human figures and heads, as well as animals) probably was a response to European influence and

interest from the turn of the century." The beautifully worn patina of this staff implies extensive use, suggesting it dates to the early period of Zulu figurative carving in the late nineteenth century.

The Detroit example is a type that was reserved for seasoned warriors. It served both as a weapon in hand-to-hand combat and as a staff of office to display rank (Nettleton, personal communication, 8/86). In form, the staff most closely resembles a knobkerry, a stick with a large knob carved at the top or with a naturally protruding knob at one end. Traditionally carried by Zulu men when traveling outside the home, these sticks made good weapons, whether against human adversaries or animals, such as snakes, encountered along paths and roadsides. In traditional Zulu areas today, old Zulu men rarely are seen along the roads without their walking sticks. According to Kennedy, (personal communication, 7/86), "because knobkerries and walking sticks invariably have a knob or protrusion at the top, the carving of a human head to replace the knob would seem to be a natural, or at least a logical, progression."

PROVENANCE: Argiles (Madame Dialossin), Paris. Merton Simpson, New York.

Cat. No. 87

87. STAFF

Eastern or southern Africa, late 19th/early 20th
century
Wood, stain, height 96.5 cm (38 in.)
Founders Society Purchase, Eleanor Clay Ford
Fund for African Art (79.38)

The stark simplicity of this staff, combined with the smoothness of its gently turning surfaces, elevate the object from the ordinary to the sublime. The long, bare shaft is broken by a spherical knob before branching into two diminutive human figures. One figure is clearly male, while the other may be female. They both, however, wear the same dramatic coiffure. The slightly asymmetrical juxtaposition of the two figures and the anatomical delineation of only one of them creates a visual tension, causing the viewer's eye to move back and forth between them to complete what the artist has deliberately left unfinished.

The overall form of this staff, with its unadorned shaft topped by a rounded knob, closely resembles a Zulu knobkerry, a walking stick and club. As Anitra Nettleton (personal communication, 8/86) points out, however, Zulu knobkerries rarely incorporate human figures. Furthermore, the coiffures shown here differ from the headrings worn by Zulu men and frequently depicted in Zulu sculpture. Nettleton considers the work to be more closely related to the Ovimbundu of southern Angola, whose traditional hairstyle is similar to those shown on this staff. This similarity is only evident from the front, however, for the back, which has a smooth, uncarved surface and a rectangular flange projecting from the bottom, differs significantly from the Ovimbundu coiffure.

More striking is the resemblance this staff bears to the art of East Africa, particularly in the minimalism of the figures, the lightness of the wood finish, and the schematic rendering of certain facial features. The treatment of the eyes,

ears, and mouth has the character of works from Tanzania. The combination of a Zulu form with Tanzanian figurative traits suggests that the staff may be a transitional object reflecting the cultures of eastern and southern Africa. This is especially plausible in light of the migrations of Nguni peoples northward into Zambia, Zimbabwe, and Tanzania during the first half of the nineteenth century to escape Zulu expansion under King Shaka (Murdock 1959, 381). The resulting acculturation of southern African peoples in East Africa might have inspired this singular and mysterious work of art.

PROVENANCE: Argiles (Madame Dialossin), Paris. Merton Simpson Gallery, New York.

88. WOMAN'S CAPE (linaga)

South Africa, Ndebele, 1930/1945

Goatskin, glass beads, 86.4 × 137.2 cm (34 × 54 in.)

Founders Society Purchase, Eleanor Clay Ford Fund for African Art (78.29)

Closely associated with the ceremonial cycle of traditional Ndebele life is a system of visual imagery through which the people proclaim their identity and mark each ritual occasion. Mural painting and ornamental beadwork not only enrich the quality of life, but also record some of the social and economic changes that have oc-

curred in Ndebele history since the turn of the century (Knight and Priebatsch 1983, 1).

The Ndebele arts of wall painting and beadwork are produced by women, who learn the techniques from their mothers and then pass their knowledge on to their daughters. Ceremonial occasions, especially initiation rites, involve painting or repainting of homestead walls with geometric images of great complexity and the creation of lavishly beaded garments that are worn by women to indicate their status in life. Ndebele beadwork, like house decoration, consists of geometric, angular design elements rather than curvilinear forms. While the patterns are usually abstract, representational imag-

Cat. No. 88

ery has become more and more common. But these representations are translated into vertical, horizontal, and diagonal elements and become symbols rather than direct likenesses.

The *linaga,* a forerunner of a later beaded blanket, is a goatskin cape worn almost exclusively by married women on ceremonial occasions, although it may be worn once by the young male initiate as he graduates from initiation school (Levinsohn 1984, 116). A curved leather base is overlaid by a large rectangular beaded piece, attached at the top. Small white beads form the background of the design. They are traditionally sewn on one at a time by pulling the thread through each bead three times to form a strong matrix. The placement of the two geometric designs in red, green, blue, ocher, and yellow between narrow bands of color is characteristic of early patterns dating from around the end of the nineteenth century. At the bottom, below a geometric border and a row of openwork squares, the lacey working of the beaded edge adds a delicate touch.

Beaded garments can be approximately dated by the materials, design, and the colors of the beads. The early examples, made of leather, are of simple design. The beads are very small and predominantly white, with the geometric designs limited to red, green, orange, and blue. More recently, with expanded availability of materials, canvas has largely replaced leather as backing and larger beads of many colors are used in increasingly complex designs.

PROVENANCE: Suzanne Priebatsch, Johannesburg.

BIBLIOGRAPHY

Baines, Thomas

1864 *Explorations in South-West Africa: Being an Account of a Journey in the Years 1861 and 1862 from the Walvisch Bay, on the Western Coast, to Lake Ngami and the Victoria Falls.* London: Longman, Green, Longman, Roberts, and Green.

Barrett, W. E. H.

1911 "Notes on the Customs and Beliefs of the Wa-Giriama, etc., British East Africa." *Journal of the Royal Anthropological Institute of Great Britain and Ireland* 41: 20–39.

Bassani, Ezio

1977 "Kongo Nail Fetishes from the Chiloango River Area." *African Arts* 10 (3): 36–40, 88.

3/86 Personal communication.

Bassani, Ezio, and William B. Fagg

1988 *Africa and the Renaissance: Art in Ivory.* New York: Center for African Art, exh. cat.

Bastin, Marie-Louise

1969 "L'Art d'un Peuple d'Angola/Arts of the Angolan Peoples." *African Arts* 2 (4): 30–37, 74–76.

1978 *Statuettes Tshokwe du Héros Civilisateur "Tshibinda Ilunga."* Arnouville: Arts d'Afrique Noire, supplément au tome 19 (October 1976).

1982 *La Sculpture Tshokwe,* trans. J. B. Donne. Meudon: Alain et Françoise Chaffin.

1984 *Introduction aux Arts d'Afrique Noire.* Arnouville: Arts d'Afrique Noire.

4/86 Personal communication.

Ben-Amos, Paula

1976 "Men and Animals in Benin Art." *Man* 11: 243–252.

1980 *The Art of Benin.* London: Thames and Hudson.

5/86 Personal communication.

Ben-Amos, Paula, and Arnold Rubin, eds.

1983 *The Art of Power, the Power of Art: Studies in Benin Iconography.* Los Angeles: Museum of Cultural History, University of California, Monograph Series, no. 19, exh. cat.

Bertrand, Alfred

1898 *Au Pays des Ba-Rotsi, Haut-Zambeze.* Paris: Hachette et cie.

Biebuyck, Daniel

1973 *Lega Culture: Art, Initiation, and Moral Philosophy Among a Central African People.* Berkeley: University of California Press.

1985 *The Arts of Zaire.* vol. 1. Berkeley: University of California Press.

Binkley, David

1988 *A View from the Forest: The Power of Southern Kuba Initiation Masks.* Ann Arbor: University Microfilms International, microfiche.

1990 Personal communication.

Blackmun, Barbara

10/86 Personal communication.

Boone, Sylvia Arden

1986 *Radiance from the Waters: Ideals of Feminine Beauty in Mende Art.* New Haven: Yale University Press.

Borgatti, Jean, and Richard Brilliant

1990 *Likeness and Beyond: Portraits from Africa and the World.* New York: Center for African Art, exh. cat.

Bourgeois, Arthur P.

1984 *Art of the Yaka and Suku,* trans. J. B. Donne. Meudon: Alain et Françoise Chaffin.

1985 *The Yaka and the Suku.* Leiden: Brill.

4/86 Personal communication.

Boyle, Frederick

1874 *Through Fanteeland to Coomassie: A Diary of the Ashantee Expedition.* London: Chapman and Hall.

Bravmann, René A.

1973 *Open Frontiers: The Mobility of Art in Black Africa.* Seattle: University of Washington Press, Index of Art in the Pacific Northwest, no. 5., exh. cat.

1974 *Islam and Tribal Art in West Africa.* London: Cambridge University Press, African Studies Series 11.

2/87 Personal communication.

Brottem, Bronwyn V., and Ann Lang

1973 "Zulu Beadwork." *African Arts* 6 (3): 8–13, 64, 83.

Brown, Jean Lucas

1980 "Miji Kenda Grave and Memorial Sculptures." *African Arts* 13 (4): 36–39, 88.

Celenko, Theodore

1983 *A Treasury of African Art from the Harrison Eiteljorg Collection.* Bloomington: Indiana University Press.

Chauvet, Stephen

1929 *Musique Nègre.* Paris: Société d'Editions Géographiques, Maritimes et Coloniales.

Cole, Herbert M.

1989 *Icons: Ideals and Power in the Art of Africa.* Washington, D.C.: National Museum of African Art, exh. cat.

Cole, Herbert M., and Chika L. Aniakor

1984 *Igbo Arts: Community and Cosmos.* Los Angeles: Museum of Cultural History, University of California, exh. cat.

Cole, Herbert M., and Doran H. Ross

1977 *The Arts of Ghana.* Los Angeles: Museum of Cultural History, University of California, exh. cat.

Conner, Michael W.

9/86 Personal communication.

Conner, Michael W., and Diane Pelrine

1983 *The Geometric Vision: Arts of the Zulu.* West Layfayette: Purdue University Galleries, exh. cat.

Cornet, Joseph

1971 *Art of Africa: Treasures from the Congo,* trans. Barbara Thompson. London: Phaidon Press.

1975 *Art from Zaire: 100 Masterworks from the National Collection; An Exhibition of Traditional Art from the Institute of National Museums of Zaire,* trans. Irwin Hersey. New York: African-American Institute, exh. cat.

1978 *A Survey of Zairian Art: The Bronson Collection,* trans. Matt McGaughey. Raleigh: North Carolina Museum of Art, exh. cat.

1981 Catalogue entries in *For Spirits and Kings: African Art from the Paul and Ruth Tishman Collection,* ed. Susan M. Vogel, pp. 205–206. New York: Metropolitan Museum of Art, exh. cat.

1985 *Art Royal Kuba.* Milan: Edizioni Sipiel (orig. pub. 1982).

Courtney-Clarke, Margaret

1986 *Ndebele: The Art of an African Tribe.* New York: Rizzoli.

Crownover, D.

1964 "Ashanti Soul-Washer Badge." *Expedition: Journal of the University Museum of the University of Pennsylvania* 6 (2): 10–13.

Cummings, Frederick J.

1970 *The Tannahill Paintings: The Robert Hudson Tannahill Bequest to the Detroit Institute of Arts.* Detroit: The Detroit Institute of Arts, exh. cat.

Davidson, Basil

1966 *African Kingdoms.* New York: Time-Life Books, Great Ages of Man.

Delange, Jacqueline

1974 *The Art and Peoples of Black Africa.* New York: C.P. Dutton.

DeMott, Barbara

1982 *Dogon Masks, A Structural Study of Form and Meaning.* Ann Arbor: UMI Research Press, Studies in Fine Arts, Iconography, no. 4.

Detroit

1977 Detroit Institute of Arts, *Detroit Collects African Art,* exh. cat.

Devisch, Renaat

1972 "Signification Socio-Culturelle des Masques chez les Yaka." *Boletim Instituto de Investigacao Cientifica de Angola* 9 (2): 151–176.

Dewey, William J.

1986 "Shona Male and Female Artistry." *African Arts* 19 (3): 64–67, 84.

6/86 Personal communication.

Doke, Clement M., and B. Wallet Vilakazi

1958 *Zulu-English Dictionary.* Johannesburg: Witwatersrand University Press.

Drewal, Henry John

1974 "Gelede Masquerade: Imagery and Motif." *African Arts* 7 (4): 8–19, 62.

1977 *Traditional Art of the Nigerian Peoples: The Milton D. Ratner Family Collection.* Washington, D. C.: National Museum of African Art, exh. cat.

1980 *African Artistry: Technique and Aesthetics in Yoruba Sculpture.* Atlanta: High Museum of Art, exh. cat.

1990 Personal communication.

Drewal, Henry John, and Margaret Thompson Drewal

1975 "Gelede Dance of the Western Yoruba." *African Arts* 8 (2): 36–45, 78.

1983 *Gelede: Art and Female Power Among the Yoruba.* Bloomington: Indiana University Press.

Drewal, Henry John, and John Pemberton III with Rowland Abiodun

1989 *Yoruba: Nine Centuries of African Art and Thought.* New York: Center for African Art, exh. cat.

Drewal, Margaret Thompson

1977 "Projections from the Top in Yoruba Art." *African Arts* 11 (1): 43–49.

Duponcheel, Christian

1980 *Masterpieces of the Peoples Republic of the Congo.* New York: African-American Institute, exh. cat.

Dupuis, Joseph

1824 *Journal of a Residence in Ashantee.* London: H. Colburn.

Edwards, Joan

1967 *Bead Embroidery.* New York: Taplinger Publishing Co.

Ehrlich, Martha

11/86 Personal communication.

Eyo, Ekpo

1977 *Two Thousand Years Nigerian Art.* Lagos, Nigeria: Federal Department of Antiquities.

Eyo, Ekpo, and Frank Willett

1980 *Treasures of Ancient Nigeria.* New York: A. Knopf.

Ezra, Kate

1983 *Figure Sculpture of the Bamana of Mali.* Ann Arbor: University Microfilms, microfilm.

1986 *A Human Ideal in African Art: Bamana Figurative Sculpture.* Washington, D.C.: National Museum of African Art, exh. cat.

5/86 Personal communication.

Fagg, William

1959 *Afro-Portuguese Ivories.* London: Batchworth Press.

1965 *Tribes and Forms in African Art.* New York: Tudor.

12/7/75 Letter to the Detroit Institute of Arts.

1978 "A Benin Equestrian Figure." In *Important Tribal Art,* pp. 42–45. London: Christie's sales cat., June 13.

1980 *Masques d'Afrique dans les Collections du Musée Barbier-Müller.* Geneva: Editions Fernand Nathan, L.E.P.

Fagg, William, and Ezio Bassani

3/86 Personal communication.

Fagg, William, John Pemberton III, and Bryce Holcombe

1982 *Yoruba Sculpture of West Africa.* New York: Knopf.

Fagg, William, and Margaret Plass

1964 *African Sculpture: An Anthology.* London: Studio Vista.

Felix, Marc Leo

8/86 Personal communication.

Fernandez, James W.

1966 "Principles of Vitality and Opposition in Fang Aesthetics." *The Journal of Aesthetics and Art Criticism* 25 (1): 53–64.

1973 "The Exposition and Imposition of Order: Artistic Expression in Fang Culture." In *The Traditional Artist in African Societies,* ed. Warren L. d'Azevedo, pp. 194–220. Bloomington: Indiana University Press.

1982 *Bwiti: An Ethnography of the Religious Imagination in Africa.* Princeton: Princeton University Press.

Fernandez, James W., and R. L. Fernandez

1975 "Fang Reliquary Art: Its Quantities and Qualities." *Cahiers d'Etudes Africaines* 15 (4): 723–746.

Fischer, Eberhard

1978 "Dan Forest Spirits: Masks in Dan Villages." *African Arts* 11 (2): 16–23, 94.

6/86 Personal communication.

Fischer, Eberhard, and Hans Himmelheber

1975 *Gold aus Westafrika.* Zurich: Museum für Völkerkunde in zusammenarbeit mit dem Museum Rietberg.

1984 *The Arts of the Dan in West Africa,* trans. Anne Buddle, ed. Susan Curtis. Zurich: Museum Rietberg, exh. cat. (orig. pub. *Die Kunst der Dan,* 1976).

Fischer, Eberhard, and Lorenz Homberger

1985 *Die Kunst der Guro, Effenbeinküste.* Zurich: Museum Rietberg.

Flam, Jack D.

1971 "The Symbolic Structure of Baluba Caryatid Stools." *African Arts* 4 (2): 54–59.

Forman, Werner, Bedrich Forman, and Philip Dark

1960 *Benin Art.* London: Paul Hamlyn.

Fraser, Douglas

1972 "The Symbols of Ashanti Kingship." In *African Art and Leadership,* eds. Douglas Fraser and Herbert M. Cole, pp. 137–152. Madison: University of Wisconsin Press.

Fraser, Douglas, and Herbert M. Cole, eds.

1972 *African Art and Leadership.* Madison: University of Wisconsin Press.

Garrard, Timothy F.

1989 *Gold of Africa: Jewellery and Ornaments from Ghana, Côte d'Ivoire, Mali, and Senegal in the Collection of the Barbier-Mueller Museum.* Munich: Prestel.

Geary, Christraud

1983 *Things of the Palace: A Catalogue of Bamum Palace Museum in Foumban (Cameroon).* Wiesbaden: F. Steiner Verlag, Studien zur Kulturkunde.

4/86 Personal communication.

1992 "Elephants, Ivory, and Chiefs: The Elephant and the Arts of the Cameroon Grassfields." In *Elephant: The Animal and Its Ivory in African Culture,* ed. Doran H. Ross. Los Angeles: Fowler Museum of Cultural History, University of California, Los Angeles, exh. cat.

Gebauer, Paul

1979 *Art of the Cameroon.* Portland: Portland Museum of Art.

Glaze, Anita J.

1981 *Art and Death in a Senufo Village.* Bloomington: Indiana University Press.

1986 "Dialectics of Gender in Senufo Masquerades." *African Arts* 19 (3): 30–39.

7/86 Personal communication.

Goldwater, Robert

1960 *Bambara Sculpture from the Western Sudan.* New York: The Museum of Primitive Art.

Griaule, Marcel

1963 *Masques Dogon.* Paris: Institut d'Ethnologie, Musée de l'Homme (orig. pub. 1938).

Grossert, John Watt

1978 *Zulu Crafts.* Peitermaritzburg, South Africa: Shuter and Shooter.

Grunne, Bernard de

8/86 Personal communication.

1987 "From Prime Objects to Masterpieces." In *Rediscovered Masterpieces of African Art,* ed. Gérald Berjonneau, pp. 15–38. Boulogne: Art 135.

1991 "Heroic Riders and Divine Horses: An Analysis of Ancient Soninke and Dogon Equestrian Figures from the Inland Niger Delta Region in Mali." *The Minneapolis Institute of Arts Bulletin* 66: 79–96.

Harley, George W.

1950 *Masks as Agents of Social Control in Northeast Liberia.* Cambridge, Mass.: Peabody Museum, Papers of the Peabody Museum of American Archaeology and Ethnology, Harvard University, 32 (2).

Harter, Pierre

7/86 Personal communication.

Himmelheber, Hans

1972 "Gold-Plated Objects of Baule Notables." In *African Art and Leadership,* eds. Douglas Fraser and Herbert M. Cole, pp. 185–208. Madison: University of Wisconsin Press.

Holý, Ladislav

1967 *Masks and Figures from Eastern and Southern Africa.* London: Paul Hamlyn.

Hommel, William L.

1974 *Art of the Mende.* College Park: University of Maryland, exh. cat.

Jacob, Mary Jane

1976 "The Modern Art Gallery 1932–1941." In *Arts and Crafts in Detroit 1906–1976: The Movement, the Society, the School,* pp. 155–211. Detroit: Detroit Institute of Arts, exh. cat.

Johnson, M. A.

1980 "Black Gold: Goldsmiths, Jewelry, and Women in Senegal." Ph.D. dissertation, Stanford University.

Jones, G. I.

1973 "Sculpture of the Umuahia Area of Nigeria." *African Arts* 6 (4): 58–63, 96.

Jonghe, Edouard de

1949 *Les Formes d'Asservissement dans les Sociétés du Congo Belge.* Brussels: de Rodeval.

Kan, Michael

1977 "Detroit Collects African Art." *African Arts* 10 (4): 24–31.

Karpinski, Peter

1984 "A Benin Bronze Horseman at the Merseyside County Museum." *African Arts* 17 (2): 54–62, 88–89.

Keim, Curtis

8/86 Personal communication.

Kennedy, Carolee G.

7/86 Personal communication.

Knight, Natalie, and Suzanne Priebatsch

1983 *Ndebele Images.* Johannesburg: Natalie Knight Gallery, exh. cat.

Koloss, Hans-Joachim

1990 *Art of Central Africa: Masterpieces from the Berlin Ethnographic Museum.* New York: Metropolitan Museum of Art, exh. cat.

Krige, Eileen

1950 *The Social System of the Zulus.* Pietermaritzburg, South Africa: Shuter and Shooter.

Kyerematen, A. A. Y.

1964 *Panoply of Ghana: Ornamental Art in Ghanaian Tradition and Culture.* New York: Praeger.

Lallemand, Suzanne

1973 "Symbolisme des poupées et acceptation de la maternité chez les Mossi." *Objets et Mondes* 13 (4): 325–346.

Lamp, Frederick

1979 *African Art of the West Atlantic Coast: Transition in Form and Content.* New York: L. Kahan Gallery, exh. cat.

Lehuard, Raoul

1986 Personal communication.

Levinsohn, Rhoda

1984 *Art and Craft of Southern Africa: Treasures in Transition.* Craighall: Delta Books.

London

1991 Sotheby's. *Important Tribal Art.* Sales cat., June 17.

Luschan, F. von

1919 *Die Altertümer von Benin.* 3 vols. Berlin.

McIntosh, Susan Keech, and Roderick J. McIntosh

10/78 Letter to the Detroit Institute of Arts.

1980 "Jenné-Jeno: An Ancient African City." *Archaeology* 33 (1): 8–44.

McKesson, John A., III

1982 "Evolution of Fang Reliquary Sculpture." M.A. thesis, Columbia University.

1987 "Réflexions sur la sculpture fang." *Arts d'Afrique Noire* 63: 7–20. Correction: "A

Propos de la Sculpture Fang." *Arts d'A-frique Noire* 64: 28–29.

McLeod, M. D.

1981 *The Asante.* London: British Museum, exh. cat.

McNaughton, Patrick

1979a "Bamana Blacksmiths." *African Arts* 12 (2): 65–71.

1979b *Secret Sculptures of the Komo: Art and Power in Bamana (Bambara) Initiation As-sociations.* Philadephia: Institute for the Study of Human Issues, Working Pa-pers in Traditional Arts 4.

1980 *The Bamana Blacksmiths: A Study of Sculptors and Their Art.* Ann Arbor: Uni-versity Microfilms, microfiche.

1988 *The Mande Blacksmiths: Knowledge, Power, and Art in West Africa.* Blooming-ton: Indiana University Press.

Maesen, Albert

2/82 Personal communication.

Merriam, Alan P.

1974 *An African World: The Basongye Village of Lupua Ngye.* Bloomington: Indiana Uni-versity Press.

Mestach, Jean Willy

7/86 Personal communication.

Micots, Cory

1994 "Warriors, Chiefs, and Composite Ani-mals: An Ivory Bracelet Attributed to Owo, Nigeria." *Bulletin of the Detroit In-stitute of Arts* 68 (3): 16–25.

Miller, Thomas Ross

1990 "Collecting Culture: Musical Instru-ments and Musical Change." In *African Reflections: Art from Northeastern Zaire,* ed. Enid Schildkraut and Curtis A. Keim, pp. 209–215. New York: Ameri-can Museum of Natural History, exh. cat.

Murdock, George Peter

1959 *Africa: Its People and Their Culture His-tory.* New York: McGraw-Hill Book Co.

Needham, Rodney, ed.

1973 *Right and Left: Essays on Dual Symbolic Classification.* Chicago: University of Chicago Press.

Nettleton, Anitra

8/86 Personal communication.

Nevadomsky, Joseph

1986 "The Benin Bronze Horseman as the Ata of Idah." *African Arts* 19 (4): 40–47, 85.

New York

1935 M. Knoedler and Company. *Bronzes and Ivories from the Old Kingdom of Benin.* exh. cat.

1978 The Friends of the Bronx Community Art Gallery, *Mortuary Posts of the Giry-ama,* exh. cat.

1966 Parke-Bernet Galleries. *African and Oce-anic Art: The Collection of Helena Rubin-stein, Parts 1 and 2.* Sales cat., April 21, 29.

Neyt, François

1981 *Traditional Arts and History of Zaire: For-est Cultures and Kingdoms of the Savan-nah.* Brussels: Société d'Arts Primitifs.

Nooter, Mary (Polly) H.

1984 "Luba Leadership Arts and the Politics of Prestige." M.A. Thesis, Columbia University.

1991 *Luba Art and Statecraft: Creating Power in a Central African Kingdom.* Ph.D. diss., Columbia University. Ann Arbor, Mich.: University Microfilms.

1992 "Fragments of Forsaken Glory: Luba Royal Culture Invented and Repre-sented 1883–1992." In *Kings of Africa: Art and Authority in Central Africa,* ed. Erna Beumers and Hans-Joachim Koloss. Berlin: Museum für Völkerkunde, exh. cat.

Nooter, Nancy Ingram

1984 "Zanzibar Doors." *African Arts* 17 (4): 34–39, 96.

Northern, Tamara

1975 *The Sign of the Leopard: Beaded Art of Cameroon.* William Benton Museum of Art. Storrs: University of Connecticut, exh. cat.

1984 *The Art of Cameroon.* Washington: Smithsonian Institution, exh. cat.

7/86 Personal communication.

Ojo, J. R. Olefumi

1978 "The Symbolism and Significance of Epa-Type Masquerade Headpieces." *Man* 13: 455–470.

Olbrechts, Frans M.

1946, 1959, 1982 *Congolese Sculpture.* New Haven: Human Relations Area Files.

1959 *Les Arts plastiques du Congo belge.* Brus-sels: Editions Erasme.

Overbergh, Cyrille van, and Edouard de Jonghe

1909 *Les Mangbetu.* Brussels: A de Wit.

Pacques, Viviana

1956 "Les Samake." *Institut Français d'Afrique Noire Bulletin,* Series B, 18 (3–4): 369–390.

Paris

1932 Musée d'Ethnographie, *Exposition des Bronzes et Ivoires du royaume de Bénin,* exh. cat.

Paudrat, Jean-Louis

1984 "From Africa." In *"Primitivism" in 20th Century Art: Affinity of the Tribal and the Modern,* vol. 1, ed. William Rubin. New York: Museum of Modern Art, exh. cat.

Peck, William H.

1991 *The Detroit Institute of Arts: A Brief His-tory.* Detroit: Detroit Institute of Arts.

Pemberton, John, III

1977 "A Cluster of Sacred Symbols: Orisha Worship Among the Igbomina Yoruba of Ila-Orangun." *History of Religions* 7 (3): 1–28.

1980 Catalogue entries in *Yoruba Beadwork: Art of Nigeria,* ed. William B. Fagg. New York: Rizzoli.

9/86 Personal communication.

Perrois, Louis

1972 *La Statuaire fan, Gabon.* Paris: ORS-TOM, Memoires no. 59.

1979 *Arts du Gabon: les arts plastiques du bassin de l'Oquoué.* Arnouville: Arts d'Afrique Noire.

1980 Catalogue entries in *For Spirits and Kings: African Art from the Paul and Ruth Tishman Collection,* ed. Susan M. Vogel. New York: Metropolitan Museum of Art.

1985 *Ancestral Art of Gabon from the Collections of the Barbier-Müller Museum.* Dallas: Dallas Museum of Art, exh. cat.

6/86 Personal communication.

1992 *Byeri Fang: Sculptures d'ancêtres en Afrique.* Marseilles: Musée d'Arts Africains, Océaniens, Amerindiens, exh. cat..

Perrois, Louis, and M. Sierra Delage

1990 *The Art of Equatorial Guinea: The Fang Tribes.* New York: Rizzoli.

Phillips, Ruth B.

1978 "Masking in Mende *Sande* Society Initiation Rituals." *Africa* 48 (3): 265–277.

1980 "The Iconography of the Mende Sowei Mask." *Ethnologische Zeitschrift* 1: 113–132.

12/94 Personal communication.

1995 *Representing Woman: Sande Society Masks of the Mende.* Los Angeles: UCLA Fowler Museum of Cultural History.

Pitt-Rivers, Augustus

1900 *Antique Works of Art from Benin.* London: Printed privately (reprinted New York: Dover, 1976).

Plancquaert, M.

1930 *Les Sociétés Secrètes chez les Bayaka.* Louvain: Imprimerie J. Kuyl-Otto.

Preston, George Nelson

1975 "Perseus and Medusa in Africa: Military Art in Fanteland 1834–1972." *African Arts* 8 (3): 36–41, 68–71.

1983 Written communication to the Detroit Institute of Arts.

Priebatsch, Suzanne, and Natalie Knight

1978 "Traditional Ndebele Beadwork." *African Arts* 11 (2): 24–27.

Prussin, Labelle

10/78 Letter to the Detroit Institute of Arts.

Richards, J. V. O.

1974 "The Sande: A Social-Cultural Organization in the Mende Community in Sierra Leone." *Baessler-Archiv* 22 (2): 265–281.

1974 "The Sande Mask." *African Arts* 7 (2): 48–51.

Richardson, E. P.

1960 *Treasures from the Detroit Institute of Arts.* Detroit: Detroit Institute of Arts.

Robbins, Warren, and Nancy Nooter

1989 *African Art in American Collections.* Washington, D.C.: Smithsonian Institution Press.

Roberts, Allen F.

1995 *Animals in African Art: From the Familiar to the Marvelous.* New York: Museum for African Art, exh. cat.

Ross, Doran H.

5/86 Personal communication.

Roy, Christopher D.

1979 *African Sculpture: The Stanley Collection.* Iowa City: University of Iowa Museum of Art, exh. cat.

1981 "Mossi Dolls." *African Arts* 14 (4): 47–51, 88.

1985 *Art and Life in Africa: Selections from the Stanley Collection.* Iowa City: University of Iowa Museum of Art, exh. cat.

Rubin, Arnold

5/86 Personal communication.

Ryder, A. F. C.

1969 *Benin and the Europeans, 1485–1897.* London: Harlow, Longmans.

Schildkraut, Enid, and Curtis A. Keim

1990 *African Reflections: Art from Northeastern Zaire.* New York: American Museum of Natural History, exh. cat.

Schmalenbach, Werner

1954 *African Art.* New York: MacMillan Company.

Schneider, Elizabeth Ann (Betty)

1973 "Body Decoration in Mozambique." *African Arts* 6 (2): 26–31.

1986 "Ndebele Mural Art." *African Arts* 18 (3): 60–67.

Schweinfurth, Georg A.

1874 *The Heart of Africa: Three Years' Travels and Adventures in the Unexplored Regions of Central Africa from 1868 to 1871,* trans. Ellen E. Frewer. New York: Harper and Brothers.

Sieber, Roy

1972 *African Textiles and Decorative Arts.* New York: Museum of Modern Art, exh. cat.

1980 *African Furniture and Household Objects.* Bloomington: Indiana University Press, exh. cat.

Sieber, Roy, and Roslyn Adele Walker

1987 *African Art in the Cycle of Life.* Washington, D. C.: National Museum of African Art, exh. cat.

Siroto, Leon

1953 "A Note on Guro Sculpture." *Man* 53: 17–18.

1979 "A *Kigangu* Figure from Kenya." *Bulletin of the Detroit Institute of Arts* 57 (3): 105–113.

Söderberg, Bertil

1974 "Les sifflets sculptés du Bas-Congo." *Arts d'Afrique Noire* 9: 25–44.

1975 "Les figures d'ancêtres chez les Babembé." *Arts d'Afrique Noire* 14: 14–37.

7/86 Personal communication.

Sousberghe, Leon de

1958 *L'Art Pende.* Gembloux: Editions J. Duculot, S.A.

Stössel, Arnulf

1985 "Recent Exhibitions: Afrikanische Keramik." *African Arts* 18 (4): 58–59.

Sweeney, James J., ed.

1935 *African Negro Art.* New York: Museum
 of Modern Art, exh. cat.

Tessman, Günter

1913 *Die Pangwe.* Berlin: E. Wasmuth.

Thompson, Robert Farris

1971 *Black Gods and Kings: Yoruba Art at
 UCLA.* Los Angeles: Museum and Labo-
 ratories of Ethnic Arts and Technology,
 Occasional Papers, no. 2.

1974 *African Art in Motion: Icon and Art in the
 Collection of Katherine Coryton White.* Los
 Angeles: University of California, exh.
 cat.

1978 "The Grand Detroit N'Kondi." *Bulletin
 of the Detroit Institute of Arts* 56 (4):
 207–221.

Thompson, Robert Farris, and Joseph Cornet

1981 *The Four Moments of the Sun: Kongo Art in
 Two Worlds.* Washington, D.C.: Na-
 tional Gallery of Art, exh. cat.

Timmermans, Paul

1966 "Essai de typologie de la sculpture des
 Bena Luluwa du Kasai." *Africa Tervuren*
 12 (1): 17–27.

Tunis, I.

1979 "Cast Benin Equestrian Statuary." *Baes-
 sler-Archiv* 27 Neue Folge (2): 389–416.

Valentiner, W. R., and Clyde H. Burroughs

1927 *A Guide to the Collection of the Detroit In-
 stitute of Arts.* Detroit: Detroit Institute
 of Arts.

Vansina, Jan

1955 "Initiation Rituals of the Bushong." *Af-
 rica* 25 (2): 138–153.

1978 *The Children of Woot: A History of the
 Kuba Peoples.* Madison: University of
 Wisconsin.

7/86 Personal communication.

Vogel, Susan M.

1977 *Baule Art as the Expression of a World
 View.* Ann Arbor: University Micro-
 films, microfilm.

1986 *African Aesthetics: The Carlo Monzino Col-
 lection.* New York: Center for African
 Art, exh. cat.

1/87 Personal communication.

1991 "Always True to the Object in Our Fash-
 ion." In *Exhibiting Cultures: The Poetics
 and Politics of Museum Display,* ed. Ivan
 Karp and Steven D. Lavine, pp. 191–
 204. Washington, D.C.: Smithsonian In-
 stitution Press.

Vogel, Susan M., ed.

1981 *For Spirits and Kings: African Art from the
 Paul and Ruth Tishman Collection.* New
 York: Metropolitan Museum of Art,
 exh. cat.

Vogel, Susan M., and Francine N'Diaye

1985 *African Masterpieces from the Musée de
 l'Homme.* New York: Center for African
 Art, exh. cat.

Volavka, Zdenka

1972 "Nkisi Figures of the Lower Kongo." *Af-
 rican Arts* 5 (2): 52–59, 84.

Warren, Dennis M.

1975 "Bono Royal Regalia." *African Arts* 8
 (2): 16–21.

Wembah-Rashid, J. A. R.

1971 "Isinyago and Midimu: Masked Danc-
 ers of Tanzania and Mozambique." *Afri-
 can Arts* 4 (2): 38–44.

Willet, Frank

1971 *African Art.* New York: Praeger.

Wolfe, Ernie, III

1979 *An Introduction to the Arts of Kenya.*
 Washington, D.C.: National Museum
 of African Art, exh. cat.

1981 *Vigango: The Commemorative Sculpture of
 the Mijikenda of Kenya.* Bloomington: Af-
 rican Studies Program, Indiana Uni-
 versity.

INDEX

Diotima, the titling typeface used in this book, is a classically proportioned letterform designed by Gudrun Zapf. The text type used for the catalogue of the book is Dante, designed by Giovanni Mardersteig. The book was typeset by Graphic Composition, Inc., in Athens, Georgia, and printed on 100 lb. Gardamatt Brillante by Amilcare Pizzi, s.p.a.—arti grafiche in Milan, Italy.